EMIL NOLDE

Robert Pois
University of Colorado

UNIVERSITY
PRESS OF
AMERICA

Library of Congress Catalog Card Number: 81-43498

This Book is dedicated to the most important women in
my life:

My mother, Rose Tomarkin Pois (1906-1981)
My wife, Anne Marie Pois
Daughters Haia Rebecca, Erica Leah, and Emily
Tamara

Acknowledgments

I am indebted to the American Philosophical Society for a grant enabling me to visit Germany during the summer of 1973, and the Council of Research and Creative work of the University of Colorado for grants in 1979 and 1981 to cover typing and photo reproduction costs. While in Germany, my wife and I stayed as guests of the <u>Stiftung Seebüll Ada und Emil Nolde</u>. The caretakers of the lovely guest-house, Fran and Herr Joachimson, were always courteous and most helpful. To them we owe a great deal and all that we can do is to express our sincere thanks for all that they did to make our stay a pleasurable one. To the Reuthers, Manfred and Brigette, we are immensely thankful for the fine times we had together, for stimulating conversations and a warth of hospitality. Dr. Martin Urban, director of the <u>Stiftung</u>, showed us both kindness and hospitality. We were most appreciative of this. A word of thanks must also be expressed to those unfortunately anonymous and unsung heroes, the unfailingly patient railway personnel, who straightened out innumerable tangles and explained away much confusion. All of those mentioned were extraordinarily tolerant of our German which, even under the best of circumstances, was not exactly fluent.

I am most deeply indebted to Martin Wangh, M.D., and Professor Peter J. Loewenberg, both of whose suggestions and criticisms were of inestimable value in completing this manuscript. Mr. John C. Woodley did an excellent job on photo reproducing the pictures. A draft typed by Ms. Aladeen Smith was especially important and Carol Watson and Ruth Major saw more of the manuscript than they wished to see. My thanks go to all of them. I owe debts to Ms. Sandra Marsh and to Ms. Marcia Elwood who devoted a great deal of time and effort to this manuscript. Ms. Wanda Fuller, a person of truly impressive skills, was responsible for typing the final draft. Without the hard work of all of these people, a piece important at least to me, would have gone exactly nowhere. Editors Helen Hudson and Louise Hohensee of the University Press of America offered guidance and assurance when both were needed in abundance. I must express my gratitude and feelings of deepest respect to my wife, without whose assistance and encouragement this work never could have been completed. Portions of Chapters II, VII, VIII appeared in articles published in April 1968 and April

1972 issues of <u>German Life and Letters</u>, and these
materials have been used in this work with kind
permission of the Editors. Peter H. Selz, <u>German
Expressionist Painting From Its Inception to the First
World War</u> c. 1957 by The Regents of the University of
California is being used with the kind permission of
the Editors of the University of California Press,
while Dr. Martin Urban of the <u>Stiftung Seebüll Ada und
Emil Nolde</u> has most graciously allowed me to quote
extensively from Nolde's four volume autobiography.
Without the assistance and approval of the <u>Stiftung</u>,
this work would not have been possible and I must
express my deepest appreciation to Dr. Urban and his
associates. The DuMont Buchverlag of Cologne has
allowed me to quote generously from Hans Fehr, <u>Emil
Nolde</u>. The Chancellor's office of the University of
Colorado has been extraordinarily generous in
providing funds to cover the costs of typing this
final draft.

Robert A. Pois, Boulder, Colorado

TABLE OF CONTENTS

Page

Introduction ix

List of Illustrations xxx

Chapter 1 The Background for the Rise of 1
 Expressionism
 A. The General European Rebellion Against 1
 Reason
 B. A Brief Look at Germany Between 1870 3
 and 1914

Chapter 2 The German Expressionist Movement 11
 in the Plastic Arts

Chapter 3 The Formative Years: 1867-1901 21

Chapter 4 Emil Nolde: German Expressionist 61
 Painter

Chapter 5 Maturation: 1913-1933 115

Chapter 6 A Psychological Summation 149

Chapter 7 Romanticism, Sentimentalism, and 175
 the Search for the Idealized
 Past

Chapter 8 Nolde and National Socialism 185

Chapter 9 The Psychic Significance of Nolde's 205
 Encounter with Nazism

Chapter 10 Nolde's Significance in German 223
 Cultural History

Epilogue 239

Appendix 245

Bibliography 246

Index 254

Illustrations

Introduction

I have been fascinated for some time with the art of Emil Nolde (1867-1956), one of the best known of the German Expressionists. The forcefulness and dynamism of his works and his incredible achievements in the use of color captured my imagination; and his amazing ability to work in a number of mediums--oils, watercolors, woodcuts, etchings and lithography--is a continuing source of wonder. Another intriguing aspect of Nolde's career, unfortunately, is his involvement with the Nazis, however ephemeral it actually was. As time passed, my interest in Nolde as a figure in German cultural history increased, encompassing both his art and personality.

In a study of this nature, it is perhaps best to describe what the work is not. Strictly speaking, it is not a work on Nolde's art per se nor, except indirectly, on art history. There is discussion of certain of Nolde's works and upon his styles and their development; I am not a trained student of art, however, nor could I pass for an expert art critic. This work is an attempt to understand Nolde as a representative of certain forces and trends in German cultural history. Of primary concern is Nolde's psychological make-up and the degree to which this is representative of psycho-cultural problems arising in the course of German history in particular and, in an admittedly rather attenuated manner, Western history in general. I have utilized the writings of a fair number of individuals concerned with psychology of art and with various psycho-cultural problems in German history in particular and Western history in general. Most of these individuals adhere to an approach which can, in a broad sense, be called Freudian. There are two reasons for my using them: (1) I have found Freud to be of considerable use in historiographical analysis, and (2) Freud's approach to psychogenesis, the etiology of psychic disorders, and the relationship between art and the previous two subjects does appear to answer quite a few questions regarding Nolde.

It is irrelevant to say that Nolde was a complex person because, since the advent of psychoanalysis, everybody is complex. Yet, in a way, this merely makes the conclusion about Nolde all the more poignant. For, in his desperate longings and unfulfillable drives, the artist was a sort of "Jedermann." In his

case, though, his creative gifts allowed him to translate secret longings, the tensions which these produced and, finally, his means of psychic resistance into works of uncannily powerful art. Of course, if one takes any psychological, to say nothing of psychoanalytical, interpretation of art seriously, every artist does the same. Presumably, then, the skilled interpreter can "read" any painting and thus view it as a sort of plastic hieroglyph of the artist's psychological state; or at least that state which predominated when he or she did the work. In focusing on Nolde I am seeking certain conclusions regarding his several psychological states; but, more important, indicating that these states represented prevalent tensions in German society and were responsible for the emergence of a particular "ideology," rather eclectic and unsystematic in Nolde's case, labeled by Fritz Stern as an ideology of "cultural despair."

It is important to realize that Nolde was never consistent in anything, particularly in his ideology. As we shall see, he both loved his parents and hated them; he needed people and wished to be alone. Painting was his way of achieving independence and he thus consciously differentiated between "man" and "artist," yet there was that in him which cried for unity. His tensions and ambiguities were all too human; the creatures "who walked by night" through his spirit were those that haunt the nights and taint the days of all people. The ideational predilections of the lower middle class--the psycho-historical milieu into which he was born--tended to provide for very particular ways in which psychological drives and tensions were translated into social and political concerns. In turn, according to the rather cheerless conclusions of T. W. Adorno, the "German" solution was and is part of a still broader one, an answer termed "Fascist."

Not a systematic "Fascist," much less a "Nazi," Nolde did join the Nazi party, for reasons which will be examined in this study. While they might well have been tormented by the same tensions and contradictions as Nolde, most Nazis did manage to do a far better job of resolving them. Probably until the end of his life, Nolde loved Jews (at times in an almost literal sense) and hated them (also in a literal sense). He loathed the urban, mechanized world which was replacing the rural idyll of his childhood-grounded fantasies; he was also fascinated by the city, however, and was

x

never able to totally reject it, certainly not in his art. For very profound psychological reasons, Nolde sought to identify himself with the primitive; yet the sophisticated world of theater and cabaret was very much his world. For very profound psychological reasons, Nolde was a German nationalist and, to some extent, a racist as well. He was incapable, however, of adhering to the hypothetically inflexible racist strictures of the Nazis, although attempting to do so at one time.

In his art and as a fear-tormented mortal, in his "cultural despair" and in his fierce joy in the living and the sensual, in his so-called "ideology" and in his inability to resolve all contradictions through it, Nolde was very human. His humanity, however, reflects the Germany between 1871 and 1933.

Nolde is testimony to the dangers inherent in lack of self-reflection. Introspective as he often was, Nolde did not and perhaps could not gain a truly meaningful awareness of self. His failure to do so allowed his various drives and tensions to become translated into attitudes and patterns of thought and feeling which led him to embrace political mysticism, the insidious nature of which was amply revealed in the Nazi movement. At times seeking refuge in a depoliticized world of the spirit, Nolde could not avoid politics. Thus, in the life of this truly creative man, we see the futility and the danger of attempting to divide the world between "political" and "non-political." There is a perhaps unfortunate unity tying together the manifold of human experience making it all of one cloth, albeit a cloth of many hues and patterns.

In Nolde's paintings we see some of the concerns of Nolde the man. In his concern for mysticism, in his continuous search for the universal in the particular and for the divine in the mundane, he was part of a German tradition of romanticism that has given so much to Western civilization. There were masked dangers in this mysticism, however, both to Nolde as a person and to Nolde as a representative and molder of German culture. Without his concerns for the mysterious, without his own particular flirtation with the daemonic, what would his art have been like? Can one subject everything to the pitiless scrutiny of reasoned analysis without damaging some of the very bases of culture itself? Mysticism is dangerous in

the political realm, to be sure; but politics is about power, and the existence of power is rationalized to the degree that it serves to protect both culture and the individual's right to partake in it. What do we gain if, in order to protect the field of politics from the dangerous influences of romanticism or mysticism, we demystify everything? If we reduce all that is strange to a prosaic melange of biological drives and societal pressures?

We will probably never be able to demystify everything. Not even those two most perspicacious critics of bourgeois society and its myths, Marx and Freud, ever claimed this as a possibility. Most important of all, for our purposes, is the realization that artistic creativity itself has something irreducible about it. What we can and must do, though, is to be on constant guard that personal mysticism does not become <u>social</u> mysticism, a phenomenon which can only lead to a fundamental and pernicious obfuscation of social ethics and, finally, personal morality. This is no easy task, especially in times of exceptional turmoil, because the line between politics and culture is necessarily a thin one and often non-existent.

No matter how dismal the results are when mysticism becomes translated into politics, the immense genius of Emil Nolde remains as a source of pleasure and admiration for us. While necessarily attempting to understand the psychological and socio-cultural significance of much that is in his works, and even that which did not find expression in them, we can never afford to lose sight of the fact that it is the unexplainable that draws us to Nolde. While the fruits of his genius are in part amenable to investigation, the roots of it had their origin in mystery.

In considering the career of Emil Nolde, I am well aware that several of those characteristics of his art that will be examined in detail--his concern for primitivism as well as such attitudes as a general reaction against urban civilization--were shared by the Expressionist movement in general. Nolde was not the only major German painter who expressed a longing for a simpler time and sought to identify himself with unsophisticated folk. Since the late 19th century, German artists had reacted strongly against the emerging mass/urban age: one of the earliest of the

important contributors to Expressionism, Paula Modersohn-Becker, spent some time around the turn of the century in a rural artist's colony at Worpswede; Ernst Ludwig Kirchner and Max Pechstein patronized a similar establishment at Goppeln. An interest in primitive peoples characterized virtually all of the Expressionists; for example, Otto Müller shared with Nolde a fascination with Gypsies. We must, therefore, ask ourselves the question: if we identify certain characteristics of Nolde, both as painter and as man, as being salient to the spiritual make-up of one who could be drawn to the far right politically, then must we say that Expressionism as a movement--in both its plastic and literary forms--was right wing? Did its concern for primitivism, rebellion against the urban world, and overall tendency towards mysticism make the movement "Fascist" in ideational content? Should the 1937-38 Moscow debate over this subject be reviewed? These are not topics that will be considered in this work. We will not be concerned with applying psychological criteria to the Expressionist movement as a whole, but rather with examining the particular character of one who helped found the Expressionist movement. Most assuredly his paintings were Expressionist in both form and content. Nolde, however, viewed himself as being essentially outside the several Expressionist circles with which he occasionally came in contact; and, considering his distinct background, he had ample reason to feel estranged from his fellow artists.

Nolde was the only one of the Expressionist painters to articulate--however muddled this expression may have been--those unfortunate right-wing phrases which have caused some to identify him as "Nazi." While we will be dealing with Expressionism as a movement in the plastic arts and Nolde's involvement with the Expressionists, primary emphasis necessarily will be placed upon Nolde's particular involvement with several of the primary concerns of Expressionism and the psychic significance of this involvement. For while Expressionism might well have embodied some of the same tensions and potentialities found in Nolde and his works, it was in the troubled life of this self-proclaimed "Northern artist" that these found greatest articulation--with results both ironic and tragic for the painter.

A Word About Methodology

One of the most engaging problems faced by the historian is that of relating the historical individual, whether person or institution, to putative "general" forces or trends of which this individual is part and to which he, she, or it contributes. Indeed, several major schools of historical thought have either dissolved, or at least endured severe criticism, due to their inability to deal sucessfully with this issue.[1] In the past fifteen years there has emerged in the historical discipline a presumably new approach to this problem--the psychohistorical method. Being with good reason the most conservative of those who make their living reflecting on the human condition, historians have often presented bitter resistance to the use of this method. This resistance usually has expressed itself in the following ways: 1) psychohistory has been viewed as a gaudy interloper from some arcane realm called the "natural sciences," and thus it involves a type of hypothesizing uncongenial to the historical approach; and 2) psychohistory, through its necessary grounding in transhistorical categories, e.g., those of the Freudian approach, is indeed anti-historical; and 3) the Freudian method is itself questionable within the field of psychology itself, hence, how can one use it as a guiding principle of historical investigation? All of these important arguments have behind them the accumulated fears and suspicions of people accustomed to seeing their discipline assailed from all sides. Nevertheless, these arguments must be faced.

First of all, historians must come to accept the fact that while the form of hypothesizing might well be different from that employed by so-called "natural," or perhaps even "social" scientists, historians do hypothesize; that indeed it would be exceedingly difficult to see how historians could avoid doing such without relagating their roles to those of almanac feteshists or mnemonic gamesman.[3] A bit of reflection upon the matter will demonstrate that while Sir Isaiah Berlin might well have been right when he suggested that the language of history is, for the most part, that "of ordinary speech," such does not obviate the strong possibility that use of this language can involve employment of such transhistorical categories as "balance of power," "reason of state," or even "revolution."[4] It is in that nexus between necessary transhistorical categories and the individual persons,

events, or institutions that gives them their content that these categories become essential moments of the historical method. Further reflection will demonstrate that the categories of psychology, Freudian or otherwise, can serve the same epistomological function and that it is only the strangeness of these categories and/or various arcane associations which we have with them that prohibits us from utilizing them in this manner. Bearing this in mind, we must ask ourselves the following question: Is it less of a capitulation to "transhistorical forces" (and hence presumably "antihistorical" ones) to utilize a universal category such as "balance of power," the historical meaning of which is defined by manifold time-bound moments, than it is to employ as a phylogenetic category such as the Oedipal Complex in describing the "history" of a person whose historical meaning (in the broad sense) is also defined by time-bound moments?[5]

At times painfully attenuated, the continuing debate over whether or not history can be viewed as being a "science," or at least utilizing methods congenial to the sciences, has produced fairly general agreement that historians do utilize hypotheses and/or generalizations to "guide their investigations."[6] Whether one uses some sort of "universal hypothesis" or a variety of "generlization"--and, as Alan Donagan has pointed out the two are not really the same--the employment of transhistorical categories and hypothesizing of any kind must necessarily go together. The validity of one's hypothesis or generalization (along with the transhistorical categories that must accompany it) depends only upon the nature of the question one chooses to ask of the past; i.e., whether or not the answer provided by a particular approach falls within the boundaries laid out by the question itself.

With regard to the third major objection raised against psychohistory, we can only confirm that the overall "cure record" of Freudian psychoanalysis is not spectacular. Furthermore, one would have to admit that many of Freud's ideas, and those of some of his followers too, were time-and-space-bound and cannot be applied to non-Western cultures or ones located in the distant past. Having said this, it is also obvious that Freud and successors were very much aware of the difficulties involved in affecting cures utilizing the various forms of analysis available to them. This

does not, however, negate their method as a valuable
means of studying the etiology of disorders within
certain societies or of utilizing discoveries made
about "contemporary" Western society as points of
departure for exploring the psychic realms of others.
Also, and this is of signal importance, it should be
obvious that while Freud provided a certain method and
language--Oedipal complex, cathexis, id, ego, super-
ego, etc.--a vast number of psychologists, in many
ways indebted to him, were able to move beyond the
limitations of one man's experience and make
significant discoveries in the areas of history and
aesthetics, never breaking with the underlying means
utilized by Freud to locate the individual within
society and in so doing to describe the relationship
between the two. Psychohistory probably is not any
more "scientific" than any other form of historical
investigation. It is, however, just as legitimate as
any and, by applying new forms of analysis to those
problems revolving around the relationship of the
individual to the general, it certainly can widen and
deepen the countours of our historical understanding.

The question of how the development of a
particular individual reflects broader concerns and
problems of a given society at a particular period of
time is probably one of the most common ones posed and
confronted by the historian. One means of dealing
with this problem is provided by the psychohistorical
method. Psychohistory offers us an approach whose
basic point of departure is that the individual can be
apprehended only in his or her social context. It is
an absurd and perhaps disingenuous argument to suggest
that the psychoanalytical approach is one which is
radically idiographic, i.e., that it ignores broader
units of history such as culture and society.[7]
Indeed, for Freud and all of those who have followed
him, that very singularity or even alienation that
makes a person asocial or anti-social (if one adheres
to the hoary Aristotelian notion of sociability) must
be seen as originating from that trauma created by the
interaction of patterns of social and biophysical
necessity. The notion of man being a "social animal"
was absurd to Freud. The "beast"--if not necessarily
the "animal"--in man were those drives that forever
sought to reman unfettered. Man became man, i.e.,
civilized, through those frail processes of reason
which pushed him to form societies, while
phylogenesis's revenge in the form of neuroses offered
grim testimony to the toll extracted by this process.

Psychohistory sees the individual as being defined by society. Without it, man is not man, and therefore a category such as individuality would have no meaning whatsoever. At the same time, though, differing geographical, environmental, and historical circumstances have created different societies, each of which has forms of psychical and social control unique to it. Thus, an individual "product" of that particular interaction of phylogenesis, psychogenetic drives and time-and-place conditioned forms of control would be expected to mirror both the salient characteristics of the society in question while embodying certain phylogenetically determined reactions to these forms of control.

On the other hand, society is seen as being no larger than the sum of those who comprise it. Thus, while the forms of control characteristic of it are those of the individual writ large, individual pathology produced by them must be seen as social pathology as well. The psychohistorical method cannot accept any qualitative separation between individual and society or, put in a broader context, between the historical individuality and the general manifold of which he is part and to whose evolution he contributes. Thus, the psychohistorical method, while perhaps most often employed in describing a particular individual, is not merely a more exotic form of historical biography.[7] Rather, it is concerned with apprehending the individual in society and further with elucidating those elements that make this person not merely representative of this society but its expression as well. An ordinary historical biography, more often than not, fills the former function, and it has the option of filling the latter; with the psychohistorical method, there is no choice.

Emil Nolde the man and, to some extent, his work are analyzed as being representative of certain basic problems in German history between 1870-1933. The employment of the psychohistorical method determined the way not only in which Nolde and his relationships to German society were analyzed but also the way in which this work was written.

It would be ridiculous to maintain that the incidents considered in this work were not selected with an eye toward a certain method of analysis and the results that could be obtained through its employment. It would be equally ridiculous, however,

to lean too heavily upon disclaimers since every historian does precisely the same thing. Realizing the dangers involved in applying the techniques of Freudian analysis to the life of a person long dead, I have attempted to avoid obvious methodological pitfalls by focusing upon aspects of his life and work which Nolde himself, in his simply written and often tediously self-centered memoirs, emphasized as of importance in describing his relationships with society, friends, art, and, above all, with himself.

Naturally, we will not be satisfied with considering Nolde as he knew and depicted himself but, through a Freudian informed psychohistorical method, seed to draw substantive conclusions about that "Nolde" unknown to himself and the significance(s) of both "known" and "unknown" man and artist as representative of certain profound problems in German cultural history. It should be emphasized here that, in so doing, I have no intention of attempting to draw any links between psychoanalysis and the basic talent of artistic expression. As is well known, Freud himself, in many respects both a very wise and very modest man, denied that psychoanalysis could have anything to say in this area. His method, he declared, "can do nothing towards elucidating the nature of the artistic gift, nor can it explain the means by which the artist works. . .artistic technique."[8] What we can do however, is to attempt to determine why certain concerns or themes appeared with some regularity in Nolde's work and the significance of these themes when viewed in the context of his environment. Of concern here is not Nolde's importance as an artist but as a man. As stated in the introduction, it is here that the psychological (and hence socio-cultural) significance of Nolde, his work, and, of great import, what Nolde could not express in it, can be discerned. When we consider Nolde as he could not have known himself, we are concerned not with an idiographic, and hence, radically non-historical, description of one man and his travails, but rather with one whose very talents allowed him to add another and most substantive dimension to his own, individual life as this life was itself the expression of a given society during a particular segment of time.

Bearing this in mind, consideration of Nolde's significance in German cultural history is not merely "natural" but indeed necessary. When we turn to such

a task, then, we are not doing so in the name of some arcane school of historical thought which, due to the demands of an extrinsic metaphysic, compels us to discover a bond between the particular and the general. The very content of the psychohistorical approach is formed by those concerns and issues correlated to the apprehension of the historical individual within a socio-cultural whole that is partly of his own making.

In one respect, however, utilizing the Freudian approach in studying art presents us with a very singular problem; viz, for Freud, there was no final system regarding aesthetics.[9] Indeed, as Spector points out, Freud's opinions on art seemed to vary a great deal. At times, he admired artists, declaring that they were possessed by "unfathomable" gifts, while at other times he disdained them for their "infantilism" and came down hard upon artistic achievement as being merely a form of sublimated sexuality. At all events, Freud appeared to be insecure with regard to artists and their talents.[10] By seeming to place a great deal of emphasis upon "traces of the artist's sexual or neurotic motives," Freud appeared to have ignored those elements which make art art, i.e., "essential qualities of form and technique."[11] Further, many critics have declared that, in seeming to suggest that artistic creation stems from neurosis, Freudians are being perversely reductionist. In this regard, an important critic has made the following observations: "mental illness and neurotic involvement generally have a negative impact upon creativity."[12]

In any case, even those sympathetic to Freud in particular and Freudian analysis in general have pointed out that, in attempting to discern putative unconscious sources for art, i.e., in emphasizing the roles of sublimation and the pleasure principle, Freudians have placed inordinate emphasis upon the "what and why" of the creative act while ignoring the important question of "how: i.e., those formal elements which provide art with its poignant singularity.[12] Ego-psychologists in particular have called attention to what they see as monumental deficiencies in a method in which consideration of such salient aesthetic elements as form and symbol has been sacrificed in favor of a highly conjectural sublimation hypothesis. For ego-psychologists, the artist had immense ego-strengths. The ego-psychologist

did not view the artist "as the prisoner of his
impulses nor his art as an uncontrolled form of
psychic explosion."[14] Rather, he or she was able to
conscientiously utilize ego activities to direct,
shape, and reshape various impulses and emotions into
aesthetic channels. To be sure, the artist might
well allow himself to be temporarily overwhelmed by
certain regressive, childhood-rooted images. This
was not the same, however, as suggesting that art was
merely the sublimation of crude, brute impulses.
Rather, to use an expression much favored by Ernst
Kris, ego-psychologists viewed art as being
"regression in the service of the ego."[15]
Furthermore, in the eyes of ego-psychologists, the
artist could not have a weak ego, something which
Freud, in his apparent occasional identification of
art and neurosis, seemed to be suggesting. A strong
ego was necessary if the artist were to be able to
submit the self to the powers of the id and at the
same time be able to disengage this self from such
powers.[16]

Indeed, one could maintain that Freud's concern
that art be investigated solely in terms of a sexual
symbolism that draws upon certain problems and
concerns of childhood caused him, and many of his
followers, to have an extremely narrow, almost
provincial view of art. In this regard, the Freudian
hostility toward modern art is well known. With "art
for art's sake," i.e., formalism, coming to
predominate in modern art, they had to see a dimunition
of the appeal provided by subtly hidden symbolism.
"Certainly the art that contains a secret buried in
symbolic dress would be preferable to the average
first generation psychoanalyst's taste."[17] To be
sure, Freudians would insist that all art, in its
efforts to use the representation of reality as a
means towards a psychic end, is "abstract." As the
early Freudian art critic, Hanns Sachs put it, however,
modern "abstract art," while recognizing this, "spoilt
it by carrying it out in an intellectual,
programmatical and, consequently, too one-sided
manner."[18] Viewpoints such as these have seen singled
out as pointing to the inadequacy of Freudian method
with regard to aesthetic analysis.

Yet, even in the face of all of this presumed
evidence, and in full recognition that a formal
Freudian aesthetic is nonexistent, it is evident that,
for many, Freud's impact upon aesthetics has been

enormous. Indeed, for Gardner Murphy, the Freudian influence upon those concerned with "creativeness" and "imagination" represent one of his most substantive influences.[19] Abraham Kaplan, while not formally "ranking" the Freudian influence, went even further than Murphy in declaring that it was in the field of "Esthetics" that the Freudian impact on twentieth-century philosophy had been the greatest. This was so, Kaplan maintained, because Freud recognized that art was created and enjoyed by "real people in their concrete individuality, with biological needs and socialized aspirations acting on materials subject to physical constraints."[20] It is this emphasis upon the artist as concrete individual that is of importance here. As we have noted before, it is grossly erroneous to assume, as many have, that Freud was concerned with an atomized, asymetrical package of inchoate drives and defenses that was the individual "man." Such was not the case. To reiterate Kaplan: a real person was concretely individual through its being characterized by "biological needs and socialized aspirations." Of course, one could maintain that, in emphasizing the role of childhood in counterposing and reconciling these needs and aspirations, Freud and his followers were and are begging the questions. It is of interest to note, however, that even those who have gone beyond Freud or have in large measure rejected his hypotheses (at least with regard to aesthetics) have had a most difficult time overthrowing the fundamental Freudian assertion that the role of childhood must be seen as crucial.

Phyllis Greenacre, one of the most prominent of post-Freudian psychologists, saw some variety of awe-inspiring childhood experience (especially one involving identification with the father "or with a specially powerful godlike father") as being of crucial importance in the germination of artistic talent.[21] Even Louis Fraiberg who, as we have seen, emphasized the centrality of the strong ego in artistic creativity, described creativity in the following manner:

.....a special form of sublimation in which natural endowment facilitates the development of the ego toward mastery of its psychic environment and toward an increasing ability to devote itself to activities which are relatively independent of conflict.[22]

As can well be imagined, Freud, to say nothing of his often more combative followers, would take issues with the notion that any human activity can be "independent of conflict," even in the most relative sense. It is of importance, however, to note that Fraiberg's use of sublimation (even a so-called "special form" of it) in describing the source of artistic creativity certainly approximates the Freudian approach to the subject while, at the same time, implicitly suggesting that the role of childhood concerns and traumas must necessarily be very prominent. After all, while Fraiberg most certainly saw the artistic ego as being a great deal stronger than Freudians would perceive it, the "psychic environment" over which it sought mastery consisted largely of various forms of energy rooted in instinctual sources.[23]

There is another matter of considerable importance which must now be considered. One can hardly gainsay the fact that, for Freud, the ego was a rather frail reed, particularly when compared to the role and character assigned to it not only by ego-psychologists, but by some post-Freudians as well. It must not be overlooked, however, that Freud saw the ego as being of ultimate importance not only with regard to man's ability to live in civilization, but also in the very creation of civilization itself. For Freud, the ultimate purpose of psychoanalysis was the strengthening of the ego, i.e., to make certain that a patient's weakened ego was given back "its mastery over the lost provinces of his mental life."[24] Indeed, throughout Freud's writings one can see that he assumed that the ego had to be and could be strengthened at least to the point where it could confront the harsh demands imposed upon it by id and superego with some hope of success. More particularly, from our point of view, was the very great emphasis placed by Freud upon the singular process of sublimation, the ego-directed means by which sexual instincts are rechanneled into socially acceptable, indeed often culture-building activities. Here, we must focus on a most important statement made by Freud on the subject of aesthetics.

First of all, we must recall that, as noted before, Freud never did develop a comprehensive view on aesthetics in general and on the artist in particular. In A General Introduction to Psychoanalysis, however, which was drawn from lectures

delivered in Vienna in 1915-1917, he presented what many have considered to be a precis of his final position on the subject of art and the artist. Because what was said here is of considerable importance for us, we will examine it at length. For Freud, the artist

> has....an introverted disposition and has not far to go to become neurotic. He is one who is urged on by instinctual needs which are too clamourous; . . . So, like any other with an unsatisfied longing, he turns away from reality and transfers all his interest, and all his libido too, on to the creation of his wishes in the life of phantasy, from which the way might readily lead to neurosis. There must be many factors in combination to prevent this becoming the whole outcome of his development; it is well known how often artists in particular suffer from partial inibition of their capacities through neurosis. Probably their constitution is endowed with a powerful capacity for sublimation and with a certain flexibility in the repressions determining the conflict.[25]

The artist, Freud went on to say, finds his "way back to reality" through being able to represent fantasy to his fellow human beings who long for it, people who ordinarily have to depend on day-dreams for their rather limited fantasy life. The artist, though,

> ...has more at his disposal. First of all he understands how to elaborate his day-dreams, so that they lose that personal note which grates upon strange ears and become enjoyable to others; he knows too how to modify them sufficiently so that their origin in prohibited sources is not easily detected. Further, he possesses the mysterious ability to mould his particular material until it expressed the ideas of his phantasy-life faithfully and then he knows how to attach to the reflections of his phantasy-life so strong a stream of pleasure that, for at time at least, the repressions are out-balanced and dispelled by it.[26]

Though his singular abilities, the artist is able to direct others back "to their own unconscious sources of pleasure, and so reaps their gratitude and

admiration." Thus, through his ability to utilize
fantasy in a creative manner he attains "what before
he could only win in phantasy: honour, power, the
love of women."[27]

In these very significant passages, several
points of view emerge. First of all, we must
recognize that, while Freud saw the artist as being
either potentially or actually neurotic, he
recognized that neurosis had an _inhibiting_ effect on
his work. Critics who have declared that neurosis
played too strong a role in Freud's approach to art
are certainly entitled to that opinion. They must
also recognize, however, that Freud was very well
aware that sickness could make no positive
contribution to artistic creativity. Furthermore,
as we have seen, he placed salient emphasis upon the
artist's unusual ability to sublimate (something he
had done earlier in his 1911 essay on Leonardo da
Vinci), as that which separated him from ordinary,
fantasy-obsessed mortals, and thus upon the ability
of the ego to deal successfully, at least for the
moment, with awesome unconscious forces. Thus,
while the ego might well have been a frail reed for
Freud, it was nonetheless absolutely central to the
development of art.[28] As can be seen from the
lengthy passage quoted above, Freud did not view art
as being composed of raw, undistilled phantasy. It
could not be the direct offspring of solipsistic
concerns--indeed, some of Freud's opposition to modern
art can be explained from this consideration--but had
to be able to arouse empathetic responses from a wide
audience. Here, it is necessary to note that later
supporters and critics of the Freudian approach to
aesthetics could agree that: 1) Freud never placed
inordinate emphasis upon the raw origins of art, and
2) that art, to be art, could never reveal its
unconscious sources.[29]

It is certainly true that Freud and his
followers never came up with an adequate explanation--
nor did they claim to--for why a particular artist
utilized one form or another expression. In this
regard, it is perhaps ironical that the Freudian
school, whose very lexicon, embracing such terms as id,
ego, superego, Oedipal Complex, and so on, points to
a concern for symbolism in a phylogenetic context,
never really thought itself able to deal with this in
the formal context of aesthetics per se and, some
would say, of religion as well. As we have seen, a

good degree of criticism has been directed against the
school because of this, and, as we shall see later on,
Gestalt psychologists do not feel similarly inhibited.
As mentioned before, however, the strength of the
Freudian approach subsists in its efforts to grasp
the individual in his or her concreteness, i.e., as a
nature-bond creature perversely suspended, like an
insect in amber, in a socio-cultural context
necessarily anti-natural in character. The analyst is
thus provided with a method that allows for meaningful
consideration of the artist as a mediator between, on
the one hand, his own and society's unexpressed--and
perhaps unexpressable--fantasy demands, and those
necessary limitations imposed by sociocultural forms
of control and material deficiencies. What is of
importance to Freudians is the artist as messenger.
The content of the message must also be considered,
most particularly as a definite congruence between
artist, his message, and the receptivity of society--
both the origin and goal of what the artist has to
say--is assumed to exist. How the artist comes to
perform the function he does and how--the question of
form--he does it are not and, within the parameters
of the Freudian approach, cannot be considered.
Parenthetically, once again we can see why modern art,
in its increasingly non-representational aspects ever
more formalistic, must have been intensely irritating
to Freud and his followers.

 For purposes of historical analysis, we are
interested in an artist, Emil Nolde, as "messenger,"
i.e., as one who was able to articulate through those
"symbols presented to the artist by the age."[30] As
historians, however, we cannot focus only upon an
artist's "public" efforts--his art in itself--but also,
and more importantly, those drives, concerns, needs,
and fears which could only be partially or
tangentially concretized in plastic form. It is in
this context, in the effort to grasp a creative being
in his socio-cultural environment, that the Freudian
approach, inherently synoptic in character, is of
great value. Formal considerations of art and art
symbolism must necessarily be left to others.
Historical considerations, the creative person and his
own history as part and parcel and reflecting agent of
a cultural unit which "presented" him with historically
conditioned symbols both embodying and masking
phylogentic concerns, fall within the purview of the
Freudian method. Freud and many of his followers
might well have been quaintly provincial in their

biedermeierisch artistic tastes. With regard to the
artist as being a mixture of individual psychic
concerns and zeitgebunden societal phylogenesis,
however, the heuristic value of the Freudian approach
is immense. It is very fortunate that the general
Freudian method outstripped the limitations of its
author.

Notes to "A Word About Methodology:

[1] On this issue, see Robert A. Pois, "Historicism, Marxism and Psychohistory: Three Approaches to the Problem of Historical Individuality", in The Social Science Journal, 13, No. 3 (October 1976).

[2] The first two points were made by Jacques Barzun, in his "History: The Muse and Her Doctor," in The American Historical Review, 77, No. 1 (February 1972). Professor Barzun later expanded his argument in his book, Clio and the Doctors: Psycho-History, Quanto-History and History (Chicago and London, 1974). The last point has been strongly emphasized in David E. Stannard, Shrinking History: On Freud and the Failure of Psychohistory, (New York, 1980).

[3] An excellent discussion of just how historians hypothesize is to be found in Louis O. Mink's "The Autonomy of Historical Understanding," in History and Theory, 5, No. 1 (1966). See particularly his discussion on p. 35.

[4] Pois, "Historicism," pp. 83-84.

[5] Ibid., pp. 84, 88.

[6] Alan Donagan, "Explanation in History," in Patrick Gardiner, ed., Theories of History (New York, 1959), p. 442.

[7] This is Barzun's argument. See especially his discussion of Erik Erickson's Young Man Luther in his book Clio and the Doctors, p. 13.

[8] Sigmund Freud, Autobiography, trans. James Strachey (New York, 1935), p. 133.

[9] Jack J. Spector, The Aesthetics of Freud: A Study of Psychoanalysis and Art (New York and Washington, 1972), p. ix.

[10] Ibid., p. 33.

[11] Ibid., p. 77. In his essay, "Creativity and Encounter," Rollo May has declared that the Freudian analytical method's unwillingness to deal with artistic symbol seriously vitiates its effectiveness as a means of aesthetic analysis. See Rollo May, "Creativity and Encounter," in Hendrik R. Ruitenbeek, The Creative Imagination: Psychoanalysis and the Genius of Inspiration (Chicago, 1965), p. 290.

[12] Ruitenbeek, p. 19.

[13] Ernest S. Wolf, "Saxa Loquuntur: Artistic Aspects of Freud's 'The Aetiology of Hysteria'," in John E. Gedo and George H. Pollock, eds., Freud. The Fusion of Science and Humanism; The Intellectual History of Psychoanalysis; Psychological Issues, Vo., IX, Nos. 2/3, Monograph 34/35, 1976, p. 222.

[14] Louis Fraiberg, "New Views of Art and the Creative Process," in Ruitenbeek, p. 224.

[15] Spector, pp. 108-109.

[16] Fraiburg, p. 226.

[17] Spector, p. 99.

[18] Hanns Sachs, The Creative Unconscious: Studies in the Psychoanalysis of Art (Cambridge, Mass., 1951), pp. 231-231.

[19] Gardner Murphy, "The Current Impact of Freud on American Psychology," in Benjamin Nelson, ed., Freud and the Twentieth Century (New York, 1960), p. 110. Emphasis is Murphy's. On a scale of 1-6, Murphy ranks Freud's impact on these areas as 4.

[20] Abraham Kaplan, "Freud and Modern Philosophy," in ibid., p. 214.

[21] Phyllis Greenacre, "The Childhood of the Artist: Libidinal Phase Development and Giftedness," in Ruitenbeek, p. 179.

[22] Fraiberg, p. 213. Here, Fraiberg is, in large measure, following guidelines laid down by Ernst Kris who, though involved in ego-psychology, was not so radical an ego-psychologist as Fraiberg.

[23] Ibid.

[24] Sigmund Freud, An Outline of Psychoanalysis, Trans. James Strachey (New York, 1969), p. 30.

[25] Sigmund Freud, A General Introduction to Psycho-Analysis, trans. Joan Rivier (Garden City, N.Y., 1943), p. 327. Emphasis is mine.

[26] Ibid., p. 328.

[27] Ibid.

[28] To say nothing, as we have noted, of civilization in general. Critics of Freud certainly have ample reason to be upset, annoyed, or infuriated at the seeming ennui-informed pessimism that characterizes such works as Civilization and its Discontents. However, to overlook or refuse to recognize the very

singular, indeed heroic, position assigned the ego by Freud is indicative either of intellectual dishonesty or of an insouciant disregard for evidence that often accompanies ideological or methodological disagreement. Indeed, the more one examines what Freud in fact had to say about the ego and its critical roles, the more one becomes convinced that differences between him and post-Freudians and ego-psychologists are ones in degree. While these can still be of considerable significance, of course, little is accomplished by exaggerated emphasis upon them.

[29]See Sachs, p. 39 and David Beres, "Communication in Psychoanalysis and in the Creative Process: A Parallel," in Ruitenbeek, pp. 221-222. Beres was writing as a post-Freudian. Louis Fraiberg, the ego-psychologist referred to above, also pointed out that Freud never emphasized the "crude origins" of art or even the secondary stage of "unconscious elaboration." See Ruitenbeek, p. 238.

[30]E. H. Gombrich, "Psychoanalysis and the History of Art," in Nelson, p. 205.

List of Illustrations (Taken from Catalogues)

1. "Before Dawn," 1901. Stiftung Seebüll Ada und Emil Nolde.
2. "Dune Spirits," 1901. Stiftung Seebüll Ada und Emil Nolde.
3. "Homecoming," 1902. Stiftung Seebüll Ada und Emil Nolde.
4. "Spring Indoors," 1904. Stiftung Seebüll Ada und Emil Nolde.
5. "Encounter," 1904. Stiftung Seebüll Ada und Emil Nolde.
6. "Free Spirit," 1906. Stiftung Seebüll Ada und Emil Nolde.
7. "The Last Supper," 1909. Statens Museum for Kunst, Kopenhagen.
8. "Ridicule," 1909. Sammlung Hanna Bekker vom Rath, Hofheim (Taunus).
9. "Pentecost," 1909. Stiftung Seebüll Ada und Emil Nolde.
10. "Vacation Guests," 1911. Brücke-Museum, Berlin.
11. "The Life of Christ," 1911-1912. Stiftung Seebüll Ada und Emil Nolde.
12. "The Fanatic," 1919. Stiftung Seebüll Ada und Emil Nolde.
13. "If you do not Become as Little Children," 1929. Sammlung Ernst Henke, Essen.
14. Emil Nolde: 1867-1956 (Picture taken in 1935). Stiftung Seebüll Ada und Emil Nolde.

Chapter One

The Background for the Rise of Expressionism

A. The General European Rebellion Against Reason

The periods between 1890 and the First World War
was a time in which the depths of the human psyche
were explored with a fervent enthusiasm unknown either
before or since that era. Gustav Le Bon, William
McDougall, Sigmund Freud, Carl Gustav Jung, each
addressed himself to the problem created by the
confrontation between basic human needs or drives and
the forces of that society that had emerged
historically either because or in spite of these
drives. The conclusions obtained or, at least, the
issues raised by those in the psychological sciences
were amplified in the writings of Marcel Proust, Andre
Gide and Frank Wedekind, among others.

In psychology, literature and, as we shall see,
in the plastic arts as well, a new type of man,
seemingly neither homo sapiens nor homo faber, was
emerging, and the cozy Aristotelian bromide of man's
being "a social animal"--one that lent itself to the
support of virtually every established political
philosophy in the Western world--was being relegated
to the status of being just that, an ironic, somewhat
shallow, bromide. In the face of over two hundred
years of generally held faith in human progress and
social ecumenism, pre-World War One writers,
researchers and aestheticians were saying that the
individual man was indeed an island.

What was responsible for this well-nigh
revolutionary conclusion, a conclusion reached by so
many during this time? Students of cultural history
are all pretty much agreed on one important point;
viz., that the emergence of a mass, largely urbanized
(or at least rapidly urbanizing) society was
responsible for the rise of a view of man as being
increasingly alienated, if not atomized, within the
fantasy-molded matrix of his own defensive ego. To be
sure, the Marxists had emphasized earlier the
increasing alientation of man in an industrialized,
bourgeois society. For the Marxists, however, this
was a phenomenon of "Entstehungsgeschichte," i.e.,
that original period of human development and,
presumably, it would disappear when man entered a
classless society ruled by the dictum of "from each

1

according to his ability, to each according to his need." Furthermore, for the Marxists (as for their Idealistic predecessors), man was basically a creative creature of reason. To be sure, bourgeois society, with its pernicious division of labor, had alienated man from his reason by fragmenting him into crude functions. However, man as man, i.e., as the creator of his own history and not as the slave of dehumanizing forces forces seemingly beyond his control, was a reasoning being. The very emergence of a "class consciousness," the product of his increasing awareness of his plight in bourgeois society, seemed, to Marx, to underscore man's ability to apply reason towards the solving of his problems. Marx's emphasis upon, or at least faith in, human reason stamped him as a child of the Enlightenment, yet one whose at least partial adherence to the more organic approach of Hegel allowed him to avoid that at times crass constructivism of the more brittle eighteenth-century French speculators.

For the other "revolutionaries" mentioned above-- e.g., Freud, Le Bon, Jung, etc.--man's alienation was something that (a) could never really be completely overcome (the conclusion of Freud), or (b) could be overcome only through plumbing the depths of mass mob irrationality (Le Bon's solution), or (c) by seeking a type of spiritual transcendence akin to that proffered by nihilistic Eastern philosophies (Jung's solution). At any rate, for these people and their followers, the problem of alienation was not one that could be solved by conscious application of human reason to human problems.

Thus, the development of the mass society was responsible for two revolutionary groups: the Marxists who called for social revolution; and the psychologists and writers, who seemed to be positing an ontological revolution, one in which a sort of social stasis emerged by default. In the twentieth century, it would appear that the second group of revolutionaries have had the greatest impact upon Western society. Either out of an innate inability to do so, or out of an unwillingness to recognize or to confront the inequities of bourgeois society ("false consciousness"), Western man, more often than not, has fallen back upon political philosophies and solutions either irrational or atavistic. The poignant history of man in the twentieth century society seems to have confirmed the views of the revolutionary irrationalists.

It is against this background of general Western developments that the emergence of German Expressionism in the plastic arts has to be seen. For, as we shall see, it too was a reaction against, or at least response to, the emergence of modern, mass society. Naturally, German Expressionists would not be concerned with any sort of scientific or even empirical approach to the problems of alienation and the mass society. In fact, unlike either Freud or Le Bon, who were disturbed by the irrational even while testifying to its efficacy in human life, the Expressionists would rejoice in it. It is important to remember that the Expressionists were part of the general European questioning of reason that characterized the period between 1890 and the First World War. The Expressionists would be one with social scientists, psychologists and writers, all of whom despaired of mass society and hoped to explain its ills and/or seek ways to escape them. While some Expressionists would be pessimistic, others would temper their pessimism with speculations of an irrational, utopian nature. As will be shown, Emil Nolde was of the latter persuasion.

B. A Brief Look at Germany Between 1870 and 1914

All of the problems and issues mentioned above seemed to have been written largely in Germany. This land, unified so late in comparison to the established nation-states of Western Europe, also enjoyed--or suffered--an extremely rapid economic development, accompanied, as it had to have been, by extremely rapid social change. Marked industrial expansion plus attendant urbanization was changing the face of Germany, once the supposed rural idyll of poets and philosophers.

Pre-1848 Germany was still largely a rural area. Around 61 percent of its population of approximately 33 million were still engaged in agricultural or forestry occupations in 1843.[1] By 1882, this figure had fallen to 42.3 percent, while the percentages involved in industries and crafts and commerce and communications had risen from 23.4 percent to 35.5 percent and from approximately 2 percent to 8.4 percent respectively.[2] By 1907, the percentage of those involved in agriculture or forestry had fallen to 34 percent of the working population, while 39.7 percent worked in industry and crafts, 13.7 percent in commerce and communications, the remainder in services,

3

public and private.[3] Between 1870 and 1900 the population of Berlin more than doubled, from 774,498 to 1,888,313, as did that of the important trade and commerce port, Hamburg (from 308,446 to 721,744). An even more spectacular index of urban and industrial growth was the population increase of Essen. In 1870, this Ruhr steel city contained 99,887 inhabitants. By 1900, its population had almost tripled, rising to 290,208. The population of the important Saxon commercial and industrial center of Leipzig also almost tripled: from 177,818 in 1870, to 519,726 in 1900.[4] Naturally, the total percentage of the German population living in rural areas fell accordingly, from 63.9 percent in 1871 to 45.6 percent in 1900.[5] Germany had obtained its first railroad in 1835, a twelve kilometer stretch linking the Bavarian cities Nürnberg and Fürth. Railroad growth was rapid and, in ten years, there were approximately 2,300 kilometers of track in Germany.[6] Germany, however, starting out late and, despite the role of the <u>Zollverein</u>, still relatively disunited, was still far behind the railraods of Great Britain and France in total mileage. Yet by the time of unification, Germany was in the midst of an economic expansion unprecedented in Europe.

By 1905, Germany had 56,480 kilometers of railroad tracks, the largest rail network in Europe.[7] In 1871, Germany's output of pig iron totalled 1,564,000 metric tons, while that of Great Britain was 6,500,000. By 1900, Germany's output was 8,520,390 metric tons, barely behind Great Britain's 9,052,107. By 1910, Germany had surpassed Great Britain in the total production of pig iron.[8] In this remarkably short period of time, Germany had become the leading industrial power in Europe and second only to the United States in the world.

As David Schoenbaum put it, "This was the classical pattern of industrialization, and the development of distribution and service industries."[9] In Germany's case, however, this "classic pattern" had unfolded during the course of an extremely short period of time, and the "classical" problems of industrialization--urban crowding, social displacement and so forth--struck the so-recently unified land with awesome suddenness. The Expressionists grew up, and in some cases matured, in a country that quite literally was changing right before their eyes.

The reactions of the German people to these developments were varied. Among the working class, of course, the growth and expansion of heavy industry was accompanied by the growth of Social Democracy and unionism. The attitude of the "left" was to accept the industrial revolution and to seek to obtain reforms within the burgeoning "system" of capitalistic society. Revolution, of course, was not precluded. The Gotha Program of 1875, however, by which the Social Democratic Party of Germany came into existence, was more melioristic than revolutionary; an attitude which no doubt reflected the views of the vast majority of Germany's proletarians. Far more complex and, for our purposes, important were the reactions of a disparate group of non-proletarian classes--the artisans, the bourgeoisie (particularly the middle and lower strata of this class), the farmer, and, for that matter, portions of Germany's intelligentsia. In large measure, their combined reactions can be reduced to one term: despair.

The reasons for this are not at all mysterious. First of all, as indicated above, Germany's industrial development was both late and quite rapid in comparison to that of other European states. Some of the results of this industrialization--urban crowding, the "flight from the land" and the sudden mushrooming of factories--we have already considered. There were others, however, which perhaps had even more of an influence in shaping a decidedly negative opinion towards the rapid changes which were overtaking Germany between 1870 and the First World War. Both a catalyst in and a result of Germany's rapid industrialization was the extremely important role played by large investiment banks. The German bank, according to Stolper, was not designed to be a source of business credits (unlike British or American banks); rather, it was an institution for the financing of industry.[10] The extremely close interrelationship between the larger banks and industry was responsible for an enormous concentration in both areas. Concentration of banking resources was accompanied, especially after 1877, by an increasing cartelization of German industries.[11] Also, the role of the state had been a prominent one in German industrial growth from the very beginning. Of course, in the history of Western Europe state mercantilism had been important in industrial growth. In Germany, however, the role of the state remained an important one until the time of the First World War. The state came not only to

5

own outright such things as the railroads, telephone and telegraph systems, but to participate actively in so-called "mixed-ownership" companies and in banking.[12] The concentrations of economic power in the hands of a relatively few large banks and in large-scale industrial cartels, plus the all-important role of the state in the German economy, led to a situation in which a limited number of bourgeois Germans either directly benefitted from or participated in the rapidly expanding German economy. True, rapid industrialization, urgan sprawl and the development of cartels also characterized economic growth in the United States. However, cartels in the United States had not been surrounded with a sacrosanct aura of legality as they had been in Germany ("trust-busting," however illusive it may have been in America, never took place in pre-World War I Germany). Furthermore, the existence of a "frontier" (officially recognized as such until 1890), a strong laissez-faire tradition, the myth of Horatio Alger and a relatively badly organized, if admittedly somewhat violent, labor class all contributed to an atmosphere in which bourgeois Americans could feel that they were (even if, in reality, they were not) somehow participants in the great national drama of industrial growth. In Germany, large elements of the bourgeoisie, having no access to the massive economic resources available to heavy industry, felt themselves squeezed between the massive growth of capitalistic giantism on the one hand and a vigorous and powerful industrial proletariat on the other. Germany's traditional artisans, the original "self-employed" working class, were also put in the same position.

 The result of this situation was an increasing restiveness against modernity, even while the average German experienced an increase in his standard of living and even while the number of small retail enterprises grew like mushrooms in the shadow of large-scale industrialization.[13] This attack upon modernity, with its anti-urban and, as to be expected, anti-Semitic biases, has been well-documented.[14] In despair at being caught between the industrial and proletarian molochs, large elements of the German bourgeoisie turned upon those signs of modernity that were most obvious and/or disturbing: the growth of cities, the Jews (influential to some extent in business and banking circles) and the general--or at least suspected--decline in folkish cohesiveness associated with idustrialization. German bourgeois

youth, in rebellion against parents and society, joined the romantically inclined Wandervögel and, with knapsacks on their backs and mandolins in hand, attempted to empathize their way into Germany's past; a past which, in their eyes, was more often than not bucolic, ingenuous and judenrein.[15]

The reaction of Germany's intelligentsia--or at least a substantial portion of it--to the urbanized, industrialized product of iron and blood policies was, as Fritz Stern has described it, characterized by "cultural despair."[16] Bismarckian and Wilhelmian Germany was not the warmhearted Volksstaat hallowed by years of German political romanticism. In place of the poet-kingdom of Herder, there was the steel and coal Empire of modern bourgeois society. In place of the reason-bound educator state of Fichte, there was the insensitive power-state dictated by cold Machiavellism. And, as in all modern societies, the bourse ruled over all. To be sure, these were phenomena that were both determinants and corollaries of developments that were European, if not world-wide. However, to one aspect of Germany's intellectual tradition--a tradition that had countered centuries of political and cultural disunity with the cloying dream of an intuition-based Volksgemeinschaft--they were signs of cultural decay and spiritual decadence. The response of the Paul de Lagardes and Julius Langbehns of Germany was to seek out that pernicious "internal enemy" that, in parasitic fashion, was gnawing away at the very innards of German culture. For an amazingly large number of these people, the enemy was the Jew, and the signs of his growing predominance were to be found in industrialization, urbanization and the growing influences of theater and press. The reaction of Germany's radical right was to seek transcendence if not an actual reversal of the industrial revolution. Seeking to preserve Germany's "soul," these individuals helped pave the way for the emergence of an ideology that would perhaps forever taint it.

The Germany of the Gründerzeit was very much divided within itself. On the one hand, it presented the picture of a powerful, self-confident Empire destined for world supremacy. It was a state of official establishment optimism, even though many in the establishment shared the same external prejudices. On the other hand, the more perceptive observer of the German scene could detect signs of bitterness and despair, not necessarily confined to the shrill

7

representatives of right-wing radicalism but visible also in Gerhart Hauptmann's moving description of childhood death in a working-class setting, _Hanneles Himmelfahrt_, or in Frank Wedekind's deliberately shocking exploration of adolescent sexuality, _Frühlings Erwachen_. The grandiose fanfare opening Richard Strauss's _Also Sprach Zarathustra_ was not merely the reveille call of official optimism; it was also a concrete manifestation of needs unsatiated by the industrial and imperial moloch that was modern, unified Germany.

Germany's reactions to the new age of industry and the city, with all the problems of alienation associated with it, was part of a broader Western reaction against worldwide phenomena. In Germany, however, these reactions were colored by a combination of traditional political and cultural romanticism and _petit bourgeois_ discontent with modern times. The former was, of course, a substantial portion of Germany's intellectual past; the latter was in large part the result of the particular course taken by modernization in Germany. The rise and development of German Expressionism both must be set against this general cultural and socio-economic background and be seen as emerging from a century-old tradition of cultural romanticism. In Emil Nolde, Expressionist Artist, the most powerful--and contradictory--psychic and cultural forces characteristic of German history in general and Expressionism in particular found embodiment. Before focusing exclusively on Nolde, though, we Nolde, though, we must take a closer look at the art movement of which he was a part.

Chapter One

Footnotes

[1] Koppel Pinson, <u>Modern Germany</u> (New York, 1965).
[2] Pinson, p. 222.
[3] Pinson, p. 222.
[4] Pinson, p. 221.
[5] Pinson, p. 221.
[6] Gustav Stolper, <u>The German Economy from 1870 to the Present</u>, trans. Toni Stolper (New York, 1967), p. 40.
[7] Stolper, p. 40.
[8] Stolper, p. 225.
[9] David Schoenbaum, <u>Hitler's Social Revolution</u> (New York, 1966), p. 3.
[10] Stolper, p. 26.
[11] Stolper, especially pp. 28-29, 46-49.
[12] Stolper, pp. 42-43.
[13] On the latter, see Schoenbaum, particularly pp. 4-5.
[14] On the response of the bourgeoisie see particularly George L. Mosse's <u>The Crisis of German Ideology</u> (New York, 1964), Peter Pulzer's <u>The Rise of Political Anti-Semitism in Germany and Austria</u> (New York, 1965), and Theodor Geiger's pioneering work, <u>Die soziale Schichtung des deutschen Volkes</u> (Stuttgart, 1932).
[15] Still the best description of this is to be found in Walter Laqueur's <u>Young Germany</u> (London, 1962).
[16] Fritz Stern, <u>The Politics of Cultural Despair</u> (New York, 1964).

Chapter Two

The German Expressionist Movement in the Plastic Arts

As in the case of most artistic "movements,"
German Expressionism began as a revolt against
established authorities of all kinds. It was a revolt
against the so-called "Academy Art" (the established
artistic modes) dominated as it was by Impressionism
and romantic realism. It was a revolt against the
materialism and self-congratulatory scientism of
modern times embodied (at least in the eyes of the
Expressionists) in French Impressionism, with its cool,
detached, almost photographic, concerns with light and
its impact upon the eye. The centers of the new
movement were Dresden ("Die Brücke"--for many, this
group, founded in 1905, was the very "heart" of the
movement), Vienna, Berlin and, late in 1911, Munich,
where the "Blaue Reiter" group, headed by Wassily
Kandinsky and Franz Marc, showed the way to total
non-representational art.

It would be quite inaccurate to overemphasize the
qualities which the so-called "Expressionist" artists
had in common. A rugged individualism was responsible
for various secessions and schisms within all of the
established groups; and the term "Expressionist" did
not appear until 1911, in the Berlin art journal Der
Sturm.[1] Despite these necessary qualifications,
however, there were certain basic concerns uniting all
of the artists of the Expressionist Movement. First
of all, German Expressionism was in part eclectic,
embodying some of the primitive elements--e.g.,
African sculpture--that influenced the art of Van
Gogh, Rousseau and Gauguin, as well as the deformation
characteristic of medieval art and of the works of the
Norwegian, Edvard Munch. The Expressionist artists
utilized these elements in their, at times, violent
rejection of academy art and flat, purely decorative
ornamentation (e.g., that art characteristic of the
Jugendstil, also known as "Art Nouveau"). They were
concerned with somehow capturing the depth of their
own psychic reactions to the world of nature and the
world of men.

> They looked at nature in an attempt to fix its
> most essential characteristics in terms of their
> own immediate reactions. They seemed to be
> searching for an intuitive expression, which they
> felt lay somewhere between imaginative and

descriptive art. The result of this instinctive
approach was an emphatic painting that, although
often exaggeratedly emotional, resulted in some
pictorial statements hardly equaled in the
annals of modern art.[2]

The Expressionist concern for directness and
forthrightness of artistic expression was evident in
the 1906 manifesto of the Dresden "Brücke" painters
written by Ernst Ludwig Kirchner:

> With faith in development and in a new generation
> of creators and appreciators we call together all
> youth. As youth, we carry the future and want to
> create for ourselves freedom of life and of
> movement against the long--established older
> forces. Everyone who with directness and
> authenticity conveys that which drives him to
> create, belongs to us.[3]

Many of the Expressionists tended to occupy
themselves with those topics of religion, human
suffering and spiritual striving with which German
artists had always been concerned. Indeed, an early
critic of the Expressionist movement characterized it
as typically German in its tension between reality and
metaphysical truth.[4] Thus, the Expressionist artist
often was concerned with attempting to represent an
infinite world in mystical or symbolic terms. He was
"animated by mystical ideals, especially as they
concerned the relationship between men and nature."[5]
In all of these concerns, the Expressionists, while
definitely rejecting the sickening Biedermeier
romanticism that had developed in Germany during the
19th century, evidenced tendencies that had been
paramount in German romantic writings and aesthetic
theories ever since the end of the 18th century. In
their emphasis upon intuition, emotion, nature and all
things mysterious and far away, the German
Expressionists were part and parcel of that neo-
romantic reaction against the modern world and its
gnawing sense of spiritual alienation described in the
previous chapter.[6] While the German Expressionist
movement had its representatives in Vienna--Gustav
Klimt and Oskar Kokoschka--and Munich, and while many
of the Expressionist artists tended to settle later
in Berlin, the real "nucleus" of the movement (to use
Hans Konrad Roethal's phrase) was the
Kunstlergemeinschaft Brücke, which was established in

the Saxon city of Dresden in 1905.[7] This "community" of artists consisted initially of Ernst Ludwig Kirchner, Erich Heckel and Karl Schmidt-Rottluff. They later would be joined, albeit for relatively brief periods, by Max Pechstein, Otto Müller and Emil Nolde. The artists lived in a self-consciously communal style. They made their own furniture and even many of their utilitarian household implements. In their rather complete submergence at this time into a communal artistic endeavor, the Brücke artists bore a marked resemblance to the adherents of the later Bauhaus school. Another similarity was their genuine attempt to disavow that pretentiousness and self-centered preciousness characteristic of the stereotypical artist of the nineteenth century. They were concerned with reaching all people with their art. The canon of "art for art's sake" was, strictly speaking, not for them.[8]

Emil Nolde came to the Brücke as a somewhat older, fairly well-established artist. A showing of his work in Dresden in January, 1906 impressed the members of the Gemeinschaft, and he was invited to join them in their revolutionary efforts. The invitational letter is interesting because it shows the almost complete ingenuousness and sincerity of the Brücke when confronted with a new and vibrant talent.

Dresden, 4. Feb. 06
Permit me to speak right out: The artists' group Brücke of Dresden would consider it a great honor to greet you as a member. To be sure--you will know as little of the Brücke as we knew of you before your exhibition at Arnold. Now, one of the aims of the Brücke is to attract all the revolutionary and surging elements--that is what the name, Brücke, signifies. The group in addition annually arranges several exhibitions, which travel through Germany, so that the individual artist is relieved from business activity. A further goal is the creation of our own exhibition space--for the time being, only wishful thinking because the funds are still lacking. Now, dear Mr. Nolde, think what you will, we want herewith to pay our tribute to your tempests of color.

With sincerity and homage.
The painters' group Brücke
per Karl Schmidt[9]

13

While Nolde remained friends with many individual artists in the Brücke, especially after 1911 when most of them moved to Berlin, his association with the Kunstlergemeinschaft Brücke lasted only one year. The communal aspects of the organization, as well as the tendency of its members--at least in Nolde's eyes--to repress individuality for the sake of a common effort, proved too much for his ferocious individualism. This will be discussed in a later chapter.

It is important for us here to consider the nature of the Expressionist movement as a whole. As we have seen, the movement was characterized by several qualities: 1) a concern for representing the world as felt by the individual artist; 2) an emphasis upon attempting to impart emotional impact to the observer through careful use of such devices as exaggeration and distortion; and 3) an overall sort of mysticism regarding such things as man's relation to nature and to his fellow man. Utilizing an analysis of Hannah Arendt, Herbert Read reached the conclusion that there was a basic fallacy in Expressionism: namely that "self-expression," uncalled for by those who view or purchase the objects of artistic activity, cannot serve as a justification for this activity.[10] Yet, Read said, "many of the 'selves' succeeded in creating worldly objects of universal value."[11] Thus, in understanding the contributions of Expressionism to twentieth-century art, we are called upon to move beyond the term "Expressionism" itself--with all of its overtones of solipsistic egotism and breat-beating self-justification. What Expressionism did for the development of so-called "modern art" was to help unchain the several aspects of the artistic experience--form, color, plane, and theme--and to recombine them in a new synthesis or, perhaps, to utilize that admittedly overused term, Gestalt, in which the artist himself becomes the mediator between a universe of infinite forms and the observer of limitless dreams but finite experience.

Two aestheticians, Wilhelm Worringer and Hermann Bahr, were of salient importance in both explaining and rationalizing the so-called "distortions" and "abstract qualities" of Expressionism. In his 1908 work, Abstraktion and Einfühlung (Abstraction and Empathy), Worringer declared that so-called artistic "naturalism," i.e., "representational art," was characteristic of human creativity only when man felt at ease in the world. It was the hallmark of an

14

almost smug contentment with one's lot. Abstraction,
on the other hand, was the sign of a sort of inner
restlessness; an attempt to tear objects out from
their hitherto accepted places in the phenomenal
manifold and to rearrange them in patterns or forms
somehow more congenial to both the artist and the
observer.[12] Abstraction was, as Worringer seemed to
be saying, the sign of intellectual and psychic
ferment taking place not only <u>within</u> a given space/
time matrix but against it. Hermann Bahr, in his 1919
work, <u>Expressionismus</u>, declared that there were two
types of art, that of a "passive, sensual optical
vision" on the one hand, and "an active mental vision"
on the other.[13] Expressionism, he said, had gone
beyond simply "seeing" and had made demands upon the
reasoning and intuitive powers of both the artist and
the observer. Expressionism had pushed art forward to
the point where it was more than a simple play of the
senses.

 In both the works of Worringer and of Bahr, there
was a rather thinly concealed contempt for those
artists, critics and observers who were bogged in the
mire of the relatively carefree, thoughtless art that
characterized man during periods of melioristic self-
satisfaction. Despite their occasional gratuitous
nods in the direction of "empathetic" or "passive"
art, respectively, one gets the impression that for
Worringer and Bahr, the abstracting, i.e., "rebelling"
artist, or the one possessed of "active mental vision,"
was the only <u>true</u> artist or at least the only artist
worthy of any form of respect.

 Neither Worringer nor Bahr were practicing
artists. Worringer was an art historian, while Bahr
was a writer who occasionally engaged in art criticism.
Their analyses, profound and rather ponderously
expressed, were quite intellectual, to a degree
unacceptable to many of the Expressionists they were
seeking to defend (certainly, although he says nothing
about them, to Nolde who, as we shall see, revelled in
a sort of almost snobbish anti-intellectualism.) In
their emphasis upon the artist as objectifier and/or
reifier, one detects strong Hegelian overtones.
Nevertheless, both of these critics were quite
perceptive in one important way: they were saying
that Expressionist art, in its remorseless picking-
away at the commonsense world of day-to-day experience,
could pass and, in some cases, already had passed
beyond the parameters of this experience into total

15

abstraction. Whether or not this was an indication, as Worringer put it, that the artist's lack of ease in this world had reached the point that he had to reject this world totally is a moot point. What is important for us to recognize is that German Expressionism played a crucial role in the establishment and legitimization of non-representational art.

Russian-born Wassily Kandinsky, one of the founders of the "Blau Reiter" school in Munich, led the way. Kandinsky, while trained as a lawyer, had obtained a somewhat scientific background while at the Royal Academy. He had been, according to his autobiography, shaken by recent discoveries about the atom, the supposedly firm ontological building-block of all things. Now, toward the end of the nineteenth century, recent discoveries, particularly those of Rutherford in Great Britain, had revealed that the atom was not irreducible and that, indeed, it had within itself mystifying subatomic particles and even a void. The once-hallowed atom had disintegrated.

> This discovery struck me with terrific impact, comparable to that of the end of the world. In the twinkling of an eye, the might arches of science lay shattered before me. All things became flimsy, with no strength or certainty. I would hardly have been surprised if the stones would have arisen in the air and disappeared.[14]

Kandinsky had more of a scientific background than did other adherents to the German Expressionist movement, and it is doubtful whether such phenomena as the "disintegrating atom" made much of an impression upon Schmidt-Rottluff, Kirchner or even Kandinsky's colleague, Franz Marc, to say nothing of Emil Nolde. However, the disintegration of physical certainties was part of the general atmosphere of Europe at that time when, at least in the eyes of many, social and moral certainties were in the process of being swamped by the remorseless forces of modernization and urban growth. Suffice it to say that Kandinsky, as well as his frind Franz Marc, took the spiritual aspects of Expressionism and elevated them to the point where relationships to the physical world became most tenuous indeed. In his famous 1912 essays, "Über das Geistige in der Kunst" and "Über die Formfrage" ("Concerning the Spiritual in Art" and "About the question of Form"), Kandinsky spoke of a necessary

16

dematerialization of art if it were to be able to express the spirituality that lay behind such things as a disintegrating physical world.[15] Kandinsky was assisted in his turning away from physical forms by his increasing repugnance for the human body, a feeling shared by Franz Marc. These "psychological reasons" (to quote Selz), no matter what their sources, were added to the more general aesthetic and philosophical reasons for the gradual turning toward abstraction characterizing both Kandinsky and Marc, the latter even abandoning his well-known fascination with animals in favor of a course which led in the direction of pure abstraction.

Despite those concerns intrinsic to Kandinsky and Marc-or, perhaps, despite their own peculiar idiosyncrasies--it is obvious that the sources for their turning toward total abstraction can be found within the parameters of German Expressionism. The unabashedly spiritual nature of the movement--a nature which found expression in severe woodcuts, wild outbursts of color surpassing even the Fauvists in savage intensity, and in self-conscious if controlled distortion of form--provided fertile ground for the abstraction. If one were concerned with capturing the spiritual intensity of the moment, as seen and felt by the artist, then the step between seeking to represent this moment through exaggeration and distortion and abandoning completely any attempt to represent the phenomenal shell in which the spiritual was ensconced was, if not insignificant, then at least logical. To be sure, not many Expressionists chose to take this step; or at least few of them chose to extend a few hesitant steps into a troubled excursion--least of all Emil Nolde. It is difficult to imagine the emergence of modern, non-representational art, however, without the mediating influence of the German Expressionist movement as a whole.

In considering the important dynamic effect Expressionism had on the development of abstract art, we must not overlook the fact that, however much Herbert Read and Hannah Arendt might criticize their dramatic self-centeredness in at least tacitly accepting the imposed name, the German Expressionists accomplished incredible things during their relatively brief period of maximum activity, i.e., roughly 1900 to 1919. Their psychological explorations in portraiture, their often somber but always illuminating capturing of the psychic impacts of nature

17

and the urban world of man, and their utilizing virtually every conceivable artistic means to these ends (oils, watercolors, woodcuts, etchings and lithography) constitutes a unique and inspiring chapter in Western cultural history. After the First World War, Expressionism as a movement in painting was finished. The rise of Dadaism and Neo-Realism in Germany testified to a sense of spiritual exhaustion and bitterness. Dadaism, symbolizing to many the final triumph of meaninglessness over spiritual aspiration, had gained a large following in Germany during the early 1920's under the tutelage of John Heartfield, Max Ernst (later, a Surrealist) and the Alsatian Hans Arp. Composed in part of those who earlier might have been Expressionists, Dadaism evinced a cynical rejection not only of bourgeois society--something which many Expressionists had sought to do, at least in the realm of aesthetics--but of the entire tradition of German idealistic romanticism in the arts.[16] Finally, the rise of Nazism put an end to any true experiments in aesthetics.[17]

Yet, individual Expressionist artists continued to paint, even if the excitement of belonging to a radical "movement" had passed. Most prominent among them was, of course, Emil Nolde. He would remain, whether he wished to or not, as one of the most prominent standard bearers of a movement whose credo could well have been the lines written by Franz Marc, just a year before he, along with some thousands of less well-known souls, perished before Verdun:

> Every thing has its shell and kernel, semblance and being, mask and truth. The fact that we only grope at the shell, instead of seeing into the being of things, that we are so blinded by the mask of things, that we can not find the truth-- how does that refute the inner definiteness of things?[18]

In the end, Nolde stood out as an embodiment of those massive forces, almost tectonic in grandeur and fury, that constituted the life-blood of German Expressionism and, in large measure, the history of the country that gave it birth.

Chapter Two

Footnotes

[1]Peter Selz, German Expressionist Painting From Its Inception to the First World War (Berkeley and Los Angeles, 1957), pp. 255-256. According to Wolf-Dieter Dube, however, Herwald Walden used it in a very confusing manner, meaning by it any sort of avant-garde movement. Dube suggests that the art critic Paul Fechter first attempted to arrive at a "firm definition" in 1914. See Wolf-Dieter Dube, Expressionism, trans. Mary Whittall" (New York, 1972), pp. 18-19.

[2]Selz, p. 78.

[3]Selz, p. 95.

[4]Eckart von Sydow, Die deutsche expressionistische Kultur and Malerei (Berlin, 1920), p. 135.

[5]Bernard Meyers, The German Expressionists (New 1956), p. 282.

[6]Early commentators and critics, particularly those in Germany, often commented on the romantic qualities of the Expressionists. As an example of this, see von Sydow, pp. 42-44.

[7]Hans Konrad Roethal, Modern German Painting, trans from the German by Desmond and Louise Clayton York, (n.d.), p. 7.

[8]Myers.

[9]Quoted in Selz, p. 84.

[10]Herbert Read, Art Now (London, 1968), p. 68.

[11]Read, p. 68.

[12]Wilhelm Worringer, Abstraction and Empathy (London, 1953), as quoted in Selz, p. 175.

[13]Selz, p. 10.

[14]From Kandinsky's "Texta Artista," quoted in Selz, p. 175.

[15]Selz, pp. 224-225.

[16]The best description of this phenomenon is still to be found in Franz Roh's Nach-Expressionismus (Leipzig, 1925).

[17]On the Nazi/Expressionist problem in particular, see Hildegard Brenner's Die Kunstpolitik des Nationalsozialismus (Hamburg, 1963), as well as her article "Die Kunst im politischen Machtkampf 1933/1934" in Vierteljahrshefte für Zeitgeschichte, 10 Jhrg., 2 Heft (Januar, 1962); also Robert Pois, "German Expressionism in the Plastic Arts and the Nazis: A Confrontation of Idealists," in German Life & Letters, 21, No. 3 (April, 1968).

[18]Franz Marc, Aphorisms, in Roethal, p. 79.

Chapter Three

The Formative Years: 1867-1901

Emil Nolde was born on August 7, 1867 on a farm
in North Schleswig, a territory belonging to Germany
at that time. It had been brought in just three years
earlier as a result of the victorious Prussian-Danish
war. The year of Nolde's birth had seen the
establishment of the North German Confederation which,
planned or not, was the first step toward the unified
German Empire of January 18, 1871.

His family name was Hansen (for reasons to be
considered later, in 1901 he changed his name to
Nolde, a village near the family's farm). His father
was Friesian, i.e., German; his mother was Danish.
One of five children, he had three brothers and a
sister. Nolde viewed his father as a more-or-less
typical farmer--stern, practical, honest and
materialistic. His mother, on the other hand, was
"dear, and beautiful and good."[1] His two older
brothers were Hans and Nikolai, and his younger was
Leonhard. While Nolde seems to have admired his
brothers, he apparently was not particularly close to
any of them. Hans, the oldest, read a great deal and
wrote stories and tales of his own. According to
Nolde, Hans went into farming and utterly exhausted
himself physically, dying at the age of sixty-five,
potential talents unrealized. Both Nikolai and
Leonhard had talents of one sort or another--Nikolai
was a skilled furniture craftsman and Leonhard was an
omnivorous reader and displayed an early interest in
religion.[2] As Nolde described them, however, both of
these brothers were quite materialistic, and Emil had
little in common with them. While he seemed to have
had a better relationship with his little sister,
Christine, he was adamant in indicating that she was
a rather ungifted, simple person. According to Nolde,
she married happily and always remained father's
"dear little girl."[3]

Young Emil Nolde (né Hansen) seems to have been a
moody, at times almost withdrawn child. Although
according to his memories he did not become so in the
extreme until his early adolescence, it would appear
that Nolde's actual memories of his early childhood
were sketchy. Hence, as is usually the case with such
things, reliance upon his memories, without a
considerable degree of reading between the lines, is

21

less than desirable. In considering Nolde from any psychological angle, however, the analyst has an enormous advantage in that this supposedly taciturn man, isolated in self-contained grandeur, was unusually loquacious. Like a great many others of his ilk, the self that he did know he took very seriously and he desperately wanted others to so, although on his terms.

Emil was fascinated with life in the countryside. He enjoyed fishing and was enthralled by the strong-willed farmers of the region, as well as by their activities in the local cattle and horse markets and at harvest time. For a while, he was even interested in cattle-slaughtering and, although he "shivered with fear" as he watched the gory process, he often played at being a slaughterer himself.[4] Despite Nolde's fascination with certain aspects of rural life, he was not really cut out for the life of a farmer. To begin with, he was extremely upset by some of the harshness of it. As an example of this, Nolde spent some time, in his memoirs, considering the unfortunate fate of the bees who were kept in a garden in back of his family's house. Nolde's father raised them and nurtured them and then, after a period of time, killed them all in order to obtain their honey. "This was monstrous," Nolde wrote, "this the thanks for their industry."[5] Also, his father would kill the occasional sport baby pigs. Nolde remembered thinking, "Why were all these wonderful animals killed? Why couldn't they have become big?"[6] The image Nolde had of his father as being, at times, a harsh engine of destruction is an important one for our understanding of Nolde and some aspects of his painting.

Young Emil's objections to the harsher aspects of farming, as well as a general indisposition to the heavy work involved, were combined with a dreamy, introspective nature. Quite naturally, the combination of these factors caused an almost complete lack of understanding of him on the part of his father. "To me," Nolde wrote of his father, "he was particularly strict, and this unfortunately led him to somewhat unjust assumptions."[7] The "unjust assumptions" were, no doubt, that his middle child was a dreamy, self-centered, rather lazy failure. As to be expected, young Emil's early interest in drawing and painting met with the severe disapproval of his stolid father, as

well as that of the local pastor who told him that
artists were not only incapable of feeding themselves,
but sinful as well.[8]

Despite such occasional diversions as eel-fishing
(in which captured eels were dispatched by biting them
in back of their heads), Nolde's childhood seems to
have been a harsh one. His father did not understand
him and he had little real empathy for or from his
siblings. Also, he was beaten occasionally both at
home and at school, where he was not the best of
students. Only his mother and the flowers she loved
so well were of any real comfort to him.[9] At least as
Nolde remembered it, we are confronted with an almost
classic situation: a young, potentially creative lad,
surrounded by people who did not and really could not
understand him. Whether this was exactly the case is
not to great importance; it is important that Nolde
chose to remember his childhood in this manner.

Throughout volume one of his memories, Nolde
depicted these childhood years as being in some ways
the happiest years of his life. First of all, he
attempted to justify the rather severe discipline of
his father. "To be sure, I was a naughty boy," he
said, thus indicating that he apparently recognized
his father's treatment of him as justified. "I have
the belief," Nolde went on to say, "that, in his
entire life, an impure word never passed his lips."[10]
At the same time, though, Nolde indicated that at
times he was unwilling to put up with real or
imagined abuses from his brothers. He fought them,
particularly Leonhard (who was, according to Nolde,
his father's favorite son), biting and kicking "like
an animal."[11] On several occasions, Nolde described
the warm, beautiful nature of his family's house, and
the crude but beautiful examples of native Schleswig
Holstein art that adorned the house. "All this life
and this beauty around the parent's home--I have the
belief that everything was truly so wonderful--and
that it was not only children's eyes that saw it
so."[12]

Despite these warm memories of early childhood,
however, it was obvious that no one took his early
artistic endeavors very seriously. Young Emil enjoyed
fashioning things out of clay, although they were
trampled upon and destroyed by his playmates; and Herr
Boyen, his somewhat unsympathetic teacher, not only
beat him but tossed his sketches and drawings into the

school stove.[13] Undeterred, Nolde continued to paint and to sketch. He liked to trace pictures in the Bible stories that lay about his parent's home, being particularly fascinated with that of Adam and Eve. He also enjoyed drawing themes of an historical nature, e.g., scenes from the lives of Gustaphus Adolphus and Martin Luther.[14] Only his mother seemed to be seriously interested in the artistic side of Nolde. She was concerned that he learn to play the violin: "My mother wanted very much that I learn to play the violin; it could be so beautiful, she thought. But, I could not learn it."[15] Again, this is another important recollection.

Of greater importance, however, is another fact that emerges from Nolde's memoirs, his fundamental loneliness. First of all, he emphasizes his essential isolation from his siblings to a great degree. Indeed, inasmuch as he was the "middle" child in age, he could have been somewhat isolated. There might well have been the tendency for two separate "sets" of older and younger siblings to have more in common with each other than with their brother. Also, the attention of the parents, particularly that of the mother, might have been limited, inasmuch as there already were two siblings on the scene when Nolde was born, and two more afterwards. If what Freud, Reich and others tell us about early childhood is correct, then it is obvious that Nolde's must have been an unhappy one; a substantial portion of his demands for maternal attention probably being frustrated.

While young Emil occasionally physically rebelled against the mistreatment and/or lack of understanding shown by his father or brothers, his usual response seems to have been withdrawal into a world of fantasy, often of a pronounced religious nature. "Often, I sat up in the hay-loft, thinking, dreaming. I concerned myself with religious problems; from time to time to the point of ecstacy."[16] One time, Nolde recalled, while engaged in such profound musings, he noticed one of his brothers necking with a girl. Emil, according to his memoirs, was somewhat backward in his relationships with girls and apparently he was rather disapproving of his brother's desecration of the hallowed hayloft.[17] By the time of Nolde's early adolescence, then, he had in effect rebelled against his harsh background and the total lack of understanding displayed by his father. Several

24

psychologists have characterized Nolde's adolescence as being colored by a "strong father-protest."[18] There can be little doubt that such a "father-protest" did take place, and that it was of immense psychic importance in Nolde's life. Also, it would appear that Nolde, in the words of Winkler, had turned into a virtually "autistic" individual, one who could not at all be influenced by the ideas and opinions of those around him.[19]

One can only assume that the world was an intensely hostile, if not dangerous, place for the young Nolde. At first his "retreat" from it took the form of simple isolation. He drew pictures of the original sinners, Adam and Eve, or went off by himself to brood over abstruse religious issues. Finally, instead of cultivating human relationships, young Emil chose to identify himself with the object of his frequently ecstatic religious speculations--Jesus Christ.

> In the high corn-field, seen by no one, I lay down, back pressed flat against the earth, my eyes closed, arms rigidly stretched out. And then I thought: thus lay they saviour Jesus Christ, when men and women released him from the cross. And I turned over, dreaming in the undefinable belief that the great, round wonderful earth was my beloved.[20]

The erotic nature of this almost millennial relationship that Nolde had established between himself as the Christ and an all-embracing but supine mother earth is obvious. As we shall see, certain themes in Nolde's well-known religious works can be tied to this early adolescent excursion into religiously shrouded eroticism.

Both Walter Winkler and Dieter Heinz maintained that Nolde's childhood, particularly his adolescence, was characterized by a strong "father protest." This was no doubt the case. The methodology of Winkler and Heinz was handicapped, however, to some extent by their adherence to the typological approach of Kretschmer, who was interested in correlating certain "body-types" with the several varieties of mental disorders. Hence, their conclusions regarding the etiology of Nolde's psychological development were fragmentary at best. Both of them, but Winkler in particular, tended to view Nolde as being an out-and-

25

out schizophrenic, whose "autism" and disassociation from reality found violent expression in his paintings. They both tended to overlook several important questions: 1) Accepting the fact that Nolde did have a strong "father protest," what was the result of this protest insofar as his personality was concerned? 2) What were Nolde's feelings in regard to his mother? Also, their respective examinations of Nolde's compulsions toward religiosity were somewhat shallow. Religiosity, for both Winkler and Heinz, was simply a manifestation of his "autism" and inability to relate to people. Why this was indeed necessary for Nolde is not explained.

In his Group Psychology and the Analysis of the Ego, among other works, Freud described the phenomenon of "identification." This is a process by virtue of which a child, generally between the ages of two and five years old, seeks to identify himself with a parent. In the case of a boy, this identification is usually with the father: "he would like to grow like him and be like him, and take his place everywhere."[21] This by no means implies that the "identification" with the father has to be a positive one. Indeed, Freud said, in this case the young boy soon finds himself in competition with the father for the attention the mother.

> His identification with his father then takes on a hostile coloring and becomes identical with the wish to replace his father in regard to his mother as well. Identification, in fact, is ambivalent from the very first; it can turn into an expression of tenderness as easily as into a wish for someone's removal.[22]

According to Freud, the object of identification becomes the "ego ideal" of the individual, i.e., his "conscience," often referred to in Freudian analysis as the "super-ego."[23] Again, even while this process is taking place, hostility towards the object of identification, in this case the father, can and usually does continue. It would appear that this process occurred with Nolde. First of all, his rebelliousness, his rejection of farming, his hating his father both for not understanding him and for destroying animals, all point to a very deep resentment against him.

26

At the same time, though, the father remained the
sole basis of Nolde's "conscience" until the former's
death in 1891.

To complicate matters further, there was Nolde's
relationship with his mother. If one accepts a few of
the basic assumptions of Freudian analysis, one
assumes that identification with the father was both
accompanied and reinforced by an Oedipal longing for
the mother, something that takes place in an overt
manner between the ages of two and five.
Identification with the father, Oedipal longings for
the mother and so on are, according to Freud, "normal."
However, in Nolde's case (and that of quite a few
million other folk), it is obvious that something
went wrong. Possibly due to the fact that Nolde was
a "middle" child, and perhaps also due to an
inherently sensitive nature, he felt deprived insofar
as maternal attention was concerned. We must presume
that Nolde's conscious positive memories of her were
at least in part reaction formations against
extremely negative attitudes, these engendered by a
felt lack of concern on his mother's part for him and
by residual hatred that was a legacy of unresolved
Oedipal longings. At the same time, while Nolde did
indeed "identify" himself with his father, paternal
support and, above all, protection, was altogether
lacking. His siblings picked on him and, later on,
his teacher beat him, and a clergy-man condemned his
interest in art as immoral. Through all of this,
his father did nothing. Thus, Nolde had a double
resentment against him. On the one hand, his father
was the usual threatening, castrating rival for the
attention of his mother. On the other, he was, in
some ways, rather weak, despite the fearsome
memories that Nolde had of him. He did not "protect"
his son against hostile forces in the world. Also,
if we take the Freudian approach, we must assume that,
during his early childhood, Nolde either witnessed
some sort of sexual encounter between his parents, or,
at the very least, fantasized such an encounter (from
the Freudian point of view, it really does not matter
if a person actually witnesses such an event or
fantasizes it). If one considers that this took
place precisely at that period of most pronounced
Oedipal longings and father identification, the
traumatice effect of such an experience (especially in
Nolde's case, in which both Oedipal longings and the
process of identification were replete with
frustrations) must have been tremendous.[24] The usual

result of seeing or even imagining an object of one's affections, e.g., the mother, yielding to the person with whom one has identified is an underlying resentment, if not hatred, of the former.

According to Freud, development of the ego necessarily is dependent upon its disengagement from the external world, i.e., the child's realization that he is distinct from his environment, even from the warm, enticing breast of the mother. In some cases, however, the delineation of a necessary "boundary" between the ego and the external world does not take place. The ego which is weak or under-developed, that is one that has not received adequate satisfaction during its early development, is unwilling to differentiate between itself and the world. Paradoxically, it attempts to deal with a threatening environment by embracing it, by avoiding the dialectical encounters with it that could prove disastrous. "In this case, the ideational contents appropriate to it (i.e., the ego) would be precisely those of limitlessness and of a bond with the universe . . . the 'oceanic' feeling."[25] Nolde, living in fear of a world that seemed not to care for or understand him, frightened of any sort of human relationship, became a lover to the entire world. It was out of his so-called "oceanic" feeling that his religious concerns developed beyond those inchoate ones of early childhood. Again we must turn to Freud:

> The derivation of religious needs from the infant's helplessness and the longing for the father aroused by it seems to be incontrovertible, especially since the feeling is not simply prolonged from childhood days, but is permanently sustained by fear of the superior power of Fate. I cannot think of any need in childhood as strong as the need for a father's protection. Thus the part played by the oceanic feeling, which might seek something like the restoration of limitless narcissim, is ousted from a place in the foreground. The origin of the religious attitude can be traced back in clear outlines as far as the feeling of infantile helplessness.[26]

Further, it would appear from Nolde's own recollections that he was somewhat under-developed sexually (i.e., in a psychic sense). His attempts to embrace the whole earth through his oustretched body, points to a definite regression to the pre-genital stage of early

28

childhood, that is to a time in which the whole body was an erotegenetic zone and sexual activities and drives were not confined to the genitals.[27]

From adolescence on, Nolde's inability to establish meaningful relationships with just about anybody (but with girls, in particular) was reinforced through the continuous intervention of a powerful "conscience" (or "super ego"), which was in reality the father with whom he had identified, although not entirely successfully. Also, his unresolved Oedipal desire for the mother contributed to his being unable to find a satisfactory heterosexual relationship. Nolde, in reality, did not want what one could call a "normal" relationship with girls. He wanted a mother. At the same time, however, an underlying hatred of his mother no doubt contributed to a basic hostility toward women, one that would remain strong throughout his life. Some of Nolde's feelings regarding his mother were captured in his fascination with flowers, a concern which would lead to incredible breakthroughs in use of color.

By the time Nolde was fifteen, it was obvious even to his otherwise non-comprehending father that the life of a farmer was not for him. Nolde remained at his parents' farm only to finish up his schooling and to complete various necessary tasks. Then, in the summer of 1884, he left the brooding, flat homeland of his parents for the uncertain world of the city. He enrolled as an apprentice in woodcutting in a furniture factory in Flensburg, where he was able to do some drawing on the side. Nolde's fling at independence was rather limited, however, by the interference of his apparently morbidly paternal father. One of Nolde's Flensburg acquaintances, no doubt out of malice, told his father that Emil was having various problems in the city (what he meant was uncertain, but he seemed to have implied that these involved wine, women and song--or rather, whatever little there was of this in Flensburg). His father's response to this was to take his son aside and to question him rather sharply. This was an apparently crushing blow to Nolde, who had tried so hard to conserve his meager resources while working away with great industry at the factory. Leaving his father during the course of the latter's ill-conceived diatribe, Emil retired to a dark corner of the garden and wept, full of "defiance and anger."[28] After describing this scene, one which truly must have been

quite heart-breaking for him, Nolde went on to make a
rather interesting observation: "In all later nightly
dreams, my father was always the strict, hard man; and
yet in real life, he was only just and good."[29] Nolde,
like quite a few adolescents of considerably less
talent, had a real difficulty in accepting his own
anger toward people, particularly those close to him.
It was an attitude that lasted throughout his entire
life.

In 1888, Nolde left Flensburg for Munich in order
to see a crafts exhibition. For several weeks he
worked in another furniture factory, before leaving
for Karlsruhe, where he obtained work in the furniture
factory of Ziegler & Weber, and where he also took
evening art lessons. Nolde's first exposure to a
really large city, Munich, produced some curious
results. First, he was understandably awed by the
grandeur of the Catholic churches there; churches in
which those praying were reduced to the size of
"worms."[30] Implied in this statement was a certain
criticism of that "Southern" grandioseness or
flamboyancy which Nolde always compared unfavorably
to the crude but honest "northern" spirit of which he
was representative. The other episode that seemed to
stand out in Nolde's mind was his encounter with a
"woman of the streets" ("Strassenweib"). Confronted
by her, Nolde fled in a near panic, crying out "You
are so ugly!" Later on, after he had gained at least
temporary security in his room, he remembered that it
was "A consecrated day," his father's birthday. A
wave of homesickness overwhelmed him as, almost
crushed by guilt and crying bitterly, he rembered his
father's words: "Be on guard against gambling, drink
and bad girls."[31] Again, the powerful influence of
Nolde's father is obvious. He had a stern upright
nature which Nolde strove desperately to emulate even
as his actual relationships with him produced
continuous hostility. Also revealed was Nolde's own
relatively immature fears of women.

The same fear--or lack of understanding--of women
was evidenced during Nolde's stay in Karlsruhe. While
there, he met a servant girl who, apparently
overwhelmed by infatuation, took his hand in hers and,
weeping, pressed it to her heart. Somewhat brusquely,
it would appear, Nolde took it away. He was, he said,
"confused" by this encounter.[32] A shy unwillingness
to participate in the festivities of a masked ball and
an unhappy liaison with a Catholic girl whose rigid
adherence to her faith "destroyed all love and

passion" rounded out Nolde's rather truncated social
life in Karlsruhe. Describing the inevitable breakup
with his Catholic girlfriend, Nolde sounded almost
Hemingwayesque: "She was sad; she was very beautiful;
she cried."[33] As Winkler pointed out with rather
heavy irony, these were the experiences of a man who,
as an adolescent, had thought of himself as a lover
to the whole world.[34] Winkler saw this withdrawal,
combined with Nolde's strong tendencies toward
fantasizing, as palpable signs of that "schizoid
automism" that, according to him, characterized much
of the German Expressionist movement as a whole.[35]
Winkler, a student of the German psychologist
Kretschmer, believed that there were definite
correlations between morphological characteristics
and several varieties of mental illness. This
approach, with its roots in rather tenuous permutations
of Adlerian and Jungian psychologies, is rather
questionable. Winkler's enthusiastic application of
it to the entire Expressionist movement was extremely
controversial; later on he retracted much of what he
said in his supposedly pioneering work.[36] Despite
some of the almost pernicious hyperbole that
characterized Winkler's approach, something that made
him sound quite bourgeois and reactionary in his view
of modern art, there was a strong measure of truth in
what both he and his student, Dieter Heinz, had to say
about Nolde in particular.

First of all, it is obvious that Nolde, as a
young man, had manifested a strong "father protest."
It is equally obvious that guilt feelings surrounding
this protest had never been satisfactorily overcome.
Nolde's autism--his inability to relate to people,
particularly to women-was a fact of life for him.
This, combined with a strong tendency to fantasize,
did point to certain schizoid qualities: withdrawal,
disassociation, and so forth. From the point of
view of any of the recognized schools of modern
psychology (other than Kretschmer's it would appear),
to say that the existence of schizoid tendencies is
equivalent to the existence of full-blown
schizophrenia, however, represents a serious and
fundamental error in psychological analysis. Also,
interestingly enough, neither Winkler nor Heinz
showed much interest in Nolde's relationship with his
mother, something that was of very deep significance
for him. Detailed consideration of Emil Nolde's
psychological development will be undertaken later.
As a young man, however, he was a shy, almost isolated

individual, incapable of entering into or sustaining
any kind of meaningful human relationship. Even as
an adult, successful in his field, he was still
deriving a certain degree of satisfaction from
viewing himself as being isolated within, if not
somewhat removed from, the world of men. The
fantasizing tendencies remained of paramount
significance throughout his life, of course.

In 1889, Nolde traveled to Berlin. Obtaining
only odd jobs of one sort or another at first, he
later found a fairly steady job as a commercial
draftsman in a furniture factory. He spent what time
he could in art museums, sketching the works of the
great masters. Accompanied by friends, he visited
cabarets, preferring the shadiest ones possible,
seeming to revel in the darker aspects of urban life.
According to Nolde, these early exposures to a
fascinating sort of urban decadence constituted a
sort of "compost-heat" for later times when "lillies
and roses would bloom."[37] This statement is important
for several reasons: first, it points to a pronounced
fascination with city life, one which both balanced
and reinforced an equally pronounced anti-urban bias
that Nolde would show from time to time; also, the
image of flowers growing out of decay is of
considerable importance. Nolde's mother was greatly
interested in flowers, and in his memoirs he spoke
often of this. Nolde identified flowers with her,
and the image of one growing out of decay is thus
particularly striking.[38] Depicted in it were notions
both of the mother triumphant over all, and the
presumed filth out of which she herself developed.

Before too long, Nolde was as isolated and
lonely in Berlin as he had been everywhere else. He
wanted to become a soldier, but was turned down
because an examining physician saw signs of
consumption. The miseries of big city life, with its
grinding poverty and isolation, bore down upon him
with ferocious relentlessness: "Everything in life
appeared to be dreary.[39]I was stifled and dull to the
point of desperation." In a rather masochistic
way, he was drawn to the company of men who seemed
to be both happier and more successful than he. At
the same time, Nolde was aware of the existent
political currents of one sort or another but
professed not to understand them: "socialist,
communist, anarchist; I knew nothing of them."[40]
Nolde seemed to enjoy depicting himself as being in

an apolitical stupor for most of his life. While
in part accurate, this representation was just a
trifle disingenuous. He once saw the aged von
Moltke, architect of the victorious wars of 1964, 1866,
and 1870, reviewing a torch-light parade held in his
honor. The figure of the proud, old marshall, bent
with age, but still radiating awesome dignity, made a
tremendous impression upon him. On several occasions
Nolde would express a great fascination strong
figures, powerful and remote in their masculinity.

According to his memoirs, Nolde was just starting
to feel reasonably at home in Berlin when he received
a telegram saying that his father was dying. The
news came at a time when Berlin was no longer so
frightening a place for him and, to make things even
better, he had just heard that he would be able to go
to Switzerland to continue his work on art and
possibly even become a professor. Now, even in
death, the long arm of a father who never understood
him was drawing him back to a home that had
associations both warm and terrifying. Nolde arrived
in time to witness the last, bitter death-throes of
his father. Later, standing by the grave, he wondered
if he would be the next to die.[41] A morbid concern
for his own helath characterized Nolde from roughly
this time until the date of his own death, sixty-five
years later.

The death of his father was an important event in
Nolde's life. First of all, he actually witnessed his
father's death struggle, something which apparently
made a strong impression on him, although his precise
reactions, at least as we can derive them from his
memoirs, are not certain. We can, though, make
certain reasoned hypotheses: 1) that Nolde
experience a recrudescence of guilt feelings due to
his oft-felt hatred for his father, and 2) that he
experienced some feelings of contempt for him while
watching him struggle against death and lose. The
stern, proud father remained as Nolde's "conscience";
but his grip was loosened to some extent. For one
thing, with the father gone he could now--when not
hindered by feelings of guilt--approach the object
of greatest love, his mother. From this point on,
Nolde would make frequent visits to the old family
Hof.

In January, 1892, Nolde traveled to St. Gallen,
Switzerland, where he taught courses in ornamental

design. Again, according to his memoirs, he had
occasional run-ins with women, this time his own
students. Once more, his seemingly natural (or
conditioned) tendency toward aloofness won out in
the end. One time he was almost overcome by sexual
desire when in the company of a particularly
appealing little ice skater, but "self-mastery
vanquished the human." He preferred to stand apart
"and preserve for myself freedom for growth and
development."[42] At times, Nolde would express the
belief that sensuality could threaten the creative
powers of the artist and that the relief from sexual
tension offered was deceptive and dangerous.

In 1892, Nolde for the first and, to all intents
and purposes, last time penned several aphorisms
which concerned matters other than art. Some of
these are of particular interest. "Once a German man
delved about in fog [dark as] the deepest night, and
now. . .now he is gone, buried in his knowledge."
This, Nolde declared, was Nietzsche. He described
Bismarck as follows: "Look, deep in the German
forest, there sits an old, grey man; grey and old,
bowed deeply by fate. But once he was so great that
all dogs barked after him and, even today, when he
stretches, the German house groans."[43] In these
aphorisms, we can detect a strong and quite
eloquently expressed concern for social justice. For
example, consider the following:

> Stultified in dust and noise a thousand men stand
> all day for a whole year--as I did. They work
> their whole lives for one person who smokes his
> cigar in beautiful Morocco. Is this human love
> of man?[44]

At the same time, however, Nolde seemed to think that,
as necessary as change often was and as admirable as
the goal of social justice could be, there was a
natural order of things with which "one-sided social
policy" could not tamper. There would be justice, to
be sure, but "justice as nature determines it . . .
not equality. Those who nature prefers will remain
preferred in life. Here also, does world wisdom
itself subsist in nature."[45] Nolde had always a very
deep-seated sense for social justice. However, this
was always counter-balanced by an almost medieval
conception of the "right order," that magical stasis
provided by an all-wise nature. Aware of politics as
he often was, Nolde tended towards that sort of soil-

bound fatalism characteristic of so many whose
formative years were spent in the countryside. For
such people, politics could be of importance from
time to time. In the final analysis, however, it
was awesome yet indifferent nature which always
held the upper hand.

There can be no gainsaying the fact, however,
that Nolde's stay in St. Gallen--with occasional side
trips to other climes--saw a tremendous intellectual
growth in him. In large measure this was due to the
influence of two of his students, Max Wittner and
Hans Fehr, people with whom he became fairly
friendly. The Fehr friendship would last a lifetime.
Nolde soon became familiar with the works of Ibsen
and Strindberg and later, under the influence of
Wittner, Knut Hamsun and Maxim Gorki. It is of some
significance, however, that Nolde was somewhat
repelled by the psychologically probing works of
Frank Wedekind. On one of his side trips he visited
Milan, where he saw Leonardo da Vinci's "The Last
Supper," a painting which had a lasting and most
important impact upon him.

While working at St. Gallen, Nolde also took a
brief vacation, visiting his widowed mother on the
old parental farm near the village whose name would
later become his own. During the course of his
visit, Nolde was her constant companion. They went
on frequent walks and visits together. One of the
people called upon was Nolde's old teacher, Boyen,
the man who seemed to relish beating him on occasion
and who had once thrown a number of young Emil's
sketches into a stove. All seemed to have been
forgiven. Nolde described in some detail his mother's
clothes, commenting, "It was so beautiful when she
was beautiful."[46] Occasionally he would go off by
himself and hunt and fish, as he had in the days of
his childhood. "I lived in the most blooming,
complete strength of youth," Nolde said of this visit.
In his memoirs, however, Nolde seemed to have placed
the greatest emphasis upon the times spent with his
mother, particularly upon those happy moments in which
the two of them would walk in the beautiful garden
in back of the house.

To Nolde, his mother had an almost magical
quality about her. Among other things, she was
clairvoyant (hellsichtig) and could foretell the
future. Nolde's feelings about her being what they

were, an incident that occurred shortly before his departure for St. Gallen must have been of particular significance for him. Early one morning, he stood by her bedside and listened while she told him of her confidence in his future. She pointed out the window towards a particularly bright star that still glowed in the grey of dawn. "I already had been lying awake for awhile," she related, "looking always there; and then [I] thought that this is your star."[47] Nolde, obviously moved, bent over and kissed her cheek. "I had never done this before," he said, "and I never did again." In an unfriendly and cold world, she was pointing the way to the future. Yet in Nolde's mind--both unconscious and at times conscious--he knew that this goddess had feet of clay.

By his mid-twenties, Nolde presented the following psychological picture: he was an isolated, lonely man/child, haunted by unresolved Oedipal desires. Although it had been weakened some, a merciless "conscience," ideationally and emotionally his father, still dominated him. Him sexual drives were expressed in largely pre-genital ways, and the underdeveloped ego of which this was a manifestation sought desperately to "embrace multitudes" in order to avoid being destroyed by them. At the same time, a tendency to identify himself consciously with Christ pointed to a desire both to punish himself for his several largely unconscious fantasies and hatreds and to his need to be comforted by sorrowing people, particularly by women. It also underscored a persistent tendency toward self-dramatization which we have seen previously. This tendency stemmed from a need to elevate himself in both his eyes and in the eyes of his parents. His father had failed him insofar as his being a protector was concerned. Now it was the object of his desires, his mother, who was both shielding him from a sea of troubles and pointing the way to the future. He was now able to form friendships with men; however, a truly meaningful relationship with women continued to elude him, if indeed he really did want one. Basically he distrusted them; this distrust stemming, of course, from an unconscious hatred of his mother. After all, she had yielded to his father's sexual demands (at least five times, one presumes) and, if the Freudian model is accepted, she most certainly had been passively acquiescent in the father's threats of

castration. Nolde had not passed beyond these concerns, and thus his attitude toward women was colored by them.

Between 1893 and 1899, Emil Hansen was transformed into Emil Nolde, even before he chose to change his name in 1901. Frequent and often dangerous mountain-climbing expeditions occupied a fair proportion of his time. Also, he began to produce an ever-increasing number of landscape and head drawings and watercolors. In 1894, there appeared a number of incredibly grotesque "masks," each representing a certain aspect of the human personality, and none of them particularly comforting. During the same year, Nolde began to produce a series of watercolor "post-cards," in which the various Alpine peaks were represented as being giants. During a two-year period, between 1894 and 1896, he produced a number of these cards, which were almost baroque in their grotesque humor. The peaks were depicted as laughing and quarreling with each other, the veiled and smiling Jungfrau shaking a finger at the male mountain giants who occasionally attempted to flirt with her. The earliest of the drawings show three peaks all in a row. The partially veiled and quite beautiful Jungfrau is exchanging glances with old, fat and bespeckled Hondi, as three tiny male figures, who apparently made it up to her cleavage, descend. Mount Eiger, leering like a dirty, old mountain giant, looks on at the far right. While it would be unfair--and probably inaccurate--to attempt to place too much psychological emphasis upon this one water color, it would seem fairly obvious that this early work reveals certain basic attitudes, conscious and unconscious, that would be of great importance in Nolde's artistic endeavors. Also, it is of importance to note that the endowing of inanimate objects with human characteristics--particularly by one removed from most so-called "normal" human contacts--is often considered as being indicative of a somewhat pathological view of one's relationships to the world.[48] Nolde's first serious efforts at creativity--for such they were, despite their whimsical nature--revealed an interest in the grotesque that would never leave him.

These cards reveal that Nolde had not yet in his own mind sharply distinguished between "man" and "artist," something that he would do later. There is a grotesqueness about them to be sure. However, this

37

is somewhat offset by a childlike, teasing quality.
The mountains have become people. In reality,
though, the reverse had happened. Parental figures
in several forms had become, or already were,
mountains. They towered over him as forces
alternately appealing and frightening. Yet the little
mountain climbers, even in fear, have dared to climb
the bosom of the Jungfrau and attain the warm
cleavage. These cards, done but a few years after the
death of Nolde's father, reveal his fear of both his
parents and, at the same time, his strong, Oedipal
longing for his mother. Artist and man were still one
in Nolde's mind, and his very human fears and
yearnings had found immediate and concrete expression
in works that might well have been utilized to
illustrate children's books. There is a certain lack
of seriousness about them.

Nolde's first serious effort in oil appeared in
1896. Entitled "Mountain Giants," it depicted a group
of mountains as being coarse old men, seated around a
heavy table. He sent it off to an art exhibition in
Munich in 1897, where it was rejected. This was
something of a blow to Nolde, especially inasmuch as
a trip to Vienna had shown him the tragic fate of
artists who, once talented, had burned themselves out
while yet young.[49]

An important turning point in Nolde's life,
"Mountain Giants" was his first serious effort in oils
and revealed to him the very strong negative reactions
that his grotesqueness could elicit. Even his newly
found friend, Hans Fehr, did not like the painting.[50]
However, the year of Nolde's first rejection also
brought him a considerable degree of fortune. The
magazine Jugend had reproduced several of his post-
cards depicting the personified mountains.
Considerable interest resulted in Nolde's being able
to sell around 100,000 of the cards for 25,000 Swiss
francs. According to Peter Selz, these cards were, in
their child-like grotesqueness, "anti-art."[51]
According to Fehr, however, the success that accrued
to Nolde because of these cards gave him a tremendous
ego boost. He now knew, as he confided to Fehr, that
"an artist slumbered within me; and not a bad one."[52]

With renewed confidence, Nolde went to Munich,
seeking entrace into the Munich art academy headed by
Franz von Stuck. He was turned down, probably as
Selz suggests, because von Stuck emphasized drawing

"almost to the complete exclusion of color."[53]
Nolde's paintings already revealed his fascination
with color. Enrolling in the private art school
of Friedrich Fehr, during the summer of 1898 he did
a good deal of landscape paintings, while during the
winter months he occupied himself with painting and
sketching nudes and heads. During the early months
of 1899, Nolde continued his work in the Fehr school.
At the same time, he paid many visits to the Alte
Pinakothek museum and to the Schleissheim Castle,
where the works of Hans von Marees were exhibited.
In the spring of 1899, Nolde gained admittance to
the school of Adolf Hölzel in Dachau, an extremely
important event for him. Hölzel, unlike von Stuck,
was primarily interested in form and color and,
particularly in his interest in color, he was rather
close to some of Nolde's own concerns. For the first
time in his life, Nolde undertook serious studies of
the works of either artists and, under Hölzel's
direction, he made analyses of the paintings of Goya,
Constable, Watts, Whistler, Böcklin and Liebermann,
among others.[54] Despite Nolde's interest in gaining
some appreciation for the art of others, he was most
adamant in preserving his own particular realm of
artistic endeavor. In this regard, several aphorisms
of that are of interest:

> Whoever loses himself in influences has not been
> born strong. The art of the artist must be his
> art. Whoever has much to learn is no genius.[55]

One can also see here evidence of Nolde's increasing
emphasis upon art as a sort of inwardly given and
intuitively grasped experience. This attidue, one
that pointed to Nolde's increasingly mystical nature,
clashed with that of Hölzel himself, who believed
that the artist ought to approach problems of
creativity with a sort of scientific detachment.[56]
Nolde, while believing that an artist ought to
distance himself from nature in order to provide
breathing space for his own creativity, nevertheless
always felt that there was something retionally
irreducible about the creative act; that the artist
could not work at his art or, worse, attempt to will
it as a man. Only the artist--apart from "the man"--
could create.[57]

Throughout his early years of struggle (and,
indeed, later as well), Nolde continued to display an
interest in exotic people and places far away. In

1899, Nolde met some gypsies in Jutland and was almost immediately fascinated with them. The same fascination was directed toward a Russian woman artist at the Hölzel school.[58] The far-away, in fact the unobtainable, was always of immense interest for Nolde. This very human characteristic would be of immence importance for his art throughout his life.

As important as Hölzel was for his career, Nolde's fundamental differences with him over the nature of the artistic experience was largely responsible for the latter's leaving Dachau for Paris in the autumn of 1899. This attitude has been best expressed, perhaps, in a letter of 7 May 1899 to his Swiss friend Hans Fehr. For art, Nolde said, three things were of ultimate importance: ability, fantasy and poetic strength. Of all the artists with whom he was familiar, only two of them had all three qualities--Watts and Böcklin.[59] Nolde went on:

> One should hold oneself to nature, at the same time, however, allowing fantasy to have a wide berth and, if one wants to poeticize, one should not disallow it. . . . I live in and for my art with body and soul.[60]

Nolde had passed beyond Hölzel. According to Fehr, he had become a person who "wanted to embrace the whole world" and it was this desire that drove him to Paris in the autumn of 1899.[61]

In Paris, he enrolled in the Academie Julien. He also visited the Louvre, where he was particularly taken by Titian's "Allegorie des D'Avalos," which he painstakingly copied. While in Paris, he also displayed a strengthened interest in the works of Rembrandt and Goya, as well as a recently discovered one in the ancient art of the Assyrians and Egyptians. Despite all of the artistic stimulation the great city had to offer, Nolde was not particularly happy there. Fehr reports that Nolde came across as a sort of Nordic country bumpkin, while Nolde himself recalled overhearing a group of French artists referring to him as a "tête de veau." His response to all of this seeming abuse was to become every more self-consciously German and Fehr recalled the obvious satisfaction displayed by Nolde when, in a cafe, he asked a waiter to bring him a German newspaper. A relatively innocent (at least in his own eyes) country lad, one who convulsed restaurant patrons by drinking

40

contendedly from his finger-bowl, was definitely out of place in cosmopolitan, cynical Paris.

At the same time, Nolde felt himself to be repelled by some of the "sweeter" aspects of French art.

The sweet, often sugary pictures of Renoir, Monet and Pissaro did not correspond to my Nordic, harsh taste; but, their art, because it meets the taste of the mean, has become the chosen darling of the world.[62]

The Paris experience was responsible for strengthening Nolde's emphasis upon the particular, racially determined, characteristics of Nordic (or German) art, as opposed to the more delicate and/or refined art of the "southern peoples." This awareness on Nolde's part had manifested itself earlier in his relationship with the Jew, Max Wittner. Wittner, like Fehr, was fascinated by Nolde. In Wittner's case, however, this fascination seemed to go very far. To begin with, this man--one of whose favorite writers was the misogynist Strindberg-- encouraged Nolde in the latter's remoteness to women. "Be happy that women don't like you," he said. "Perhaps you would not be what you are."[63] To Nolde, Wittner was "in appearance and being, dark, warm, intelligent and very good to me."[64] In fact, Nolde thought, the man almost loved him.[65] Yet, despite Wittner's important role in widening Nolde's intellectual horizons, as well as his great kindness, there were substantive differences between the two, differences which were eventually responsible for ending the friendship. First of all, as Nolde pointed out (in his Das eigene Leben, a book which was in large measure written in light of his Paris experiences), Wittner was wealthy and he was not. Also, Nolde's art was grounded in the emotional and intuitive well-springs of his own creative drive. For Wittner, all that seemed to count was his friend's financial success as an artist.[66]
More important for Nolde, however, was the fact that Wittner seemed not to understand his art. While the friendship broke up because of some "ridiculous little thing," Nolde thought that different views of art, conditioned by different racial backgrounds, had had a great deal to do with it.[67] "Racial differences contributed to the separation. My art, in its strongest expressions, was strange to him. Peoples born in the south can grasp the twilight fantasy of

the north--these hours of fantasy excitements, in life and in art--only with difficulty. The south knows not the twilight hour. On the other hand, it is difficult for us to find contentment exclusively in the charm of the sunny superficial."[68]

To be sure, Wittner excited in Nolde an interest in different races and strange peoples, one upon which we have commented previously; and, particularly after meeting him, Nolde realized that even the "nocturnal, decayed bid-city dweller," as well as sharply defined "Jewish types," would always play important roles in his own interests and in his art.[69] On the other hand, however, Nolde's experiences with Wittner, combined with some of the more unfortunate aspects of his stay in Paris (and again, it is well to note that many of Nolde's conclusions regarding Wittner were drawn after and probably at least adumbrated by his Paris experiences) led him in the direction of establishing certain racial criteria as helping to define both the art and the art of others. In his own mind, he tended to become more and more conscious of himself as a "German" (or at least a "northern") artist. After Nolde became well known, many critics tended to do the same thing.

While in Paris, Nolde claimed to have had a most frightening experience. One day, according to Fehr (who was in Paris as a Swiss attache), he had an encounter with his friend, who told him a fantastic tale of a murder attempt made upon him. According to the excited Nolde, he had decided to take the advice of several people and meet a French girl; this, according to him, to improve his command of the French language.[70] While in a cafe, he met a rather tough looking little gamin. The denouement of the meeting was Nolde's winding up in her apartment (or at least an apartment). Fascinated by her "cold eyes and cunning look," he commenced to sketch her.[71] His eyes happened to wander over to a vase filled with flowers. Not knowing why, exactly, he lifted up the flowers, only to find a number of kitchen knives tied to the stem. Somewhat uneasy, but calm, nevertheless, Nolde obeyed the girl's command to stay put. However, when he saw the girl lay out a large trunk-like affair, complete with lock, upon the floor, panic seized him. Hat in hand, and with loosened bowels, Nolde fled. Later during the day, he pointed her out to the Fehr-- a tough, cold street-creature who was shaking with rage.[72] According to Nolde, Fehr was quite shaken by

his friend's close brush with a hideous fate (the otherwise indifferent Paris police--again, according to Nolde--told him that several hundred people, mostly foreigners--simply disappeared every year). In Nolde's memoirs, he had Fehr, telling him, "If I had had to report such a fate to your old mother!"[73] Fehr, however, being as gentle about it as possible, expressed the notion that his friend's "rich fantasy" might well have been responsible for exaggerating, or at least embroidering upon, an otherwise very trivial incident.[74]

From a psychoanalytical point of view, what did this supposed incident mean? Nolde made the terrifying "discovery" that the tough little Parisian girl planned to do away with him and, no doubt, take his money when he lifted up some flowers out of a vase and discovered a number of kitchen knives tied to the stems. Then, he saw a trunk being laid out to receive his body, and he fled. Whether or not this incident actually took place, or whether he simply exaggerated something that had happened is immaterial. What is important to note is the image presented, that of the knives dangling from flower stems. Flowers were his mother to Nolde, and from time to time, on a conscious level. Unconsciously, they were women. The knives were, of course, instruments of castration. One is tempted to ask the following questions: Did Nolde in fact attempt to have an affair with this girl and, if so, was he terrified or shamed into impotency by the image described? Or, was the girl his mother (in his mind's eye of course) all along; an identification strengthened through Nolde's discovery of maternal beauty inextricably intertwined with the threat of castration? Whatever the case, it is obvious that for Nolde his mother was an object not merely of love but of real feelings of horror as well, feelings that had to influence him in relationships with women.

In any event, the above incident points out a persistent tendency of Nolde's, a tendency toward self-dramatization. It is one that would remain throughout his life. Obviously, such a phenomenon both stemmed from and reinforced his grim determination to see himself as being a loner--an isolated figure, threatened by all sorts of pernicious forces against which he had to defend himself. Also, the particular details of this "incident"--the role of the tough French girl, the knives tied to a

bouquet of flowers and, finally, Fehr's comment about how Nolde's mother would have taken the news of his murder--point to certain psychological issues that are of considerable importance in our understand of this interesting figure.

Also revealed here was a very early concern of Nolde's, the tension between the sexes. This was revealed in another way. As we have seen, during his Paris visit, one of the very few things in which he developed a serious interest was Titian's painting "Allegorie d'Avalos." Titian was, as many have pointed out, a forerunner of the modern use of color. As Urban points out, however, this painting was mainly concerned with representing the tension between men and women.[75] In this work which was done by Titian in the 1530's, we see a man in armor, partially concealed in shadows which serve to emphasize both this sadness and the firmness and strength of his upper face and forehead, bidding farewell to a rather sad, but very sensual woman. Obviously, he is off to the wars.[76] Nolde was very much taken with this painting, one in which a strong, silent and heroically sad soldier is taking leave of a buxom, sensual but somehow weak woman.

Nolde left Paris in the summer of 1900. He had expected much of his visit--or so he claimed--but had gained relatively little. His own northern homeland beckoned him and thus he once more came home to visit his mother. The latter displayed a genuine interest in his artistic career, something which no one else had understood.[77] Again, he and his mother paid a visit to the pleasant old man, Boyen, who had given Nolde so many thrashings during his youth. Again, there were several visits to the markets, especially the one in Tondern (after the First World War, in Denmark). Around this time, Nolde attempted to write a short story. Entitled "Young People" ("Junge Menschen"), this story reflected both Nolde's earlier experience with a Catholic girl and certain problems involved in Nolde's relationships with women in general. In this story, a young man found himself alone with a girl in her mother's house. At first, there was an initial exchange of compliments: "What beautiful eyes you have," she said to him, something which he in turn said to her (an almost fairy-tale like atmosphere is obvious). Then, the young man kissed her. The young people separated, each going to his or her respective beds. The young man was

unable to sleep however. He only "dreamed without sleeping." Finally, he went to her bed. The girl invited him to come in and warm himself. He had never lain with a girl before. She, for her part, was quite coy; alternately covering herself up and tempting him. "Virtue triumphed," Nolde declared, in that the couple either never did (or were unable to) engage in sexual intercourse. The two of them sat very still together, while thunder rolled and the wind sighed through the garden outside. Finally, the young man formally asked if he might sleep with her. No, she declared, never again. In tears, she cried out, "I have sworn an oath to my God."[78]

Obviously, Nolde had in mind his problems with the Catholic girl in Karlsruhe. Also, however, strong overtones of an almost fated incompatibility between members of the opposite sexes are present, while the overriding maternal influence--the mother's house, the presence of a garden through which a sad wind moaned--upon Nolde can be easily recognized. Quite revealing of Nolde's discomfiture with his expression of frustrated sensuality was his sudden switching of theme in his autobiography. He now spoke of the mythical significance of Egyptian and Assyrian art: that these were not merely historical facts to him, but great works of art as well.[79]

Certainly, this story embodied an enormous amount of Nolde's tension regarding women. When he was interested in making love, she was not; when she was interested, he was not. In short, nothing seemed to work out very well. It is instructive to note that Nolde chose to emphasize three things in this story: 1) that the encounter took place in the girl's mother's house; 2) that there was a beautiful garden outside, through which a cold wind blew; and 3) that finally, when he really did want to make love to her, she cried out that he could not--"I have sworn an oath to my God." As indicated previously, this in part pointed to Nolde's earlier encounter with a Catholic girl who, to him, was fanatically religious. However, the failure of physical love--and this failure taking place in a "mother's" house--plus the presence of a garden through which a wind howled (perhaps reprovingly?) point to several interesting possibilities. First of all, the girl herself could have been Nolde's mother, in sublimated form of course. The failure of sex between the two of them was then due to the harsh judgment of the "super-ego"

(in such a case, the wind and thunder could well have
been the spirit of Nolde's father). Another
possibility is that Nolde was expressing his
intuitive realization that the spirit of a mother
(really his own, and not the girl's) always would
prevent him from having a satisfactory relationship
with a young woman. In either case, one can posit
that this story was indicative of a large amount of
hostility on Nolde's part in regard to his mother.
His burdening the heroine down with religious motives
was, despite his experience with the Catholic girl in
Karlsruhe, probably a protection of his own feelings.
After all, he was in love with God's earth, and the
awesome responsibilities imposed by this relationship
left neither time nor psychic energy for human
relationships. No matter how one chooses to
interpret this story, the theme of tension between
the sexes comes through strongly.

In 1901, Nolde painted a work which, perhaps more
than any other one up to that time, revealed his
tendency toward fantasy, a tendency which, in the eyes
of such people as Heinz and Winkler, was symptomatic
of a general withdrawal from a reality too hard to
face. The painting was entitled "Before Dawn" ("Vor
Sonnenaufgang"). It shows two fantastic reptilian,
yet furred, creatures. One of them is on a cliff and
barely visible in the blue/green, black darkness. The
other, foul breath steaming in the chill of dawn, is
in clumsy flight, with no wings visible. The
background of jagged peaks and desiccated ground could
well be a representation of hell itself. In this
painting, Nolde utilized a jarring clash between light
and dark colors to heighten the dramatic effect
attained through his depiction of these hideous
creatures of the night. The painting contains
overtones both of thinly veiled aggressive tendencies
and of stark, terrifying loneliness.

By the turn of the century Nolde was becoming
aware of himself as "artist"; identification with the
mother was in part replacing that with the father, and
Nolde was emerging as a tense, self-conscious
visionary. This was revealed in heightened and,
above all, more subtle forms of sublimation, as Nolde
sought to draw a more palpable line between weak,
tormented man and the alternately gloomy and
visionary, providentially ordained (and "star-
directed") artist. The foul monsters depicted in
"Before Dawn" and the alternately gloomy and garish

46

colors in which they were portrayed pointed to a first
step in his separation between artist and man. Unlike
the playful "card pictures" of the 1890s, this grim oil
painting has a visionary quality about it. It is a
morbid, grotesque work to be sure. Nolde is giving us
a frank and well-defined look into his own world;
however, a world apart from men. Of course, in the
eyes of the psychologist every work of art fulfills
this function, whether or not the artist intended it.
Nevertheless, "Before Dawn" reveals an effort, almost
a conscious one, to draw a sharp line between Nolde
as a man among men, and Nolde as an artist having a
particular and frightening insight into a private
mysterious world. The monsters, furry, but both bird-
like and reptilian all at once represented his
negative attitude toward sex, something that would
endure until the end of his life. In 1901, Nolde was
about to leave his mother and seek out a permanent
relationship with another women. Yet, as we have
seen, he was also beginning to identify himself with
his mother, the separation between the two sides of
his personality being a reflection of this. The
tensions that this situation produced for him are
clearly visible in this painting. In any case, 1901
was a very stormy year for Nolde. Pictures that he
sent off to several art exhibitions were rejected,
and a visit to Copenhagen had started out disastrously.
As usual, he found himself totally isolated in an
indifferent urban setting. There was much beautiful
art in Copenhagen, "well-dressed men" and "tall,
blonde women"; but none of this was for him. Again,
this unhappy man lived only with his art and his
increasingly turbulent fantasies. He engaged the
services of a most beautiful model, one who "excited"
him (how, he did not say) a great deal. A glance at
him, however, convinced the girl that her potential
employer was mad. Hastily putting on her clothes,
she fled his studio.[80]

It was perhaps of utmost importance for Nolde's
sanity that he was able to get away from Copenhagen
and visit the Danish fishing village of Hundestad, on
Isefjord. There, he was able to meet a number of
young men and women who had gathered around the poet
Carl Ewald, who made his home there. He also met Ada
Vilstrup, who was in the company of the famous
explorer Knud Rasmussen. Nolde noticed that she was
unable to keep from staring at him. Later, he spent
some evenings with her, listening to her singing. To
his surprise, she once placed a pillow in back of his

head in order to make him more comforable. She had
done this for him, "the tattered painter."[81]
Rasmussen was able to read some of Nolde's aphorisms
and, according to Nolde, was quite impressed by them.
"You write only thoughts," Rasmussen said, "others
write without thinking."[82] Ada seemed to be equally
as impressed by this strange, silent artist, so much
so that Rasmussen once commented to her that Nolde
would be the man she eventually married.

For the time being, however, Nolde had to leave
Hundestad in order to go to Berlin, where he secured
a studio. For reasons that are rather obscure,
Nolde then did not return to see Ada, at least not
immediately. Rather, he chose instead to spend his
summer of 1901 at the little Danish fishing villiage
of Lildstrand. While there, he seems to have
experienced something akin to a breakdown. He spent
much time lying upon the sand near his small hut,
gazing out ot sea. From this sea, there came an army
of legendary and terrible creatures--bandits, beasts
of prey, monsters, some half-human, others of an
utterly alien and grotesque aspect. Nolde, almost in
a frenzy, sketched and occasionally painted these
apparitions. He felt himself to be transformed into
a natural force, something which he described in a
letter of August 7, 1901:

> My hands and fingers strike roots deep under the
> sand, my toes have approximately doubled, so long
> have they become; and soon they have grown into
> great trees which bloom in strange colors.[83]

In this same ltter, Nolde described another, rather
frightening experience, one that occurred as he was
attempting to paint. A great storm was raging over
the sea and, caught up in its fury, Nolde struggled
to depict it.

> . . . suddenly, a might brush-stroke drove
> through the canvas. The painter came around,
> he looked about. It was still the quiet
> beautiful evening hour; only he himself had
> been so frenziedly swept along and had lived
> with the storm. The picture was there! Dear
> Fräulein, so things are with me.[84]

Referring to this last incident, Otto Antonia
Graf made the interesting observation that art was,
for Nolde, just about his sole means of self-

exploration.[85] While Graf was referring to another
incident, it is possible that on the Lildstrand
beach he had gone so far into himself, into the
turbulence of his own otherwise unexpressed emotions,
that only abandonment of the painting could have saved
him.

Nolde was indeed experiencing difficulties. He
wrote an almost hysterical letter to his mother,
speaking of the phantoms that haunted him by night.
Deeply shaken by the letter, and convinced that her
rather odd son was losing his mind, she thought of
sending one of his brothers up to visit him. A
further letter was more rational, however, and so the
visit did not take place.[86] Another letter, this one
to his friend Fehr, in St. Gallen, convinced his
more prosaic former student that Nolde was "mentally
sick." "I burrow in the sand," Nolde had written.
"Then, I find bones--not dog--but human bones,
bleached by the wind and sun. So things are with
me . . ."[87] Fehr, who had just recently married,
told both his new bride and his own mother about his
friend's unhappy state. Finally, Fehr's mother
invited Nolde to come to St. Gallen, which he did in
due time.

According to Fehr, an important contributing
factor to Nolde's Lildstrand experience was his
inability to develop himself artistically as an
Impressionist, as something outside of himself. He
wanted to come into his own artistically. At the
moment, however, he was "a swaying tree," neither
fish nor foul. There was, at this point, no reality
for him. He had no friends--"only shadows"--and he
longed for a wife and children. Under these
circumstancies, Fehr said, the collapse was
understandable.[88] There were more important reasons
for Nolde's breakdown, however, which must be
considered.

Nolde was no doubt aware that he was going to
marry Ada Vilstrup. Before he could do this, however,
his already tormented mind had to undergo another
series of violent shocks. The Lildstrand experience,
in which Nolde confronted the elements in all their
fury, must be seen in this light. It was during the
course of this experience that he encountered monsters
and demons of all forms and shapes, many of whom he
succeeded in depicting. It was also at this time that
Nolde had the terrifying encounter with his own raging

passions: when he suddenly realized that a storm
which he was attempting to capture on canvas was
within him, and the real ocean was calm. Nolde was
having a nervous breakdown, one that was accompanied
by hideous delusions. He sent hysterical letters to
his friend Fehr, to a young lady (possibly Ada
Vilstrup?) and to his mother. Finally, it was Fehr's
mother who succeeded getting Nolde away from the
haunted sands of Lildstrand, and he spent a brief,
recuperative period in Gallen. After this, he went
north again, to marry Ada.

Nolde's "breakdown" at Lildstrand was
symptomatic of a tremendous psychic explosion. He was
about to enter into a relationship with a woman, one
other than his mother. We must see this against the
background of Nolde's development as we have thus far
considered it. Until now, Nolde had tended to
identify with his father. After the father's death
in 1891, this identification was weakened. However, it
was still present in large measure. Now, and quite a
bit later than normal, Nolde was about to exchange his
mother "for some other sexual object."[89] According to
Freud, a male who is undergoing this sort of change
does not abandon his mother; rather, he "identifies
himself with her he transforms himself into
her, and now looks about for objects which can replace
his ego for him, and on which he can bestow such love
and care as he has experienced from his mother."[90]
Here, we must realize that Freud is discussing what he
called "the genesis of male homosexuality." He seems
also to be discussing the more general plight of the
young man who "has been unusually long and intensely
fixated upon his mother in the sense of the Oedipus
complex."[91] While it is true that Nolde was close at
one time to a person who seemed to have a homosexual
fixation upon him, Max Wittner, he appeared to manifest
few overt signs of homosexuality himself.

There was yet another source for psychic tension
that must examined: Nolde's relationship with Hans
Fehr, at least in his own eyes, about the best friend
that the troubled artist ever had. To be sure, Fehr
was certainly interested in art and, at times, could
be most supportive (especially with regard to money).
Also, he was somebody in whom Nolde could confide.
At the same time, though, he was a practical, at
times seemingly hard-headed Swiss lawyer,
temperamentally quite different from his German
friend. He did not always appreciate the more

grotesque aspects of Nolde's art and, as we shall see, Nolde though that Fehr (and his wife) were "dumb" politically.

Nolde, who had never been close to his own stern, practical father, was constantly seeking the approval of some sort of "father figure." In Fehr--who, with regard to his practical, upright nature, probably shared many qualities with Nolde's father--the artist found such a person. At the same time, though, Fehr offered Nolde the enticing prospect of providing for a much sought-after negative dependency. Nolde could criticize him, even be slightly contemptuous, without fear of parental punishment. With the existence of this new "father," Nolde was able to reinforce what elements of father identification he had left even as, in the form of "artist," and through his marriage to Ada, he began to identify, at times quite consciously, more with his mother. Fehr himself had recently married. While there is not too much evidence on way or the other about this, it is most certainly possible that Nolde, no doubt aware of the fact, felt a strong compulsion to emulate this figure, one with whom he had achieved an at least partial, but nonetheless extremely important, identification. This might well have been an added source of increased psychic tension. In any case, with his marrying of Ada, a number of important changes took place in his life.

First of all, as we will see, he literally "became" Nolde, he changed his name from Hansen. He declared that this change of name signified a turning point in his life; man was to become artist. The name change also pointed to something else: Nolde was now identifying himself with a new person, namely his mother. The father identification was never totally rejected. Nonetheless, Nolde's abandoning the paternal name and selecting that of a village near the old Hof, where his mother still lived, pointed to the emergence of a new identification figure. His mother had been a beautiful woman to him, in love with nature in general and with flowers in particular. For Nolde she was now his "artistic conscience." There was yet more. Nolde had married a woman who took joy in mothering him. Throughout their married life, it was his wife who, despite her own weak health, handled virtually all practical matters. She put up with his moods, comforted him in times of despair and when they obtained a car on Utenwarft, it was Ada who drove it. At the same time, though, as Freud put it, Emil now

51

had an "object" which could "replace his ego for him" and on which he could "bestow such love and care as he has experienced from his mother," Ada was a sickly woman and would remain such all the days of her life. Her husband was put in the position of having to care for her, of having to mother her. Identification with his own mother, with her own "artistic" temperament and with her loving care and concern--things which Nolde himself probably did not receive in satisfactory amounts--was, in certain realms, almost complete. Perhaps it was this that allowed him to overcome the trauma of his mother's death in 1902.

Yet, as indicated above, the spirit of his father lived on as well, at least in part in his relationship with Hans Fehr. Nolde was never able to completely identify with only one of his parents. His father's stern manliness was something that he always admired, even after he identified with his mother by "becoming" Nolde, the artist. As "man," he would still often be dominated by his own stern "conscience," the memory of his father. Falling back in desperation upon the old, humanistic bromide, we can only state that, particularly after his marriage to Ada, Nolde was an extraordinarily "complex" person. On the one hand, there was Nolde the artist, with his mother as ego-ideal; on the other, there was Nolde the man, still tyrannized by the pitiless ghost of his father, who now lived on as super-ego. It was out of this situation that there developed Nolde's tendency to differentiate sharply between "man" and "painter." Nolde mentioned this in a most revealing letter of October 9, 1926:

> You know my tendency, preferring to separate artist and man. The artist is to me somewhat of a supplement to man, and I can speak of him as somewhat different from the self. . .men are almost all his [i.e., the artist's] enemies; friends, those nearest to him, the worst. As police are to those who shun light, he sees their lanterns. The devil in him lives in his brain; the divine in his heart. . .Unrecognized, unknown people are his friends--gypsies and Papuans. They carry no lanterns.[92]

Here, Nolde seemed to be recognizing that what he had done was to divide his personality between a creative, relatively free side, that of the "artist," and that disturbed, controlled side, that of the "man."

52

Throughout his writings on art, he always emphasized the artistic act as being in large measure a spontaneous, unconscious, one. It was only in this realm, one to a great degree dominated by the mother as ego-ideal, that Nolde could be in small measure free.

After the frightening Lildstrand episode, Nolde realized that his life of total isolation had to come to an end. In the autumn of 1901, he returned to Copenhagen. He had a reunion with Ada, and the two of them took a joyous trip together to Aalborg. In a rare outburst of enthusiasm, Nolde even danced with her, something that was unusual enough for him that he recorded it in some detail.[93] Quashing whatever remaining qualms he had, Nolde married her. The couple then moved to Berlin. At this point, Nolde changed his name. In his memoirs, he admitted that this seemed like a terribly romantic thing to do. He remarked, however, there were simply too many Hansens in the world. Furthermore, this name-change was to mark the end of the first half of his life, and the beginning of the second--the life of the artist. Man was to become artist, and a new life, "bitter-sweet and monstrously beautiful, as blood and white song" was to begin.

As we have thus far considered him, Nolde must appear to us as a man of almost morbid sensitivities, isolated and, at times, desperate in this isolation. He was a man who, as trite as it might sound, was torn by unresolved psychic conflicts. Fear of a nonunderstanding and tyrannical father was combined with a persistent drive for a mother's love. At times, he had a desperate need to be lonely, even though this was a condition that he dreaded, and an occasionally expressed tendency towards self-dramatization was utilized to this end. Here, the Paris experience and, perhaps, that at Lildstrand as well, stand out clearly. To become an artist would allow this tormented human being to both express and in part to circumvent those drives and conflicts that were tearing him apart. At the same time, his becoming "artist" was marked by his getting married and, perhaps more important, by his name-change. He was both progressing and returning: progressing forward to new and incredibly vibrant forms of expression, while returning to the soil of his youth. The two were inextricably intertwined, and out of this

53

at times painful nexus there emerged some of the most
brilliant art of the twentieth century.

Chapter Three

Footnotes

[1] Emil Nolde, Das eigene Leben, dritte erweiterte Auflage (Köln, 1967), p. 12.

[2] Ibid., pp. 14-15.

[3] Ibid., p. 15.

[4] Ibid., p. 22.

[5] Ibid., p. 28.

[6] Ibid., p. 37.

[7] Ibid., p. 12.

[8] Ibid., p. 29.

[9] Ibid., p. 12.

[10] Ibid.

[11] Ibid., p. 37.

[12] Ibid., p. 39.

[13] Ibid., pp. 41, 50.

[14] Ibid., pp. 41-42.

[15] Ibid., p. 42.

[16] Ibid., p. 43.

[17] Ibid.

[18] Walter Winkler, Psychologie der Modern Kunst (Tübingen, 1949), pp. 175-176. Dieter Heinz, Emil Nolde: Sein Leben und Werk als Ausdruck seines Charakters, unpublished dissertation, Tubingen, 1948, p. 7.

[19] Winkler, pp. 175-177.

[20] Quoted in Emil Nolde; Landschaften: Aquarelle und Zeichnungen (Köln, 1959), p. 14.

[21] Sigmund Freud, Group Psychology and the Analysis of the Ego, trans. James Strachey (New York, 1965), p. 46.

[22] Ibid., pp. 46-47.

[23] Ibid., pp. 57-58.

[24] Sigmund Freud, An Outline of Psychoanalysis, trans. James Starchey (New York, 1969), p. 44.

[25]Sigmund Freud, <u>Civilization and Its Discontents</u>, trans. James Strachey (New York, 1962), p. 15.

[26]Ibid., p. 19.

[27]Freud, <u>An Outline of Psychoanalysis</u>, pp. 9-11.

[28]Nolde, <u>Das eigene Leben</u>, p. 67.

[29]Ibid.

[30]Ibid., p. 70.

[31]Ibid., p. 73.

[32]Ibid., p. 76.

[33]Ibid., p. 79.

[34]Winkler, p. 176.

[35]Ibid., pp. 110 ff.

[36]As an example of this, see Friedrich Deich's article, "Moderne Kunst und Psychiatrie," in <u>Die Welt</u>, 23 September 1965.

[37]Nolde, p. 83.

[38]If one bears in mind Nolde's tendency to remember his mother in connection with flowers and, further, to identify himself with his mother, this remark can be seen as containing much hostility toward her. In such a displacement, the "compost heap" would be Nolde's mother, or rather her belly, while Nolde would himself be the "lillies." I am indebted to Martin Wangh, M. D. for this suggestion. Also, it is important to note that in Freudian interpretation of dream symbolism the flower is seen as representing the vagina. On the role of flowers as representing the female organ, see Angel Garma, <u>The Psychoanalysis of Dreams</u> (Chicago, 1966), p. 51.

[39]Nolde, p. 83.

[40]Ibid.

[41]Ibid., p. 87.

[42]Ibid., p. 101.

[43]Ibid., p. 103.

[44]Ibid., p. 104.

[45]Ibid.

[46]Ibid., p. 119.

[47]Ibid., p. 120.

[48]Heinz, p. 6.

[49]Nolde, p. 149.

[50]Hans Fehr, Emil Nolde: Ein Buch der Freundschaft (München, 1960), p. 11. For rather mundane technical reasons, I have had, from time to time, to utilize the 1957 editions of Fehr's book. This has been noted when necessary.

[51]Peter Selz, Emil Nolde (New York, 1963), p. 11.

[52]Ibid., p. 12.

[53]Peter Selz, German Expressionist Painting From Its Inception to the First World War (Berkeley and Los Angeles, (1957), p. 86. Franz von Stuck was noted for paintings infused by crude sensuality. He seemed to be particularly fascinated by the image of snakes either wrapped around or writhing between the legs of beautiful young women. According to Robert G. L. Waite, he was a great favorite of Adolf Hitler. See his The Psychopathic God: Adolf Hitler (New York, 1977). Admittedly, von Stuck's impact on Nolde must be seen as problematical.

[54]Selz, p. 86 and Nolde, p. 183.

[55]Nolde, pp. 183-184. Emphasis is Nolde's.

[56]Selz.

[57]As an example of this type of attitude, see Nolde, p. 212.

[58]Ibid., pp. 185-187.

[59]Fehr, p. 17.

[60]Ibid., p. 18.

[61]Ibid., p. 19.

[62]Nolde, p. 240. It is of some interest to note that Freud, who visited Paris in 1885 to become acquainted with Charcot and his method, had an initially negative reaction to the city. In a letter of December 3, 1885 to Minna Bernays he said that Paris could be compared "to a vast overdressed Sphinx who gobbles up every foreigner unable to solve her riddles My heart is German provincial and it hasn't accompanied me here, which raises the question whether I should not return to fetch it." Julian A. Miller, Melvin Shabsin, John E. Gedo, George Pollock, Leo Sadow and Nathan Schlessinger, "Some Aspects of Charcot's Influence on Freud," in

John E. Gedo and George H. Pollock, eds., <u>Freud:</u>
<u>The Fusion of Science and Humanism. The</u>
<u>Intellectual History of Psychoanalysis</u>, p. 129,
<u>Psychological Issues</u>, Vol. IX, Nos. 2/3 Monograph
34/35, 1976. Freud went on to develop at least a
great deal of respect for Paris, however.

[63]Nolde, p. 165. This quotation is taken from the
1967 edition of <u>Das eigene Leben</u>, as will be all
further ones.

[64]Ibid., p. 166.

[65]In a July 9, 1973 conversation with Dr. Martin Urban,
director of the <u>Stiftung Seebüll Ada und Emil Nolde</u>,
Urban suggested that Wittner's fascination with
Nolde was indeed a most unusual one. If not
overtly homosexual, there were at least strong
homosexual overtones to it. After the rupture of
their friendship (to be described below) around the
turn of the century, Wittner attempted to renew it
again. Nolde, who was at least consciously unaware
of some of the more peculiar aspects of Wittner's
interest in him, would have been willing to have
renewed the friendship. According to Dr. Urban,
however, his wife Ada, somewhat repelled by the
cloying qualities of Wittner's letters to her
husband, was extremely cool to the idea. Thus, the
friendship was not revived.

[66]Nolde, pp. 168-169.

[67]Fehr, p. 11.

[68]Nolde, p. 170. See also Fehr.

[69]Nolde, p. 166.

[70]Nolde had made an earlier attempt to learn the
French language, but this came to naught since he
found his female teacher to be too ugly. See Hans
Fehr, <u>Emil Nolde; Ein Buch der Freundschaft</u> (Köln,
1957), p. 25.

[71]Ibid., p. 207.

[72]Ibid., p. 208.

[73]Fehr, pp. 20-21. Dr. Urban, in the interview of
July 9, 1973, also expressed doubts as to the
veracity of Nolde's tale. At times, Urban said,
Nolde gave the impression of not knowing the
difference between "fact and fancy."

[74] Emil Nolde, Blumen und Tiere. Aquarelle und Zeichnungen, ed. Martin Urban (Köln, 1972), p. 16.

[75] According to tradition, this was supposed to represent Alfonso d'Avalos, Marchese del Vasto, bidding farewell to his wife, Mary of Aragon. He was presumably on his way to fight the Turks in 1532. According to Panofsky, however, this was not the case; there being almost no resemblance at all between the real marchese and the male figure in the painting. See Edwin Panofsky's Problems in Titian: Mostly Iconographic (New York, 1969), p. 126.

[76] Nolde, Das eigene Leben, p. 210.

[77] Ibid., p. 213.

[78] Ibid., p. 214.

[79] Ibid., p. 226.

[80] Ibid., p. 229.

[81] Ibid.

[82] Nolde Landschafen, Aquarelle und Zeichnungen, p. 14.

[83] Ibid.

[84] Otto Antonia Graf, "Kampf um Möglichkeiten," in Museum des 20. Jahrhunderts, Katalog 23, Wein, 1965, p. 11.

[85] Nolde.

[86] Fehr, p. 25.

[87] Ibid., p. 26.

[88] Freud, Group Psychology and the Analysis of the Ego, p. 50.

[89] Ibid.

[90] Ibid.

[91] Ibid.

[92] Emil Nolde, Briefe: 1894-1926, herausgegeben von Max Sauerlandt (Hamburg, 1907), pp. 179-180. From time to time, Nolde seemed eager to assert the unity of man and artist, particularly when his art was being attacked. For example, when Paul Cassirer attacked a painting of his, Nolde surprised him with his response: "Only my rage showed him the unity of person and work." Fehr (Köln, 1957), p. 58.

[93] Nolde, p. 241.

Chapter Four

Emil Nolde: German Expressionist Painter

In his article "Das Selbstbildnis bei Emil Nolde," Klaus Leonardi made the point that Nolde did not like self-portraits.[1] Psychological things, consciously psychological things, were foreign to him, Leonhardi stated. Yet, art was a struggle and depictions of self represented touchstones for artistic development.[2] So, Leonhardi indicated, like it or not, Nolde often did self-portraits, ones that were very revealing as to the respective states of his mind. Of course it was not necessary for him to have done these paintings in order for the observer to attempt to get to Nolde through his art. As in the case of all artists, Nolde's thoughts and feelings about himself and his world were reflected in all of his works. Nevertheless, Leonhardi's essay is a useful one, and it will be utilized as a sort of point of departure for the considerations of how Nolde's personality and its several problems found reflection in early artistic concerns.

According to Leonhardi, Nolde's first self-portrait of "1891" (it really was done in 1893), or at least the first one which he chose to consider, shows a certain degree of self assuredness. From 1900 to 1904, however, his paintings and sketches of himself had a searching, almost haunting quality to them, these characteristics being summed up in his 1904 work, "The Painter" ("Der Maler"), in which a dream-like quality prevails.[3] The title of this work was of utmost significance, according to Leonhardi, because it showed that Nolde had started to separate between man and painter and that he was also beginning to identify the visionary, light-and-men-hating side of his personality (that which shunned "men with lanterns") with the world of the artist.[4] Thus, according to Leonhardi, Nolde's works between 1900 and 1904 reflected the anguish and insecurities of one who, aware of his visions and dreams, was seeking to find some sort of expression for them; a process which necessarily led him to sharply differentiate between the world of artist and the world of man. In any case, by 1901, as we have seen, a year which marked a turning point for Nolde in several ways, he was certainly aware of these complex qualities that characterized his art.

While Nolde was being tormented by the Lildstrand visions, he wrote a letter to a young woman named Bjerget. In this letter August 21, 1901, the following statement is to be found:

> There, where in men, the multivaried aspects are combined in highest potential, is the foundation upon which the highest art can blossom--for men of nature and men of culture alike. [He can] be godlike and an animal, a child or a giant [He can] be naive and refined, full of feeling and of understanding; full of passion and devoid of passion, sparkling life and silent peace.[5]

In his letter, Nolde was of course describing himself. Inasmuch as Nolde at one time or another was every one of the creatures described in the letter, he was being quite insightful in telling of those characteristics that marked the great artist. At the same time, however, Nolde was not insightful in any psychological sense, and perhaps insofar as his artistic creativity was involved, this was fortunate. On the other hand, though, this lack of insight was to prove to be most damaging insofar as the "man" polarity of the "man/artist" synthesis was concerned. This lack of insight would contribute to his making a political decision that would forever, and perhaps unfairly, taint him, even as a large portion of cultured humanity has rejoiced in the fruits of his seemingly inexhaustible creative powers. In this chapter, we will be mainly concerned with Nolde as artist. From time to time, however, as in the previous chapter we will be necessarily focusing upon other aspects of our subject's life. As determined as he was to separate sharply between artist and man, this at times somewhat disingenuous, at times totally unconscious, separation cannot always serve model for this approach.

Nolde's marriage to Ada Vilstrup did not seem to mitigate his feelings of loneliness, at least at first. Life in Berlin was as oppressive as life in a big city always had been for him. In a letter of January 27, 1902, he wrote that "This city of millions--no person is close to my heart. I am lonely as never before."[6] Berlin was celebrating Wilhelm II's birthday, there were busts of the national leader everywhere, and the capital was swarming with officers and policemen. "Let me run away from here, far away," Nolde cried out in pain. As cheap dance music seemed to fill the streets, he longed for the world of nature:

"The soldiers dance. The sons of farmers dance with sallow-fat, poisonous coquettes."[7] Furthermore, professional frustration dogged his footsteps. Paintings sent to several exhibitions were rejected. Nolde responded to these disappointments as he had done to similar ones in the past--he went home.

In the spring of 1902, he brought Ada with him to his family. His siblings--especially Hans who, since serving in the army, had become a strong German nationalist--all rejected Nolde's Danish wife. Only his "good, dear mother" accepted her immediately, despite the tensions that had been unleashed by the visit.[8] Later on, the rest of his family came gradually to accept her as well, but his mother had led the way. A later trip to Viborg, then in Swedish-held Finland, proved to be somewhat of a disappointment. Ada, who turned out to be an extraordinarily delicate person, became quite ill and was forced to spend much time in a local hospital. Somewhat proudly, Nolde recorded that he and his wife both rejected those medicines prescribed by the physicians. Harking back to childhood fairy tales, he referred to these medicines as "little, poisonous apples."[9]

Nolde's mother died in the summer of 1902. Her last words, as reported by one of his brother, had been "the artist's name and an uncomprehendable name."[10] "A fire was extinguished," Nolde said. Upon his return to the old family Hof, a painful shock greeted him: his brothers had taken the place over, in reality, even before his mother had died. "Strange men" wandered about the grounds where Nolde and his mother had spent so much time together.[11] The bitterness he felt was intense. A large number of people came to the funeral, however, and this was of some consolation to him. Among the many wreaths was one from Ada, "bound in colorful and beautiful flowers, soaked with her tears."[12]

After a temporary stay in Flensburg, Nolde and his wife finally settled on the island of Alsen, near the town of Notmarkskov. There, they were visited by Hans Fehr and his wife Nelly. In the fall of 1903, the Nolde's moved into a small fisherman's hut near the village of Guderup. This would be the summer home for them until 1916.

Between 1901 and 1903, Nolde's paintings and sketchings--his still life works, landscapes and seascapes--showed the marked influences of Impressionism. The blurred, somewhat filtered effect produced by the Impressionistic concern for color as a permutation of the momentary impact of light upon the senses is quite apparent in many of Nolde's works. A good example of this was his "Moonlit night" of 1903 ("Mondnacht"). This painting, dominated by soft, gray tones, could have been done, at least at first glance, by any of the earlier French Impressionists. As Selz pointed out, however, these early efforts "have little of the plesant and charming appeal of the impressionists."13 Furthermore, there was that grotesque side to Nolde, such as had been evidence in his "Before Dawn" of 1901, and in Lildstrand works of the same year. His extremely strong sense for the dramatic also came out during this time, as evidenced by the pen and ink drawing "Home-coming" ("Heimkehr") of 1902. Here, a somewhat older man, wearing incidentally the kind of floppy, fisherman-type hat much favored by Nolde, is reaching out towards a woman who, overcome by emotion, is being supported by two friends or members of her family. There is little reason to doubt that Nolde's own "homecoming" of that year, as well as his mother's death, had much to do with the theme of this work.

Thus, between 1901 and 1902, there were two tendencies in Nolde's works. First of all, we can detect the still strong influence of the French Impressionists. On the other hand, though, particularly in his drawings, one can see traits that would soon blossom into magnificent fruition: Nolde's facination with the grotesque, and his concern for the dramatic aspects of human relationships. In 1904, this dichotomy was adumbrated even further. Again, Impressionistic influences are clearly visible in his oil painting "Spring Indoors" ("Frühling im Zimmer"), in which Ada is depicted in a somewhat pensive mood, surrounded by flowers. The filtered subtlety that characterized the work of so many of the French Impressionists is obvious (also, though, perhaps a poignant sadness--one that was Nolde's alone). In his "Encounter" ("Begegnung") of the same year, however, we are confronted with Nolde's perennial concern for the grotesque. Here, against an almost slashed turbulence of blue/black and white-- obviously the sea--a more-or-less normally proportioned man is shrinking back in horror from two

eldritch figures. One figure seems to be a sort of
ghostly, high-priest of the night. He is accompanied
by a familiar representation who seems to be half-wolf
and half-woman in appearance. During the same year,
Nolde also produced a number of fantasy sketches,
many of which bore striking resemblance to the
Lildstrand ones of 1901.

At this point, though, Nolde still had not
completely discovered his own unique style.
Impressionistic influences, this to be seen in his
"Spring Indoors" of 1904, clashed with his own
inherent tendency towards the grotesque, the latter
being embodied in his "Encounter" of the same year.
The appearance of the woman in this painting, half
wolf-like in appearance, points to Nolde's fears of
them as being aggressive and destructive. This view
of women was both a commentary upon his own mother
who, in his fantasies was dangerous and seductive,
and upon women in general. His negative feelings
toward the latter allowed him to continue his
identification with the mother, a necessary thing for
him despite the very negative attitudes that he had
toward her as well. This pattern is, of course,
common among those who have an inordinate degree of
mother fixation.

According to Selz, however, it is in Nolde's
"Harvest Day" ("Erntetag") that his move "beyond
Impressionism" can be most clearly seen. Here, the
vigorous motion of the harvesters against a strong,
yet pliant sea of grain is both depicted and
underscored through Nolde's dramatic use of color.
The theme was not an unusual one, and in some ways,
the painting has vague van Gogh overtones about it.
Nevertheless, it is Nolde's use of and mastery over
color which distinguishes this work. Apparently, the
critics sensed the coarse but vibrant genius that was
expressing itself in this painting, for it was
accepted by the Berlin Secession in 1906. While,
according to many, his total command over color would
not emerge until somewhat later, there can be little
doubt that the early Alsen years saw Nolde's emergence
as a full-fledged and, in some ways, self-sufficient
artist.

We are not looking upon Nolde through the
distended lens of hindsight, however. For the
Noldes, the early Alsen years were ones of virtual
poverty and bleak disappointment. First of all,

Nolde's neighbors were friendly but not exactly
enthralled with having an artist in their midst.
When Nolde announced that he was a painter, one of
them replied a bit brusquely, "We paint our own
house." "Can someone live off that?" was another
neightbor's astonished query (at this point, Nolde
was probably wondering the same thing).[14] In
exchange for meals and such, Nolde at first
attempted to assist a neighboring farm family with
the harvest. Nolde was a dismal failure at this sort
of work, however, despite his being raised on a farm.
"My husband," Ada once remarked, "cannot handle
horses and wagons. His eyes always are diverted
from practical work, because he'd rather observe
nature[!]--grain, sheaves, trees, and bushes."[15] As
opposed to Nolde's incompetence with things physical,
Ada, according to the reminiscences of Alsen
neighbors and despite her own weakened condition,
"could do everything."[16] It was due to his inability
or willingness to do physical things for himself that
Nolde became very much dependent upon others--a common
trait of those who, in pursuit of isolation,
withdraw from things. Nolde had someone bring him his
mail and, when he was able to afford it, had a young
girl come in to help take care of the house.[17] While
Emil apparently came across as something of a recluse,
Ada became very well known around Guderup, especially
at baptisms, and she was often called upon to be a
godparent. Jorn pointed out, however, that the
Nolde's seldom went to Sunday church services since
both tended to be late risers.[18]

As indicated previously, the early Alsen years
were disastrous financially. Dependent upon his
friend Fehr's sending him small monthly subsidies,
at least during 1904, Nolde found the fifty marks per
month sent by Fehr was barely enough to cover
expenses. So, in desperation, and apparently with
her husband's cautious blessings, Ada left Alsen for
Berlin, hoping to earn some money as a cafe singer.
There occurred one of the most unhappy, yet in
retrospect, amusing episodes in the life of this
couple. Apparently, Emil Nolde's occasional visits
to Berlin had not given him much of a feel for the
tastes of that rather sophisticated city. Ada went to
Berlin accompanied by a large goose (apparently a
family favorite), where she hoped to do a sort of
"goose-girl" act upon the stage. In Volume II of his
memoirs, Nolde waxed rhapsodic over the idealism of
his frail wife--hustling off to Berlin in a brave

attempt to earn some money--with only a goose for an escort. "We dumb, little painting people," Nolde said, in marvelling upon the courage of his wife.[19] Ada's efforts were, however, doomed to failure. First of all, the theatrical agents with whom she came into contact were horrible people, immensely cynical and with no feeling at all for the immense idealism that lay behind Ada's decision to come to Berlin or the naïve and gentle nature of her proposed act. Her natural beauty was not enough for them. "But, you must make up your eyes industriously!" one of them reportedly said to her.[20] This remark, particularly in view of Nolde's bucolic horror of painted women, must have really struck home. When Ada--along with her feathered companion--eventually did take to the stage, she was almost blown away by gales of laughter. Sick at heart and weakened by her efforts, Ada went home to her hotel and collapsed. The fate of the goose is unclear. Nolde indicated that, somehow, he may have been eaten by parties unknown in Berlin.

According to Nolde, 1904 was a year in which he became seriously concerned with the question of sexual passion and its relationship to the artist. Had not women often "killed the artist in men"? Was not unhappiness, or perhaps even an early death, necessary in order that truly good art be created?[21] In these statements, he sounds a good deal like Freud, although Nolde probably would have been distressed to hear of it. At this point, Nolde raised the rhetorical question of how truly great people--Christ, Muhammed, Dante and Nietzsche--behaved in the world. With some scorn, he answered his own questioning as follows: "Where are you now, little painter? You are appropriating the ranks and concerning yourself with the names of the greatest--be careful and be modest and don't look for rules."[22] Artists, thought Nolde, were pretty much beyond rules anyway. Nolde spoke of his financial problems and of his own silence in the face of them. Here, however, it would appear that he was exaggerating somewhat--perhaps this was symptomatic of his tendency toward self-dramatization. Fehr mentioned receiving a letter from Nolde, dated 17 October 1904, in which he described Ada's traumatic experiences in Berlin, complained that his friend Max Wittner did not understand his art, and also spoke of his need for money. His clothes were "turning into rags" he said.[23]

During this period, Nolde had another curious psychic experience regarding his art. "One afternoon, in a burning desire to create, I painted a picture, waves breaking against rocks. In the same instant when it was finished, I took the palette knife and slashed it....I have never been able to paint sky and water so wild again."[24] Here, the comments of Otto Antonia Graf are again important. Nolde, he suggested, was so deeply into himself through his painting that only the death of this particular picture could save him from being overwhelmed by his own psychic tensions.[25] Certainly it was true that, in the somewhat hackneyed phrase, Nolde really did put himself into his paintings. In describing the above-related incident, Nolde spoke of once seeing a sow eat several of her progeny. He wondered rhetorically if he were not doing the same thing.[26] "In the hands of the painter, pictures are his life's essence; they bear joy and passion."[27]

It should be fairly obvious that, for Nolde, painting was both a vehicle for the expression of emotions and, at the same time, a sort of substitute/censor for sensuality. If too much emotion, too much of himself, were expressed, the painting had to be destroyed; the parent had to devour his progeny. Around this time, Nolde (perhaps in part out of loneliness, since Ada way away for at least a portion of this period) seemed to be grappling with several problems of creation. Most prominent of these was the perennial one of the interaction of natural elements: light, sky, and water. "The painter is their dictator," Nolde said.[28] At the same time, he drew apart from people, with whom he occasionally quarreled and passed into the more confortable world of nature. He spoke of befriending a badger, of translating animal cries--the death scream of a rabbit, the mournful hooting of an owl--into colors (yellow and dark violet, respectively).[29] He seemed to have been possessed by a consuming dislike of humanity, who, he claimed, stood like a "hangman" in relation to nature, raising animals only to kill them, or simply hunting them down. Once more the image of the vandalized bees came to the fore.[30] Nolde even questioned whether or not human beings had the right to kill the garden pests who destroyed living plants and flowers: "Whether they, in adhering to their drives were right, or we humans in consciousness of our self-mastery--I don't know."[31]

In considering these statements and attitudes
as expressed by Nolde, we must bear in mind that he
was writing them down quite a bit after the face.
Jahre der Kämpfe was first published in 1934.
Judging from Nolde's fairly consistent pattern of
reaction to such things as isolation, however, it
would appear that his memories of at least past
thoughts were reasonably accurate, with admittedly
a certain degree of shading provided by more recent
events. What we can say with complete certainty is
that Nolde, when under strong psychic pressure, tended
at times to withdraw into a world of harsh yet
idealized nature. It was in this realm that his own
emotional turbulence could be expressed (but only up
to a point) and, through capturing the terrified or
mournful cries of animals in color, the artist
provided needed surrogates for this longely anguish
of the man.

Toward the end of 1904, however, it was obvious
to Nolde that his wife needed to recover from her
disastrous venture to Berlin. Seeking the warmth of
the south, the couple traveled to Italy.

Italy--the land of Donatello and Pierro de la
Francescas; the land of Dante, Titian and
Leonardo da Vinci. Italy, the land of German
longing; for centuries enticing all Nordic-
German artists until they turned, homeward, with
distended wings. Even the strongest.[32]

Once again, Nolde's venturing to southern climes proved
to be less than satisfying. He did paint many ruins in
Rome, of course, and the couple did find a pleasant
enough pension in Taormina. Yet, Ada's sickness
interfered with his work, and Nolde seemed to have
considerable trouble getting along with, much less
understanding, the Italians. The owner of their
pension, Marziani, had a German wife and, according to
Nolde, this proved to be quite a blessing. He
described a trip taken with some other Germans to
Mount Etna with Marziani and his wife as guides. Near
Etna, they ran into another Italian, who asked
Marziani some questions. After a somewhat lengthy
exchange, Marziani said that they all had to go back.
The strange Italian, it seems, had asked the guide if
their charges were English, and possibly rich. He,
the stranger said, would take care of Nolde and leave
the others to Marziani. "Perhaps yet under the
influence of his German wife," Nolde said, "he allowed

us to escape the Maffia (sic)."[33] It certainly was possible that the stranger sought to rob them; but, again, we have an example of that self-dramatizing aspect of Nolde's personality, particularly his assumption that the Mafia was somehow out to get him.

Also, in his memoirs, Nolde expressed a certain dismay over the racial differences that separated German (or "northern peoples) from the more vociferous ones of the south. In considering his remarks here, we must hear in mind that when he wrote this second volume (1934) he was attempting to participate in the National Socialist revolution. Hence, many of his comments about race and such have to be seen in this context. Yet, if one considers Nolde's well-established tendency toward archetyping-- "northern" peoples, "southern" peoples, "city" people, etc.--as well as his inclination (a common one among poorly educated people and, unfortunately, often among well educated ones as well) to make rather sweeping generalizations on the basis of personal experiences, some of his remarks on varieties of national character would appear to correspond to attitudes held during the period under considerations.

Nolde was very much impressed with the German wife of his landlord. First of all, she was an artist, and secondly, she was German and, Nolde indicated, had a depth and warmth to her that her more frivolous Italian husband could never understand. Far from her homeland (and, Nolde suggested, afar from her creative roots) and tyrannized by Marziani, the poor woman had a most unhappy life.

> Her colors lay dried up. Books of German poetry stood about. She was an uprooted plant, longing for her distant German homeland, one that she could never see again, languishing in obligation, until body and soul were severed.[34]

Her "dark, beautiful boy" never got to know her very well because she died quite young. According to Nolde, Marziani wept bitterly for awhile; but, then, after an appropriate period of mourning, announced that he was going to marry somebody else. Nolde and his companions exchanged glances at this news, "scarcely grasping this difference between men of the North and of the South."[35]

humor, did not have a very well-developed sense of irony. There is little doubt that this party and those who seemed to be its luminaries, Liebermann and the Cassirer brothers--all of whom were Jewish--made a rather bad impression upon him.

Nolde exhibited some of his etchings in Hamburg, where he became acquainted with another individual who would be most important in his future--Gustav Schiefler. This well-established art director and critic was very much taken with Nolde's "Fantasies" of 1905, which he had done while in Berlin. Schiefler's support came at a very propitious time, for Nolde's work was now under devastating attack in the Berlin press. He was described as being a "mad man"; as evidencing the "crudest importence"; as a "charlatan"; and as showing a "clumsiness and brutality."[45] Nevertheless, in Schiefler, Nolde had found a friend and supporter for life.

Schiefler was also acquainted with the Norwegian artist, Edvard Munch, and he was able to arrange a meeting between the two artists. This encounter apparently produced little impact upon either Nolde or Munch. According to Nolde, nobody said much of anything. He did note that Munch appeared to be worn out and quite drunk; but he thought Munch's best paintings were produced when he was in this state. Nolde indicated that when Munch finally was able to escape his neuroses, his art suffered.[46] At least hypothetically, suffering remained an important source of creativity in Nolde's eyes.

Initially, Nolde had been delighted with the invitation to join the Brücke. "I was not alone. There were also other young painters, rejoicing in the future, with efforts that were similar to my own."[47] The Dresden artists had been very much taken with Nolde's work, particularly with his etchings. The purchasing of some of them by one Herr Tillberg caused the artist to "dance with joy."[48] Yet, as Fehr described it, Nolde could not remain associated with a group for very long. He did have good relationships with several of the Brücke artists, particularly with Karl Schmidt-Rottluff, who visited him on Alsen in the summer of 1906. Nolde's antisocial nature, however, made it impossible for him to get along with the Brücke as a group for very long. The artists were selfconsciously "revolutionary," concerned with encouraging "fermenting elements" in the arts as a

heaven" for all young German artists and he was most flattered that its director was taking an interest in his work.[40] He was pleased to notice that Osthaus' wife, Gertrud, received Ada "as a human being, and not as the little wife of a starving artist; that did her [Ada] a world of good."[41] Dr. Osthaus purchased "Springtime Indoors" from the artist, and Nolde apparently was overwhelmed when Frau Osthaus took him by the arm and asked him to sit by her at the head of the dinner table "me, the shabby painter, in my miserable suit."[42] Nolde seemed to think that Gertrud Osthaus was more sensitive to art than was her husband. Also, he thought, Osthaus was a man of words rather than of deeds (what Nolde meant by this is not terribly certain). According to Dr. Herta Hesse-Frielinghaus, however, this was not strictly accurate. What was needed, she said, was monetary and personal support for artists such as Nolde, and Osthaus was unstinting in providing both.[43] Whether or not Nolde's partially critical attitude toward a man who would be of invaluable assistance to him was justified, what is revealed in a tendency of his to be drawn toward women who tended to "mother" him. At any rate, Nolde's stay at Hagen was to prove to be of immense importance. Under Osthaus' direction, his paintings would be exhibited there between 1907-1912, and the director would be extremely influential in having Nolde's works displayed in major German cities.

Nolde's "Harvest Day" was accepted by the Berlin Secession in 1906, and the artist went to Berlin to see it exhibited. He apparently was not too offended when he discovered that the director of the Secession, Paul Cassirer, had hung it in the only available place, above the entrace to a restroom. Nolde was somewhat disturbed, however, by the tone of a banquet that he attended while in Berlin. The banquet was also attended by several luminaries of the Berlin Secession--Max Liebermann, Walter Leistikow, Max Slevogt and Lovis Corinth. There was also a sprinkling of bankers and art dealers. The art dealers Bruno and Paul Cassirer heaped praise upon the beaming--and apparently inebriated--Liebermann: "You have your own art organization! You have your own art magazine! You have your own art dealers!" Gazing over a roaring bacchanal of back-slapping financiers, dealers and artists, Cassirer declared, "These artists are all my slaves."[44] Whether or not Cassirer actually meant this is beside the point. Nolde, while he did have something of a sense of

These comments are most important, because they
reveal that, despite his ideological dislike of
cities and of the presumably artificial people who
inhabited them (and, one might add, in spite of his
wife's terrible Berlin experience), Nolde derived a
great deal of stimulus from his exposure to urban
life. The surging crowds, the bright lights and
half-degenerate cabarets--these were materials for
Nolde in his "less harmless" moods. Nolde, who often
in his writings depicted himself as a lonely man from
the harsh soil of the north, always was fascinated by
cities and those who lived in them. At times, this
was a somewhat morbid fascination to be sure. Yet,
despite his anti-urban biases, much of the power and
coarse vibrancy of his art would have been unthinkable
without his self-willed exposure to in the metropolis.

On the other hand, there was always that side to
Nolde's personality that seemed to reject the world
of men in favor of a sort of mythical world of nature.
Nolde described Ada'a reaction to his ministrations
during her frequent periods of illness. "You are my
best doctor," she said. That was certainly true,
Nolde admitted, perhaps a trifle immodestly. He
hated doctors with their operations, poisons and
medicines. The "artificial drops and pills" of the
chemical industry upset him greatly. They were apart
from nature. The time would soon come, he predicted,
"when all new means of healing will be once more
devised by doctors born in and linked to nature."[39]
In many of his statements regarding the relationship
between man and nature, Nolde sounds curiously
contemporary, even in his at times rather perverse
romanticism. As was so often the case in the Germany
of his time, such views did have certain ideological
ramifications.

In 1906, Nolde painted the first of his famous
flower pictures. He also completed a number of
etchings and, perhaps under the influence of some of
the Brücke artists (as we recall, he was invited to
join this organization of February 4, 1906), various
mostly grotesque woodcuts began to appear. At this
time, Nolde made the acquaintance of a most important
individual, Dr. Karl-Ernst Osthaus, director of the
Folkwang Museum at Hagen. The writer Wilhelm Schäfer,
who had become familiar with Nolde's art, had
recommended him to Osthaus who, in turn, invited the
painter and his wife to spend some time with them.
The Folkwang Museum was, according to Nolde, a "song of

During Nolde's stay in Taormina, he was "honored" by the visit of a member of the Hohenzollern royal family, the--according to Nolde--"vain" Prince Friedrich, who happened to be in Italy at that time. Nolde seemed to derive a great deal of satisfaction from the fact that the prince arrived seated on an ass. Whether or not he purchased any of Nolde's paintings was unrecorded. Soon after, the Noldes left their Italian idyll by stages, and returned to Germany.

Again, Nolde had discovered that for various reasons he was unable to get along well in southern climes. He even rebelled against the area physically. In a letter to Fehr, written in June 1905, Ada noted that "His eyes could not stand the strong light and the glare from the white walls."[36] There was not enough green to suit her husband and, while he was much taken by the colorful clothing of the Italians, he really did not care for the landscape all that much. Nolde's consciousness of himself as being a distinctly German artist was substantially reinforced by his 1904-1905 stay in Italy. This particular tendency would have rather unfortunate consequences.

After returning to Germany, the artist took his wife to several sanatoriums in search of a cure for her seemingly endless series of illnesses. He himself spent some time in Berlin, and in the summer home at Alsen. While in Berlin, he did a fair number of etchings. "Fantasies" he called them, and in a letter to Hans Fehr of November 21, 1905, he made the following extremely interesting remarks:

> The drawings are (in any case, for the most part) water and forest pictures. The etchings have originated in the middle of the metropolis; they are less harmless...The etchings please me greatly in a very important manner, because an unruly life streams out from them.[37]

In another letter to Fehr, this one written on December 23, 1905, Nolde discussed the etchings again:

> The etchings are full of life, an ecstacy, a dance, a rocking and surging in tone. They do not belong to that art which can be comfortably enjoyed in an easy chair; they demand that the observer leap along in the ecstacy.[38]

71

whole. Nolde, Fehr said simply wanted to be left
alone to do his own art.[49] Thus, although Nolde
exhibited in Brücke exhibitions in 1906 and 1907 in
Dresden, Flensburg and Hamburg, his ties with the
Gemeinschaft became ever more tenuous. At one point,
Nolde went so far as to declare that the Brücke
artists, in their collective efforts, tended to
suppress individuality; and he attacked a 1907
exhibition of the art of Schmidt-Rottluff, Heckel
and Kirchner as being a "vanGoghiana."[50]

Regardless of Nolde's relationship to the Brücke
group, it is obvious that by the end of 1906 he was
starting to gain a national reputation. Also, he was
starting to establish something of an "aesthetic," a
self-consciously accepted point of departure for his
own work. In a letter of October 20, 1906, Nolde
described this:

> In my art I utilize all means at my disposal in
> order to attain the effect I desire. I want my
> work to develop from the material exactly, as in
> nature, a plant grows out of soil which
> corresponds to its character.[51]

As indicated previously, the roles of intuition and
the unconscious were most important. In another
letter, this one written on October 28, 1906, Nolde
remarked: "My etchings are not thoughtfully
constructed, they form themselves."[52]

A certain degree of self-confidence was expressed
in Nolde's painting, the "Free Spirit" ("Freigeist")
of 1906. This was Nolde's first oil painting of
figures done in his new style. On the left there
stands a woman-like figure in red, hands lifted in
praise. Next to her, there is a figure in orange,
hands crossed and with calm eyes staring straight
ahead. On the left, a figure in green points a
mocking finger at him; while, on the far right, a
figure in blue stands aside in cold, somewhat
cynical detachment. The orange figure, obviously
representing Nolde himself, is indifferent to one
and all. According to Selz, this painting has an
almost comical aspect to it. It does display humor--
and this is rare in Nolde's tendency toward self-
dramatization. According to Selz, Nolde was himself
aware of the weaknesses of this work and it was
because of this that he refused even to look at it
once he had completed the painting.[53] In his memoirs

75

Nolde did admit that the figure in orange was supposed to be himself and that, in some disgust, he turned the painting to the wall and refused to show it to anyone.[54] Nevertheless, this work, however hackneyed it may have been in the eyes of the artist and of posterity, represented a landmark in Nolde's life. He was now certain enough of himself, at least as artist, to stand alone.

This is an important work for yet another reason. While the artist was the domination of the mother within Nolde's psyche, this domination, which allowed him a certain degree of freedom unobtainable in the harsher world of man, gave him considerable latitude to express negative feelings about her in particular and about women in general. Naturally, Nolde was not consistent in this regard. In "Free Spirit" we see another most interesting phenomenon: Nolde is emphasizing an indifference to all around him, glorifying himself as a strong, independent individual. While there are certain ascetic qualities about him (he seems to be dressed in monk's robes) there is also clearly expressed a very strong sense of heroic masculinity. He is ignoring the whining praise of his mother and rejecting the snide criticism and cold indifference of the two men figures. In brief, he is presenting himself as a powerful, lonely man, the "ego-ideal" which dominated him in the world of men. This points out the fact that, despite Nolde's desire to separate sharply between the world of the artist and the world of man, the two realms often overlapped. Painting was the world of the mother; however, demands from his other world were often represented in it. The division between two worlds was a fact of life for the artist. Nevertheless, bridging of this division was also a fact, although Nolde was no doubt unaware of this.

Between 1906 and 1908 Nolde developed those techniques, especially concerning color, that would characterize his work up to the time of his death. Beginning with his oil paintings of flowers on Alsen in 1906, Nolde had begun to exalt colors as being of pivotal importance in his own particular variety of Expressionist art.[55] Nolde did experiment in realms other than painting. As we have seen, etchings and woodcuts had become of considerable importance for him and, in 1907, he began to do serious work in lithography. It was perhaps Nolde's experience with watercolors that was of greatest significance for

him, however. In 1908 Nolde visited his friend Hans
Fehr in Jena, where Ada was again in a sanatorium.
Nolde stayed in the small village of Cospeda, which
was located near that city. After some initial
failures with oil paintings, Nolde did some landscape
and flower paintings in watercolors. He was very
much surprised how the colors seemed to flow and
almost arrange themselves in beautiful forms. "The
frozen colors arranged themselves in crystal stars
and rays.....I loved such cooperation with nature."[56]
Nolde had done some experiments with color while in
Switzerland, working through such opposites as "cool
and warm" and striving always to attain perfection in
tension and harmony.[57] Now, watercolors had become
the most important means for him to put his
discoveries into action, and flowers his most
important subject. "I loved the fate of flowers:
growing-up, blooming, shining, glowing, providing
happiness, bowing down, withering, ending up being
tossed in the pit."[58] "Human fate," Nolde went on
to observe, "is not always as consequential and
beautiful, however it too also ends in flames or in
the grave."

Most important for Nolde was his feelings that he
and nature were "working together" in a sort of
providentially provided intuitively grasped harmony.

I wanted very much in my paintings that the
colors would develop themselves through me, the
painter; develop themselves consequentially on
the canvas, as though nature herself were
creating her picture--as ores and crystals
arrange themselves, as moss and algae grow, as
flowers must develop and bloom under the rays
of the sun.[59]

Nolde continuously stressed the necessity of the
artist's being driven by a sort of inward, irrational
compulsion: "I did not want to paint what I wanted,
only what I had to."[60] An artist who painted only
what he wished to paint was no artist at all,
according to Nolde. Unlike many other artists, such
as van Gogh, Nolde tended to deprecate will as being
important to the artist. A sort of intuitively sensed
inner drive was of importance; and the medium which,
at least in painting, was of greatest importance in
expression was color. To Nolde, color was like
"friendship, or love."[61]

Nolde's discovery of his skill with color was probably the most significant event in his early career as a recognized German artist. Here, the Cospeda experience and his use of flowers to achieve an incredible breakthrough in color are of interest. Consider the hypothesis put forward by Hans and Shulamith Kreitler: a "work of art produces tensions for which they afford specific reliefs."[62] The role of color in this regard would be a crucial one. The use of violently contrasting colors, ones of radically different "saturation" or brightness, both indicates the existence of a considerable degree of tension on the part of the painter and awakens such in the mind of the observer.[63] Interestingly enough, the Kreitlers made considerable use of Goethe's theory of color, which no doubt would have delighted him (as is well known, he thought that his theories on light and color were the most valuable ones of his career). An important aspect of his theory was his notion that the human mind strives for totality in all things and that this tends to push the eye beyond the limitations imposed upon it by the colors themselves.[64] The authors maintained that an interesting phenomenon was obvious toward the end of the nineteenth century: the public had been satiated by "the conventional means of arousing tension."[65] The totality-seeking mind's eye had driven the sensuous eye beyond established parameters of color use. Thus, beginning with van Gogh, artists began to reduce the use of intermediate colors in order to stimulate a greater degree of tension. There began to occur "a loosening of conscious control" over color, something that was inextricably intertwined with a reduction in the role form and representational content.[66] Color was now being utilized in a way that contradicted everyday experience. Here the Kreitlers singled out Nolde and the Russian Jewish Expressionist, Marc Chagall. Colors, more than ever before, were being utilized as a language, to create and/or carry moods. "Undoubtedly, awareness of the importance of colors underlies the attempts of the Synchronist group of Expressionists to relegate to colors some of the functions of form in paintings, such as the production of depth and movement effect...."[67]

Nolde, unlike such painters as Kandinsky, was no great theoretician regarding the use of color. He was quite aware of the impact of color, however, both in painting in general, and in his own work. He

wanted to paint so "that the colors would, through me
the painter, develop themselves," as if "nature
herself were creating her picture." Nolde was
viewing himself as a parent to his works. Nature was
to work through him and he was to function as a
bearer of life into the world. The life was in
color, which was "like friendship or love." The
painter, as mediator between manifold nature and the
world of men, had an extraordinarily important role
to perform. "Colors will be killed by the painter or
allowed to live, elevated to a higher being."[68] This
statement is of immense importance for us in coming to
an understanding of just how Nolde's personality was
reflected in his art. For Nolde, his paintings were
his children. He, as a parent, and like a mother,
had the divine task of bringing a particular life out
of the life-manifold into the world. In this process,
the spontaneous, unreflective act was of utmost
importance. "The painter doesn't have to know much;
it is beautiful if, under the direction of instinct,
he can paint as certain of his goal as when he
breathes or walks."[69] Nolde continuously emphasized
that a painting ought to be done quickly; that
intelligence ought to play but a limited role in the
process. These statments of Nolde point to the fact
that, for him, the act of painting was a sensual act.
The most immediate and palpable form of expression for
this sensuality was in color.

Naturally one must not overestimate the role of
color in Nolde's works. He did do work in areas in
which color--outside of the role of chiaroscuro--
played little real part, such things as pen and ink
drawings, woodcuts and etchings. In Nolde's eyes
and those of commentators and critics, however, it
was in the realm of color that he made his greatest
achievements, elevating him to an unassailable
position in the world of art. In turn, it was in the
area of watercolors and his use of these in flower
and landscape paintings that Nolde attained true
greatness in the use of color. As we have seen,
flowers for Nolde were symbolic of his mother, first
an object of Oedipal striving and then one of
identification. It was through immediate, almost
unconscious (the colors "arranging themselves";
nature "working through" the painter, etc.)
identification and representation of the mother that
Nolde achieved liberation in expression. As Urban
pointed out in Blumen und Tiere, he never remained
with flowers for very long; his Cospeda experience

was in 1908 and by 1909 he was away from flowers
again, not to return to them until the end of the
First World War. However, Nolde was always the
freest in this realm. In his animal paintings, for
example, his use of color was less pronounced and
he seemed always to need the assistance of sketched
outlines.[70] On the other hand, as Urban said, such
tentativeness was never apparent in his flower
paintings; the painter felt closer to them.[71] This
closeness to flowers was one that was, in part,
extended to landscapes in general and it was in
depicting nature that Nolde achieved the most
immediate expression of his innermost feelings. Thus,
it was in this realm that he was exposed to the most
danger. Again, what is important for us to remember
is the role of Nolde's longing for and identification
with his mother. It was through her, through flowers,
that Nolde became the "revolutionary," even though
flower paintings constituted but a small portion of
his immense lifetime output. It was through the
mother that the painter became parent to his awe-
inspiring progeny. He would always be most reluctant
to part with them.[72]

By 1908, Nolde had become quite well known. The
critic Rosa Schapiere had written a brief newspaper
article on his work in a Hamburg newspaper in 1907.
Of far greater significance, however, was an article
written by Gustav Schiefler emphasizing Nolde's
artistic honesty; he would not paint a stroke that
"went against his artistic conscience."[73] Schiefler
emphasized Nolde's use of color. He had been
influenced to some extent by van Gogh and Munch,
Schiefler said; but, he was not an imitator of
foreign art. He created out of himself.[75] Schiefler
also heaped praise upon Nolde's graphics, particularly
those that had been exhibited in Hamburg in 1907.

Apparently Nolde's response to increasing fame
(or at least, notoriety) was to justify further his
self-imposed isolation from the world. The painter
could not allow himself to be "embraced by flattering,
vampire-arms; such a painter owns the world, and he
belongs to it."[76] Nolde went on to declare that in
his own work of 1907-1908 he had discovered that
spontaneity and the rapid completion of the work at
hand were of great importance. "The quicker a
painting is done, the better it is."[77] In many ways,
Nolde sounded like the far more theoretically inclined

Kandinsky when he said, "In art, I fight for unconscious creation. Labor destroys painting."[78]

As certain as Nolde was becoming of the validity of his own aesthetic, he was also becoming more and more conscious of himself as being a distinctly German artist. In a bitter letter of March 4, 1907, Nolde attacked a critic who had scorned his works and those of some of his friends. "They say that truly living art, which belongs to the future, eludes your artistic sensibilities. It is understandable that these facts are bitterly sensed and condemned by German artists."[79] In another letter, this one dated March 20, 1908, Nolde stated following:

> The most efficaciously meaningful struggles have been fought in France; with us in Germany, there have been only small after-effects. The great Frenchmen, Manet, Cezanne, van Gogh, Gauguin and Signac broke the ice.[80]

Germany had had a great period of art of its own--that of Grünewald, Holbein and Dürer--and he hoped that another new, great period was on its way. "The artists have to lead the great struggle. However, they need young, new men with a free sense."[81] Nolde's increasing sensitivity toward his position as a "German artist" was probably (along with various psychological factors) responsible for his becoming increasingly concerned with questions of race and, more pointedly, the role of racial differences in art. Nolde's earlier tendencies toward a certain, rather mild variety of racial thinking has been already considered. Between 1907 and the outbreak of the First World War, Nolde, artistically open to the whole world, will become something of a qualified racist, at least ideologically.

Despite occasional setbacks, such as the rejection of some of his paintings by the Berlin Secession in 1908, Nolde apparently felt confident enough in his art to undertake the first of his extremely ambitious religious works. According to Nolde, Ada received an invitation to visit England in the summer of 1909. Hence, she left him for awhile and he was now alone with his thoughts. He moved to Rottebüll (now in Denmark), which was close to the village whose name had become his own. While in this village, he occupied himself painting cattle and

children. Suddenly, he became violently ill,
apparently from drinking bad water. While in semi-
conscious state, he heard one of his neighbors ask,
"Is he already dead?"[82] Ada returned from England to
be with her husband in his time of trouble, but Nolde
had already passed through his major crisis.
According to Selz, Nolde virtually threw Ada out of
the house, being unable to face the awesome task of
depicting religious scenes while she was around.[83]

Nolde began his work by sketching Christ,
surrounded by the Apostles. He felt almost compelled
to paint and, in shock, contemplated his task. He
was about to paint "the deepest secret, the most
inner event of the Christian religion."[84] Yet, he
overcame what qualms he had and began. "I painted
and painted, scarcely knowing whether it was day or
night, whether I was human or painter only."[85] First
of all, he painted "The Last Supper" ("Abendmahl").
Then, to save himself "from sinking into religion
and ecstasy," he painted "Ridicule" ("Verspottung"),
a painting which depicted Christ being mocked by
Roman soldiers. "Then, again, into the depths. . ."[86]
He began to paint "Pentecost" ("Pfingsten"). While
working upon this particular work, he was disturbed
greatly by Ada's return. Noticing this, Ada left the
next day, and her husband went on to complete the
painting.

The three paintings represented a monumental
achievement in the history of Western art. In Nolde's
"The Last Supper," the Apostles are tied together in
unity by the singular figure of Christ. He is
depicted as having a yellowish face, with eyes half-
closed as if transported in awareness of his own
imminent betrayal and death. The clash between his
bright red robe and his white shirt creates a tension
that helps to focus the observer's attention upon him,
while the cool blue color of the cup held in his hands
adds a quality of peacefulness. The blue cup serves
to tie the Apostles together in a powerful unity, a
unity strengthened by the dark colors in which they
are depicted. The crude, as Selz put it, "mask-like,"
faces of the Apostles seem to draw a line between
them as mere men and Christ as God/Man. According to
Max Sauerlandt, this painting really was a
revolutionary one, both as a painting of the Last
Supper, and as a singular work in the history of
Western art. Leonardo da Vinci, Sauerlandt said, had
painted an historical work, one dominated by a sense

of despair. Nolde's work, on the other hand, was far
more "inward." The emphasis here was on a sense of
unity and strength. The power of the gesture was
evident in Nolde's depiction of one of the Apostles
with his arm around another's shoulder. Even more
important, though, was the power of color. According
to Sauerlandt, it was color that carried both the
theme and the overriding power of the work.[87] While,
according to Sauerlandt, Nolde's work was more "inward"
than that of Leonardo da Vinci, it was the power of
externals that really dominated it; color and gesture,
inextricably intertwined in fantastic symbiosis, made
this painting one of incredible power.[88] In the work
"Ridicule," which Nolde painted in order to avoid
"sinking into religion and ecstacy," Christ himself
almost disappears in a melange of sadistic, almost
ape-like soldiery. The painting hardly seems to be a
religious one; but rather a dramatic representation
of man's brutality to man. According to Nolde, work
on this decidedly unspiritual painting allowed him to
recover his strength and paint "Pentecost."

 In the opinions of Heise, Sauerlandt and Selz,
"Pentecost" was one of Nolde's most spiritual works.
In the "Last Supper," a great deal of emphasis had
been placed upon gesture and optical effects. In
"Pentecost," however, the emphasis is upon the "felt
inner experience."[89] In the "Last Supper" there is
a certain degree of homogeneity among the Apostles.
The figure of Christ is so singular and overpowering
that all attention is necessarily focused upon him.
In "Pentecost," however, each figure is unique, and
each has his own characteristic reaction to the
mystifying events taking place. Reactions range
from bewilderment to fear-tinged wonder, and the
painting depicts a beautiful synthesis of "tenderness
and strength."[90] According to Heise, Nolde attained
a peak of spirituality in this painting; one which
would be unable to surpass in later works. What Nolde
had succeeded in doing in these first religious
paintings was incredible. He had taken his sense of
the grotesque that had characterized much of his
graphic work (and some of the early paintings) and
combined it with his new feeling for color, a feeling
that had been attained during his stay in Cospeda.
The result was a virtual psychic explosion in oils.
In many ways, Nolde had broken with traditional
religious art and, as we shall see, some critics have
maintained that Nolde's so-called religious paintings
were not religious at all, at least in the

83

traditional use of that word. Nolde himself declared
that he had broken with all religious dogma and the
letter of the Bible as well. "I had to be artistically
free; not to have God before me as a steel-hard
Assyrian ruler, but God in me, hot and holy as the
love of Christ."[91] In a word, Nolde, both in
retrospect and that time in which he was engaged in
painting, thought that he was being guided by an
internalized Providence, a Providence that had first
caught him in talons of ecstasy when he sat alone in
a hay-loft as a boy, pondering the dark secrets of
God and creation. He was indeed painting out of the
"ideational world of childhood." In this world, an
identify with Christ had been established.

Nolde's identification with Christ came from
several sources. It was, first of all, a product of
his desperate need for religion, something that came
out of his lacking a protective father during the
early years of his life. It also stemmed from a need
for self-dramatization in a world which, as a man, he
felt crushingly insignificant. A need to suffer--
common among neurotics--combined with a more
pronounced need to be mothered by a sorrowing
humanity--these also played important roles in
identifying himself with the Christ. By 1909, he
was certain enough of himself to undertake the first
of his important religious paintings. In "The Last
Supper" we see Christ as the personage toward whom all
attention is directed. In fact, as mentioned above,
his presence--accentuated by the clash between his
bright red robe and white shirt--is so overpowering
that the Apostles seem to receive their personalities
only in terms of his. Furthermore, they are depicted
as being crude and somewhat uncouth, with mask-like
faces. Only Jesus, with his hand upon the cool, blue
chalice comes across as a figure of quite dignity.
The apostles are in awe of him; but he does not
really care. While knowing that he is the source of
their salvation, his eyes are directed toward an
inward truth which his crude followers can only
barely understand. In "The Last Supper" we can see
the "Free Spirit" of 1906; but, more subtly
represented, a painting of incredible dignity and
power.

In "Ridicule" ("Verspottung") the Christ is
depicted as an object of pity. He is being scorned
and spat upon by ape-like soldiers and, in fact,
despite his dignified appearance, seems to have

84

disappeared among them. Here, Christ is suffering the abuses of those who not only do not understand him, but are seeking to destroy him as well. Here, Nolde is really depicting himself as pitiable. The Christ figure here, while bearing the burden of sinful humanity on his shoulders, is not really strong. He has been beaten to the ground.

In "Pentecost" the spirit of the Christ has returned, though of course it is not visible in human form. Only the flames which dance above the heads of the enraptured Apostles testify to his presence. This painting, however, one of the most powerful religious works in the history of art, has a deep inward quality to it. Each of the disciples seems to be transfixed in ecstatic or fearful rapture, drawn to an unknown world of awesome supernatural powers. The Holy Spirit is moving within them, and it would not be too much to suppose that this spirit is a sublimation of Nolde's own. Each of the Apostles has a well-defined individuality in this painting. However, this has been obtained through the presence of Christ's spirit. Here, we have Nolde the redeemer, the heroic fantasy-form dreamed of by a small, lonely boy who, despairing of all human relationships, once embraced earth.

In describing the mood that possessed him when he painted these magnificent works, Nolde said that the father God, the "steel-hard Assyrian ruler" God had to be rejected. The cold, paternal God of Old Testament authority, the Father God who, out of a sort of divine crankiness turned people to salt or swallowed them up in earthquakes, had to be shoved away from him. Instead, God had to live in him: "hot and holy as the love of Christ." That which lived in him as he did these religious paintings was not so much the love of Christ, however, but the love of his mother, or rather the idealized love of an idealized mother. The "steel-hard Assyrian ruler" of biblical chapter and verse and cold religious dogma was the father; the sort of person who found embodiment in the bestial Roman soldiers depicted in "Ridicule."

In view of the above, it is not surprising that the three 1909 works (and later ones as well) did seem to be characterized by a sort of child-like, fantasy aspect, and it was perhaps this quality that caused many to reject these magnificent paintings. In 1910,

85

the Berlin Secession disappointed Nolde in the
extreme, when it rejected "The Last Supper." Only
simple people, Nolde thought, understood his work.
For the "superficial" people of civilization, those
who lived in cities, it was hard. They preferred the
"sweet paintings" of the Italian Renaissance.[93] It
was perhaps of some significance that, in 1908,
Nolde had met Professor Botha Graef in Jena. This
man, who was to become a great defender of Nolde in
later years, was a professor of art history and of
archeology. He was very much interested in primitive
art of all kinds, an interest which would truly
blossom in Nolde in the years immediately preceding
the outbreak of World War One.

Naturally, Nolde did not confine himself to
religious pictures at this time. As a matter of
fact, it was during the period of his "religious
paints," 1909-1912, that he did much further work with
watercolors, emphasizing landscapes and animals. As
Urban pointed out, it was at this time that Nolde
discovered the marvelous, absorptive qualities of
Japan paper, and began utilizing it to give his
watercolors incredible qualities of depth.[94] Urban
also made the interesting point that Nolde often
painted animals and landscapes (both in oils and in
watercolors) in order to avoid the tensions and
religious fears that seemed to haunt him whenever he
concentrated on biblical topics.[95] Further, it is of
come importance to note that in 1910 and 1911 he
devoted much of his time talent to depicting scenes
in the big city.

In 1910, Nolde produced a series of splendid
etchings of Hamburg harbour. These works captured
the vibrant, at time, harsh excitement of cranes,
tugs and great ocean streamers. The following year
he painted and sketched dozens of scenes of Berlin
night life. As one might suspect, it was cabaret folk
and theater people who fascinated him. In his
memoirs, Nolde professed to have no special feelings
for the people of Berlin society. "These people were
not important to me; what I was able to bring away
on paper--that was all that appeared to be
essential." Again, in describing city life, Nolde
used the somewhat pungent metaphor of the fruit-
bearing compost-heap. "Big city manure" was of value
to him. "The farmer loves his manure, and the painter
observes poisonous flowers, like a druggist, taking
note of what he can use."[96] Yet, despite the rather

86

acrid comments noted above, we must, as Walter Jens suggested, at least occasionally differentiate between what Nolde said and what he did. As Jens pointed out, Nolde's curiosity regarding the city overcame his somewhat romantic dogman, his bucolic anti-urban bias. His facination with the extraordinary and the strange, that same fascination which was expressed in his paintings and graphic works on religious or supernatural topics, found expression in his urban studies of cabaret and theater people.[97] Pressing his point a bit further, Jens claimed that Nolde's search for the primitive Typus, which was emboided in his interest in masks and in primitive art, was expressed in his interest in urban "primitives" and their own particular social masks.[98] This last judgment was perhaps a bit controversial. Yet, we cannot gainsay the fact that Nolde's fascination with mysticism and with untrammeled forces of nature was counterbalanced by a fascination with the so-called "degenerate" people and places characteristic of the big city. In his negative comments on city life we can sense an almost compulsive quality, as if something in him was demanding that he make such provincially abrasive statements. As an example of this, we can consider Nolde's description of a masked ball in Karlsruhe (whether or not it was the same one mentioned earlier is unclear). The ball was fantastic, he said. Dancing was the "cult and joy of all nature peoples. Only with the masquerades of us civilized folk do masks become artificial, ugly and ordinary, estranged from all artistic feeling."[99] Perhaps Nolde meant this; perhaps not. At any rate, it is of some significance that there was always something in him that made him qualify whatever interest he might have had in the fun and games of city people. Perhaps Jens should have qualified his own theories regarding Nolde's common interests in primitives and primitives disguised as sophisticates.

Nolde's divided attitude toward the city can be seen as being the result of parental restraints and a strong reaction against them. Nolde, as ideologist, despised both the city and those who inhabited it. The night people of Berlin, "asphalt lions" were "sallow as powder and smelled like corpses."[100] He was fascinated with these seemingly unlikable people, however, and in 1910 and 1911 he spent much time depicting urban life. He was drawn to the bustling post of Hamburg and to the cabarets and theaters of

Berlin. It was, as indicated previously, the clash
between raw primitivism and urban sophistication
that intrigued him. This also served to give his
"city" art a biting edge which made it less
"harmless," as he put it, than other of his
paintings. Psychologically, the city was of immense
importance for Nolde. Its primitivism drew him to
the pre-cognizant world of the mother, while his
partaking of the "forbidden fruit" or urban decadence
at the same time served him as a rebellion against the
stultifying influence of the parents. Nolde's
interest in the city was no doubt in part due to Ada,
who was a singer. Of greater importance was the art
of dancing, however, and Nolde was quite free in
admitting that this urban-based activity held a
great degree of fascination for him.[101]

In his "Dancing Partners" watercolor of 1910/1911
we can see a concrete manifestation of this interest.
Here, against a throbbing blue background, a thin,
rather drawn-looking man is dancing with a woman in
reddish-orange dress and a yellow robe. The man's
feet are turned inward in an almost crabbed position.
He is somber, and his bluish-purple eveing suit is
barely distinguishable from the blue background. The
woman, on the other hand, is a veritable blaze of
color. Passion is carried in the bright colors of
her evening dress and, with a powerful arm, she seems
almost to be forcing back that of her partner's. Her
face is almost indistinguishable from the background
of the painting; only a piercing blue eye shows us
its position. The man's face, though it stands out
strongly, is very sallow, almost weak, in appearance.
He seems to be possessed by a powerful feminine force
that is moving him about at will. In this painting,
we can see both fear and wish-fulfillment on the part
of Nolde. The woman is woman per se; no particular
one is being depicted. She is a passionate life
force, overpowering in her strength. She is an
element to be feared, as a force of nature. Yet, at
the same time, Nolde's obvious relish in painting
such scenes would indicate that he enjoyed them.
There was a strong element of sexual masochism in
Nolde, a need to be both dominated and punished by
women, and he was alternately repelled by or drawn to
this drive. In Munich, a woman of the streets
terrified him; in Paris a tough little gamin
threatened him with a knife (castration) and, in many
paintings, the woman is represented either as being a
dumb sort of clod-like being, or as a strong, over-

powering figure. Again, the primal, woman-figure
here was the mother, possessed--at least in Nolde's
fantasy world--with a sensuality that both attracted
and repulsed him. In his oil painting "Audience in
the Cabaret" ("Publikum im Cabaret") we can observe
the same phenomenon. In this 1911 painting, the
woman singer is almost beside the point. In her pale
blue dress and indifferent features and gestures, she
seems not to count for very much. Since, as we have
seen, Ada Nolde was originally a singer, we can
speculate that in his depiction of the cabaret singer
as pale and lifeless, Nolde was revealing a certain
contempt for her. Two rather substantial looking men
sit in the foreground of the painting, their bulk
being accentuated by dark blue suits and the beefy
face of one of them. Their features are indistinct,
however. We can observe the full faces of two other
men, but their features are either indistinct or
rather weak. The passion of the singer's song is
expressed not on her face nor on those of the men,
but in the sharply defined features of two women.
While their faces are yellow ("sallow as powder") like
those of the men, their heavily painted lips and made-
up eyes cause them to stand out almost like masks of
primitive energy. The city-women of Nolde's paintings
were the sensual Semitic or Asiatic women of the Old
Testament paintings; furthermore, women compared to
whom those real ones in his life were drab and
unfulfilling. It is in Nolde's city works that we
can see reflected again a striking quality in his
personality, i.e., efforts both to recapture an
idealized, primitive past, in which a woman served as
sensual, powerful, but occasionally threatening
figure, and to escape this past by plunging into a
mother-related but outwardly unmaternal sensuality.
Nolde, as mentioned above, escaped the problems
posed by this dilemma by developing an ideological
hatred of the big city which, despite its many
attractive qualities, posed at the same time a threat
to the mother through its sophistication and coldness.
Nolde's falling back upon an anti-urban--and, at
times, an anti-Semitic--bias, was in part a conscious
decision on his part. The poignant drives and
sensual longings that put him in the position of
having to make such a decision were not, although at
times Nolde had an intuitive feeling for their
existence.

In 1910, the same year in which he made his
etchings of Hamburg harbor, Nolde continued his

involvement with biblical topics. He painted a
number of New Testament themes, among them "The
Clever and foolish Maidens" ("Die klugen und
törichten Jungfrauen"), "Christ in Bethaney"
("Christus in Bethanien") and "Christ and the
Children" ("Christus und die Kinder"). In the latter
painting, Nolde used the children of Alsen as models,
and, in his memoirs, he described his joy at seeing
them prancing about and rolling around in the grass.
"What grown-ups do, little ones play."[102] Perhaps
the most moving of these three paintings was "Christ
and the Children." This painting was most
interesting, inasmuch as the face of Christ is not
depicted. The observer views him from the back as he
bends over to embrace one of the many children who
have come to see him. The children are painted in
bright colors and Nolde has succeeded in capturing
their ingenuous enthusiasm in meeting a person about
whom, no doubt, they had heard a great deal. In the
right, background, a child raises his (or her) arms,
and seems to be crying "Me too! Hey, over Here!"
Christ, depicted in medium hues, seems to mediate
between the radiant enthusiasm of the children, and
the dark, skeptical attitude of his disciples, who
are painted precisely in these tones. In this
painting, Nolde seems to have been as much concerned
with contrasting the warm, spontaneous happiness of
children to the dreary skepticism of adults as he was
with depicting a religious scene per se.

Perhaps the clearest example of Nolde's separation
between father and mother is to be found in "Christ
and the Children." Jesus, in bright blue robes, has
his face turned towards a flowing crowd of happy
children. Beautiful mothers thrust them towards him
while, on the left side of the painting, his disciples
peer about in dark bemusement. Here, Nolde is the
mother, comforting children as he himself would have
liked to have been comforted by her when he grew up
in the stern rural environment of Schleswig-Holstein.
The dark, grim disciples are the father, indifferent to
children and slightly contemptuous of one who cares
for them.[103] In the New Testament paintings of 1909
and 1910, we can see two things: 1) Nolde as the
Christ, the redeemer of a mankind who will never
really understand him, and, tied closely to this,
2) Nolde as the spirit of his loving mother, the "God
of love" of the New Testament. Despite the ecastatic
mood which overtook him as he painted these works--at
least the ones of 1909--Nolde seems to have been

almost conscious of what he was doing. His very
sharp separation between God "as a steel-hard
Assyrian ruler"and the God within him, "hot and holy
as the love of Christ," would point to this. Nolde
was certainly aware of his identification with Christ,
that which was supposedly alive in him when he did
these works. He was even aware that these paintings
really stemmed from treasured youthful fantasies, and
confessed that it was in part because of this that[104]
he was particularly annoyed by attacks upon them.
What he was not aware of was his identification with
his mother, that which was being depicted in the
paintings and which also serving to allow him to be
"artistically free."

Nolde did not confine his religious interests to
the New Testament and, also in 1910, he produced a
number of paintings concerned with Old Testament
themes. Among these themes were "The Dance Around
the Golden Calf" ("Der Tanz ums goldene Kalb"),
"Pharaoh's Daughter Discovering Moses" ("Pharos
Tochter Findet Moses"), "Joseph Explains his Dreams"
(Josef erzählt seine Traume") and "The Temptation of
Joseph" ("Josefs Versuchung"). In "The Dance Around
the Golden Calf" we are able to see fairly clearly
the very close link between religious ecstasy and
raw sensuality. The Jews' "unrestrained worship of
forbidden idols serves as a pretext for painting a
sensual and frenzied scene, expressed through
movement and color."[105] The painting really has but
little to do with religion. Rather, as Selz pointed
out, a theme tangentially related to religion allowed
Nolde to express some of his inner longings and
desires, much as his depiction of Christ among the
children allowed him to express his basic
identification with children, as well as his sadness
at being unable to have any children of his own
(Ada's weakened condition and problems of his own
apparently obviated this possibility).

Throughout much of his religious art, one can
see a thinly veiled sensuality. Indeed, the violence
and sensual qualities of some of Nolde's religious
paintings have caused some critics to declare that he[106]
was often more idiosyncratic than religious. Here,
we can certainly differentiate between the respective
tones of his New Testament and Old Testament
paintings. To be sure, sensual and mundane themes
were not absent from Nolde's New Testament works. In
none of the Old Testament works, however, at least
those of 1910, can we discover anything of a

particularly inward or spiritual nature. As we have
seen, raw sensuality dominated "The Dance Around the
Golden Calf." In "Joseph Explains his Dreams," we
are confronted with a scene that could well be that
of a precocious first-year law student presenting a
hypothetical brief to his half-critical, half-bored
professors. Technically excellent, the painting was
hardly an inward one. In "Pharaoh's Daughter
Discovering Moses," we see the beautiful princess,
surrounded by handmaidens, gazing with less than
overwhelming interest into the traditional tiny
basket, made from bullrushes. Moses is not to be
seen. Again, the painting is an excellent one, with
the dark, Oriental faces of the Egyptians set off
in sensuouse prominence by the bright blues and reds
of their dresses. But the faces and gestures are
hardly profound. Indeed, the group of them resembles
a bevy of sorority sisters contemplating a fraternity
pin that one of them has received just at the moment.

"The Temptation of Joseph" is even more replete
with sensual overtones. Potiphar's wife is
stunningly beautiful. She is dark of course, with
raven-black hair and almond shaped, piercing eyes.
Her right hand is pointing to her genitalia (not
pictured), and she seems to be capable of almost
physically overpowering Joseph. The latter is
painted in strong bluish hues, with a sharp, Semitic
face. He seems to be almost smug in the realization
that he is not going to "lie" with her, yet somewhat
tempted by the great opportunity with which he is
being confronted. In this painting, it is Potiphar's
wife who comes across as being a person of strength;
this, despite the fact that she would soon express
her anger at Joseph's unwillingness to lie with her
by falsely accusing him to her husband. Joseph
seems a bit weak, if not somewhat hypocritical.
Again, the painting--a powerful example of Nolde's
concern with the tension between men and women--is
really not religious in any deep, inward sense.

In the religious paintings of 1910, we can see at
least a few of the qualities that have caused some
critics to maintain that Nolde's religious paintings
(or at least several of them) were not religious in
any real sense of the word. Yet, to judge all of
Nolde's paintings in this fashion (particularly when
we bear in mind his "Pentecost" of 1909) would be
something of an overstatement. What we can say,
however, is that the Old Testament paintings of 1910

are primarily mundane and/or sensual in character.
They were not, apparently, truly "spiritual" works.
Rather, Nolde seems to have created, in his own mind,
a fairly sharp dichotomy between the New Testament
themes, which could have elements of sensuousness
or sensuality about them, but more often than not,
were strongly spiritual, and those of the Old
Testament, which were hardly spiritual at all. In
dealing with the religion of the Jews, it would
appear, Nolde felt freer to indulge his sensual
imagination. The figure of the tempting woman, with
strong Semitic or Oriental features, was one that
would appear with considerable frequency in his art.
His famous etching of "Solomon and his Wives,"
which was one of the well known biblical etchings of
1911, is an example of this. A well-satisfied King
Solomon presides over a mincing bevy of Semitic
beauties. Once again, religion is not emphasized in
work.[107]

The Old Testament paintings did not have the
inward, mystical qualities of those concerned with the
life of Jesus. In the former--as in the "Mary of
Egypt" tritych of 1911 which we will consider
later--the mundane and the sensual predominate. Of
particular interest in this regard are "The Dance
Around the Golden Calf," "Pharaoh's Daughter
Discovering Moses," and "The Temptation of Joseph."
In both "The Dance Around the Golden Calf" and "The
Temptation of Joseph," Nolde utilized biblical
themes as a pretext to express a heavily repressed
sensuality. The wildly dancing Jewish women--similar
to his "Wildly Dancing Children" of 1909--and the
voluptuous wife of Potiphar were manifestations of
Nolde's own lusting for sexual fulfillment while, at
the same time, expressions of his fear of powerful,
savage women. In "Pharaoh's Daughter Discovering
Moses," the women simply appear to be rather dumb,
albeit very attractive. In these Old Testament
paintings, Nolde was concerned with depicting a
"foreign," i.e., Asiatic or Semitic, people. Thus, he
could express both his own sensuality and his contempt
for the very object of this, women who, through
projection, have been endowed with those qualities
which Nolde feared most in himself. In a way, these
paintings were realistic in that the role of fantasy,
i.e., a conscious identification with Christ, was not
as important here as in the New Testament works.
Indeed, in their depiction of raw natural forces, they
bear marked resemblances--at least in ideational

content--to some of Nolde's works depicting life in
the city, as well as to some of his works on nature.
Again, we become aware of the basic unity that often
underlaid Nolde's self-consciously divided psyche.
The Old Testament paintings did not merely manifest
feelings of hostility and rebellion against his
mother. They were just as much manifestations of a
rebellion against the stultifying paternal super-ego.
Only, as mentioned before, a foreign and hence
unobtainable people had to be the bearers of this
rebellion.

The elements of an almost nature-bound sensuality
that are to be found in Nolde's Old Testament
paintings of 1910 underscore his fascination with
strange races. In particular, it points out a curious
problem, his attitude toward the Jews. Due to several
statements in his writings, and due, of course, to his
early interest in Nazism, Nolde has been accused of
anti-Semitism. According to Selz, Nolde's attitude,
particularly after his 1910 confrontation with the
Berlin Secession, revealed a "narrow-minded anti-
Semitism, nationalism and racism prevalent among the
isolated German peasantry."[108] This statement has a
degree of accuracy to it. At the same time, though,
we must recognize that Nolde's attitude towards the
Jews was an extraordinarily complex one. Indeed,
this complex position served simply to make his
unfortunate political stance all the more tragic.
While, as we have already seen, Jews were, in his
eyes, materialistic and cynical, there was another
aspect to them which he found fascinating. They were,
after all, an ancient race; one, moreover, that was
possessed of a raw sort of natural strength. In
many ways, Nolde's sensual fantasies were focused
upon them, particularly upon the strongly defined
features of Semitic women. In his spiritual confusion
regarding the Jews, Nolde was representative of
powerful psychohistorical forces. The tensions
produced by these forces would be both represented in
and resolved by the hideous stasis imposed by Nazism,
itself in part a product of them. As representatives
of a "foreign race," Jewish women provided a means by
which his own forbidden and possibly dangerous
sensual longings could be projected and, as we have
seen, they could bear the burden of Nolde's rebellion
against the parental superego. At the same time,
though, projection can have a most negative influence
on the conscious attitudes of an individual toward the
particular group concerned. Most assuredly, this

happened in the case of Nolde and, while we will
examine this particular phenomenon in detail later
on, we must now consider certain issues that arose in
the period 1908-1910, the year in which a very
definite anti-Semitism emerged.

As we have seen, one of Nolde's earliest support
was the art critic Rosa Schapiere. This friendship
did not last very long, however. Apparently,
Schapiere made the cataclysmic error of somehow
insulting Nolde's mother. In a piece describing
Nolde and his family background, she said that his
mother had been fond of collecting "baubles" of one
sort or another. Thus, Nolde declared, the
"friendship" had to end.[109] Whether or not Nolde
chose to take Schapiere's "insults" as being somehow
indicative of a general Jewish tendency toward
cynicism is unclear, although it certainly was a
strong possibility. The unfortunate events
surrounding the Berlin Secession of 1910 brought out
several negative tendencies in Nolde's personality.

In 1910, the Berlin Secession rejected Nolde's
"Pentecost" as well as several other paintings that
had been submitted by members of the Brücke. As we
have seen, the Berlin Secession was dominated by the
Jewish critic and art dealer, Paul Cassirer, and by
the Jewish painter, Max Liebermann. Nolde's response
to this very great (and, in view of the brillance of
the painting, totally unjustifiable) rejection was to
attack the Secession head-on. In all fairness, it
must be noted that this attack followed an extremely
vitriolic one upon him that had been made by the organ
of the Secession, Kunst und Kunstler. Nolde's letter
of December 10, 1910, accused Liebermann of "not
knowing his limits" and of being insensitive to the
art of the younger generation.[110] Not illogically,
Nolde was in turn attacked, most importantly by Paul
Cassirer. The Jewish critic Alfred Kerr wrote a
vicious doggerel/poem, the last stanza of which went
as follows:

> Nolde hangs, the miserable creature,
> dangling in December storms. To be
> hung so young, how mean an end! (But
> yet, still no talent.)[111]
>> Nolde hangt, der Ungluckswurm
>> Baumelt in Dezembersturm Jung gehängt,
>> o schnödes End! (Doch auch jetzt noch
>> kein Talent)

Furthermore, Nolde was accused of being anti-Semitic (why such accusations were made is not terribly clear, at least from Nolde's writings). His response to all of this is somewhat uncertain and, indeed, there are two separate versions of it. First of all, there is that version which is to be found in the 1934 edition of Jahre der Kämpfe. This was the first edition of this book and, it must be pointed out, it was written at a time in which Nolde was desperately trying to accommodate himself to the Nazi revolution. While he took no public part in the debate over Expressionist art that was raging in Nazi circles at that time, he did hope that certain attitudes expressed in the book would perhaps attract favorable attention. In later editions of Jahre der Kämpfe, those which appeared after World War II, almost all of the specifically anti-Semitic statements were withdraw-, even if some of the more generally racist were not. The very fact that Nolde wanted to be accepted by the Nazis, however, would indicate that National Socialist racist attitudes appealed to at least one aspect of his own complex position on the Jews, an aspect which was no doubt exacerbated by the acrimonious debate surrounding the Berlin Secession of 1910. At any rate, we must note that in the 1934 edition of the Jahre der Kämpfe, written of course considerably after the fact of the 1910 Secession, Nolde expressed a number of viewpoints indicative of an extreme German nationalism and of a well-developed anti-Semitism. There was little real consistency to these remarks, which were made in a random, almost haphazard fashion. "Jews," Nolde said, "have much intelligence and intellectuality, but little soul and little creative gift."[112] Furthermore, Jewish men seemed to be both obnoxious and aggressive. Nolde spoke of a young Jew whom he met while in Berlin. According to Nolde (and here we should perhaps bear his tendency to fantasize in mind), the young Jew made the following statement: "Every young girl with whom I've been together for the third time must fall."[113] This statement made a "monstrous" impression on him, according to Nolde, and he wondered if "Jews are a different people than we are. Or ought a German girl chosen want and do the same." The Jewish critic Herwarth Walden who, Nolde admitted, recognized many good artists, such as Marc, Kokoschka, Klee and Kandinsky, had little feeling to that particular art rooted in the soul and soil of the homeland. A specific "Jewish intellectual sense" prohibited him from having such a feeling.[114]

96

At one point, Nolde even sounded a bit like
Alfred Rosenberg, when he declared that, at one
time, England had been an extremely creative nation.
But then it was invaded by "Spanish Jews" and became
"greedy for power and possessions." British
Imperialism was thus the result of a Jewish influence
which, at the same time, had made the English
incapable of producing art![115] Nolde credited the
Jews with having the "Bible and Christianity as
accomplishments"; he thought, however, through their
settling among Aryan peoples "a situation unbearable
for both parties has been created." This was not
entirely their fault, he added. In fact, he thought,
the Jews ought not to be harmed, but rather settled
on "some healthy and fruitful part of the earth."
This would be "the most humanely reconciliative and
greatest act for people and the future."[116]

Again, these statements appeared in 1934, a fact
which does not, of course, excuse their extremely ugly
and hateful nature, although it might well explain it.
As mentioned before, none of them were reproduced in
later editions of Jahre der Kämpfe, although, as
mentioned above, various racist statements of a more
general nature were left untouched. At the same time
we must recognize the fact that Nolde's very definite
awareness of "racial" differences, something that had
been part of his Bildung for quite awhile,
constituted fertile ground within which some very
pernicious "plants" (to use an image much favored by
Nolde) could take root. Above all, Nolde was not an
analytical person. Thus, it was probably no great
task for him to respond to attacks by Jewish critics--
rather unjust and crude attacks at that--by
cultivating some of the negative aspects of his stance
toward the Jews as a whole. Nolde's anti-Semitism,
unlike that of others, was thus to a certain extent
experientially grounded, as indeed are some prejudices.
Nolde's failing, one common to less-talented mortals,
was his inability to recognize the limited nature of
his own experience. Also, being quite unanalytical
in regard to himself (he was at times quite
introspective, but never really analytical), he did
not seek out the psychological significance of his
several attitudes, both positive and negative, toward
the Jews. In both of these very signal failings he
was, alas, not alone. Thus, presumably until the day
of his death, Nolde could exalt the Jews as being
founders of the Bible and of Christianity, and as
being possessed of a primitive, natural strength
which he found admirable. At the same time, he could

view them as materialistic, cold, over-intellectual creatures who had no soul whatsoever for artistic creativity. "Jewishness" would be at the very heart of perhaps his most famous series of paintings, the "Das Leben Christi" of 1911-1912. Nevertheless, Nolde would be able to support and to join a movement which had openly called for the destruction of that people which he found so fascinating.

The experience with the 1910 Berlin Secession also served to make Nolde ever more conscious of his role as being a "German" artist, while at the same time he felt himself to be more alone than ever. To be sure, Nolde never fell into the racist trap of viewing everything that was of any artistic value at all as being of German origin. In this regard, a letter of his to Hans Fehr, in which he mentioned the ultranationalistic art critic Willy Pastor, is of interest. In this letter, dated July 21, 1910 (after the outbreak of the Berlin Secession controversy), Nolde made the following remarks:

There is, perhaps, something of a weak possibility in what he says; but, as you also write, these glorifiers of the German [Germanenverherrlicher] know how to elucidate and to twist everything as if all that is great and good were German. He has incidentally discovered that Titian, Raphael, Michelangelo and Leonardi da Vince were all German![117]

Further, in a letter of September 14, 1911, Nolde made the remark that German paintings of the nineteenth century would not be very significant in the future. For the most part, they were done "in the shadows of the great masters" or they were dependent upon French Impressionism for their inspiration.[118] Indeed, according to Nolde, only the French had thus far proved that they could create a new art. Here, he mentioned the names of Manet, Degas, Cezanne, Gauguin and van Gogh, while, at the same time attacking the "sweet types"--Monet, Renoir, Sisley and Rodin (!)[119] The Berlin Secession, Nolde said, seemed determined to emphasize "that the French are the totally greatest painters and they they were half-great." They certainly were right in this, he added with a sort of grim humor. "If our art is to be equal to or more meaningful than the French, then it will also have to be, without especially wanting it, completely German."[120] Germans had proven themselves to be superior in such fields as industry and science. Now

was the time for Germany to assert her superiority in the field of art as well.[121]

Despite his cry for German "superiority" in the arts, Nolde sounded much like a sort of latter-day Johann Gottfried Herder. He was calling for a distinctly "national art," while recognizing that the most significant artistic revolution that had thus far taken place had occurred in France. He was opposed to slavish imitation of a foreign model, and most especially to the domination of French Impressionism that seemingly was being encouraged by the Berlin Secession. At the same time, according to Nolde, he was very much alone in his defense of German art. The young Secessionists would not support him. "Have you a financial backer?" one of them asked. When Nolde replied in the negative, the Secessionists replied, "Then we cannot risk a leap in the dark, for many of us have wives and children. We must be able to exhibit."[122] Nolde found himself outside of the Berlin Secession.

Nolde now found himself to be in the midst of a bitter artistic controversy. "A 'Nolde quarrel' had errupted, in which the parties battled each other like religious fanatics. I myself stood apart from it all."[123] Again, Nolde assumed the pose of the strong, silent lonely man. During his years in Switzerland, he had been exposed to some of the plays of Ibsen, and one wonders if he had not taken to heart the world defying cry of the "Enemy of the People": "He stands strongest who stands alone." The more prosaic Winkler, however, chose to view this isolated stand as being more symtomatic of Nolde's schizophrenic tendencies than anything else.[124]

At any rate, it would appear that Nolde's expulsion from the Berlin Secession and the violent quarrels that rose up on all sides constituted no great tragedy for him. He had his friends--Hans Fehr, Gustav Schiefler, Karl-Ernst Osthaus and Botho Graef--growing recognition, and concerns of his own. He displayed a considerable interest in the works of the Italian Futurists who, like himself, were in rebellion against established aesthetic rules and a society opaque to meaningful artistic change. In 1911, he visited the Belgian Expressionistic artist James Ensor in Brussels. Ensor, whose art could be just as morbid as Nolde's--without any of the latter's redeeming religious optimism--already had established

the reputation of utilizing masks in paintings of
biting social sommentary and acid wit. According to
Selz, Nolde had little interest in social commentary
and no sense of humor whatsoever. Hence, Ensor's
influence was more in the direction of reinforcing
certain tendecies that were already well-developed in
him.[125] Nolde did have more of a sense of humor than
Selz suspected. Nolde had been interested in masks
for some time, however, and it is probably that
Ensor represented more of an encouragement to him
than anything else.[126] After 1911, Nolde did tend
more toward themes of tropical primitivism, and
flowers and figures were integrated more often than
not.

After spending spring and summer with Ada on
Alsen, Nolde traveled to Berlin in the fall of 1911.
Ada was left behind in her native city of Copenhagen.
Nolde was about to begin perhaps his most ambitious
and best-known work, depicting the life and death of
Jesus Christ. Why Nolde felt it necessary to
separate himself from his wife whenever he was about
to commence works of this nature is hard to say.
Perhaps, though, a statement drawn from an earlier
letter to Hans Fehr is illuminating:

> You know how very much I love my wife. She is to
> me the dearest of all people. But, if she were
> to hinder me in my art, I would strongly decide
> to separate from her. I need absolute peace in
> order to work.[127]

By the spring of 1912, he had completed the nine-part
"Das Leben Christi."

This masterful work depicts nine scenes from the
life and death (and resurrection) of Christ 1) his
birth; 2) the visit of the three wise men; 3) the
young Jesus surrounded by carping and critical
Pharises; 4) his betrayal by the kiss of Judas; 5) his
dying upon the cross (the "centerpiece" of this nine
part altar-piece); 6) mournful women about his tomb;
7) his rising; 8) his ascent to heaven, surrounded by
disciples, and 9) his confrontation with the
"Doubting Thomas." In all of these paintings, Nolde
utilized color in a masterful fashion. Indeed, color
really bears the emotional impact of all of these
works. None of the nine paintings contain the deep
inwardness that characterized "Pentecost." Yet, the

power of these works is undeniable. We well confine
our comments to two of them.

Perhaps the most touching of the paintings is
that depicting the Mother Mary, holding up her
newly born son against a rich, blue sky. In the
right background, we can see the three wise men
approaching, and in back of Mary there stands
Joseph. Both Mary and Joseph are obviously proud of
their newly born child; but, it is Mary's pride that
illumines the scene. The mother, with identifiably
Jewish features, is holding her child up toward an
almost crudely painted five-pointed yellow star. Her
raven-black hair frames a face that almost sparkles
with joy, while her dark eyes betray a wistfulness, a
longing for her son. She seems to sense that a
tragic fate awaits him, but is determined to enjoy
his company for as long as she can. Joseph, one
feels, is attempting to share in this joy, however he
really cannot participate in it to the extent of the
mother. The child itself has pink, indiscernible
features. It is still a fetus. What is being
celebrated in this almost naturalistic depiction of
childbirth is life and motherhood itself. While the
theme is obviously of a religious nature, Nolde--for
various reasons--was utilizing it as a pretext for
depicting something that of almost existential
significance to him.

In the crucifixion scene ("Kreuzigung"), there is
little emphasis upon the spiritual. To the left of
Jesus stand two women, their greenish-yellow faces
stamped with expressions of sorrow and horror. Their
eyes are dark, contrasting with rich, sensual lips,
parted as if emitting gasps of pain. The anguished
mother, whose dark hair sets off the blood-red agony
of death, is being supported by a friend. Jesus
himself is yellowed by the nearness of approaching
death. Blood flows in streams from his wounds, and
his crown of thorns is also the color of blood, as is
his garmet. His cross seems to merge with those of
the two on either side of him, and there is a hideous
melange of bloodied wood and twisted hands. On the
right, four soldiers, their cool indifference
captured by their ice-blue helmets and a white
spearpoint, are casting lots for Jesus's clothing.
On the left, the earth beneath the feet of the
mourning women is green with life (as is the dress of
Mary Magdalene). On the right, the earth upon which
the soldiers kneel is blood-red (they are presumably

101

casting their lots upon Jesus's upper garment). The
agony of the scene is captured in a pulsating sky--
deep red blending into a dark bluish-purple. Sky,
earth and figures seem tied together in a paroxysm
of pain; one is reminded of the masterful effect
achieved by Edvard Munch in his 1893 work "The
Scream:". What Nolde his pictured here is an
agonizing, very human death; and he was very much
aware of this. Death for all men is horrible, Nolde
tells us in his memoirs; and it was this that he was
attempting to capture in "The Crucifixion."[128]

 At first, the nine-part "altar-piece" was shown
in Osthaus's Folkwang Museum in Hagen. Later, under
Osthaus's auspices, it was sent to an exhibition in
Brussels. There it was bitterly attacked by the
Catholic clergy, while the Evangelical clergy of
Nolde's homeland did the same. Everyone, it seemed,
was most annoyed by Nolde's depicting Jesus, his
mother, father and apostles as being Jewish. Many
Jews as well protested the work. "I painted them as
strong Jewish types, because those who acknowledged
Christ's revolutionary new teachings were certainly
not weaklings."[129] Such a statement, which did
appear in the 1934 edition of Jahre der Kämpfe, shows
that Nolde had little real appreciation for the
systematic racism of the Nazis, whose views of
religion were rooted in some of the stranger teachings
of such people as Eugen Dühring and Houston Stewart
Chamberlain, who went so far as to deny that Christ
was Jewish at all. "Where would this lead?" Nolde
asked rhetorically. "If we wish to see Christ and
the apostles painted as Aryan, should not the Chinese
Christian see him as Chinese, or the Negro represent
him as black?"[130] "Art stands elevated over religion
and race." Many ancient races were gone forever, and
only their art remained. Yet, Nolde remained
convinced that Germany needed to produce her own
vital art. "Praised be our strong, healthy German
art," he enthused and, in a somewhat questionable
attempt at synthesis, he attempted to tie together
the Isenheim altar, Goethe's Faust and Nietzsche as
all being representative of peculiar German spirit
in the arts.[131]

 We have examined in some detail at least two of
the paintings of Nolde's nine-part "Das Leben
Christi." In the painting which depicts the birth of
Christ, we can see another example of Nolde's
fascination with the mother. Here, as mentioned

earlier, it is the mother around which all is centered. The fact that the features of her child are indistinct (there is an almost fetus-like quality about it) was perhaps responsible for Max Sauerlandt's stating that Nolde was not depicting any particular child or, more important, any particular mother. Rather, he thought, the painter was celebrating the universal phenomenon of a mother's love for her child.[132] While this view perhaps had some merit to it, there is another interpretation that can be offered. The painting was not really a celebration of birth in general; rather, it is a celebration of Nolde's own fantasized birth. The features of the infant are indistinct because Nolde knew that this child was supposed to be him. In this painting the great artist is expressing a forlorn fantasy--to be born of a woman devoted exclusively to him, to be born ordained. Part of the fantasy is his own mother. There, in the heavens, we can see the "lucky star" (the "Star of Bethlehem", but Nolde's star in actuality) of which she had spoken some years before. The mother, proud yet seemingly aware of the great sadness that awaits her in the future, is holding the infant up to this star. One can almost draw a straight line down from the star, through the infant's head, to the eyes of the mother. There is a unity here of mother/infant/fate, while the father, although obviously pleased, is somewhat in the shadows.

The first painting of "Das Leben Christi" thus reveals an almost poignant-longing for wish-fulfillment on Nolde's part. He is representing an experience which, as a child he never had, uninterrupted and, indeed, unlimited devotion from a worshipful mother. Yet there is another aspect to the painting that is of interest. The features of Mary are hardly those of his mother. They are strongly Semitic in all aspects. As we have seen, Nolde justified his painting Christ and those around him with strongly Jewish features on the grounds of historical accuracy. There was another angle to this, however, namely, his desire to experience sensuality from a mothering figure other than his real mother. After all, his real mother's sensual life was something over which he had had no control whatsoever, most certainly at least not when the father was alive. On the one hand, she had surrendered herself to the father; on the other, like any object of prolonged Oedipal fixation, she must have seemed to have been alternately cold and

unresponsive, and aggressive and threatening. Now, in the figure of a Jewish woman, darkly sensual but with deep, almost hauntingly gently eyes, Nolde had replaced his real mother with a mythical one whose overwhelming possession of him he could control. Again, he had chosen a representative of a "foreign race," thus making the substitution impossible. An underlying sense of guilt prohibited him from creating a plausible situation of parental transference.

In the "Crucifixion" ("Kreuzigung") work of 1911-1912, the blood-red which predominates in the painting also can symbolize a strong passion (in dreams, as we have noted, it is usually seen to symbolize semen). In this painting, the mother, almost overwhelmed by sorrow and horror, is dressed in white, a traditional sign of purity or virginity. While in anguish, her full red lips and dark eyes are those of the night women of Berlin. Meanwhile, the father is represented by four soldiers who are coolly gambling away what little material dignity the son has left. In this painting, as much as in the one depicting the birth of Jesus, an almost desperate longing is revealed: to be observed, if not comforted, by a pure and warm mother (obviously, she had not had intercourse of any kind with the brutish soldiers, the father), one whose sensuality is reserved for him. Yet it is now impossible for there to be actual physical intercourse between mother and son, just as it was impossible at the moment of birth. The powerful force of Nolde's conscience, the father as super-ego, has seen to that.

Obviously, 1912 was a most significant year in Emil Nolde's life. First of all, as we have seen, he completed his "Das Leben Christi." Also, his paintings were exhibited in the Grillo-Haus in Essen, under the directorship of Botho Graef, while Nolde participated in the second exhibition of the Blaue Reiter and in the great international exhibition of the Sonderbund in Cologne. The Neue Sezession, of which Nolde had been a member since 1910, did break up due to lack of support from many of the Brücke artists. As indicated above, however, a close, artistic Gemeinschaft never had been of overriding importance to him anyway. More important for him were his continued efforts in several different directions. He painted several fine seascapes and continued his work with woodcuts. Also, he produced another group

of religious paintings, the triptych, "Mary of Egypt" ("Marie Agyptiaca"). This group depicts Mary of Egypt as a woman lost in sin who, after having a powerful religious experience (she had a vision of the Virgin Mary), led a saintly life, and eventually died peacefully in the desert, where she was buried by St. Zosimus and a lion. The first painting of the triptych, which shows Mary engaged in lustful interaction with three incredibly brutish-looking men, pointed to a theme that would become ever more prominent in Nolde's work, the tension between men and women. Through violent use of red and yellow and an almost hideous deformation, he has succeeded, as Selz pointed out, in almost caricaturing sex.[133] The remaining two paintings of the triptych, which, respectively, depict Mary in an act of almost violent contrition before the image of the Virgin, and then show her as an essentially asexual corpse, being buried by St. Zosimus and a lion (which, as Selz points out, could well have been taken from a children's book), tell us a great deal about Nolde's Weltanschauung. They do lack the forcefulness of the first painting, however, in which color serves as a medium of almost daemonic force.

The triptych, while not one of Nolde's better-known works, points out a characteristic which had become quite prominent in his art by this time, his interest in somehow capturing duality. Nolde himself recognized this. "Duality always had had an important role to play in my pictures, and even in my graphics. With or against one another--man and woman, joy and grief, God and devil." This duality was expressed in colors, or course: "Cold and warm, bright and dark, subdued and strong."[134] Max Sauerlandt saw this use of "hot" color as contrast-producing in Nolde's "Vacation Guests" ("Feriengaste") of 1911. Here, a seemingly relaxed scene of three women and a cigar-smoking man seated upon the grass, with a picket fence in the background, is turned into something of incredible fantasy through the sharp orange, red and blue colors in which the figures are depicted. Against the cool green of the grass, they appear to be almost like visitors from another planet.[135] The same sense of contrast can be observed in the use of color in "Das Leben Christi," while in "Mary of Egypt" violent sensuality clashes with a sanctified sense of peace. In a way, this incredible sense for contrast carried over, at least to some degree, into Nolde's attitude toward the Jews.

One senses a real feeling of frustration in letter of September 15, 1911 to Ada.

> With the exhibition of my pictures it has become
> clear to me that anything in which I depict Jews,
> biblical or otherwise, cannot be exhibited.
> This is very strange; I really want to paint
> this strange race which is among us here, and
> everything is perceived in a distorted manner.[136]

Magnificent use of color to express raw emotion, a fascination with the strange and with often violent contrasts, and a pronounced anti-intellectual stance ("Intellect is antiartistic in the creative man; intelligence can be a false friend to the artists")-- by 1912, many of the most prominent aesthetic and ideational characteristics of Nolde as artist and man had been established. Also present was a sense of mission and of prophecy. In 1913 a series of Soldaten pictures appeared. In his memoirs, Nolde spoke of having certain clairvoyant qualities (as we recall, he thought that his mother had had the same qualities) which, in the midst of peace (at least peace in Western Europe; the Balkan Wars were raging at the time), caused him to paint apocalyptic scenes of destruction. In one painting, moreover, "Cavalry Picture" ("Reiterbild"), a Frenchman is depicted cutting down his German opponent.[137] Nolde was implying, of course that he sensed coming German defeat in an approaching war.

Whether or not Nolde was indeed clairvoyant, or whether he was merely yielding to a well-established tendency toward self-dramatization, there can be no doubt that, by 1912, he had established himself as an artist. Karl-Ernst Osthaus, Hans Fehr, Gustav Schiefler and Botho Graef supported him, and soon Max Sauerlandt would join their ranks. More important, though, was the fact that Nolde had showed himself as one of the most original (if not necessarily the best loved) religious painter in modern times. At the same time, his brilliant use of color elevated him above the achievements of the Fauvists and most Expressionists in this area. He could depict flowers in tones of incredible, gentle beauty. He could also capture the agony of human suffering and death and in his "Prophet" woodcut of 1912, the tortured aspect of the mortal who plumbs the depths of future miseries. He could depict the excitement and degeneracy of the big city; yet he showed a growing interest in

primitive art of all kinds. Almost perverse in his anti-intellectualism, Nolde had revealed himself to be one of the most perspicacious commentators upon all aspects of the human condition. In all of these triumphs, we can see the striving of a soul seeking to overcome alienation. We can also see that Nolde, as both man and artist, often drove himself into precisely this same alienated posture. We can see Nolde as the most universal of men, interested in all aspects of human life and intrigued by strange races and faraway lands. We can also see him as sharing many of the popular prejudices extant in Germany at that time, and as being a somewhat splenetic nationalist. In his tortured sensitivity, and in his less admirable qualities as well, Nolde was both an exponent of the spirit of his age, and a catalyst, who assisted in rationalizing this spirit and expanding its parameters. Yet, there was much that awaited both him and his homeland.

Chapter Four

Footnotes

[1] Klaus Leonhardi, "Das Selbtsbildnis bei Emil Nolde," in Niederdeutsche Beitrage zur Kunstgeschichte, Band II, (München/Berlin, 1962), p. 242.

[2] Ibid., p. 243.

[3] Ibid., pp. 245-246.

[4] Ibid., p. 246.

[5] Emil Nolde, Briefe: 1894-1926, Herausgegeben von Max Sauerlandt (Hamburg, 1967), p. 35.

[6] Ibid., p. 38.

[7] Ibid.

[8] Emil Nolde, Jahre der Kämpfe, dritte erweiterte Auflage (Köln, 1965), p. 11.

[9] Ibid., p. 14.

[10] Ibid., p. 15.

[11] Ibid.

[12] Ibid.

[13] Peter Selz, German Expressionist Painting From its Inception in the First World War. (Berkeley and Los Angeles, 1957), p. 87. See also Peter Selz, Emil Nolde (New York, 1963), p. 14.

[14] Karl Jorn, "Ada und Emil Nolde auf Alsen: 1902-1906," in Deutscher Volkskalender Nordschleswig, 1972 (Aabendraa, 1972), p. 41.

[15] Ibid., p. 42.

[16] Ibid.

[17] Ibid.

[18] Ibid.

[19] Nolde, Jahre der Kämpfe, p. 47.

[20] Ibid.

[21] Ibid., p. 33.

[22] Ibid.

[23] Hans Fehr, Emil Nolde: Ein Buch der Freundschaft (München, 1960), p. 29.

[24] Nolde, Jahre der Kämpfe, p. 37.

[25] Otto Antonia Graf, "Kämpf um Möglichkeiten" in Museum des 20. Jahrhunderts Wien III, Katalog 23 (Wien, 1965), p. 11. "If there should be horror we can safely say that it is due to the arousal of early phobias and fantasies in which raging elements are surrogates in persons whom he himself has lashed to fury, and that he dreads to witness the external fulfillment of his own secret wishes or to see before him the awful chaos which lies within himself." John Rickman, "On the Nature of Ugliness and the Creative Impulse," in Hendrick M. Ruitenbeck, The Creative Imagination: Psychoanalysis and the Genius of Inspiration (Chicago, 1965), p. 118.

[26] Nolde, Jahre der Kämpfe, p. 37.

[27] Ibid.

[28] Ibid., p. 39.

[29] Ibid., p. 43.

[30] Ibid.

[31] Ibid., pp. 43-44.

[32] Ibid., p. 51.

[33] Ibid., p. 57.

[34] Ibid., p. 58.

[35] Ibid.

[36] Fehr, p. 30.

[37] Letter property of Stiftung Seebüll Ada und Emil Nolde, courtesy of Dr. Martin Urban.

[38] Ibid.

[39] Nolde, Jahre der Kämpfe, p. 39.

[40] Ibid., p. 81.

[41] Ibid.

[42] Ibid.

[43] Dr. Herta Hesse-Frielinghaus, "Karl-Ernst Osthaus und Emil Nolde" in Hagner Heimatkalender 1966 (Hagen, 1966), p. 45. On Nolde's view of Osthaus, see Jahre der Kämpfe, p. 82.

[44] Nolde, Jahre der Kämpfe, p. 84.

[45] Ibid., p. 87.

[46] Ibid., p. 89.

[47] Ibid., p. 99. See also Peter Selz, Emil Nolde, p. 15.

[48] Nolde, Jahre der Kämpfe, p. 100.

[49] Fehr, p. 34.

[50] Ibid., p. 41.

[51] Emil Nolde, Briefe 1894-1926, p. 54.

[52] Ibid., p. 55.

[53] Selz, Emil Nolde, p. 15.

[54] Nolde, Jahre der Kämpfe, p. 100.

[55] Emil Nolde: Blumen und Tiere, ed. by Martin Urban (Koln, 1972), p. 7.

[56] Nolde, Jahre der Kämpfe, p. 90.

[57] Nolde, Blumen und Tiere, p. 12.

[58] Nolde, Jahre der Kämpfe, p. 100.

[59] Ibid., p. 101.

[60] Ibid.

[61] Ibid.

[62] Hans and Shulamith Kreitler, Psychology of the Arts (Durham, North Carolina, 1972), p. 32.

[63] Ibid., pp. 38-39.

[64] Ibid., p. 46.

[65] Ibid., p. 50.

[66] Ibid., pp. 76-77.

[67] Ibid., p. 78.

[68] Nolde, Jahre der Kämpfe, p. 101.

[69] Ibid., p. 201.

[70] Nolde, Blumen und Tiere, p. 38.

[71] Ibid., p. 41.

[72] This characteristic was not common to all creative spirits. In his "Leonardo da Vinci and a Memory of His Childhood," Freud described this painter's willingness to part with his works, or to abandon them altogether even before they were completed. "The effect which Leonardo's identification with his father had on his paintings was a fateful one. He created them and then cared no more about them, much as his father had not cared about him." See Sigmund Freud, The Complete Psychological Works of Sigmund

Freud, trans. from the German under the General
Editorship of James Strachey, Vol. XI, "Leonardo da
Vinci and a Memory of His Childhood" (London, 1968),
p. 121. Leonardo da Vinci also suffered the
indifference of his father although, according to
Freud his mother was such a source of identification
for him that he became a homosexual. In many ways,
the etiology of Leonardo da Vinci's problems was
similar to that of Nolde's. Yet the two developed
quite differently, both artistically and personally.
This points out the danger of dogmatic adherence to
the notion that a particular pattern of childhood
development must always necessarily lead to
particular consequences. Of course, Freud's
interpretation of Leonardo da Vinci's artistic life
has not gone unchallenged. See particularly Meyer
Schapiro's "Leonardo and Freud: An Art Historical
Study," in the Journal of the History of Ideas,
Vol. XVII, No. 2 (April, 1956), and Raymond S.
Stites' "Alfred Adler on Leonardo da Vinci" in the
Journal of Individual Psychology, Vol. 27, No. 2
(November, 1971).

[73] Gustav Schiefler, "Emil Nolde," in Zeitschrift für
bildende Kunst, neue Folge, Neunzehnter Jahrgang
(Leipzig, 1908), p. 25.

[74] Ibid., p. 26.

[75] Ibid., pp. 26-27.

[76] Nolde, Jahre der Kämpfe, p. 101.

[77] Ibid.

[78] Selz, Emil Nolde, p. 16.

[79] Nolde, Briefe 1894-1926, p. 56.

[80] Ibid., p. 73.

[81] Ibid., p. 74.

[82] Nolde, Jahre der Kämpfe, p. 121.

[83] Selz, Emil Nolde, p. 19.

[84] Nolde, Jahre der Kämpfe, p. 121.

[85] Ibid.

[86] Ibid.

[87] Max Sauerlandt, Emil Nolde (München, 1921), p. 43.

[88] See Carl Georg Heise's essay "Emil Noldes religiöse
Malerei" which first appeared in the journal Genius

in 1919, in Der gegenwärtige Augenblick, Reden und
Aufsätze aus vier Jahrzehnten (Berlin, 1960), p. 6.

[89] Selz, Emil Nolde, p. 19.

[90] Sauerlandt, p. 60.

[91] Nolde, Jahre der Kämpfe, p. 125.

[92] Dieter Heinz, "Emil Nolde: Sein Leben und Werk als
Ausdruck seines Charakters," unpublished
dissertation (Tübingen, 1948), pp. 11-12. Nolde was
not the only artist who, because of various
unresolved childhood problems, identified himself
with Jesus Christ. Vincent van Gogh did as well,
although he rarely painted biblical scenes per se.
See Albert J. Lubin, Stranger on the Earth (Bungay,
Suffolk, 1975), pp. 242-257, 272-273.

[93] Nolde, Jahre der Kämpfe, p. 126.

[94] Nolde, Blumen und Tiere, p. 29.

[95] Ibid.

[96] Nolde, Jahre der Kämpfe, pp. 147-148.

[97] Walter Jens, "Der Hundertjährige: Emil Nolde," in
Von deutscher Rede (München, 1969), p. 112.

[98] Ibid., pp. 115-116.

[99] Walter Jens, p. 143.

[100] Nolde, Jahre der Kämpfe, p. 147.

[101] Ibid., p. 218.

[102] Ibid., p. 130.

[103] At the same time, however, one can notice that the
lower portion of Christ's body seems to be pulling
away from the children, as if he really did not want
to get too close to them. This suggests that while
Nolde consciously idealized them, he did not wish
to be involved with them in any physical sense.
Nolde, as we know, had no children. I am indebted
to Martin Wangh, M.D., for calling my attention to
this. In turn, Dr. Wangh informs me that it was
his wife who called his attention to the position
assumed toward the children by Christ.

[104] Fehr, p. 95.

[105] Selz, Emil Nolde, p. 19.

[106] Heise, p. 5. Graf went further, and maintained that
Nolde came close to "perverting" Christian art. See
Graf, p. 9.

[107] In Nolde's very sensitive etching of King Saul and David, there are of course no sensual overtones of any kind. It is the jealousy of King Saul that dominates the painting, however. In other words, passion really has taken the place of religion.

[108] Selz, Emil Nolde, p. 28.

[109] Hans Fehr, "Gespräche mit Nolde im Jahre 1908," in Kontrapunkte: Jahrbuch der Freien Akademie der Kunste (Hamburg, 1956), p. 26. See also Fehr, Emil Nolde, Ein Buch der Freundschaft, p. 39.

[110] Nolde, Jahre der Kämpfe, p. 169.

[111] Ibid, p. 171.

[112] Nolde, Jahre der Kämpfe (Berlin, 1934), p. 101.

[113] Ibid., p. 102. Emphasis is Nolde's.

[114] Ibid., p. 121.

[115] Ibid., p. 124.

[116] Ibid.

[117] Emil Nolde, letter to Hans Fehr, dated 21.7.1910, property of the Stiftung Seebüll Ada und Emil Nolde, courtesy of Dr. Martin Urban.

[118] Nolde, Briefe, 1894-1926, p. 78.

[119] Ibid.

[120] Ibid., pp. 78-79.

[121] Ibid., p. 79.

[122] Nolde, Jahre der Kämpfe, 1965 edition, pp. 172-173.

[123] Ibid., p. 145.

[124] Walter Winkler, Psychologie der modernen Kunst (Tübingen, 1949), p. 177.

[125] Selz, Emil Nolde, p. 32.

[126] On this question, see Martin Urban's perceptive essay in Emil Nolde: Masken und Figuren, ed. Martin Urban (Kunsthalle Bielefeld, 7 Januar-14 Februar, 1971).

[127] Fehr, Emil Nolde, Ein Buch der Freundschaft, p. 47.

[128] Nolde, Jahre der Kämpfe, p. 190.

[129] Ibid., p. 192.

[130] Ibid.

[131] Ibid., pp. 195-196.

[132] Max Sauerlandt, "Emil Nolde," in Zeitschrift für bildende Kunst, neue Folge, Funfundzwanzigster Jahrgang (Leipzig, 1914), p. 192.

[133] Selz, Emil Nolde, p. 24.

[134] Nolde, Jahre der Kämpfe, p. 200.

[135] Max Sauerlandt, Emil Nolde, pp. 44-45.

[136] Letter of 15,9.1911, property of the Stiftung Seebüll Ada und Emil Nolde, courtesy of Dr. Martin Urban.

[137] Nolde, Jahre der Kämpfe, p. 215.

Chapter Five

Maturation: 1913-1933

In 1913, Nolde enjoyed a considerable degree of
financial success. Max Sauerlandt, who originally had
been rather cool toward him, purchased "The Last
Supper" for his museum in Halle, while the Folkwang
Museum purchased "The Clever and the Foolish Maidens."
Perhaps the greatest indication of the national
recognition that Nolde had gained by this time,
however, was his being invited to participate in an
expedition to New Guinea organized by the German
colonial office. The trip began on October 2, 1913,
and Ada accompanied her husband on a journey that
covered visits to Moscow, Mukden, Seoul, Tokyo,
several cities in China, Hong Kong, Manila, the South
Sea Islands and New Guinea. In volume three of his
memoirs, Nolde went into some detail describing how he
and Ada trained with rifle and pistol, and learned to
ride, in preparation for this memorable journey.[1]

Nolde was fascinated by the native art, and for
that matter by the natives of Russia. As his train
inched its way along the single-tracked Trans-Siberian
Railroad, Asiatic types of all kinds passed before his
astounded eyes. "The young women with their children
were often very dear. The painter would not forget
them."[2] Incidentally, it was in this third volume that
Nolde first began differentiating continuously between
man and artist. Wherever he went, he attempted to
avoid what he called the "European-American luxury
hotel" and immerse himself in the population. Visits
to Mukden and to Seoul apparently did not impress him
very much, although Nolde might have been relieved not
to have found anything resembling a "European-American
luxury hotel" in either backwater city. Evidencing a
very common prejudice, Nolde viewed the Japanese as
great collectors. Perhaps, he thought, a bit
ironically, the Japanese were performing a service,
saving much of artistic value from wars and
revolutions in such places as China. This was
"doubtless a service similar to that performed by the
English in Europe, who have collected so much of value
on their island."[3] Nolde was not particularly
impressed by Japanese art. It was too tasteful, too
clean. In this regard, he thought, "Mount Fujiyama,
with clean, smooth, cone-shaped form, with its flat
peak, can serve as a satisfactory symbol for Japan."[4]
Strangely enough, China also did not seem to move

Nolde, at least artistically. He was more awed by the
incredible poverty of that land than anything else.
He expressed embarrassment at being pulled in a
rickshaw in Peking and, somehow missing the irony of
it all, he described how he and his wife tossed
crusts of bread and "gnawed chicken bones" from a
train window to an excited, milling crowd.[5] He
described the bargemen of the Han River, pulling boats
upstream, and the thousands of impoverished people,
burdened down with household and trade objects. Their
chant of "Oh-a-oh" seemed to Nolde "as if it were the
song of sweat-drops; the tears of slaves."[6] Later, in
a letter written on the steamship Prinz Waldemar,
Nolde described his impressions in some detail:

> The Japanese and Chinese are Kulturvolker; Japan,
> the Germany of the East. Only, I don't believe
> that the Japanese have as deep a capacity within
> them as the Germans. The Chinese are a people
> of high culture-subtle, cowardly and, at the
> same time, inhuman, decayed and shattered.[7]

All nations seemed to be working to destroy China, he
thought. Missionaries, trade and military influence--
all seemed to be working hand-in-hand. It was
disturbing to notice, Nolde said, how many foreign
products, quite a few of them German, were to be found
in China.[8] In another letter, this one dated December
3, 1913, Nolde declared that China was threatened both
by Western culture and by Japan. The Western powers
and Japan dealt with helpless China "exactly as a
usurer with a debtor."[9]

During all of the trip, "the painter painted."
Ocean steamers, fishing boats, junks, people--all were
assiduously recorded in sketches and, later, in
watercolors. Occasionally, there was an adventure.
One day, according to Nolde, a Chinese fell overboard
during a storm and was, apparently, eaten by a shark.
When one recalls Nolde's terrifying "experience" in
Paris, it would seem that, during his travels, he was
always accompanied by a small black cloud.

Trips to the South Sea Islands and New Guinea
strengthened Nolde in his conviction that the impact
of the so-called civilized world upon the East (and
especially upon the primitive peoples) was a most
negative one. He was shocked at the exploitation of
the New Guinea natives by planters. "If a colonial
history were ever written from the point of view of

116

the natives, then we Europeans would have to crawl ashamed into our holes."[10] Europeans were a "calamity" (Unheil) for the people of nature, as were the Japanese. Soon, Nolde predicted, Americans would be in much the same position. Nolde expressed disgust over the behavior of Europeans in a New Guinea club-house. They ate "raw [!] beefsteak" and raw eggs with fiendish relish. "The greed for fresh meat was that of a beast of prey; weird."[11]

In a letter of March, 1914, Nolde praised the courage of the missionaries he had met. They sacrificed themselves selflessly. Their deaths were always avenged by soldiers, however, and then the doors were open to adventurers and traders of all sorts. "We live in a time in which all primal states and primal peoples are being destroyed; everything is discovered and Europeanized. . . In twenty years, everything will be lost."[12] "Primitive people live in their nature, are one with it and part of everything. Sometimes, I have the feeling that only they are still really human; we, however, are somewhat like poorly educated puppets, artificial and full of darkness."[13] Somewhat pompously, perhaps, Nolde went on to say that he knew of no other artists, outside of Gauguin and himself, who brought anything of value out of the East.

Time and again, Nolde attacked the traders and business-men he met during his travels as crude and materialistic. They had no respect at all for the artistic value of the native jewelry and masks. All that they were interested in was money. Always, Nolde contrasted himself to such people; and, as he was wont to do, he tended toward self-dramatization. He described painting a native of Manu who posed, spear in hand. Nolde kept a revolver nearby, while Ada (and, as matters turned out, a group of soldiers as well) covered him against a possible rush by the native's friends. "Perhaps never before had a painter worked under such tension."[14]

Certainly Nolde's condemnation of colonialism and of European insensitivity toward native art was more than justified. Moreover, there can be little doubt that, painting a spear-toting native, while many of his somewhat suspicious comrades milled about in the background, must have been tension producing. Nolde's perennial tendency toward self-dramatization, however, and his apparent belief that only he (and perhaps people like him) really had an appreciation for the

natives as creative human beings point to an urgent
need in him to establish a very personal relationship
to the primitive world. As Graf pointed out, this was
part of a protest against the harsh world of Nolde's
father. He was reaching backward in time, toward the
untrammeled relationship of child/mother that he
never had.[15]

Bad luck--at least to those unfortunate enough
to be traveling with him--continued to plague Nolde
wherever he went. In Java, an old woman sat next to
the Noldes on a train. The train whistle and the hiss
of steam apparently terrified her. She "screamed and
screamed--and died."[16] The unhappy grandson cried,
chaos reigned supreme, and Nolde was given a concrete
example of cold technology's triumphing over the
children of nature.

Not surprisingly, Nolde met Englishmen
throughout the Orient. Once, one of them startled him
by asking why Germany wanted war, and why she was
building a fleet to threaten England. Usually, however,
it was simply the demeanor of the English that
disturbed him. "Thye are absolute masters and every
Englishman or European is supposed to be able to
travel only on a first class train; the second is
beneath the dignity of a whiteman."[17] Again, Nolde's
feelings are certainly understandable, particularly
when we bear in mind his sympathetic attitude toward
the ill-treated natives. As in the case of his love
for primitive peoples, however, there were substantive
psychic reasons for his almost unmitigated dislike
for Europeans in general, and the English in
particular.

The Noldes were on a ship anchored off Aden, on
the way home, when they heared the news that war had
broken out in Europe. With enthusiasm, they sang
patriotic songs. A Swiss offered to be of assistance
to them in whatever way possible. Ada and Emil, for
reasons apparently having little to do with the war,
had to change ships. They were fortunate enough to
book passage on a vessel commanded by a sympathetic
Dutch captain. Since the ship was to dock in
Marseilles, he thought it best that the German couple
claim to be Danish, something that was in the realm of
possibility since both of them spoke that language.
The ship landed in a flurry of military activity.
French warships and troops were everywhere, and reports
of French victories on the Western front filled the

air. Nolde was pleased to note, however, that the maps seemed to indicate that Germany was pushing further and further West.[18] The outbreak of war caused Nolde to become somewhat reflective, at least for awhile, about Germany. Perhaps she ought not to have become a great power so quickly; perhaps, through "its science, its music, its fine art" it ought to have remained a spiritual influence upon the world.[19]

Nolde spent the war years on his beloved island of Alsen and in Utenwarft. Occasional visits to Berlin broke the monotony. Due to wartime tensions and probably--although Nolde does not mention this--a growing food shortage in that city, however, they never stayed there for very long. According to him, he and his wife "lived off the land" for the duration of the war. Here again, however, we do seem to run into his tendency to exaggerate his own self-sufficiency, and thus to dramatize. According to H. J. Glaser, Nolde was correct in indicating that he lived a more-or-less isolated existence. Neighbors remembered him as being friendly only to children and not being particularly hospitable to anyone else.[20] Nolde was no farmer (nor, should it be pointed out, did he really pretend to be), and thus he was dependent upon others doing most of the farm work.[21] The neighbors also noted that whenever the Noldes went out in horse and buggy, Ada drove. Later they obtained a car, "which also was bravely steered by Frau Ada."[22] He did paint some young girls and did various other works and, from time to time, he showed these to the neighbors; but, by and large, we have the picture of a brooding, isolated man, rather completely removed from the world around him. In day to day matters, "Frau Ada" was pretty much in charge of things. Occasionally this led to unfortunate incidents.

Probably the most unfortunate of these concerned a Russian prisoner of war who, as custom often had it, was earning his keep working for a local farmer. The farmer, Paul Madsen, supplied the Noldes with firewood during the winter. One day, Ada invited Madsen in for coffee. She did not offer any to the Russian prisoner, however. Madsen, angered at this discourtesy, wanted to refuse her offer to serve him.

Frau Nolde opined that it was not allowed to provide coffee for the Russian. She didn't want to circumvent the prescribed order; but, if Paul

Madsen would take responsibility, then she would gladly entertain the Russian as well.[23]

Apparently Madsen was willing to "take responsibility," for the Russian prisoner was served coffee. Having been born in Denmark, Ada must have felt herself in an awkward position vis-à-vis German military regulations. Perhaps she felt that she, of all people, had to be scrupulous in obeying them. The Russian prisoner incident, however, apparently did not make a good impression upon the neighbors.

The war touched both of the Noldes to a great extent, and Emil recorded some of his impressions in his memoirs:

> Only those who stayed behind and the hagglers sat protected. And the rolling money was the filthy oil of the whole murderous war machine. The share-holders of the steel-works, of the oil companies and of poisonous gas--they all celebrated dark, devilish triumphs.[24]

In a statement like this, Nolde sounds almost like a Marxist, or certainly like a sort of Gerald Nye or latter-day Populist. Of course he was neither. What his diatribes against the fat and sheltered war-profiteer revealed was a basic dislike for the cold, industrial society, one that had, nevertheless, fascinated him from time to time. Although there is little doubt that he hated the war, Nolde did follow military events fairly closely, as a September 28, 1924 letter to Gustav Schiefler reveals: "If we hear a report about the intrepid voyage of a submarine, or of the fall of the first fortresses, then we breath a bit easier."[25]

During the war years, Nolde continued to paint, etch, and until 1917 to work at woodcuts. He also reflected upon his journey to the Far East of 1913-1914. He pondered the fact that his trip to this most colorful part of the world had really taught him very little about color. Color, he concluded (time and time again), was more important to "northern men" than to those of the tropics. Men from southern climes were surfeited with color all the time, while those of the north were forced to develop more of an appreciation for and sensitivity to it. "We men in the north love warmth and color."[26] This helps to explain a phenomenon that several students of Nolde,

including Peter Selz and Max Sauerlandt, have pointed
out: that Nolde never made much actual use of
primitive art, and that his own style was not terribly
influenced by it. According to Selz, Nolde had really
hoped, through his South Sea journey, to come into
contact with the primitive source of art, what Jung
would call a "racial memory."[27] As Sauerlandt would
have it, Nolde was not driven to the South Seas by any
sort of sentimentalism. Rather, he was concerned with
tapping the well-springs of a "new strength."[28] Yet,
it is difficult to find anything radically new that
came out of the monumental journey. Certainly there
were new objects pictured. In his very early interest
in masks and in his own dabbling in primitivism,
however, Nolde really anticipated much of what he
would see during the course of his journey. His
observation about the significance of color for men
of the north, while overladen with the glib
acceptance of racial differences, would seem to
indicate that for him the trip to the Far East served
to extend the parameters of his experience, not to
serve as the foundation for a new departure in
aesthetics. At the same time, as we have stated above,
there were psychological needs that presumably were
fulfilled by the journey. Nevertheless, we cannot
gainsay the fact that Nolde's 1913-1914 adventure was
responsible for a number of brilliant, sensitive
paintings of Russians, Siberians and South Sea
Islanders. It was the style in which they were
depicted that remained essentially unchanged.

Nolde's agonizing over the war and the suffering
that resulted from it was in part responsible for
probably the most powerful of his religious works. In
1915 he did "Entombment" ("Grablegung"). This painting
depicts the dead Jesus being placed in the tomb by
sorrowing friends and his mother. As Selz described
it, Mary and St. Joseph of Arimatha seem to be holding
the body of Christ as they would a coffin. Mary, in a
sky-blue, all-consuming dress, is holding the head and
shoulders of her son with a tenacity born of despair.
It is almost as if she "wants to take Him back into
her womb."[29] Jesus, yellowed and stiffened by death,
is, according to Selz, too big for Mary and for the
picture. He seems to be reaching out beyond it. Here,
the writer would like to take issue with Selz's
interpretation. To me, it seems that Jesus actually
appears to be shrunken in death. The frail, yellow
body seems almost to be overwhelmed by the thick blues
of St. Joseph and Mary. All of his strength seems to

121

have been drained out from the now clotted nail and
spear wounds. St. John is holding Jesus's right hand
in his own. His hand is a ruddy pink, throbbing with
life, even though his face is a mask of anguish.
Jesus's hand, yellow and wizened, appears very frail;
almost as if St. John could break it off without too
much effort. His face is partially hidden in the
enfolding arms of his mother whose face is also not
visible; but, we can see that his eyes are closed in
the finality of death. Only the lines above his nose
give testimony to the agony of the death struggle.
Here again, I would like to take issue with Selz. In
his eyes, Jesus is still in a death struggle; in mine,
he is quite dead. As in his "Crucifixion" painting of
1911, Nolde had succeeded in capturing the
overwhelming pain and sorrow of human death.

In "Grablegung" a persistent underlying theme of
great significance in Nolde's religious works, the
longing for the mother, can be detected. The mother, a
powerful figure in blue, has Jesus in a firm embrace.
As Selz pointed out, it is as if she is trying to take
him back into her womb. There is a sensual aspect to
this. Nothing can come of it, however, because the
brave son is now yellowed by death.[30]

At the point, perhaps we can briefly summarize
the character of Nolde's religious paintings of 1911-
1915. With the exception of the "Mary of Egypt"
triptych, the outward content of these works is not at
all sensual--unlike his old Testament works of a
year or so before. There is an underlying sensuality,
however, in all of those works in which Jesus appears
with his mother. In the religious paintings of 1909
and the later ones of 1911-1915, we can see several
aspects of Nolde's identification with Jesus. In the
first series, "The Last Supper," "Ridicule," and
"Pentecost," he is the saviour of an uncomprehending
humanity, the very embodiment of a loving God on earth.
In the 1911-1915 paintings, he is a child, a heroic
and rather special one to be sure, but a child
nonetheless. In this role he suffers and he is held,
adored and comforted by a pure yet sensual woman, who
is both Nolde's mother and a more tender, vibrant
substitution for her. Nolde was most certainly
conscious of his identification with Christ, although
his Oedipal desires for his mother, which were
responsible both for a longing for her as object and
an identification with her, remained a mystery to him.
Insofar as his art was concerned, this was all to the

122

good, for it allowed him to depict powerful emotions in a spontaneous manner, unhindered by self-consciousness.

By the time of the First World War, Nolde's reputation had been established. Several important articles were devoted to him, one of the most significant being that written by Max Sauerlandt in 1914. In this article, which appeared in the Zeitschrift für bildende Kunst, he placed great emphasis upon Nolde's racial background. The strong people of the north, men who "know no masters," were inherently complex.[31] Sauerlandt spoke approvingly of Nolde's intense struggles against great odds, and of his unique efforts to "individualize the object," to impress upon it the personal experience of the artist.[32] As was to be expected, he spoke approvingly of his use of color, and of the unique power that such a use gave his paintings. Nolde, he declared, was a "revolutionary" in the arts.[33] Of special interest, however, was Sauerlant's above-mentioned emphasis upon Nolde's racial roots in the northern landscape. Perhaps the outbreak of the First World War, with the subsequent reinforcement of nationalistic moods had something to do with this. Sauerlandt's tendency to view Nolde as a "nordic" artist, however, was one that came to be shared by an increasing number of critics around this time. As another example of this, we can consider Paul Erich Kuppers' article of 1918. Here Kuppers, like Sauerlandt, emphasized Nolde's background. Due to its continuous exposure to the roar of the seas and to threatening storms and clouds, "The northern spirit is tied inextricably to a tendency towards mysticism."[34] "An art which is formed out of such a world mood cannot be a congenial reflection of external phenomena."[35] Kuppers spoke of the "tragic conflict of the Nordic soul," something that expressed itself in the grotesque and in wild fantasies, and of that strong, farming race from which Nolde came, a race which eschewed empty language and superficiality.[36] Nolde had sought to overthrow the superficiality of Impressionism, something that had hindered expression of "Nordic mysticism; this new religiosity."[37] Through his strong character--which had found expression in an almost ecstatic use of color--Nolde "dissolves the singular and the accidental, and provides for the typical and that which is generally valid; he overcomes worldly capriciousness and provides spiritual essence, the final truth."[38] Thus, unlike Sauerlandt, who

123

emphasized Nolde's concern for the untrammeled
expression of objective individuality, Kuppers,
sounding very much like a German Historicist, declared
that Nolde was seeking the typical in the individual,
universality in the particular. He and Sauerlandt were
one in emphasizing Nolde's racial background, although
Kuppers did go further in this direction, at least at
this time. Nolde's primitivism, the latter said, was
part of his search for the very roots of life itself.
He, like the heroes of old Nordic myths, was seeking
to go beyond the bounds of being.[39]

　　　This emphasis upon the Germanic or Nordic
qualities of Nolde's art reinforced Nolde's own
tendency to view himself as being a German artist. In
a way, of course, he was quite German in several ways.
His brooding mysticism, his efforts to establish
intuitive ties between men and nature, as well as his
interest in the mysterious and grotesque were all
qualities prominent in the German romantic tradition
as well as in the Expressionist movement of which,
like it or not, he was a part. Both Sauerlandt and
Kuppers--and Nolde himself--evidenced a somewhat
dangerous tendency to view these qualities as being
inherent in a particular land-bound and spiritually
homogeneous race; in other words, to emphasize a sort
of iron-clad racial determinism rather than cultural
conditioning. Unfortunately, this also was a legacy
Germany's romantic heritage.

　　　In Utenwarft and Berlin, Nolde continued to live
in the same self-consciously isolated manner as before.
Lonely and, to some extent, embittered by the war
(some of this was reflected, as we have seen, in
"Entombment"), he remained ferociously defensive of
his privacy. This attitude can be seen in a letter
of his, sent to an art dealer and dated March 29, 1917:

　　　Dear Sir:

　　　You appear to know very little about my state of
　　　affairs. I am in the extraordinarily fortunate
　　　situation not to be unconditionally dependent
　　　upon art dealers. Therefore, I am not as happy
　　　in the same measure with the appearance of an
　　　art dealer as that of a god. Rather I apply to
　　　him the same standards as I would to other men.
　　　Now, it would never occur to our most intimate
　　　friends to come with strangers into the house
　　　without having my permission to do so; all the

less could we allow you to do so. You must know
that I do not have a trade-store, but a studio
where I work, and that this studio is my home
at the same time.

Respectfully,

Emil Nolde[40]

Despite such disturbances, and despite his grim moods
due to the war, the years 1914-1918 were good ones
insofar as Nolde's personal success was concerned.
First of all, as we have seen, he painted "Entombment,"
a work of such immense genius and power that it could
well have sufficed as his only major piece of the war
period. It was not. As a matter of fact, 1915 was one
of his greatest years insofar as output was concerned--
eighty-eight paintings were produced! While Nolde
would never again attain this level of achievement,
the acquisition of fifty of his New Guinea paintings
in 1917 by the colonial office must have been very
gratifying. Furthermore, in 1918 Nolde participated
in two art exhibitions, in Hannover and in Munich.
In 1918 and 1919 some of his finest landscape paintings
appeared. Nolde would continue to struggle with
himself and with the inchoate, at times dark, forces
which threatened him. The struggle to attain
recognition, however--a struggle which Nolde in part
denied ever took place--was over.

Germany's defeat at first did not seem to trouble
Nolde very much, at least according to his memoirs. In
a letter to Hans Fehr, Nolde said that, although the
war was lost, Germany still had certain spiritual
energies that had not been touched by the war and by
defeat. "I believe in beautiful and great
possibilities," he said, although few around him seemed
to share this belief.[41] This early optimism was in
large measure shattered by the unfortunate intrusion of
political realities. As a result of the German defeat,
plebiscites were remaking the map of Nolde's
fatherland. The most important of these elections
took place in Silesia, of course, where large chunks
of German land went to the newly founded state of
Poland. Insofar as Nolde was concerned, however, the
most immediately important of the plebiscites took
place in Schleswig-Holstein. Denmark, which had not
participated in the World War, was to gain territory
due to the somewhat tendentious application of Wilson's
doctrine of self-determination. In October, 1919,

Nolde wrote a somewhat unhappy letter to Ada over the
approaching plebiscite:

> . . .I don't know anything particular about the
> vote. The newspapers write of the middle of
> November. I don't think that it alters anything
> essential in our intentions. I cannot vote
> against Germany; against Denmark appears to me
> also not that I wish. . . .One must feel himself
> to be an unhappy border-man (<u>Grenzmensch</u>).[42]

He was shocked to discover that, in Denmark, all
sympathy for Germany seemed to have been lost.
"Humanity was poisoned."[43] After the plebiscite, the
result of which determined the return of large
portions of Schleswig to Denmark, Nolde expressed
great bitterness. "The tearing of our Schleswig
homeland through the middle appeared brutal and struck
us hard."[44] His family had always spoken German in
Schleswig, Nolde declared, and he was infuriated by
the great celebrations that took place amongst the
Danes when portions of his old <u>Heimat</u> were delivered
to Denmark.[45] Nolde's consciousness of himself as a
German was no doubt exacerbated by all of this,
especially inasmuch as that, in order to remain at
Utenwarft, he had to become a Danish citizen.[46]

Perhaps in part because of his anguishing over
the future of the <u>Heimat</u>, Nolde sought seclusion at
Hallig Hooge, on the North Sea near the island of
Fohr. The result of this was another experience
similar to that of Lildstrand. Again, demons and
weird shapes, some of them rather comical, others
frightening, seemed to haunt him. Now, however,
Nolde made more substantive use of watercolors in an
effort to depict them. In his "Devil and Scholar"
("<u>Teufel und Gelehrter</u>") and "The Fanatic" ("Der
Schwärmer") Nolde's traditional concern with contrast
and tension found grotesque expression. In the
former work, a scholar, nose in his book, travels a
lonely road into the demonic unknown, while a sort of
appealing, leprechaun-like devil points a mocking
thumb at him. In "The Fanatic" a man who could be
a missionary, with a shock of white hair, appears to
be throttling a snakelike creature that is emerging
and breats are pale and reasonably life-like. Her
head, however, is at the end of the snakelike (almost
fecal in its brown, distended character) creature,
around which the man has a firm grip. He seems to be
remonstrating with her, and his sharp features contrast

strongly with those of her face, which are dully sensual. The Hallig Hooge paintings, some of which were later translated into oils, covered a variety of topics. Tension, sometimes rawly sensual, characterizes almost all of them.

The Hallig Hooge paintings were symptomatic of Nolde's somewhat unhappy mood in 1919. The pictures themselves were not all unhappy in tone; however, there is a restlessness about them and, underlying all of the pictures, a general mood of tension. Again, much of this was due to the results of the First World War and Nolde's feeling of helplessness in the face of them. Part of this feeling was embodied in a letter to his friend Hans Fehr (obviously, in view of the fact that Nolde was talking about voting in German elections, this was written before political events forced him to become a Danish citizen).

> In politics I am really helpless. I often don't know whether I should vote German--national or left, that means socialist. Occasionally, I believe strongly in the state, as a good citizen. Occasionally, however, I think that it would be a good idea if it were dissolved. These doubts often torture me.[47]

After Versailles, Nolde made the following, rather perceptive statement:

> The just peace which our government hopes for, is a vague thing. What is truth? What is just? Doesn't power, might, construct, extend [and] form justice as it wants? Whether rulers or people, whether military power or national socialism, each constructs its justice[47]

In another letter, this one written in January, 1920, Nolde went a bit further in expressing some bitterness over the results of the First World War.

> Bagatelles are . . . great events in these times; unfortunately these are great only for the enemies of the German and Germany. Everything is so different. With a sharp sword, Germans could not deal a fatal blow to the spirit of clever intrigue. Much has been neglected and much muddled in earlier years Bismarck the great was not there. Wilhelm the small ruled.[48]

Nolde, while not a political person, to use a phrase common in Germany now and then, definitely had a certain degree of political consciousness. As we will see in a later chapter, he had Social Democratic tendencies before the war and, after the German defeat, and particularly with the tearing away of a portion of Nolde's Heimat, there seemed to be a certain elevation of his political consciousness. Only now, whatever views he had were tinged with bitterness. Consciously, Nolde had been hurt by the consequences of defeat; however, much of this hurt stemmed from subconscious sources. The most important of these was a profound underlying resentment at being separated from the maternal soil of a heavily fantasized youth. So bitter a blow had to lead to both an increased identification with his mother and increased resentment against putative inimical powers seen as responsible for the separation.

In 1921 Nolde traveled to England where he recovered a trunkfull of his tropical paintings, which had been taken from him by the English after the war had been declared. He and Ada then traveled to Paris where, once again, he indulged himself in his dislike for the French. "Paris," he said, with some exaggeration, "is the city of the modern . . .founded by profit-seeking trades-people."[50] Nolde seemed to be more interested in Spain. There, he saw several bull fights, which sickened him; but he was nevertheless fascinated by them. Most fascinating, however, were the gypsies. To Nolde, these were the happiest people of all. They believed in neither God nor the devil: "No God makes them happy, and no devil hates them."[51] To Nolde, fearing both God and the devil, and caught between two nations that he loved, the gypsies must indeed have seemed to have been blessed. He was German, consciously so more than ever before, yet, he could not abandon his summer home in Utenwarft or that land in which he had been raised. As we have seen, he became a Danish citizen, and would remain such until his death in 1956. At the same time, his battle with God and the devil would continue.

In 1921 Nolde painted the second of his triptychs, "Martyrdom" (Martyrium"). The center painting depicted a small, crucified Christ surrounded by four gigantic nonbelievers. On the left, there is an intellectual, book in hand, index finger pressed to his forehead in concentration. He is oblivious to the suffering of the small Christ figure in the center.

128

On the right, a cynic, his mockery amplified through
flaming red hair, grins at the suffering one, jerking
his thumb toward him as one would toward an amusing
spectacle. In the foreground, two more cynics, arms
about each other, exchange skeptical glances over the
scene. The cynical figure in the right foreground does
have extremely strong Semitic features; although he
is wearing something that could be a monk's cassock.
All four figures tower over the tiny, tormented Christ.
From the Christ figure, however, there comes a warm
glow, the only light in the painting. In the painting
to the left of this, Christians, in some cases entire
families, are being eaten by lions. The lions have a
curious aspect to them, rather like the ingenuous
almost deliberately artificial lion in "St. Mary of
Egypt." They are tearing people apart; blood flows in
nightmarish proportions and one lion is carrying off a
man who might well be still alive. The man's sexual
organs, now useless and almost blackened, stand out
prominently. In the painting on the right of the
centerpiece, a bronzed and handsome people are being
burned alive at the stake, before cheering crowds and
grinning soldiers. The impact of these works is not
as strong as that of "Pentecost," or of the
"Crucifixion" in "The Life of Christ," to say nothing
of "Entombment." The depictions of the slaughter of
innocent people are simply shocking--there is really
little that is very impressive about them from an
artistic point of view. The centerpiece shows
greater care and is a much more balanced work. In
the scenes of massacre, color shocks and, at the same
time, rivets one's attention upon the terrible events
depicted. In the painting of the small Christ
surrounded by scoffers, the clash between the
alternately dark or garish colors of the scoffers and
the subdued yet persistent warmth of the suffering
Christ provides for that same brilliance in contrast
that we have seen in "Christ and the Children." Yet,
the painting is, in a way, almost too didactic to
impress us as much as some of Nolde's other religious
works. From what we know of Nolde (and, of course,
this is a most unfair way to judge a work of art), we
can see elements of self-pity and dramatization in
this work. Technically excellent--Nolde's use of
color and gesture is certainly up to his usual
standard--the overly didactic and simplistic nature
of this painting diminishes it in terms of its
spiritual impact. In any event, in the 1921 "Martyrdom"
triptych, Jesus, i.e., Nolde, is again depicted as a
mocked, suffering saviour, in this case surrounded by

cynics, as people of all ages go through the pangs
of hell in his name (perhaps those "simple,"
"uncivilized" folk who, Nolde thought, understood
him).

 In 1921 Nolde painted several more religious
pictures. Perhaps the most striking of these is his
"Paradise Lost" ("Verlorenes Paradies"). "For the
first time in all of art," he declared in a letter to
Fehr, "I have dared to paint the paradise couple
sitting."[52] What Nolde wanted to do was to capture
the moods of Adam and Eve immediately after the
realization of what it meant to partake of the fruit.
Adam and Eve are indeed sitting on the ground,
separated by a tree, around which is wrapped the
snake. In the left-hand corner of the picture,
another one of Nolde's ubiquitous lions is apparently
waiting to move in. Eve, almost obscenely fat, is
sitting in the right-hand portion of the picture.
Adam is on the left. Nolde wanted them to appear as
follows: "Adam as the symbol of strength; Eve, in her
frightened awareness, as the sinful primal mother of
all men."[53] Nolde's expressed intentions, whether ex
post facto or not, are very interesting, but it is
important to note that an unexpressed one, the
portrayal of the tension between men and women,
achieves virtual apogee here. Eve is staring straight
ahead, blue eyes wide, almost bulging, and with half-
opened mouth. She has a dumb, almost bovine aspect,
and her feet are hooved, to accentuate this
impression.[54] On the other side of the tree is Adam,
his brow furrowed and his eyes sparkling black with
emotion. He is the very opposite of Eve, although
whether or not he comes across as a "symbol of
strength" is a moot point. He seems bitter, but the
only sign of real anger that we can see is an
extended big toe, presumably twitching against the
ground which they will soon be forced to vacate. His
dark, sensitive, almost Lincolnesque features are
stamped with the full realization of what Eve has
done, although he does not appear to be about to lose
his temper. Rather, he resembles a husband who has
been forced to accept something that he expected to
see all along--the primal evil of womanhood. He is
upset, perhaps a little angry; but he sort of
anticipated something like this all along. At any
rate, his strong silence is in sharp contrast to the
silence of Eve, which is rooted in dumb terror.
Around the dark tree that separates man from wife,
there is a rather pretty green and yellow snake. He

has been the real winner in this encounter, and his
reptilian smile seems to reflect this. If he is
particularly heart-broken because of God's condemning
him and all of his descendents to crawl on their
bellies till the end of time, you would never know it
from this painting. He is simply radiant with joy.

In the "Paradise Lost" work, Nolde's fears of
and contempt for woman, something that appeared in his
portrayals of Berlin nightlife, appeared in a biblical
setting. Eve is the dumb, sensual beast, "the sinful
primal mother of all men," while her husband is
depicted as anguishing in annoyed sensitivity. They
are separated by a large tree, around which the happy
snake is coiled. It would not be too much of an
exaggeration to suggest that this is a very reinforced
symbol for the male sex organ. The male--in this case,
possibly Nolde's father--is separated from the female
by the supremacy of his sex. He seems to be aware of
this, because one eye is directed toward the snake,
while the other is focused on his horrified wife. Of
great importance is the fact that Nolde placed a most
interesting object next to her--a small flower. In a
broad sense, as we have seen, the symbolic nature of
this was even more pronounced, in that he closely
identified flowers with his mother. There can be
little doubt that the woman depicted was supposed to
be his mother, particularly inasmuch as Nolde himself
said that she was "the sinful primal mother of all
men," himself. Eve is sensual, to be sure; however,
the warm, deep sensuality of the Jewish mother
depicted in "Des Leben Christi" is gone. We see
instead a great, dumb cow of a woman, utterly without
charm and exuding a sort of crude sensuality. Nolde's
attitude toward his mother and toward women in
general, at least as it was expressed in his work, was
hostile. It stemmed from the same early childhood
tensions surrounding her that produced unresolved
longings, identification and severe sexual repression.
Paradoxically enough, he could express and mediate
these tensions only through painting, i.e., in the
realm of the mother. Yet, in the religious paintings--
and particularly in those concerning Christ--Nolde's
tensions achieved only indirect representation. They
were sublimated into Nolde's conscious identification
with Jesus. In the "Martyrdom" triptych and in
"Paradise Lost," we see Nolde in a somewhat
misanthropic mood. He was angry at the human race
and all of its foibles and this anger found strong
expression. Part of this anger--or perhaps disgust

would be better word--was expressed in a letter sent
to Hans Fehr in 1922:

> Beauty is dead Man is certainly no
> beautiful creature. His arms and legs dangle
> about him like sausages. I prefer the ancient
> statues with missing arms. Yesterday, a little
> wood figure from New Guinea fell down. It lost
> an arm. At first, I wanted to fix it. Then,
> however, I let it be, since to me the figure
> appeared so much more beautiful.[55]

Of course a dislike for humanity has been expressed
from time to time previously. Beginning with the
Hallig Hooge works, the human form had been usurped by
a wild, brilliant fantasy. In the religious paintings
of 1921, humanity comes across as cynical, cruel,
insensitive, or just plain dumb. People would be
better if they were shattered in some way, if they lost
an appendage or two. What had happened to Nolde at
this time? It would appear to be fairly obvious that
Nolde, both consciously and unconsciously, was
reacting against the German defeat in the First World
War. We can find a few clues in some of his
political remarks. He was not angry in the usual
nationalistic sense (although Nolde was most definitely
a nationalist of sorts). Rather he was angry at being
separated from his roots by a newly established
border. Utenwarft and the old cattle market of
Tondern, and, more important, Ruttebull and the
"Nolde" of his youth--all were now in a land made
foreign and a people made indifferent by the
capricious drawing of a border-line. Although,
according to Nolde, his initial reaction to the German
military defeat had been a calm one, there can be
little doubt that the results (or, perhaps a result) of
the First World War had the effect of embittering him.
Those very strong psychic drives that had caused
Nolde always to maintain (or, perhaps even to create)
ties to his homeland had been sharply frustrated by
the division of Schleswig into Danish and German areas.

By the 1920s, almost all of the elements that we
recognize as characterizing Nolde's art had appeared.
To be sure, his weakening eyesight forced him to give
up his excellent work in lithography and in etching.[56]
Nolde's several techniques in painting, however--the
use of Japan paper in watercolors, his mastery of color
in general, as well as of gesture, his ability to
combine the spiritual with the grotesque and so on--had

132

been established. The first biography of him, that of
Max Sauerlandt had appeared in 1921; and Nolde,
whether he chose to admit it or not, was now part of
the intellectual and artistic scene in Germany,
particularly in Berlin.[57] According to his memoirs,
he was still an insecure and always restless person,
still harassed by attacks upon him in the press.
Again, Nolde professed to be isolated, by choice, from
the sources of these attacks. "Living with and in
nature, I had become foreign to the men of the city
and distant from the entire public."[58] Yet Nolde did
respond, albeit not very often publicly, to attacks
made upon him, much as he had in 1910 and 1911. A
letter of December 26, 1924 contains this biting
remark about Wilhelm von Bode, one of his most
persistent enemies: "No sentimental respect for the
work of art hinders him."[59] When one of his earliest
and most bitter enemies, Paul Cassirer, died in 1926,
Nolde wrote the following in a letter to one of his
friends: "Berlin has become poorer. He was my
strongest enemy and, as a personality, explosive and
exciting."[60] In a letter to Fehr in 1930, Nolde went
even further: "Behind Paul Cassirer's walls, people
industriously rummage in old rubble, like worms in
church figures. The original spirit is gone. Is it
not strange, that deep within me, I always had a
secret admiration for Paul Cassirer?"[61] Indeed, this
was rather strange; so much so, in fact, that Fehr
could hardly believe this statement. "Perhaps,"
Fehr said, "it was the strong, always industrious
nature combined with much taste which impressed him."[62]
Whether or not Nolde actually felt that way is hard to
tell. During the 1920s he continued to attack that
for which Cassirer supposedly stood, "French
influences" in the arts--the "sweet Monets, Sisleys,
Pissaros."[63] Since Nolde's attitude toward Jews was
an extraordinarily complex one, perhaps Cassirer's
obvious sophistication and cool intellect, qualities
which Nolde lacked (and, at times, expressed great
satisfaction in lacking), appealed to that side of his
personality which longed for a father-figure toward
which a posture of love-hate could be assumed without
fear. At any rate, by 1926 Nolde could well afford
to be generous toward a dead critic. In both well
deserved fame and respect, Nolde had passed far
beyond that point reached by Paul Cassirer and his
protege, Liebermann.

In May, 1927 Hans Fehr's wife Nelly was killed
in an automobile accident. Ada and Emil came to

Switzerland to attend her funeral and comfort her
bereaved husband. From there, the Noldes went to
Colmar to see the Isenheim altar. Somewhat pointedly,
Nolde remarked that this to him most German of
artistic creations was in a city now in French hands.[64]
Whatever unhappy feelings there might have been in
Nolde, due to the death of his friend's wife and to
his visit to French occupied Colmar, were in part
offset by the splendid _Festschrift_ that was presented
in August, 1927, on the occasion of his sixtieth
birthday. Otto Fischer (director of the art museum in
Stuttgart), Ernst Gosebruch (director of the city art
museum in Essen), Dr. Max Sauerlandt, Dr. Gustav Pauli
(director of the Hamburg art hall), Dr. Alois Schardt
(director of the art museum in Halle), Paul Klee, and
the noted critic Rudolf Probst among other, all
contributed to it. Probst praised Nolde's feeling
for life, and Nolde's concern for "the resurrection of
eternal life from the sacrifice of the person, from
the martyrdom of corporeal existence."[65] Kurt
Breysig, of the University of Berlin, spoke of the
strengths in Nolde's blood and spirit. He seemed to
be especially impressed by his "Martyrdom" work of
1921; the tragedy depicted there, that of a strong
person crucified by the "fat and well-heeled" was a
powerful one.[66] He praised Nolde's "flaming,
blazing, spurting choice of colors" and declared that
Nolde was a gift to the German people.[67] Otto
Fischer declared that Nolde's art was like a seed of
grain, which bore the future within it. Nobody could
say what would come out of it: "We welcome the
seeds."[68] Ernst Gosebruch, on the other hand, made
subtle criticism of Nolde's oft-expressed unwillingness
to part from his paintings. If they were to remain in
Nolde's home or in the hands of a few private
collectors, who would see them? In the industrial
regions of Germany, there were many thousands who
"hungered" for his colorful works. If such people
were placed before his biblical pictures, they would
forget their "hard work and misery." Nolde ought to
forget the "artiticial" people who used his paintings
as decoration, and put them at the disposal of the
people, those "who bear the burden of a hard life."[69]
Max Sauerlandt, again revealing his racial approach to
art criticism (at least insofar as Nolde was
concerned), made the following statement, one which
might have indicated that he had taken some of the
aesthetic and racial theories of Julius Langbehn
rather seriously: "As Shakespeare does not belong to
Germany alone, so Nolde does not belong to Germany

alone. Both belong to the whole world of Germanic spirits which nurtured them."[70] Others exaclted Nolde as a "Magus from the North," or spoke of his vision of Christ as embodying the "suffering of the world, and its necessity."[71] Both Paul Westheim and Heinrich Zimmer praised Nolde as a German painter, Zimmer going so far as to declare that Germans were in the process of rediscovering their Nordic ancestry through him.[72]

Perhaps the most moving tribute, however, came from the Swiss-German artist Paul Klee:

> Abstractionists, who are removed or in flight from earth, occasionally forget that Nolde exists. Not so I, not even on my most far-flung flights, from which I tend to return to earth, again and again, resting in renewed heaviness. Nolde is more than just earthly; he is also a daemon of that region. Even those at home in other places, feel in him a cousin from the depths, a cousin by choice.[73]

Nolde never dealt in the sort of abstraction or, at times, non-representational whimsy which characterized the work of Klee. As we shall see, there were probably very good reasons for this.

Of considerable importance for our considerations is the increasingly persistent tendency of many critics to see Nolde as a German artist. Paul Ferdinand Schmidt, one of the contributors to the Festschrift of 1927, wrote an article which appeared in volume 53 of the Junge Kunst series. In this article, Schmidt praised Nolde's extreme individualism and his rhapsodic use of color to express emotions. Also, though, he emphasized the northern quality of Nolde's art.[74] Nolde's use of color reflected the "inwardness of his true Nordic nature," while the seemingly inexhaustible possibilities of his works exemplified both a "German barbarism" and that true German greatness embodied in the search for an "unknown God."[75] This sort of nationalistic hyperbole had some grounding in fact; Nolde's paintings in particular and the German Expressionistic movement in general contained many of those elements that cultural historians have identified as being prominent in Germany's romantic tradition. However, much of this particular variety of praise came out during and after the First World War, during a period of great national

anxiety and humiliation. It was part and parcel of a
rise in German nationalism, the same sort of
nationalism as was being touted by the radical right
and, at times, by Nolde himself.

In 1927 Nolde left Utenwarft which, as pointed
out, was now in Danish territory. Despite his oft-
expressed admiration for the Danes, Nolde's bitterness
concerning the results of the plebiscite had remained.
In 1923 Nolde took a fling at engineering. The new
Danish inhabitants of Schleswig were contemplating a
draining project in order to increase the amount of
acreage available for agricultural purposes. Nolde,
in order to avoid possible damage to the beautiful
marsh environment he loved so well, submitted a plan
of his own, one which presumably would have avoided
those errors made by "engineers foreign to the land."[76]
The plan was rejected, apparently for political
reasons. "In many ways the Danes ravage like
barbarians," Nolde remarked in a letter to Fehr.[77] It
pained him to say this, Nolde went on; there were,
after all, very many nice Danes, but politics ruined
everything. Danish politicians were destroying the
best in Schleswig, just as the Italians were doing in
the Tyrol.[78] Thus, Nolde went south, to the region
around the tiny village of Neukirchen. There he
discovered a small, isolated hillock (a "Warft," in
local parlance), about five meters in height. How
flat the surrounding land actually is can be deduced
from Nolde's satisfaction in the beautiful view over
it provided by this small rise. The house,
construction of which began in 1927, was named
Seebüll. When completed, it stood out as a strangely
massive, six-sided house, "too heavy for the landscape,
which it dominates like a castle."[79] After Nolde's
death, in 1956, this would become the Nolde-Museum, in
which an unimaginably rich profusion of his paintings
would be on permanent display.

Considering his otherwise retiring personality,
Nolde's construction of the "castle-like" house,
Seebüll, strikes one as odd, Yet, we can view it as a
sign of Nolde's increasing confidence in himself, at
least as a painter. This was, in his own eyes, his
land. He did not mean this in an arrogant,
overbearing sense at all. Rather, what was no doubt
involved was the realization that it was up to him to
capture the stark intensity of its many moods, as well
as the sharply defined characters of those who
inhabited it. Despite his oft-expressed love for rural

folk, he was well aware that their artistic
sensitivity was on a rather low level and that, in
fact, he had little in common with them. Some of this
feeling can be seen in his description of his farming
neighbors. "The great farmers of the surrounding
farms had only little sense for our strange artist
existence. There were few points of contact."[80] By
1927 his role as an artist had been secured for all
posterity, even though self-doubts would nag at Nolde
until his death. The construction of Seebüll was thus
the manifestation of confidence in himself and, at the
same time, a sign of his intuitive feeling that he was
somehow ordained to represent this strange, hauntingly
beautiful land to the outside world. Seebüll, with
its massive construction and, apart from the
beautiful garden which fronted it, forbidding
appearance, was in fact a castle. From within its
red-brown walls, the master of this land could
overlook his kingdom.

Some of this confidence was expressed in two of
Nolde's religious paintings, "Christ and the
Adultress" ("Die Sünderin") which was painted in 1926,
and "If You do not Become as Little Children" ("So ihr
nicht werdet wie die Kinder"), which appeared in 1929.
In the "Adultress," as Selz pointed out, Jesus is seen
in a "loving mood. There is a golden-yellow glow
about him, and his red cheeks complement those of the
woman he is comforting, a woman fallen in sin."[81] In
this painting, Jesus is neither suffering nor
attempting to assert any sort of spiritual superiority.
He is a calm, merciful and compassionate man
comforting a fellow human. Acknowledging that Nolde
did tend to identify himself with Christ, this would
point to a somewhat more assured posture on his part.
In "If you do not Become as Little Children," the
scene is far different than that depicted in 1909. In
the 1909 painting, Christ's face is not seen, and the
tension of the painting is carried by the contrast
between the brightly depicted children and the
darkly skeptical aspect of the apostles. In the 1929
painting, Christ is depicted with two children and two
of the Apostles. The Apostles in this painting have
mask-like faces; however, there is nothing powerful or
frightening about them. They look almost stultified
in stupidity. The Apostles of the 1909 painting,
while depicted in a negative manner, as being darkly
skeptical, were quite human looking and rather
powerful. In the 1909 painting, there was a romping
exuberance about the children. They desperately

wanted to see and to touch Jesus, but they did not
appear to be in awe of him. In the 1929 painting, the
two children are looking at Christ with almost
worshipful eyes. He himself is painted in full-face.
While holding one child, he is looking at one of the
Apostles, and his right hand is raised, either to
bless or to reprove. Yet, there is something daemonic
about him and, as Selz put it, he appears like a
"benevolent and blessing demon."[82] Despite the
grotesque appearance of the Apostles (and, for that
matter, of Jesus Himself), this painting glows with a
sense of confidence. Jesus, gazing full-faced at the
observer, does indeed seem to be a self-assured, as
Klee might put it, "Daemon" of the earthly realm.
Despite the difference in appearance between this
Jesus and the one painted in 1926, there is one basic
similarity, a sense of confidence and power. In both
paintings, he is no longer being victimized by a
brutalized humanity somehow stronger than he. He is
the Lord-master, both as man and as daemon.

Yet, interestingly enough, some of Nolde's
landscapes done during the 1920s and early 1930s have
a strikingly ominous quality about them. As an
example of this, we can consider his "Windmill"
("Mühle") painting of 1924. Here, the scene is
dominated by a stark, black mill with a white base.
With an oppressive silence that one can almost feel,
this work of man--but with no men in sight--seems to
brood over a threatening landscape of heavy, dark
green grass and purple water, in which violent orange-
yellow clouds are reflected. To the right of the
mill, an orange-colored path seems to slash its way
across the cool grass to a house. In this painting,
Nolde appears to have overcome the dichotomy between
man and nature with which he had been so often
concerned. Only now, products of man--the mill, the
path and the house--seem to have been transformed into
natural beings, possessed of the same daemonic power
as that depicted in sky and water. In this brilliant
landscape, there are forces which do not comfort the
observer. It is a work both beautiful and grim. The
same feelings are provided by his "Sultry Evening"
("Schwuler Abend") of 1930. Here, a dark, reddish-
black cloud, in which strange faces can be seen, looms
over a red house, with a green roof. The green roof
seems to tie this house to the sky which, apart from
the cloud which seems to dominate it, is also green,
as is the grass. The house seems to be drawing in
upon itself in terror, and the windows and the door

138

give it an almost animal-like appearance. It looks
as if it is crying out in fear. In the right
foreground there are violet and blue flowers. At
first glance, it would appear that they were there
almost gratuitously. Yet, if one looks at the painting
for awhile, one becomes aware that even these flowers,
normally so bright if not always cheerful, in Nolde's
paintings, have an ominous, almost deathlike quality
about them. They put the encounter between the
creature-like house and the threatening cloud in
perspective.

Not all of Nolde's landscapes painted at this
time were ominous and grim. An unusually large number
of them were, however, and the two paintings described
must stand out as being particularly so, even in
comparison to some of his fantasy paintings. The
latter were at least usually characterized by the
presence of animal-like or semi-human forms. Here,
there are no discernible animal or human forms, not
even a friendly monster. We are standing before an
unfriendly, dark elemental, the stuff of which
nightmares are made. The brilliant use of color in
both of these paintings serves to deepen this
impression.

Thus, there would appear to be a contradiction
within Nolde during this time. On the one hand,
mastery and self assuredness can be seen in his
religious works; on the other hand, the landscape
paintings have a threatening, grim quality to them.
In attempting to explain this phenomenon, we should
consider a statement by Nolde which appeared in a
letter in 1925. Nolde commented that it was very
difficult for him to paint landscapes. Also, he said,
he really was not very satisfied with many of those he
did paint. As far as oils were concerned, he
preferred to depict figures. "In a smaller format,
in water-colors, I can attain a better and more
complete effect."[83] Did Nolde mean that it was only
technically hard for him to paint landscapes, hard to
do them in oils? From what we know of him up to this
point, it can be assumed that Nolde, while in part
probably concerned with technical problems, was also
disturbed by those forces unleashed in him through
attempts to depict the landscape. At Lildstrand,
Nolde did not experience the "storm within him" while
painting his monsters. The storm raged when he was
attempting to paint the sea. Later on, when he
slashed a work of his with a palette knife, it was a

landscape painting which aroused this reaction. In
explaining Nolde's occasional abrupt turning away
from the realm of the fantastic, that of the preter-
and-supernatural, and toward landscape painting,
Urban said that he did this in order not to "lose
himself in intoxication and dream." Thus, turning
"towards the beloved earth" was a way out of complete
submergence in the threatening realm of the unknown.[84]
This is undoubtedly true. Yet, if one concludes that
the landscape was Nolde's reality, and that he seemed
to know that this was the case, this presents us with
another problem.

It would appear that, for Nolde, the monster or
super-natural works were a form of escape from
problems and issues of an overwhelming character. The
religious paintings served as a vehicle of expression
for more-or-less conscious fantasies, an identification
with biblical episodes in general and, more pointedly,
with Christ in particular. Nolde knew what he was
doing, although he probably did not have any insight
into the unconscious forces that drove him in this
direction. However, Nolde's emotions--his deep
hostilities and powerful sensual and spiritual drives--
found expression in his depiction of nature,
particularly in his paintings of the sea and of the
brooding, flat landscape of his Heimat. A clue here
could be his very early postcard watercolors of the
1890s, where the mountains had become alive with
emotions. At any rate, the landscapes more than any
other artistic form, served to express Nolde's raw
emotions. They were indeed vehicles for the "free and
immediate expression of the artistic and human
experience," and, in this regard, Urban's comparison
of them to the works of the German romantic painter,
Casper David Friedrich, is a good one.

What this says about Nolde's spiritual condition
during the 1920s and early 1930 is fairly clear. Nolde
as painter, as the man with a God-given mission to
bring beauty and enlightenment to the world, was
reasonably confident, or at least sure of himself. As
a man with a wife who was lamost continuously sick, as
a man who loved children and was deprived of the
experience of ever having any, and finally, as a man
torn by resentments that he could not adequately
articulate, Nolde was deeply troubled. The landscapes
reflected this, perhaps to a degree uncomforable to
Nolde himself. The differences between the amount of
emotion expressed in landscapes and that to be found in

140

figure or fantasy representations were probably one of
degree; however, this quantitative difference was
apparently significant enough for Nolde to notice it.
Ecstasy and a sort of intoxication might well have
been present, as he described it, when Nolde was
devoting himself to religious works. Nevertheless,
this was the ecstasy of fantasy identification with the
subject of his work. The ecstasy or intoxication
which drove him to drive a palette knife through one
of his seascapes was the eruption of violent, very
real emotions, some conscious, some unconscious, to
the surface. These were not forces that could be
satiated by recognition of his art, not even by his
being named to the Prussian Academy of Art in 1931,
the same year in which volume one of his memoirs,
Das eigene Leben appeared. As Nolde and his
fatherland stood before the storm, before events so
awesome and tectonic in nature, that even an
imagination as sharply honed as his could not
encompass them, the great artist perhaps realized
that the agony of his own being could never find
adequate expression; or, perhaps that he could not
allow it to do so.

 Most assuredly, the brooding, awesome power of
Nolde's landscapes, as revealed in the "Windmill" work
of 1924 and the "Sultry Eveing" work of 1930, were
more immediate expressions of the repressed sexuality
and deeply seated bitterness and frustration that
characterized Nolde as man. Yet, even in the landscape
paintings, Nolde was not free. As he himself expressed
it, he often found it hard to do them (oils were more
difficult than watercolors), and during the most
stormy period of his life, that around the turn of the
century, those forces that found expression in at
least a few of his paintings proved to be frightening
to him, and the works were destroyed. In this regard,
it is important to point out something emphasized by
Otto Antonia Graf; that Nolde was unable to transform
into art those things which were threatening to him.[85]

 Perhaps this in part explains Nolde's
unwillingness to break totally from representational
art, his refusal to become involved with formalistic
abstraction. This was reflected in Nolde's inability
to appreciate the art of Franz Marc, whose fine animal
paintings were, in Nolde's opinion marred by his
prismatic approach. Franz Marc was on the path toward
abstraction when he was killed before Verdun in 1916.
Nolde was very much concerned that objects remain as

objects and not be broken up into planer forms, much
less be abolished altogether. It was thus that Nolde
violently opposed cubism. It was, he said, "a denial
of nature" and, revealing his romantic-bound ideology,
he wondered whether or not this anti-natural movement
came from Jewish sources.[86] However much Nolde strove
to find intellectual or aesthetic rationalization for
his rejection of non-representational art, this
rejection corresponded to a very deep psychological
need. Here, we must consider the Kreitler work again.
In their book, the authors make a most important point
concerning the role of form ("Gestalt") in primitive
cultures. In these cultures, a good artistic form
expressed "simplicity, closure, regularity and
symmetry."[87] The primitive artist is often viewed as
a God or as a magician because he brings "order out
of chaos and vanquishes the formless by form."[88] In
other words, the artist of a primitive culture stands
almost like an embodiment of the Kantian categories,
facing an undefined, frightening manifold. It is up
to him to order this manifold and present it in a
manner that is comforting, if not necessarily pleasing,
to the observer. If we recall Worringer's hypothesis,
that purely representational art appears during periods
of certainty, and that nonrepresentational art comes
out of periods of fear or uncertainty, it would seem
that the Kreitler's thesis runs counter to it. After
all, according to the Kreitlers, the primitive artist
has to reduce confusion to comforting forms, while, in
Worringer's case, the artist's role during a period of
stress is to create his own world from one of
confusion, whether or not this world is necessarily
comforting. The two approaches can at least co-exist
in that, for both Worringer and the Kreitlers, the
artist's role in a situation of stress is to really
create his own world in a situation in which a
so-called "real world" either does not exist or is
filled with a frightening confusion. Also, the
Kreitlers were describing only an artist in a
primitive society, while Worringer was attempting to
establish a more-or-less universal hypothesis, valid
for art at all places and all times.

Nolde lived in a world of rapid, disturbing
change. Following Worringer's dictum, at least up to
a point, he created a new one. Yet he was never able
to take the final plunge into a world divorced from
objective reality. He, like the primitive peoples
whose art he admired so much, needed recognizable
forms and patterns, even though he was quite willing

to utilize deformation and violent contrasts of color
to alter these forms and patterns to fit his own
emotional and aesthetic needs. While Nolde's art
spanned a whole world of imagination, there were, as
he himself well knew, certain concerns--patterns, if
one wishes--to which he always returned. He was
concerned with duality--man and woman, God and devil,
life and death--and the tensions which sprang from
this. He was concerned with contrasting asceticism
and sensuality, and the primitive with the
sophisticated. In his landscape paintings, he was
particularly concerned that he feel nature working
through him. To be part of and yet distinct from
nature was important for him. In all of these
patterns, the objective world remained, not only as
a point of departure--for such it continued to be even
for Marc, if not necessarily for Kandinsky--but as a
point of return. Nolde as Klee put it, was earth-
bound; he was so not merely because of taste, but
because he was immensely fearful of powerful forces
within him, of those forces which, at bottom, tied man
and artist together in unbreakable synthesis. The
earth-bound art of primitive peoples, of which he was
so fond, was similar to his own in that, however much
deformation might have played a role in it, it served
the purpose of creating pattern and form out of chaos.
It objectified both the natural and the supernatural
and thus helped to alleviate spiritual tension. What
the primitive artist could not capture, he feared.
Nolde, through the reshaping and reordering
imagination of his own immense genius, had pushed to
the very limits of representational art. He could go
no further; for that which he feared most, the
turbulent forces which compelled him to paint for want
of any other form of expression, lay on the other side.
In large measure out of fear, Nolde remained an "earth-
daemon," and we must accept the power and tension of
his works as being only pale indices of that which
remained unexpressed.

We must recognize that when Nolde said that to
know his paintings was to know him, he was not being
completely accurate. To know his paintings was to
know part of him, i.e., the means utilized by him to
mediate between those feelings and powerful emotions
that he dared not express, and the compelling need to
say something, to draw people to him. Throughout his
writings, Nolde emphasized that he was not painting
pictures" which can be enjoyed in an easy chair"; he
wanted people to "join in the intoxication" of his

143

art. To his friend Hans Fehr, he once said: "You
know, my greatest wish would be that men would be
drawn along by my art, like children running along
behind a military band. Thus, I would like to take
people along with me in effervescent jubilation."[89]
Considering the nature of at least some of Nolde's
works, many of the participants in this parade would
have been unusual. In this statement, however, Nolde's
was being completely candid. He wanted people to
join, if not follow, him. His art was to be a bond
that tied him to a humanity which, as man, he could
not approach.

Chapter Five

Footnotes

[1] Emil Nolde, Welt und Heimat (Köln, 1965), p. 13.

[2] Ibid., p. 25.

[3] Ibid., p. 39.

[4] Ibid., pp. 39-40.

[5] Ibid., p. 43.

[6] Ibid., pp. 47-4 .

[7] Ibid., p. 48.

[8] Ibid.

[9] Ibid., p. 50.

[10] Ibid., pp. 57-58.

[11] Ibid., p. 61.

[12] Ibid., p. 88.

[13] Ibid.

[14] Ibid., p. 97.

[15] Otto Antonia Graf, "Kampf um Möglichkeiten" in Museum des 20. Jarhhunderts, Katalog 23 (Wien, 1965), p. 12.

[16] Nolde, Welt und Heimat, p. 116.

[17] Ibid., p. 119.

[18] Ibid., p. 130.

[19] Ibid., p. 137.

[20] H. J. Glaser, "Die Tage von Utenwarft" in Deutscher Volkskalender. Nordschleswig, 1972 (AAbenraa, 1972), p. 45.

[21] Ibid., p. 48.

[22] Ibid., p. 47.

[23] Karl Jorn, "Ada und Emil Nolde auf Alsen 1902-1916" in Deutscher Volkskalender Nordschleswig, 1972 (AAbenraa, 1972), p. 42.

[24] Nolde, Welt und Heimat, p. 140.

[25] Emil Nolde, Briefe: 1894-1926, Herausgegeben von Max Sauerlandt (Hamburg, 1967), p. 111.

[26] Nolde, Welt und Heimat, p. 146.

[27] Peter Selz, Emil Nolde (New York, 1963), p. 34.

[28] Max Sauerlandt, Die Kunst der letzen 30 Jahre (Berlin, 1935), pp. 112-113.

[29] Selz, Emil Nolde, p. 24.

[30] Another interesting possibility, particularly applicable in Nolde's case, is that offered by Rudolph Loewenstein who, in his Christians and Jews: A Psychoanalytic Study, trans. from the French by Vera Damman (New York, 1963), suggests that the Christ story embodies a desire to replace the "father" God of the Jews with the Son, even at the price of death. In this type of analysis, the crucifixion is of ultimate importance because it represents for that man who identifies with Christ a "culmination of the unconscious death wishes of his Oedipal period" (Loewenstein, p. 41).
At the same time, Christ has become in death a "divine scapegoat," thus serving to obviate the necessity of guilt, at least at the conscious level (Loewenstein, p. 191).

[31] Max Sauerlandt, "Emil Nolde," in Zeitschrift für bildende Kunst, neue Folge, funf und zwanzigster Jahrgang (Leipzig, 1914), p. 181.

[32] Ibid., p. 184.

[33] Ibid., p. 183.

[34] Paul Erich Kuppers, "Emil Nolde," in Das Kunstblatt, 2. Jahrgang, Heft 11, 1918, p. 329.

[35] Ibid., p. 330.

[36] Ibid.

[37] Ibid., p. 332.

[38] Ibid., p. 339.

[39] Ibid., p. 340.

[40] Nolde, Briefe, p. 125.

[41] Nolde, Welt und Heimat, p. 172.

[42] Letter property of Stiftung Seebüll Ada und Emil Nolde, courtesy of Dr. Martin Urban.

[43] Emil Nolde, Reisen, Ächtung, Befreiung, 1919-1946 (Köln, 1967), p. 11.

[44] Ibid., p. 32.

[45] Ibid., pp. 35-36.

[46] Werner Haftmann, in his introduction to The Forbidden Pictures, suggests that Nolde's coming from a "border area" in the first place was greatly responsible for his, at times, overweening nationalism. See Emil Nolde, The Forbidden Pictures, intro. and ed. by Werner Haftmann, trans. from the German by Inge Goodwin (London, 1965), p. 16. A general study of the rise of Nazism in the Schleswig-Holstein "border area" is to be found in Rudolf Heberle's From Democracy to Nazism: A Regional Case Study on Political Parties in Germany (New York, 1970).

[47] Hans Fehr, Emil Nolde: Ein Buch der freundschaft (München, 1960), p. 53.

[48] Ibid.

[49] Nolde, Briefe, p. 139.

[50] Nolde, Reisen, Ächtung, Befreiung, p. 42.

[51] Nolde, Briefe, p. 151.

[52] Fehr, Emil Nolde, p. 53.

[53] Nolde, Reisen, Ächtung, Befreiung, p. 32.

[54] When I first looked at the painting, I thought that the hooved feet were those of the devil, Nolde having expressed his desire to paint "the sinful primal mother of all men." Both Dr. Urban and my wife, Anne Marie, however, pointed out that the cow-like image would be reinforced if Eve did indeed have cow-like feet.

[55] Fehr, Emil Nolde, p. 54.

[56] On this, see Martin Urban's article "The Graphic Works of Emil Nolde," in Emil Nolde, Woodcuts, Lithography, Etchings, Alan Frumkin Gallery (Chicago, 1969).

[57] Max Sauerlandt, Emil Nolde (München, 1921).

[58] Nolde, Reisen, Ächtung, Befreiung, p. 71.

[59] Nolde, Briefe, p. 168.

[60] Ibid., p. 177.

[61] Fehr, Emil Nolde, p. 109.

[62] Ibid.

[63] Nolde, Briefe, p. 177.

[64] Nolde, Reisen, Ächtung, Befreiung, pp. 82-83.

[65] Festschrift für Emil Nolde anlässlich seines 60. Geburtstages (Dresden, 1927), pp. 11-12.

[66] Ibid., p. 18.

[67] Ibid.

[68] Ibid., p. 20.

[69] Ibid., p. 23.

[70] Ibid., p. 28.

[71] Ibid., pp. 20-31.

[72] Ibid., pp. 32-36.

[73] Ibid., p. 26.

[74] Paul Ferdinand Schmidt, Emil Nolde, Junge Kunst, Band 53 (Leipzig und Berlin, 1929), pp. 5, 6.

[75] Ibid., p. 10.

[76] Nolde, Reisen, Ächtung, Befreiung, p. 50.

[77] Fehr, Emil Nolde, p. 99.

[78] Ibid.

[79] Selz, Emil Nolde, p. 42.

[80] H. J. Glaser, "Die Tage von Utenwarft," p. 49.

[81] Selz, Emil Nolde, p. 24.

[82] Ibid.

[83] Nolde, Briefe, p. 171.

[84] Emil Nolde, Landschaften: Aquarelle und Zeichnungen, ed. Martin Urban (Köln, 1969), p. 29.

[85] Grag, p. 11.

[86] Nolde, Jahre der Kämpfe (Köln, 1965), pp. 221-222.

[87] Hans and Shulamith Kreitler, Psychology of the Arts (Durham, North Carolina, 1972), p. 91.

[88] Ibid., p. 92.

[89] Fehr, Emil Nolde, p. 43.

Chapter Six

A Psychological Summation

We must now summarize our examination of Nolde's psyche. First of all, his youth was characterized by a prolonged Oedipal yearning for his mother, something which he was never able to completely overcome. This, plus deeply felt resentments against his father--who, Oedipal matters to the side, seemed bad enough as a parent--and an underlying hostility against the object of his affections, severely inhibited his sexual development. As is common, the father became his "conscience" or "super-ego," a state of affairs which continued without moderation until 1891, the year in which his father died. For awhile, with the rival father gone, Nolde drew very close to his mother, and when the time came for him to choose a partner other than her, he identified with her just as he had previously done with his father. This did produce something of a division in his personality; identification with the father did persist in him in the man side of it, while an identification with his mother signified the blossoming of the artist. Yet, as we have seen, such a division was not, and could not have been, a totally successful one, and the powerful influence of the father affected his artistic side, as well as influencing many of his social attitudes, e.g., his desire always to appear as masculine as possible. The influence of both his parents could be seen in his art, although it was his identification, as artist, with his mother that allowed him to create. At the same time, Nolde often rebelled against both parental influences. Identification with the mother can be seen in his interest in the primitive, and in his utilization of flowers as the point of departure for his incredible experiments in color. It can also be seen in his anger at the big city and the Jews who inhabited it, anger directed against those things that threatened the fancied rural idyll of his youth. Rebellion against both her and the stultifying influence of the paternal conscience can be seen in his fascination for the sensual, sometimes identified with the Jews, particularly Jewish women of course, and always linked to the city. Identification with the father can be seen in his somewhat unyielding social ethic, in his conscious adherence to an old-fashioned morality and, as indicated above, in his persistent attempts to appear masculine and brave. Rebellion against the

149

father took the form of rebellion against anything
harsh or critical, e.g., in his bitter reaction
against Jewish critics and art dealers, or against
"Jewish materialism."

In Nolde's conscious identification with Christ,
we can see several important factors: 1) a religious
impetus stemming from an original "oceanic feeling" of
ego-identification with the entire world--the mark of
both an early lack of paternal protection and of a
weak ego development; 2) the continued existence of
unresolved Oedipal longings, the desire to be held and
comforted by women; 3) a strong rebellion against the
father, who was always identified as being the "steel-
hard Assyrian ruler" (or quite possibly the "Father"
God of the Old Testament) or the persecuting Roman
soldiers; 4) a rebellion against the mother as well;
this being particularly manifested in "Das Leben
Christi" where his own mother had been in part
supplanted by the sensual, warm figure of the Jewish
Mary. As we can see, by looking at this one extremely
important example of how Nolde's psychological
conditions were reflected in his art, there was no
simple straight line pattern of causation. Rather, as
in the case of less talented mortals, a given
phenomenon, human or artistic, for the analyst was
often the product of several contradictory forces.
The usual problem posed by "overdetermination" is
complicated further by Nolde's partially conscious
division of himself into man and artist. He could, in
identifying with his mother and rebelling against his
father, loathe and fear the Jews who threatened his
childhood memories of rural bliss and who represented
the critical world of his father. Yet, in rebellion
against his mother, he could be fascinated by them.
At the same time, he occasionally sensed a primitive
strength in the Jews, and his yearning for an
identification with his mother, as reflected in his
admiration for the primitive, could allow him to have
positive feelings concerning this people.

Negative feelings concerning Nolde's mother were
reflected in a general distrust or fear of women, an
attitude that was no doubt reinforced by the paternal
super-ego. At the same time, he continued to have
unrequited sensual demands, these in part stemming out
of unresolved childhood Oedipal problems. While these
were sometimes reflected in his paintings, he was, as
man, inclined to set up a strong reaction formation
against them. The denouement of this was his

projection of these demands onto others, e.g., the Jews.

Of special interest for us is Nolde's obvious distaste, as man, for the world of people. Nolde, as did a fair number of other artists--most prominent among them, Rousseau and Gauguin--rebelled against civilization. Whether or not Rousseau and Gauguin rebelled for the same reasons as did Nolde must remain a moot point insofar as this study is concerned. Nolde's turning toward primitive peoples was, as Graf pointed out, a protest against the harsh world of his father, and an identification with the primal world of his mother.[1] The world of the father--the harsh, critical world of the probing lantern-beam of practicality and reason--was something that Nolde strove assiduously to avoid. Instead, to some extent as artist, but mainly as man, he sought to identify himself with a child-like world of the primitive; a precognizant world in which the mother ruled over all. In the man side of his so-called divided personality, this was part of his rebellion against the continued domination of the spirit of that person who haunted his dreams. As Freud put it, "It is easy, as we can see, for a barbarian to be healthy; for a civilized man the task is hard."[2] The task of adjusting to a highly critical and competitive civilization, i.e., the world of the father, was an almost impossible one for Nolde. Incidentally, the fact that Nolde's turning back to primitivism was part and parcel of his development as man rather than as artist (although, to be sure, primitive themes, e.g., his use of masks, waxed large in his work) helps to explain a problem that has interested many critics: that his South Sea journey of 1913-1914 had relatively little impact on the nature and method of his work. Nolde's interest in primitive art and primitive life in general was not something that was pivotal in the development of Nolde the artist. Rather, it was the emotional and ideational bridge that linked his rebellion as man against the civilized and ordered world of the father to that other portion of his life, the world of the mother (the realm of the artist). This latter world lived in Nolde as the psychic response to unsatisfied demands and irrepressible fears that came out of a bitter childhood. In both worlds, however, Nolde paid a harsh penalty: submission to a well-nigh tyrannical super-ego that was the product of necessary (but at times bitterly resented) identifications with both of his parents. Truly the restless life of this isolated

151

man was "an example of the in which the present is changed into the past."3

Within the world of the man, Nolde was a weak and insecure individual. "It is certainly not valuable for you to know me personally," he once remarked to a sympathetic visitor, "for I am smaller than all other men which could exist in reality, in life itself."4 To "know me personally" meant, of course, "to know me as man rather than as artist." His almost painful shyness in the world of men and women has been alluded to previously. To say that such shyness stemmed from a sense of inadequacy, in large measure sexual, is to state the obvious. In the world of Nolde as artist, however, he was neither shy nor modest. Indeed, there is the sense in his writings that he was divinely ordained to become an artist. Here, we must recall the incident of his mother's pointing out her son's "lucky star." This sense of being providentially ordained to paint can be seen in a sort of fable which Nolde included in an 1894 letter to a female acquaintance (as we see from the date, this letter written three years after the death of Nolde's father):

> It was at home. It was on a Sunday morning, all were gone to church; only the mother sat alone at the cradle of her little baby, who was crying continuously. She was deeply afflicted and she prayed. An angel descended to the cradle, and handed a little, colorful flower to the child; and he spoke to the striken mother: "See, thine child does not cry any more, and this flower is a sacred gift; and the Lord says: thou shouldst not desire that the world love thee, for I have loved thee and my grace is suffering for thee. . . . Now the sea is quiet. Also my soul is still. Only little waves still splash softly on the bank and only a little fire still glows deep in my bleeding heart.5

The warm, creative sense of the mother, the flower, was being given to Nolde as a sign of divine encouragement. It was due to this, at times, desperately cherished belief, the belief in the divinity of his art, that Nolde's shyness absolutely vanished in this realm. Attacks upon his art, such as those mounted by Cassirer, Liebermann and others, constituted attacks upon that one aspect of his being in which he would feel secure, or at least more secure than in other areas. Thus, Nolde's responses to such challenges

152

were instantaneous and bitter, and seemingly not
accompanied by self-deprecating defensiveness.

Thus far, we necessarily have been considering
Nolde as being rather singular. To be sure, we can
perceive certain idiosyncrasies which one often, in a
rather undifferentiated manner, can ascribe to a sort
of archetypal "artistic personality": tendencies
toward brooding, outbursts of ecstatic emotionalism,
and occasional periods of autism. Yet, it is
important to realize that, even beyond these general
qualities, Nolde, for all of his peculiarities, can
well be considered as embodying phylogenetic
characteristics which a variety of psychologists have
associated with the artistic personality. We will
soon examine this issue in detail. For now, though,
we must face two disturbing questions: if indeed,
Nolde's personality can be seen as being typical of
an artistic type, then how can one explain both his
extremely singular political decisions, much less the
background for such decisions? Further, we have
implied throughout that, in some apparently
significant way, Nolde can be seen as embodying the
burden of German cultural history. If he can be
considered as being merely an artist-and in the most
universal conception of the term--then will our
broader historical concerns prove devoid of substance?
In the final analysis, these questions can be dealt
with in a satisfactory manner. Now, necessarily
bearing them in mind, we must attempt to place Nolde
within the broader context of the phylogenesis of the
artistic personality.

We have spent a good deal of time on Nolde's
childhood. Bearing in mind what we know about this
significant period, we can see that, however singular
and tempting it seemed (at least in retrospect) to
him, there are important points of comparison between
it and that archetypal childhood seen by psychologists
as characterizing the genesis and development of
artistic creativity. First of all, psychologists who
have studied the phenomena mentioned above have come
to the conclusion--no doubt, not entirely unexpected!--
that the artistic personality has in large measure
been influenced by problems centered around the father
or a powerful father figure, "a specially powerful
god-like father," as we quoted Phyllis Greenacre in
the introduction to this work. Early conflict and
fantasies become fixated upon this father or father-
figure and, with the question of identification or

possibly lack of it being of utmost importance,
there must be a continuous clashing between "active
and passive tendencies."[6] Naturally, for the
creativity-bound child (as for a great many other
children, one must assume) the real father might very
well not fulfill the parental ideal. In that case,
the child carries the ideal with him as if that is
the real father. In this case, identification can be
made at least in part by "the chance encounter with
some individual or even some experience which strikes
a decisive harmonizing note with a part of the hidden
image of the father."[7] While, at least for the male
artist, the role of the father and, more important
than that, conflict centered on identification--or
lack of it--with him, is seen as central, many
psychologists point to the problems created by the
oversensitized child who continuously demands "an
intense and demanding relationship to the mother and
to other early personal objects."[8] This relationship
is in part maintained but, particularly in the case of
the child who has an unsatisfactory pattern of
identification with his father, it is almost never
strong or consistent enough.

 As many psychologists view it, then, Oedipal
problems--always of importance in the psychic
development of males--would be of far greater
prominence in the lives of male artists. Again,
particularly in view of what Dr. Greenacre said with
regard to the development of the image of an idealized,
fantasized father, it is most important to remember
that, for young males in general, it is not the father
and mother of real life for whom Oedipal feelings are
entertained, but rather, as Hanns Sachs put it, the
"Imago" of the father and mother retained as fantasy
in the unconscious.[9] For the artist, of course, there
is the possibility, indeed, necessity, that the
elaborate fantasy-material available to all people, be
woven together into patterns of poignant force and
power. All the time, the forces which subsist at the
base of the psyche, phenomena which, in the case of
the artist, demand at least partial representation in
plastic form, can never be fully represented. For the
artist, as we have seen, this is all to the good. For
man, this is tragic. Very often the artist might well
have substantive intuitive insights into the existence
of Oedipal problems and even the necessity of the
existence of the "Imago"--as we have seen, Nolde in his
memoirs was quite specific in recognizing the need
that a person view his childhood past in a romantic

manner--but analytical understanding must remain elusive.

It is perhaps because of unusually strongly Oedipal tensions combined with and exacerbated by inherent creative powers that the artist often finds his real parents to be unsatisfactory. We already have considered the role of "Imago" in this regard. Besides this, a good many psychologists have called attention to a persistent tendency among artists to fantasize about being born of parents other than their real ones or of being separated from the original parents.[10] The following suggestion by Harry Trosman is worthy of consideration, particularly regarding our examination of Nolde: "In the face of doubt a fantasy of exalted birth attains credibility. By this means, not only does the young boy deny his fears of retaliation for his positive Oedipal longings, he also removes his real father as a potential rival for the mother by denying paternal sexuality."[11] Romanticizing one's real family can either displace or accompany fantasizing about being born of parents more exalted than one's own. Here, romanticizing family origins is something which Greenacre sees as being "ubiquitous in artists of all sorts," often expressing itself in the selection of various 'non de plumes' and also is a continuous tendency towards naive dependency."[12]

Fantasizing about some sort of exalted birth and/or the romanticization of one's real family are means of dealing with those negative feelings toward parents that have to stem from unresolved Oedipal conflicts and unsatisfactory patterns of identification. "Fortunate is that creative child or youth who has available within his own family individuals suitable for these identifications and reinforcements of his own creative needs."[13] With the failure of so idyllic a situation to develop, the fantasy patterns described above are often of little real value. Indeed, due to childhood trauma stemming from a lack of adequate identification and reinforcement, there is often the tendency among creative people to divide their personalities into two or more selves. This is due to a powerful concern to "deny the creative self in favor of the social stereotype." Indeed, the creative is felt as freakish, abnormal, and has to be fought." This condition lasts into adulthood with the conventional self functioning as the "guardian or enemy of the creative self."[14] Of course, this constructivistic sort of dichotomization

155

does not provide for satisfaction in personal relationships, and disappointment in the personal object "might well cause the creative person to turn towards the collective one(s)."[15] Furthermore, exaggerated development of an approved social stereotype, e.g., manlines or "toughness," hardly serves to strengthen the ego of the whole person. Indeed, for the person to be anybody at all, he or she has to be creating. "'Unless I am creating, I am nothing!'" has been the plaintive cry of many creative spirits.[16]

It is especially interesting to note that, according to Rickman, the artist often perceives a self completely separate from the self that is creating. The latter produces "art-children" and sees itself as being essentially passive with respect to creative powers but active in response to their demands. What is being expressed here is a passive relationship "to a creative image of infancy, the father figure and to the part of him which is capable of creating another person."[17] Extrapolating upon this, we can readily see that, for an artist, the act of creativity is not something which is willed, but rather an almost sensual force which moves through him, utilizing him as the vehicle of creative expression. What is important to remember here is that the artist often chooses to view himself as being a passive vehicle for creative drives. In any act of creation, there has to be some some of willed control over instinctual demands.[18] It would appear, however--and here, our considerations of Emil Nolde must be borne in mind--for many psychologists, the artist, however much he or she does in fact will elements of creativity, is seemingly driven to view himself as being essentially passive in nature.

Art as a form of self-immortalization is something which has been commented upon by a host of critics, psychologists, and, indeed, by artists themselves. According to Otto Rank, however, this can have most disturbing results. First of all, in order that the creative ego is not consumed by the very life he seeks to perpetuate, the artist seeks "to protect himself against the transient experience."[19] Secondly, this desire to immortalize the self--in effect as others, besides Rank, have pointed out as being a desire for rebirth--must express itself in an effort to draw as close as possible to one's likeness, something which is most "readily found in his own sex."

156

It is no great surprise then, that "the other sex is felt to be biologically a disturbing element except where it can be idealized as a muse."[20] Obviously, according to Rank, the very impulse "to perpetuate himself drives him away from the biological sex life."[21] It is important in all of this to bear in mind that homosexuality, while never completely precluded, is not an issue here. Rather, what is of primary importance is the desire to recapitulate or even to recreate one's own life in this case in the form of a "youthful love" (as Rank put it) which must necessarily preclude the establishment (or at the very least, reduce its importance) of mature ties with women. At the same time, though, the male artist is dependent upon women (or a woman) to serve the vital function of justifying "the artistic ego, with its creativeness, and the real self, with its life."[22] This, of course, she is unable to do, and she must necessarily be relegated to the role of being alternately hallowed as muse or utilized--or despised-- as mistress. Thus, in his desire for immortality, a condition attendent upon his continual rebirth, the artist compounds a problem inherent in normal unresolved Oedipal fixations, dependence upon women in a most naive, indeed, childlike manner, even as psychic conditions must prevent the establishment of mature sexual relationships with them.

It is of interest to note that for Rank--and indeed for most psychologically informed analysts of aesthetics--these problems are seen as being heightened by the extreme subjectivism of so-called modern art. As we have noted, such art, at times paradoxically attempting to build ideational bridges through solipcism, could and did arouse hostility on the part of early Freudians. Indeed, in their considerations of art, it is obvious that, while psychologists--especially Freudians--had to place emphasis upon its phylogenetic character, they were most sensitive to certain zeitgebunden aspects of it which seemed to underscore fundamental problems of modern society. In this regard, it is of great interest to point out that art critics have discovered a most curious phenomenon: while the art and literature of the early nineteenth century tended to depict the male in a sadistic sort of role in relation to women, the end of this century saw an increasing inclination toward masochism. Women "appear as powerful and domineering--Freud would say castrating-- whereas the man appears increasingly nervous and

157

sensitive."[23] In view of the fact that, throughout
this discussion of psychoanalytical approaches to
aesthetics and the artist, we presumably have been
establishing connections between general conclusions
and the character and work of Emil Nolde, it is
perhaps redundant to point out in this particular
case that his work was certainly characterized by
strong, masochistic overtones.

With regard to the etiology of Nolde the artist,
we can only express astonishment at some of the
general conclusions on artistic creativity drawn by
Freudian, post-Freudian, and even ego psychologists.
As we have seen, one does not have to do too much
untoward reading between the lines in order to see
that Nolde was indeed beset with identification
problems; that his father did indeed assume a negative
god-like role in his life; that he was intensely
involved in establishing a strong relationship with
his mother. Furthermore, romanticization of his
family was most assuredly involved in changing his
name from Hansen to Nolde (his "nom de plume"), the
village strongly associated with his mother, and
fantasized rebirth and immortality can be clearly
observed in his art, most particularly in his
depictions of the birth, life, death, and rebirth of
Jesus Christ. Nolde very consciously chose to divide
himself into man and artist, and, through identifying
the former with an idealized supermoralistic father,
provided for himself an apparently necessary, if often
inconvenient, realm where the masculine social
stereotype could prevail. Nolde most assuredly viewed
his art as his children, and the creation of them was
accomplished, as he saw it, by his being the passive
vehicle of overpowering drives. While drawing back
from biological sexual relationships--in large measure
due to his own idiosyncratic psychological
development, but in part, analysts would say, because
of his desire for an immortality not contingent upon
transient events--he had a naive dependency on women,
something which lasted his entire life.

After at first expressing satisfaction over the
way in which psychoanalytically oriented critics have
offered us categories and conclusions which, in their
applicability to Nolde (an individual who none of
them ever mentions) seem to go beyond heuristics, we
then must face those two questions posed at the
beginning of our more recent discussion: 1) if Nolde
can be seen as a typical artist, from whence come

158

those qualities which can be singled out as explaining his unique political decision? and 2) if Nolde, again, can be viewed as a typical artist, what does this do to our general historical concerns, most particularly that one involving Nolde as somehow bearing the burden of German cultural history?

To answer these most important questions it is necessary for us to focus upon Nolde as a unified personality (not as artist), and upon the very particular social and, to some extent, cultural circumstances which, paradoxically, allowed him to become a microcosm of his nation's anguish.

In part, we already have considered Nolde as a complete person and not merely as an artist. After all, even if one chooses to focus only upon a putative artistic side of an individual, it is part and parcel of the whole person, just as artistic production itself cannot be analyzed in vacuo. We must now consider the whole man within a particular social and cultural context. First of all, we will be concerned with those aspects of Nolde's psyche that can be considered as tying together man and artist. Necessarily, we will be in part recapitulating materials presented earlier. Our primary concern here, however, is to view this unified psyche, necessarily manifesting meta-historical phylogenetic concerns, within that socio-historical context which determined that Nolde's formal adherence to a certain fundamental phylogenetic pattern would be marked by an ideational development which, most especially when compared to at least other Expressionists, was disastrously singular. In a word, we will distinguish between psychoanalytical concerns and those which can be more accurately distinguished as being psychohistorical. This will lay the groundwork necessary for later efforts to determine the significance of Nolde's turning toward National Socialism and more general considerations of those fundamental social and cultural problems of which he can be seen as representative. First we must consider those aspects of Nolde's life and work which the unity of man and artist is clearly revealed.

As we have noted earlier, Nolde's interest in primitivism constituted a bridge between the two sides of his personality. Also important in this regard was need to feel a sense of rootedness in the soil of his native land. Both as man and as artist, Nolde felt

this need very strongly. In a letter dated October
29, 1922, he made the following remark: "for myself,
I am of the opinion that my art, in spite of travels
abroad, is rooted deeply in the soil of the homeland,
in the small land here between the two seas."[24] As
we can see, by "homeland" (Heimat), Nolde did not mean
Germany; he was referring to but a small portion of it,
his own particular "homeland," Schleswig-Holstein. As
man too, however, he was deeply tied to this homeland.
As we have seen in the Hallig Hooge experience, he
underwent a profound depression after the First World
War when Schleswig was divided between Germany and
Denmark. This experience bore a marked resemblance to
the perhaps more frightening one of Lildstrand and,
like this earlier event, it found reflection in his
art. Both experiences shared this in common: they
were responses to Nolde's fear of--and to some extent
anger at--being torn from maternal arms; only, in the
first case, he was being torn away from something
after which he yearned, and in the second, from
something with which he had identified. In both of
these experiences, however, we can see artist and man
as one. Tying them together was the fear of
abandonment to the paternal super-ego. As Graf put it,
"The threatening dream figure of the father was
avoided through discovery of the soil and its
history."[25] The denouement of the events of 1901 was,
of course, his marriage to Ada and, now as artist, a
definite identification with his mother. There was to
be no satisfactory solution to the problems raised by
the second traumatic event, however, although he would
attempt to arrive at one, in part through a most
unfortunate political decision.

Another bond that tied the several aspects of
Nolde's personality together was a strong tendency to
self-consciously assert his manliness. As an artist,
Nolde continuously condemned the "soft" or "sweet"
tendencies which he saw as predominant in French
Impressionism. Much of this was simply a matter of
taste, of course, and has to be viewed as such.
Wiesenhutter recorded the following remark by Nolde:
"French art, in its features, is womanish (weiblich)."[26]
To be sure, commentators from Friedrich Ludwig Jahn all
the way to the somewhat more prosaic British Field
Marshall Douglas Haig have criticized the French for
their supposedly feminine qualities. In Nolde's case,
however, this was part of a well-established pattern
of attempting to assert his masculinity. As we have
seen, he had greatly exaggerated his self-sufficiency,

virtually asserting that he "lived off of the land"
during the First World War years. This tendency led
to periodic episodes of self-dramatization, e.g.,
his supposed confrontation with the Mafia in Italy,
and his emphasis upon the tension involved in his
painting an armed native on the island of Manu:
"Perhaps never before had a painter worked under such
tension."[27]

 An important element of Nolde's personality
which reinforced his morbid concern with masculinity--
at least on the conscious level--was his basically
negative attitude toward women and the sensuality
they supposedly embodied. After marrying Ada, Nolde
had asked himself whether or not the maintenance of
tension, sexual or otherwise, was necessary in the
creation of art. He was seriously worried about the
possibility that women often "killed the artist in
men."[28] Nolde was so concerned over this that, in the
previously mentioned letter to Hans Fehr, he had
stated that he would leave his wife if he considered
her a threat to his art.[29] This negative attitude
toward women was reflected in many of his paintings,
in which they were depicted as being either strong-
willed and wise souls or as helpless victims of a
feminine onslaught. A very concrete example of the
qualitative distinction that Nolde made between men
and women can be seen in a letter of December 23, 1900
to Hans Fehr. In fantasizing about raising children,
he described the several varieties of fairy tales
which he would tell them: for boys, there would be
ones concerning brawling, drinking mountain giants;
the ones to be told to girls would be concerned with,
among other things, "bad people, who are turned to
stone because they are bad."[30] Of course, Nolde's
rejection of women was indicative of a basic fear and,
at times, hatred of them. The "primal mother" of his
Adam and Even painting of 1921 is a fat, sensual cow
and, as we have seen, Nolde made much of the image of
a flower, i.e., his own mother, growing out of filth.
Yet, as we have seen, there was an irony in all of
this. Nolde, who in his conscious life distrusted
women or looked down upon them as being less sensitive
than men, needed them desperately. In this, he fits
the pattern of the sexually underdeveloped male. "A
residue of his erotic fixation to his mother is often
left in the form of an excessive dependence on her,
and this persists as a kind of bondage to women."[31]
Nolde was much impressed by the fact that Ada put a
pillow in back of his head when he listened to her

sing. He was deeply moved when Frau Osthaus took him--"me, the shabby painter, in my miserable suit"--by the arm and brought him over to sit with her at the head of the family table.[32] Finally, when Ada died in 1946 he would be driven to marry again, in this case to a woman very much younger than he (fifty-three years younger, to be exact), a woman who could take care of him in his last years, during a period of time in which his own need to "mother" somebody had lessened to a considerable degree.

Nolde's efforts to assert manliness in both artistic and personal spheres--his continuous emphases upon his strong northern personality and his independence from the world of men--and his negative attitudes toward women and sex testified to the continued influence of the father in the form of an oppressive conscience or super-ego. This was manifested in both his artistic endeavors and in his life as a man, and it complemented his efforts to identify himself with his mother. Again, these efforts were part of an attempt to oust the harsh paternal influence and to replace it with some other object of identification. Yet, in its own way, this new object was just as oppressive as the older one, and strong rebellions against both were evidenced in Nolde's private life as well as in his paintings. Thus, the two sides of halves of his personality can be seen as one. To be sure, the amalgamation that we have discovered was not a complete one, and there are points at which the two sides overlapped or did not meet. Similarly, the previously established division of Nolde's personality was also necessarily an imperfect one. Nevertheless, the fact that there was a unity--or better, perhaps, dialectical relationship--between man and artist led to some extremely curious results, particularly regarding his attitudes toward two concerns: the city and the Jews.

For Nolde, the city was a threat to the homey, bucolic world of the mother. Its cold sophistication stood for all that made him unconfortable, and the cynical and coolly rational people he met there--the art dealers and critics--were harsh figures drawn from the world of his father. It was from the city that unfeeling engineers came to drain the marshes and to spread an unwelcome civilization into the warm motherland of his youth. At the same time, though, the city coursed with a vital, at times primitive sensuality which fascinated him. Nolde might well

have despised the overly sophisticated city dweller. He frequented the cabarets and the theater, however, the very places urban ultra-sophistication and raw urban primitivism met head-on. Nolde's fascination with the sensual, and his frequent portrayal of it in his paintings, was part of a strong rebellion against both the influences of his father and his mother. The city might well have been a dirty place for him; the phrase "bit city manure" is one that appears in several places in his writings. Nevertheless, he found this dirt to be fascinating and, in both observing and depicting it, he was able to express a certain contempt for both of his rather simple parents. At the same time, though, as Walter Jens pointed out, the city contained a certain primitive Typus; there was an almost primeval quality about it, and Nolde was able to reduce such diverse figures as expatriate Slovenians, cabaret singers, and dangers to a common level, that of the "mask".[33] Thus, while the city was a disturbing place for him, threatening as it did the world of the mother (and embodying at least in part the harshly critical spirit of the father), Nolde was able to gain a great deal of satisfaction, of excitement from it. He revelled in its sensuality and thus rebelled against both parental influences, and at the same time he was able to see in it that precognizant primitivism which he associated with his mother, and for which he longed. As we have seen, Nolde's attitude towards Jews was a similarly divided one.

In the end, Nolde chose to align himself with a self-consciously anti-urban political movement that openly declared itself to be inimical to the Jews. Why did he make such a far-reaching decision? First of all, after the First World War, the forced separation from the Heimat strengthened the mother identification to some extent. Thus, his emphasis upon big-city Jewry as being "an enemy" also was increased. As this occurred, he had to reject much of his fantasizing about them, particularly the notion that he would wish to substitute a sensual, dark figure for that of his mother. Finally, of course, these foreign and somewhat strange people represented a convenient group upon which he could project all of his own frustrated sensuality. The Jewish lad, perhaps in part apocrypahl, who told him that "Every young girl with whom I've been together for the third time must fall," was no doubt a projection of Nolde's own strong desires; desires

which were in large measure directed toward the women of this peculiar race. Thus, in rejecting the Jewish people as a whole (although not individual Jews), Nolde was doing two things primarily: 1) he was rejecting those who stood for forces threatening the "mother world," i.e., the idealized rural homeland of his youth, and 2) he was rejecting all of the raw sensuality and lust that was part of his rebellion against both of his parents, but which now, through repression, he had projected onto an alien but convenient people. Universal psychological realities were responsible for this process. Several hundred years of cultural conditioning had determined which people would fill the role.

When we bear in mind the conclusion drawn above, we can at least in part understand the roots of Nolde's "racism" and tendencies toward xenophobia, his at times strident emphasis upon a particularly "German" art. Part of this, of course--like Nolde's anti-Semitism--was due simply to the fact that, in late nineteenth- and early twentieth-century Germany such notions were very prevalent. For Nolde, however, nationalistic concerns were of particular importance. As Wilhelm Reich pointed out, the notions of "homeland and nation are notions of mother and family."[34] We have in part alluded to this before, i.e., Nolde's desires first to possess his mother, and second, particularly after the death of his father, to increasingly identify himself with her. Both of these tendencies contributed to his identification first with the particular homeland of his birth--Schleswig-Hostein--and second with Germany as a whole. There would appear to be a contradiction here, however; while Nolde's mother of course lived in an area that was initially German, she was herself Danish and indeed spoke that language. If Nolde eventually came to identify himself with her, why did he not identify himself with the Danes and Denmark? Again, to answer this question, we must turn to Wilhelm Reich. In The Mass Psychology of Fascism, he described what he called "the typical peasant way of looking at things," the core of which "is formed by patriarchal sexual morality."[35] This type of morality, which involves the most stringent sexual subjugation of women and children, necessarily results in an initially very strong identification with the father.[36] In other words, while the mother is the family, the father is its master. Naturally, in a family in which primary emphasis is placed upon a radical separation between

164

men and women, as well as upon the father as
representing the only legitimate source of social
control, conditions conducive to massive childhood
rebellion have been created. At the same time, though,
these very same conditions must necessarily stifle any
such rebellion, forcing it so deeply inward that it
can emerge only in the most distorted of forms.[37] For
the male child, life indeed becomes a battleground,
for he is forever being called upon to justify himself
in terms of assumed rugged masculinity, something that
is doubly necessary due to those nagging doubts and
socially inexpressible desires which must remain as
grim legacies of an authoritarian household. Such a
household and the problems that emerge from it are not
confined to Germany. As Erikson and others have
pointed out, however, it was in Germany that this
authoritarian family structure was exposed to the
greatest stresses.

In Germany, the father came to lack 'true inner
authority."[38] There were several reasons for this,
but basically they can all be reduced to the
overriding fact that during the last three decades of
the nineteenth century Germany underwent a period of
intensified capitalistic growth unprecedented in
Western history. The type of society which began to
emerge was one in which the whole essence of the
patriarchal family structure began to be called into
question, as indeed was the very integrity of the
family unit.[39] Traditional patterns of authority, the
preservation of which was necessary in order that
socially conditioned roles be maintained, underwent a
severe challenge. The denouement of all of this was a
situation in which a more-or-less traditional family,
i.e., one that was the legacy of a presumably simpler
rural past, was juxtaposed against a society which
basically undermined it in all essentials.
Traditional family roles--the father as authority
figure, the mother as the preserver of domestic order--
became gutted of content. Children who grew up in
Germany between 1870 and the First World War did so in
an environment in which the hollowness of the
bourgeois family became more and more apparent, even
as the parents tried desperately to preserve what
status they had by adhering to their traditional roles
and those patterns of behavior associated with them.
In such an environment all of the consequences one
associates with childhood and adolescent problems--the
unresolved Oedipal complex, unsuccessful patterns of
identification, rebellion and the guilt attendant upon

165

this--became greatly exaggerated. The child growing
up during this time would thus be one who had more
than its share of those problems which psychoanalysis
associates with childhood and adolescence.

Of great importance for us is the fact that the
unsuccessful childhood of Emil Nolde created in him a
yearning for another childhood, an imaginary paridise
which never existed.[40] In such a situation, hostility
toward parents would be offset by the reaction-
formation of idealization, tied of course to a
desperate effort not so much to recapture the past
but, through idealization, to recreate it.[41] In such
a way would despair over a bitter childhood become the
source for vain search for the "Golden Age."[42]

Nolde's own search was both typical and more
complex. On the one hand, he at first longed for and
later identified himself with his mother; there was on
the other hand that side of him, the super-ego of him
as man, which continued to identify itself with the
father. This identification was, of course, a source
both of Nolde's strong respect for--but occasional
rebellion against--authority, and for his sexual
repression. The father's--the super-ego's--language
was German. In Nolde's strong German nationalism
(rather than his devotion to the particular part of
Germany that was his home), we can observe the
confluence of his identifications with both parents:
Schleswig-Holstein was his mother; however, it was
part of Germany, a source of authority and power which
directed its fate to the same degree as a father
directed that of the family. This source of authority
and power was the father for Nolde. In this regard,
we seem to be contravening an important psychological
principle, particularly as it had been developed by
Reich; namely, that identification with the national
leader is identification with the father. In Nolde's
case, however, there were two patterns of
identification, a situation that was both reflected in
and reinforced by his separation between man and
artist. Thus, his love for his particular homeland
and his love for the nation as a whole--a powerful
father figure embodied in the personalities of von
Moltke, Bismarck and Nietzsche--stemmed from two
different psychic realms. Nolde did not seem to be
terribly concerned with authority in the form of a
person per se. For him, the nation as a whole, albeit
perhaps concretized in a person, seemed to be the
leader. Furthermore, Nolde's strident identification

166

of himself as German (as opposed to being merely an inhabitant of Schleswig) was also in part a reaction formation to that love which he had for his mother, naturally identified with Denmark. As we have seen, such a love was inadmissible. Furthermore, it was a love for one whom Nolde at the same time despised.

This in part helps to explain Nolde's condemnation of "sweet" or "soft" French art, and his continuous exultation of the "rough" or "harsh" northern "art" of which he was representative. While the artist in him was his mother, the powerful conscience, i.e., super-ego of the father, provided him with aesthetic principles and assisted in the formation of an ideology. The warm family of Nolde's idealized youth was still ruled by patriarchal authority. The result of this was a strong German nationalism and an equally strong concern with "purity," i.e., a poorly defined racism. Again, we can observe a point at which man and artist came together. However, this unity of an often unconscious artistic spontaneity and the paternal conscience that sought to control it was not always a perfect one. This helps to explain and important point made by Walter Jens: there often was a great difference between what Nolde said--his ideology--and what he painted.[43]

Nolde's personality was thus both divided and indivisible all at once. An original identification with his father remained strong in him as man throughout his life. At the same time, he identified with his mother in the artistic side of his personality. As we have seen, however, the two aspects--man and artist--could and often did influence each other. Moreover, Nolde was in almost continuous rebellion against both forms of parental control, and occasionally lines were crossed. As an example of this, we can consider an incident mentioned by Glaser in his essay "Die Tage von Untenwarft." On the occasion of Ada's birthday--which one, he does not say--Nolde surprised his wife by presenting her with a silver brooch and with a relief of the head of his father that he had hammered out of an old wall stone.[44] The meaning of the silver brooch is really not too clear. We would have to know a good deal more about Nolde's background than we do in order to determine this. However, it is an almost universally accepted psychological fact that the head, in both preconscious and dream states, symbolizes either the

167

male or the female genitals.[45] This was a very
definite sign of Nolde's rebellion against the
paternal super-ego and his expression of this in
artistic form. He was presenting the genitals of one
who so often had threatened to castrate him to a
woman whom he mothered and who, in turn, mothered him.

As mentioned before, Nolde's art served the
function of mediating between powerful drives and
needs--which he himself feared to express--and his
overriding need to create and thus to express himself.
Yet his art did not suffice to give him peace. He had
married a person whom he could mother and who could do
the same for him in return; as devoted as they were to
one another, however, there can be little doubt that
Nolde felt from time to time the pangs of frustration
in their deepest form. He loved children, but they
could have none.[46] Ada's perpetually weak condition
and/or his own sexual make-up seemed to preclude that
possibility. He longed for passion, but how much he
could give or receive is an open question. After the
First World War, an insensitive treaty had cut him off
from his very roots, his own special motherland,
hallowed by fantasy and idealization. These were
deficiencies and losses for which no possible degree of
artistic success could compensate him. In commenting
on the relationship of art to life, Freud remarked:
". . .the mild narcosis induced in us by art can do no
more than bring about a transient withdrawal from the
pressure of vital needs, and it is not strong enough
to make us forget real misery."[47] In the life of Emil
Nolde, one of the greatest artists of modern times,
there was more than adequate evidence to testify to
the validity of that statement.

Freud was considering art from the point of view
of psychoanalysis, and psychoanalytical considerations
have been of immense assistance in gaining an
understanding of the etiology of Emil Nolde, artist.
However, to gain an understanding of those forces
reponsible for Nolde's ideational world--the world of
the whole man--it has been necessary to complement a
purely psychoanalytical approach with social and
cultural considerations. In large measure this hardly
represents a break with the Freudian tradition of
psychoanalysis. After all, the individual, artistic
or not, was perceived in a social context. For Freud
and his followers, however, society was a phenomenon
that, while not historical, nevertheless had to be
perceived in a metahistorical fashion. It was the

permanent arena of conflict between <u>homo sapien</u> and
<u>homo faber</u>, between man as a natural being,
psychically transfixed between pleasure and self-
imposed anguish, and man as sublimator and hence
anti-natural. Why given phylogenetically determined
patterns of behavior clothed themselves in raiments
of one sort or another is a question that can be only
partially answered by an appeal to psychoanalysis.
The explanation of why Nolde who was in so many ways
the prototypical artist, responded to life's
challenges in so singular a fashion must be sought in
the social and cultural history of Germany. It was
in the interaction of phylogenesis and socio-cultural
conditions that Nolde arrived at a rough-hewn ideology
that would forever haunt him.

Chapter Six

Footnotes

[1] Otto Antonia Graf, "Kampf um Möglichkeiten," in Museum des 20. Jarhhunderts, Katalog 23, Wien, 1965, p. 12.

[2] Freud, An Outline of Psychoanalysis, trans. James Strache (New York, 1969), p. 42.

[3] Ibid., p. 64. Bernard Meyers in his The German Expressionists (New York, 1956) pointed out that Expressionism as a whole seemed to represent a revolt against authority figures. See Meyers, pp. 11-12.

[4] Alfred Wiesenhutter, "Emil Nolde," in Die Furche. In neue folge herausgegeben von Otto Schmitz. XVI. Jg., (Berlin, 1930), p. 1.

[5] Ibid., p. 3.

[6] Ernst Kris, "On Inspiration" Preliminary Notes on Emotional Conditions in Creative State," in Hendrik M. Ruitenbeek, The Creative Imagination: Psychoanalysis and the Genius of Inspiration (Chicago, 1965), p. 157.

[7] Phyllis Greenacre, "The Childhood of the Artist: Libidinal Phase Development and Giftedness," in ibid., p. 179.

[8] Ibid., p. 183.

[9] Hanns Sachs, The Creative Unconscious: Studies in the Psychoanalysis of Art (Cambridge, Mass., 1951), pp. 326-327.

[10] Ernst Kris, "Psychoanalysis and the Study of Creative Imagination," in Ruitenbeek, p. 29.

[11] Harry Trosman, "Freud and the Controversy Over Shakespearean Authorship," in John E. Gedo and George H. Pollock, eds., Freud. The Fusion of Science and Humanism: The Intellectual History of Psychoanalysis; Psychological Issues, Vol. IX, Nos. 2/3, Monograph 34/35, 1976, p. 330.

[12] Greenacre, in Ruitenbeek, pp. 179-180.

[13] Ibid., p. 184.

[14] Ibid.

[15] Ibid.

[16] Rickman, ibid., p. 113.

[17] Ibid.

[18] For a most interesting discussion of this, see Otto Rank, "Life and Creation," in Ruitenbeck, pp. 70-71.

[19] Ibid., p. 69.

[20] Ibid., p. 86.

[21] Ibid.

[22] Ibid., p. 82.

[23] Jack J. Spector. The Aesthetics of Freud: A Study of Psychoanalysis and Art (New York & Washington, 1972), p. 31. Here Spector is making particular use of the observations of the critic, Mario Praz.

[24] Emil Nolde, Briefe, 1895-1926, herausgegeben von Max Sauerlandt (Hamburg, 1967), p. 160.

[25] Graf, p. 10.

[26] Wiesenhutter, p. 9.

[27] See Chapter IV.

[28] See Chapter IV.

[29] See Chapter IV.

[30] Hans Fehr, Emil Nolde. Ein Buch der Freundschaft (München, 1960), p. 30.

[31] Freud, p. 48.

[32] See Chapter IV.

[33] Walter Jens, "Der Hundertjährige: Emil Nolde" in Von deutscher Rede (München, 1969), p. 112.

[34] Wilhelm Reich, The Mass Psychology of Fascism, trans. by Vincent R. Carfagno (New York, 1970), p. 57. Emphasisis Reich's. On p. 110 of Melanie Klein's Love, Hate and Reparation (New York, 1964), we find the following: "people who strive with the severity of nature thus not only take care of themselves but also serve nature herself. In not severing their connection with her they keep alive the image of the mother of early days. They preserve themselves and her in phantasy by remaining close to her--actually by not leaving their country." I am indebted to Professor Peter J. Loewenberg for calling my attention to this passage.

[35] Ibid., p. 48.

171

[36] Ibid., p. 54.

[37] The best known, and probably still best description, of this type of family is to be found in Erik Erikson's Childhood and Society (New York, 1963). See particularly his discussion in the chapter entitled "The Legend of Hitler's Childhood."

[38] Erikson, p. 323.

[39] Ibid., pp. 323-324. In the Studien über Autoritat und Familie, put out by the Institut fur Sozialforschung (Paris, 1936), Max Horkheimer has a most instructive essay in the so-called "Allgemeiner Teil" of the section entitled "Theoretische Entwurfe über Autorität and Familie." See the discussion on pp. 63-76.

[40] Horkheimer, p. 64. See also Peter Loewenberg's "The Psychohistorical origins of the Nazi Youth Cohort," The American Historical Review, 76, No. 5 (December 1971). Professor Loewenberg is not concerned here with exactly the same problem as is Horkheimer. However, he has a most interesting discussion of the dynamics involved in the idealization of the past, and of one's parents. See particularly pp. 1486-1487, 1501-1502. Obviously, the needs for romanticizing one's own family and/or creating fantacized parents, phenomena which Greenacre, Kris, and others have emphasized as being of singular importance in the development of the artistic personality, were strongly reinforced in a situation in which the family was subjected to the stresses described above.

[41] Alexander Mitscherlich, Auf dem Weg zur vaterlosen Gesellschaft (München, 1963), trans. Eric Mosbacher, Society Without the Father (London, 1969), pp. 54-55.

[42] The role of fantasizing about a return to a sort of mythical Golden Age and rebellion against established cultural values is discussed periodically in Leon Poliakov's The Aryan Myth: A History of Racist and Nationalist Ideas in Europe, trans. Edmund Howard (New York, 1974). See particularly his discussion on pp. 204-205. Poliakov identifies all searches for past origins as being sublimations for desires to return to the womb.

[43] Jens, p. 111.

[44]H. J. Glaser, "Die Tage von Unterwarft" in
Deutscher Volkskalender Nordschleswig 1972
(AAbenraa, 1972), pp. 48-49.

[45]Angel Garma, The Psychoanalysis of Dreams (Chicago,
1966), pp. 51, 101.

[46]This at least conscious longing for children came
out in a July 3, 1927, letter to Hans Fehr in
which Nolde made the following remarks: "To you
[Fehr] is [given] the world of knowledge, and you
live with it. The gift of form is given to me.
However, we two lack children, this great value of
life." Fehr, p. 110.

[47]Freud, Civilization and Its Discontents, trans.
James Strachey (New York, 1962), p. 28.

Chapter Seven

Romanticism, Sentimentalism, and the Search for the Idealized Past

Whether or not Nolde's childhood was a happy one--and it probably was not--what is of primary importance in determining whether one seeks refuge in "an idealized past" is how one chooses to remember it. For very profound psychological reasons, Nolde <u>had</u> to place a great deal of emphasis upon the wholesome nature of rural family life. He summed his rather falsely sentimental memories as follows:

> In the parents' house there was peace. Much beauty and some religiosity. I never experienced anything concerning politics. Only that on festive occasions my father liked to sing 'Die Wacht am Rhein' or the song of the homeland 'Schleswig-Holstein meerumschlungen.'[1]

Nolde remembered his mother as "dear and beautiful and good." The household, seemingly blessed by her presence, appeared to exude a sort of ingenuous warmth. Yet, in <u>Das eigene Leben</u>, Nolde seemed to have been aware of the transient nature of this sort of bucolic idyll. All of it "is quickly blown away with the wind of rapid[ly changing] times and quickly forgotten."[2] His parents had decorated their modest farmhouse with simple decorations and home-made furniture. With the "great economic ascent" that occurred between the time of German unification and the turn of the century, however, the old "values of culture and <u>Volk</u>" were "disregarded, cheapened, annihilated."[3] Briefly, all those values which Nolde, for very profound psychological reasons, chose to view as being important in his own life--the secure village existence, the quiet sanctity of the home, and the handcrafted implements of the simple, good life--were negated through economic advancement and the effects of urbanization. In <u>Jahre der Kämpfe</u>, he described his anguish--and rage--over the transformation that had taken place in the beautiful <u>Heimat</u> of his youth:

> And where are the mills, the bridges, sluice-courses, the canals, the boats? Replaced by customs sheds, filling stations and obstructive dikes. . . .[4]

Changes, technological and political, had combined to destroy that homeland which Nolde chose to remember

as being sheltering to him during his time of greatest happiness.

> The most singular, perhaps the most beautiful
> region in the holy German Reich, has been
> divided, torn, destroyed through the cold gaze
> of engineers and people foreign to the area and
> through the injustice of a border.[5]

Technology, coolly indifferent to natural beauty and tender memories, and the brutal forces of international politics had turned Nolde's Heimat into almost an obscene caricature what it once had been.

These forces of destruction in large part came from the urban world and yet, ironically enough, Nolde's rejection of farming as a career forced him to go to the city to seek training and, eventually, a trade. "As the first of the family, of generations, I went away from the village to the city and out into the world."[6] Throughout both volumes of his memoirs, Nolde continuously contrasted his own longing for the simple, rooted life with the activities of his siblings, and of his friends; one of whom he described as follows: "he had become an American; he always spoke of his farm, of his auto, of money and of much earning of it."[7] For Nolde as ideologist, as one who suffered from what Fritz Stern called "cultural despair," America was a materialistic, destructive moloch, which drew the uprooted to its shores, only to degenerate or to destroy them (as an example of this, see his discussion of the death of Hermann Bang, the Danish poet, in America in Jahre der Kämpfe, p. 97).

Nolde's first visit to a really large city occurred in 1888 when he visited Munich. It was here that he encountered the whore who aroused--among other things--such a strong sense of guilt. In 1889 he traveled to Berlin, where he would live for several years. Even though much about this great city fascinated him, among his aphorisms written in 1892 when he was teaching in St. Gallen, Switzerland, is found the following:

> There lies the big city, where men simper behind
> walls of chalk. They stink of perfume; they
> have water on the brain and live as fodder for
> bacillus and shameless as dogs. Get sand-soap
> and a wire-brush to get rid of the rouge and
> gloss.[8]

Nolde always admitted that the big city fascinated him to a great extent, and his own psychological drives and needs caused him to assume a rather complicated position vis-à-vis both it and those who lived there.[9] The strange races which dwelt there, the degenerate night-people remained objects of great interest for him and Nolde never denied this. Much of his fascination with his Jewish friend Max Wittner was due to the latter's racial background and to the fact that he was a "big-city person." Life in the metropolis always had degenerate or degraded aspects of it, as far as Nolde was concerned, aspects which set it apart from the warm and cozy life which he chose to associate with a rural world that once was his. His visit to Paris in 1899-1900 served simply to exacerbate his feelings of bitterness toward the big city and the sophisticated and cold souls inhabiting it. To be sure, at least part of this was a matter of taste, just as taste had much to do with his rejection of the so called "sweet" art of French Impressionism. Just as there were strong psychological factors involved in his rejection of this particular art form, however, so were there such in attacks on the city.

The city represented a threat to the world of Nolde's childhood, to an idealized maternal world. Especially as his own feelings about this world became ever more mixed, and especially as strong elements of hostility and attendant guilt entered the picture, his own particular sense of cultural despair deepened. Rosa Schapiere, a city dweller and a Jew, was one of his earliest supporters; yet because she once described Nolde's mother as being a sort of Biedermeierisch collector of baubles and Kitsch, he had to reject her. Perhaps an important reason why he did so was that she expressed aloud feelings that he himself had had. At any rate, the fact that she was a Jewish city-dweller (she lived in Hamburg) allowed him to add another brick to the ideological edifice that he was constructing. When Nolde quarrelled with Paul Cassirer and Max Liebermann in 1910 and 1911, this simply added fuel to the flames. Nolde blamed "racial differences" for separating him from Max Wittner; now these differences were making it impossible for city people--particularly Jews--to understand him. This attitude was exemplified in Nolde's discussion of the Jewish art dealer and critic, Herwarth Walden, who recognized many good artists such as Marc, Kokoschka, Klee and Kandinsky,

whereas "that which was sensuous, primeval and soulishly rooted deep in the homeland was foreign to him."[10] This statement is extremely important in that it reveals that Nolde in many ways did not feel himself to be part of the German Expressionist movement (his 1907 break with the Brücke would certainly underscore this). He did share many of the feelings of the Expressionists--the revolts against alienation and French Impressionism and the general exaltation of intuition and emotion that was shared by all of them--but there seems to be ample reason for Nolde's statement: "Intellectual art-litterateurs call me Expressionist; I don't like limitation. German artist, that I am."[11]

Nolde was right in setting himself apart from the other Expressionists: he was older than almost all of them; he came from a background somewhat different from that of most of his Expressionist colleagues; also, his ideology tended to set him apart. While all Expressionists were in rebellion against the depersonalizing forces which they saw as stemming from industrial civilization and mass society, emphases upon national forms of art and a strong anti-urban bias did not play much of a role in an ideological sense. As concerned as they were about nature and as bitingly cynical as they could be in depicting the impersonal cruelty of city life (Kirchner's 1907 painting "The Street" is a far more bitter and depressing depiction of city life than any of Nolde's), they did not reject the urban world as Nolde did, at least in his writings. In this regard, we must consider Georg Biermann's biography of Max Pechstein, which appeared in 1919. While Biermann attacked the materialism of the masses, he declared that the Expressionist artist must not flee from the cities and seek out an idealized nature. Indeed, the Expressionist artist was dependent upon the city in order to be in continuous contact with that dynamism which would be found nowhere else.[12] Nolde recognized that the dynamism of the city was valuable for his art. This awareness, however, was counter-balanced by an ideological prejudice against urban life and against the inhabitants of the city, "the impotent asphalt lions and hectic demi-monde women," to when he seemed to think himself superior.[13]

Nolde's negative attitude toward the city was accompanied by a general tendency to worship the primitive, the deeper, underlying roots of which have

already been examined. Whatever these roots may have
been, however, "primitivism" became an important part
of Nolde's ideology. He combined a quite justifiable
attack upon European colonialism with his own
persistent tendency to exaggerate his role as being a
purveyor of hitherto misunderstood "native" art to
over-civilized Europe. Nolde was almost fanatically
dedicated to the proposition that the native culture
of the South Seas had to remain pure, although he was
realistic enough to realize that such would be
difficult. In letters from the South Seas, Nolde
expressed a grave fear that the "indigenous nature
people" he met there would be degenerated through
contact with the culture of white people.[14] Nolde
asked rhetorically whether civilized men were indeed
better than the so-called warlike New Guinea natives;
despite the barbarous nature of the latter, they
killed relatively few in their wars, while Europeans
killed thousands in their own.[15] Nolde's letters
from the South Seas contained frequent contrasts
between the "indigenous nature people" and the
"degenerate city people."

In his condemnation of European colonialism and
exploitation, Nolde was on very firm ground and, in
this regard at least, he sounds almost startlingly
contemporary. In his admiration for the primitive,
however, he really was concerned, on a mostly
unconscious level of course, with preserving a sort
of reserve for his own childlike longings. The realm
of the primitive, being close to nature, allowed him
to give freer rein to his sexual fantasies. This can
be seen in his "Trophies of the Wilds" ("Trophaen der
Wilden"), one of his mask paintings (this particular
one was done in 1914). Here, the mask theme is
reinforced by four bloody heads hanging from a stake,
like a bouquet of grisly flowers. The symbolism of
this, particularly when we bear in mind Nolde's own
particular development, would seem to be obvious.
Furthermore, Nolde often placed flowers in his mask
paintings.[16] As seen before, his concern with masks
was something that antedated his 1913-1914 journey.
There can be little doubt, however, that this trip
certainly allowed him to indulge this tendency more
than ever.

In understanding Nolde's interest in nature in
general and the primitive in particular we should
bear in mind Schiller's important distinction between
the "naive" and the "sentimental." A naive person

was one who was really part of nature; he did not
have to struggle to become such. Such a person was
usually realistic in his view of himself and of the
world around him. On the other hand, a sentimental
person was one who had to struggle to become part of
nature. He was, in reality, alienated from it, and
this forced him to become an idealist.[17] Nolde, as
much as he professed to hate the creatures of
civilization, and however strongly he identified
himself with nature and with primitive peoples, was a
sentimentalist. He may have despised the
sophisticated world of Western civilization. He was
unable to escape the psychic effects of that
suppression, however, which necessarily subsisted at
its base. He was not a naive man of nature, but
rather one who was struggling to become such. His
interest in and concern for the primitive world,
exaggerated and to some extent self-centered, was a
very palpable manifestation of his idealistic effort
to capture that which was not really his.

The division of Nolde's ancestral Heimat between
Denmark and Germany as a result of the First World War
as a bitter blow. Also, the results of the war
heightened his feelings of resentment (if not blatant
hatred) against the French. Ada spoke French and had
something of an appreciation for French culture.
According to Fehr; however, she could not bring her
husband any closer to it and he continued to attack
the French in general and French art in particular.
In this regard, Nolde felt a real sense of despair.
German art needed leadership in order to fight
against French influences to maximum advantage. Here
too, there was disappointment: "Our generation has
no unity and no leader. However, the art public
wants to see a banner, a sign; otherwise, it has no
faith and no trust."[18] Despite his participation in
the bitter pre-World War One art controversy, Nolde
seemed to realize that he was not a "public" enough
figure to provide the needed leadership in this cause.
Fehr had a certain degree of admiration for the French;
after all, he was Swiss and his land had not suffered
from the results of a lost war as had his friend's.
Nolde continuously contrasted the state of "poor,
tortured Germany" with what he called "the Napoleonic
lust for domination of the French."[19] Parenthetically,
he never did mention the somewhat burdensome treaty
of Brest-Litovsk which Germany had imposed on Russia.
In this tendency toward a sort of national bathos he
was at one with quite a few of his less talented

180

countrymen. At any rate, Nolde made much of the gold
that was piling up in Paris due to reparations, "the
devil's power," he called it and, according to Fehr,
he so hated France that he was unable to read
translations of the literature of that country.[20]
Paris, "the city of modernity," became ever more
symbolic for him of all those forces which threatened
him as man and artist.

As in the case of many Germans during the
interwar period, Nolde seemed to be concerned with
the Bolshevik menace, although this did not loom as
large in his mind as did the perennial threat from
France. Nolde mentioned meeting a distant relative of
his wife's and her little girl. The two of them had
been caught in Russia during the revolution. In their
town, "a crippled little tailor had seized
revolutionary leadership and exercised authority over
life and death as if he were in a sadistic frenzy."[21]
There was, of course, the very strong possibility that
his tailor had been Jewish. Nolde's own gnawing sense
of cultural despair deepened during the 1920s and
early 1930s, understandable in view of his desperate
search for an idealized past. Whatever the
psychological roots of this depair, it was reflected
in a constant hostility toward France and continued
concerns over the several menaces which threatened
Germany. Basically it was a rebellion against
impersonal history itself, against those forces of
modernity and change which threatened not merely him
but large numbers of his countrymen.

While Nolde was no doubt aware of the conflicts
which ate away at his battered psyche, he knew little
if anything of their origin or of the incredibly
complex defenses which he, like legions of others so
tormented, had erected in self-defense. Thus, both
conflicts and defenses were reflected in his art.
This lack of introspection had definite drawbacks in
the field of politics: it allowed Nolde, in the form
of a crude but nevertheless penetrating ideology, to
give free reign to his prejudices--something which
had to occur if he could not or would not investigate
their psychological roots. In his conflicts, he was
mankind; in the ways they both influenced and were
embodied in his work, he was Emil Nolde, painter; in
the peculiar ways in which they were reflected in
politics, he was Germany. "Tout commence en mystique
et tout finit en politique."[22]

Chapter Seven

Footnotes

[1] Emil Nolde, Das eigene Leben: Die Zeit der Jugend (Flensburg, 1949), pp. 12-13. In this chapter for various technical reasons, the 1949 edition of volume I of Nolde's memoirs and the 1934 edition of Jahre der Kämpfe will be utilized. There were no changes at all in the several editions of the first volume. There were several in the second, Jahre der Kämpfe, and these will be noted where necessary.

[2] Ibid., p. 22.

[3] Ibid., pp. 44-45.

[4] Emil Nolde, Jahre der Kämpfe (Berlin, 1934), p. 111.

[5] Ibid., p. 112.

[6] Nolde, Das eigene Leben, p. 55.

[7] Ibid., pp. 61-62.

[8] Ibid., p. 111.

[9] See discussion in Chapter VI. On Nolde's dual attitude toward the city, see Robert A. Pois's "The Cultural Despair of Emil Nolde," in German Life & Letters, XXV, No. 3 (April 1972), especially 254-255.

[10] Nolde, Jahre der Kämpfe, pp. 121-122. In the postwar editions of Jahre der Kämpfe, Walden's Jewishness is not mentioned.

[11] Ibid., p. 182. In the postward editions of Jahre der Kämpfe, the word "German" does not appear.

[12] Georg Biermann, Max Pechstein (Leipzig, 1919), p. 5.

[13] Ibid., p. 137.

[14] Fehr, p. 70.

[15] Ibid., p. 71.

[16] Emil Nolde, Masken und Figuren Kunsthalle Bielefeld, ed. Martin Urban, 7 Januar-14 Februar (Bielefeld, 1971), no page number.

[17] Walter Winkler, Psychologie der Modernen Kunst (Tübingen, 1949), p. 258.

[18] Hans Fehr, Emil Nolde: Ein Buch der Freundschaft (München, 1960), p. 110.

[19]Ibid., p. 109.

[20]Ibid.

[21]Emil Nolde, _Reisen, Ächtung, Befreiung_ (Köln, 1967), p. 78.

[22]Charles Peguy, quoted in Fritz Stern, _The Politics of Cultural Despair_ (New York, 1964), p. 1.

Chapter Eight

Nolde and National Socialism

The non-political status of the artist in the twentieth century is a generally accepted one. Picasso's famous dove, Leninist in soul if not necessarily in body, is an exception to this of course. As a general rule of thumb, however, the so-called modern artist, solipsistic in method and universalist in message, has declared himself to be non-political and most observers have taken this declaration at face value. In many ways Nolde viewed himself as being a non-political person; politics had played little if any role in his home, and he often complained at being confused by political issues and parties. In some ways, however, Nolde was perhaps more political--and, at times, consciously so--than others of his profession.

As we have seen in Chapter III, he had a crude sense of social justice. The question of why some had to work at menial tasks in order to provide luxuries for others concerned him a great deal and, even though Nolde had accepted differences between men as being somehow representative of immutable laws of nature, his first participation in politics was on the side of the left. In the national elections of January 25, 1907, he voted Social Democratic. In these elections, the Social Democratic Party gained in votes over those obtained in 1903--from 3,101,771 to 3,259,029. The number of Reichstag seats was determined by the proportion of the total vote, however, and since the Social Democratic proportion declined, they lost thirty-eight seats, falling from eighty-one to forty-three.[1] In letters to Ada, who was then in a sanatorium near Kassel, Nolde expressed both indignation over the losses and anger against the conservative university professors, one of whom had gone so far as to order his students to drag people from their homes in order to vote for the Conservative Party.[2] Nolde wrote several letters to his wife in which he expressed great hostility toward university professors; their conservative attitudes seemed to irritate him and, like many at all places and all times, he attacked them for lacking "common sense." Nolde did not exempt his friend Fehr from this charge, having argued with him and his professional colleagues over the elections. Politically, he seemed not to

respect either of the Fehrs: "Nelly is not intelligent," he said, and he concurrently attacked Fehr and his acquaintances for their political narrowness, "I really believe that I can say that they are dumb."[3] With his usual grim satisfaction at having bested one of the professional intellectual caste, Nolde went on to tell of a professor who did not know the correct number of eligible voters to be found in the smallest and the largest voting districts in Germany. The professor had said 11,000 and 88,000 respectively; Nolde knew that the correct figures were 9,556 and 247,414.[4] With some anger, he declared that the largest district was Charlottenburg in Berlin, and that it was Social Democratic. According to German voting laws, Nolde said, the maximum number that a Reichstag delegate should represent was 100,000. It was often the case, however, that particularly in working-class districts one delegate would represent 147,000 (per the example just given), 194,000 or 133,000. On the other hand, districts which voted Centre or Conservative, places like some in Bavaria, Schleswig "and other areas, where only farmers live" (!), often had one delegate representing between 10,000 and 15,000 inhabitants.[5] Nolde expressed rage over this obvious injustice.

Despite his own rural background and despite his oft-expressed dislike for big cities, Nolde both voted for and vigorously defended probably the most urban-oriented party in Germany, the Social Democrats. Perhaps his own unhappy experiences as a worker in urban factories was still uppermost in his mind, at least insofar as politics were concerned. Whatever the reason, it would appear that Nolde was most actively involved in politics in 1907, and on the left at that. Perhaps it was of some importance that one of the crucial issues in this election was that of reform of the colonial office. It would be six years before Nolde began his monumental journey to the East; but he had already expressed an interest in gypsies and other primitive folk.

A combination of factors--attacks upon him by big-city often Jewish art critics, the emotional and cultural shocks that were produced by the First World War, the loss of the Heimat and his having to become a Danish citizen--was responsible for Nolde's turning toward the right. After the 1907 elections Nolde never mentioned how he actually voted in subsequent ones. It is obvious that, insofar as his ideological

186

stance was concerned, however, he had become right
wing; indeed, some of his statements made him sound
like a member of the radical right.

Being a Danish citizen, Nolde could not vote in
the 1928 elections (which returned a Social Democratic
chancellor for the first time since 1920). In any
case the German political scene confused him.

> I could not vote. I didn't even know how I
> should vote, for the Nationals [i.e.,
> National Socialists] to the Communists, each
> party has my approval and disapproval at the
> same time. . . .Where it is beautiful, I really
> like das Deutschtum. And Communism? Pure
> Communism is very beautiful. There is Communism
> even in heaven. The blessed state of the
> blessed. But all bad men are set apart there,
> banned to hell.[6]

If Nolde supported the Nazis in this election--the
National Socialist party received twelve seats--it
certainly not clear from the letter. What is clear is
spiritual confusion and Nolde's tendency to choose
between extremes, to go either with the Nazis or the
Communists. Yet, his belief in a sort of natural
order of things prevented him from remaining on the
left for very long, even hypothetically. The sense
of bitter personal loss that increased considerably
after the First World War prevented him from casting
his lot with a party which, hypothetically at least,
was rooted in an acceptance of the industrial age and
Enlightenment theories of progress.

The preconditions for Nolde's involvement with
Nazism, present for a long time, had been exacerbated
by the results of the First World War. As a Danish
citizen, he joined a Danish branch of the National
Socialist Party. More importantly, as we have seen in
volume two of his memoirs, Jahre der Kämpfe, first
published in 1934, Nolde presented himself as strongly
anti-Semitic and a volkishly inclined racist. How
much of this stemmed from a genuine belief in National
Socialist ideology and how much of this stemmed from
opportunism will be determined later. Even before the
Nazis came to power Nolde apparently was aware of some
of the problems he would face when his own vibrant and
sensual art ran counter to the petit-bourgeois tastes
of the Nazis. While he and Fehr were looking at
paintings at an art dealer's in Munich in 1931 or 1932

(a precise date is not given), their attention was
caught by a brown-uniformed SA man who, upon
noticing some paintings by Franz Marc, called loudly
to the art dealer: "What kind of painting is this?
Why do you have this stuff here? Get rid of this
crap immediately. These times no longer tolerate
such exhibitions. Exhibit solid, German art;
otherwise your salon will shut down!"[7] Both Fehr
and Nolde feared that the SA man would then cast his
sensitive eyes over some of Nolde's works, but he went
away. Nolde, visibly shaken, turned toward his
friend and said, "Now, I know my future."[8]

In view of the above incident, Nolde's
flirtations with the Nazis must have stemmed from
purely opportunistic motives: he did not want to be
threatened when they came to power. This answer does
not bear in mind the immensely complex nature of
Nolde's personality, however. To be sure, he feared
the National Socialists; at the same time, however,
was much in the movement that attracted him.

Whether or not the Nazis lived up to each of
the twenty-five points of their 1920 program once they
were in power is rather beside the point.
Ideologically, as has been pointed out frequently,
they were romantics. They represented the aspirations
and the hatreds of all of those who were unable to
assimilate modernity or deal with the immense problems
created by urbanization and mechanization. They
eschewed logic in favor of a self-consciously
irrational Mythus and, as Martin Gosebruch pointed
out, their emphasis upon movement (Bewegung) rather
than party and their concurrent depreciation of cold
reason, as well as their promise of a "völkische"
renewal for the German people were all points which
attracted Nolde.[9] Nolde was, after all, a romantic.
So were the rest of the Expressionists, of course.
Nolde's romanticism, however, was tied to that sense
of cultural despair characteristic of the radical
right. Moveover, what Stern called "the politics of
cultural despair" was none other than the application
of romantic ideas and criteria to the politics of the
late nineteenth and twentieth centuries. As Wilhelm
Reich has demonstrated in his The Mass Psychology of
Fascism, "mysticism" in politics is always
reactionary.

Whereas Nolde's attitude toward anti-Semitism
and the Jews was a mixed one, there can be little

doubt that he believed in races. In postwar editions of Jahre der Kämpfe, the openly espoused anti-Semitism which characterized the 1934 edition of this work was removed. However, Nolde's condemnations of "blood mixing" remained. Mixing produced "mongrels," he declared, and he violently condemned the art of "Mischlingen, Bastards und Mulatten."[10] "Many places in the tropical lands provide frightful examples of the carrying out of race mixing. The sweetness of sin is without conscience. . . .There is a striving towards self-degeneration."[11] Sounding very much like Johann Gottfried Herder, whose own gentle doctrines of national differences probably have caused more than their share of pain in this world, Nolde made the following statement:

> Looked at in a broad sense, no race is worse or better than any other--before God, they are all equal. But they are different, very different in their stages of development, in their lives, in their ethics, forms, smell and color . . . and it is probably not nature's intention that they should mix.[12]

One should respect people in their differences, Nolde added; however, such differences could not be transcended without doing permanent damage to the races concerned. This sort of a doctrine could cut several ways, and Nolde was well aware of this. He glorified the "pure" race of the South Sea people, and seemed to despise that of the whites who were oppressing them. This glorification of the primitive had as much to do with his own desperate attempts to recapture a maternal, precognitive youth as it did with a love of native culture per se. Throughout this work it has been obvious that Nolde believed very strongly in a type of art--deep, brooding and harsh-- that was not merely indigenous to Germany but seemed to be rooted in the very fabric of the national unconscious. His persistant contrasting of northern and southern peoples and the types of art they produced points to his belief in the well-nigh immutable character of races, provided of course that they remained pure. At the same time, his emphasis upon the deeper and more profound character of German art would seem to indicate, disclaimers to the contrary, that he viewed such art as superior to the "sweet," more "refined" art of the so-called southern peoples (i.e., usually the French). It would appear that Nolde always retained a considerable degree of

fascination for those "strange races" and things
foreign to him. The Jews continued to fascinate him,
in large measure due to the several psychological
factors mentioned earlier. In this regard, he
expressed some interest in the Zionist movement.[13]
Berlin remained throughout his life something of a
second home to him. Yet, there can be little doubt
that his pre-World War One clash with Paul Cassirer
and Max Liebermann and his personal and political
frustrations created in him a sort of syndrome in
which the art of the south, the "impotent asphat lions
and demi-monde women" of the big cities and Jewish
artists and art dealers stood together in an unholy
alliance against him and the art he represented. The
Nazi movement, however much it may have posed a threat
to his art, did embody many of his longings and
reflect not a few of his hatreds.

> Clouds interlaced with piercing beams had
> appeared in the German sky. Much was said and
> the time was full of speeches and assemblies.
> At first, I didn't concern myself about
> anything. Later, I quietly observed events
> from a distance, until a new order was spoken
> of in my own area of art, and great promises
> were made. An unknown, great future for art
> was prophetically announced. We artists, often
> trusting and somewhat unworldly, really didn't
> know what was happening. All, almost all, lived
> in tension, full of expectation. Therewith, I
> heard that my name had been mentioned. Whether
> in a good or bad context, I didn't know. But,
> a great artistic architecture was projected--and
> the Greeks were proffered as models in all arts,
> as had been already done before many times. I
> didn't like this, and even less the measured
> sentence that artists would be cultivated.[14]

In this paragraph Nolde summed up both his initial
reactions to Nazism and his eventual realization that
the so-called Nazi Revolution was not one that was
going to be carried into the field of aesthetics.

At first, though, Nolde did strive to be
accepted by the Nazis. The very tone of Jahre der
Kämpfe was indicative of this. His divided attitude
about the Jews, cities and modern civilization as a
whole was thrown to the wind, as he presented himself
as a thorough-going racist and German nationalist.
Yet, even here, he was unable to be consistent. The

Nazis, totalitarian at least in ideology, could not accept his painting Jesus and the Apostles "as strong, Jewish types." Even less could they accept his explanation that he did so because those who accepted the teachings of Christ "were certainly not weaklings."[15] Nolde probably did not know that the official ideologist of the party had fallen back upon the teachings of Wilhelm Marr, Houston Stewart Chamberlain and Eugen Dühring inter alia in actually denying that Jesus was Jewish in the first place. Nolde's glorification of native art, something that was condemned by Nazi aestheticians as "nigger art," could hardly have been acceptable either. In his own particular variety of racism--for such it was--Nolde was as consistent as he could be. For National Socialists, however, driven both by the pragmatic demands for state control and by their own perverse idealism (an idealism in part rooted in the same romantic soil as was Nolde's), it was all or nothing. In the fields of foreign policy, economics, and government, concessions had to be made to the prosaic realities of the modern world. In the field of art, however, a not inconsiderable degree of force could be applied.

"The war came," Nolde wrote in Jahre der Kämpfe. "There came deep humiliation for Germans. There came decades of agitation--wretchedness and liberation. Storms are rustling through the tree tops of German beeches and oaks."[16] That wind which once had moaned through a mythical garden of dream-haunted memory was now being felt throughout Germany. Nolde's desire to be carried along with it, to become part of the great national revolution, was to be frustrated. The romanticism of the Nazi Revolution partially concealed that Biedermeier, petit-bourgeois narrowness which, like Nolde's own unrealized desires, sought satiation in it.

Whether or not Nolde had joined the Danish branch of the National Socialist Party, the fate of his art was in large measure contingent upon the rather prosaic realities of intraparty struggles within the Nazi ranks. For awhile at least, there was no consistent policy on the part of the new National Socialist government. There were, at first, two positions toward art that were to be found in the party: that of the more-or-less official party ideologist, Alfred Rosenberg, and that of Paul Josef Goebbels, head of the Reich Ministry of Public Enlightenment and

191

Propaganda. Alfred Rosenberg called for the encouragement and, in some cases, the creation of a new Volkskunst, an art of the people in which the national spirit would be figuratively transformed into form and symbol. For Rosenberg, "Volk art was "healthy" art, robust and unreflective, and divorced from morbid introspection. It was the art of the peasant and the artisan, wholesome and possessed of a naive ingenuousness. While modern art doubted, "Volk" art confirmed. While modern art signified the triumph of decadent and self-centered individualism, "Volk" art signified the triumph of warm-hearted collectivism.[17] Rosenberg was calling for a revolution in art; but, a revolution which would confirm the healthy, integrative aspects of the national spirit. Goebbels, on the other hand, while as dedicated a National Socialist as Rosenberg, was a bit more open to forces of modernity. He was, as befitted a propaganda minister, somewhat more cosmopolitan and cynical than Rosenberg, who had the embarrassing habit of taking everything that he said seriously. Thus, in 1933, there took place a most fascinating clash between Rosenberg, who called for the establishment of a true Volk art while concurrently attacking modern art as degenerate, and Goebbels, who viewed Rosenberg's efforts as chimerical and, on his part, sought to provide a place for modern art in the Nazi revolution. In this fight Goebbels received support from many young National Socialists, among the most important those concentrated in the "National-Sozialistischer Deutscher Studentendbund."[18]

Rosenberg's attacks on modern art were extremely vitriolic, especially inasmuch as he had encountered unexpected resistance to implementation of his ideas within his own party. In a July, 1933 issue of the Völkischer Beobachter, Rosenberg published an article entitled "Revolution in The Fine Arts?" In this piece, he attacked both Nolde and the Expressionist painter and sculptor, Ernst Barlach. While admitting that a particular Nolde seascape was "strongly and forcefully painted," Rosenberg went on to declare that "other representative attempts are negroid, irreverent, raw and devoid of true inner strength of form."[19] He attacked Barlach's Magdeburg War Memorial, and declared that "any healthy SA man could arrive at the same judgment as a conscious artist."[20] "I, in any case, have found men like the Noldes and the Barlachs to be self-inspired 'revolutionaries,' most of whom have little real contact with the fine arts, but who now

192

believe that they also must be active in this area."[21]
Rosenberg emphasized that such people were "inwardly
not authentic" and thus made untrustworthy "troops" in
the great National Socialist Revolution.

Nolde in particular and the Expressionist
movement in general did receive support from young
Nazi artists, the most prominent of them being Otto
Andreas Schreiber of the NSD Studentenbund. He
declared that the "daemonic mystique" of Emil Nolde,
among others, represented an integral part of a
specifically German art, and that Expressionism as
a whole was thus worthy of inclusion within the Nazi
Revolution.[22] Professor Alois Schardt, a renowned
defender of the Expressionists, made a similar
defense.[23] These people, one of whom at least
belonged to the Nazi party, claimed that in his art
Nolde captured a unique peculiarly German spirit, the
same spirit then being concretized in the Nazi
Revolution. Probably the most vigorous defense of
Nolde came from his friend and supporter Max
Sauerlandt. In 1933 he delivered a series of
addresses at the University of Hamburg, entitled
Die Kunst der letzten 30 Jahre, later published in
booklet form in 1935.[24] In many ways, the lectures
which he devoted to Nolde were recapitulations of
what he had said in his biography of 1921. Only now,
with the Nazis in power, there was a great deal more
emphasis upon German Expressionism in general and
Nolde in particular as being representatives of a
uniquely German form of art, conditioned by blood and
soil. German Expressionism, he maintained, stemmed
from "the deepest sources of German phantasy
representation."[25] Sauerlandt bitterly attacked
Oswald Spengler and others for putting Expressionism
together with Jazz and other symbols of "modern
decadence."[26] German Expressionism was, "nothing
other but the most recent German form of a lofty,
elevated powerful drawing forth of truth from
feeling."[27] Nolde was the most powerful expression
of the particularly North German form of this.
Sauerlandt felt constrained, in 1933, to thank "the
Führer" for drawing a sharp line between "true volk-
soulish" artists and charlatans;[28] implicit in this
statement was Sauerlandt's fervent hope that "the
Führer" would recognize that Nolde was not a
"charlatan." At the same time, Sauerlandt suggested
that so-called "Volkskunst" was not the only form of
national art. In a desperate attempt to play it
both ways, however, Sauerlandt attempted to sound like

obscurantist-in-chief Rosenberg when he declared, in ending his addresses, that "certainly we know that Nordic blood bears Greek art and Italian as well."[29] In his own tendentious, nauseating manner, Sauerlandt was one of many it seems who took up the cudgel for Expressionistic art. With Nolde, all of these people wanted to see a real artistic revolution, one in which the dynamism of National Socialism both encouraged and reinforced that distinctly "German" revolution in the fine arts, Expressionism.

After Hitler had succeeded in concretizing his power in the spring of 1934, these efforts gradually came to an end. In a September 5, 1934 speech before the Reichstag, Hitler lashed out against the "danger to the German nation" that he felt abstract painters with their "artistic corruption" represented. From this point on, trouble ensued for modern art in Germany. In 1935 the Expressionist magazine Kunst der Nation was officially banned. On June 7, 1935, Rosenberg publicly attacked those National Socialists who defended a variety of art "whose content and form contradicts to the letter all the values which have borne the National Socialist movement and which led to its victory."[30] In this context, Rosenberg made a promise that was soon to be broken: "In this regard, we do not want to suppress these artists politically; we will cheerfully leave alone all those who enjoy them. However, here and now--and completely openly-- we forbid these men for all time to talk themselves into being standard-bearers of National Socialist revolutionary art."[31] As the future clearly revealed, one had to be a "standard-bearer" of sorts, or be nothing at all. Also, in 1935, the leader of student resistance against Rosenberg's threatened völkische domination, Otto Andreas Schreiber, recanted and joined the "NS-Germeinschaft Kraft durch Freude." The hapless Alois Schardt fled to America. The fight to have Expressionism play its role in the great, völkische revival many saw in the National Socialist revolution was lost.

With a stubborness that can only be described as amazing, Nolde attempted to hang on to some role in public life. In 1933 he and others associated either with "modern art" or "modern architecture" (Bauhaus, for example) were asked to leave the Prussian Academy of Arts "voluntarily." Nolde was among those who refused to do so. While most had left by 1938, Nolde obstinately held on. He was determined to remain in

some sort of position from which he could be of some influence. When one bears in mind that in 1935 at the age of sixty-eight he had undergone a dangerous operation for cancer of the stomach, his tenacity seems all the more remarkable. Paintings of his were still being exhibited as late as 1936, despite the attacks of Rosenberg and others, and perhaps Nolde thought that he could keep going through simple inertia. Such was not to be the case.

One of the most disgraceful episodes in German cultural history occurred in 1937 when the Nazi government sponsored an "Exhibition of Degenerate Art" in Munich. Devoted mainly to the German Expressionists, the exhibition prominently displayed some of Nolde's works, oils, watercolors and graphics. The paintings, many of them without frames, were placed in cramped rooms with poor lighting and were accompanied by tendentious and mocking captions, amply reflecting the petit bourgeois tastes and coarse humor of the Nazis. For example, under Nolde's "Paradise Lost" work of 1921 the following caption appeared: "These creatures are supposed to be the first human couple, portrayals of the Creator. Completely apart from the fact that this 'work' has a repulsive effect, it offends religious sensitivity."[32] After remaining in Munich for a period of time, the "Exhibition of Degenerate Art" traveled throughout Germany. The exhibit included over forty works by Nolde, only a small fraction of his works seized by the National Socialist government out of museums and some private collections. Altogether, 1052 works of Nolde were taken. Some of these, along with the works of other "degenerate" artists, were sold in auctions to foreign buyers; others publicly burned on March 20, 1939.

Nolde's response to all this reflected a complete lack of comprehension as to what was happening. Like so many others such as Gottfried Benn and Martin Heidegger, who tried to cooperate with Nazism, he demonstrated a total lack of understanding as to what totalitarianism could mean in practice. Throughout 1937, he wrote alternately angry and pleading letters to various officials asking for the return of his paintings. Finally in 1938 he got results: after writing a letter to Propaganda Minister Goebbels, some paintings--including the nine-part "Life of Christ"--were returned. He was continuously harassed by the Nazi government, however, which sent

him letters demanding to know where he sold his works, to whom, and even about foreign exhibitions where they might have been shown during the last few years. Under such pressure, Nolde became more and more self-centered and petulant in his dealings with people. In 1938 one of the greatest of the Expressionist painters, Ernst Ludwig Kirchner, committed suicide while in exile in Switzerland. Horrified by this, Fehr sent Nolde a letter describing what had happened. Nolde expressed shock over Kirchner's death; but then, in the very same letter, he also expressed anger over how Kirchner supposedly had spoken out against him to Sauerlandt and had raised false accusations against both him and his art.[33] Seemingly willing to put up with just about anything from his occasionally rather peevish friend, Fehr was disturbed by Nolde's response.

German armies invaded Norway and Denmark on April 9, 1940. Whereas fighting raged in Norway until June, Denmark fell in one day. The Danish branch of the National Socialist Party to which Nolde belonged was now incorporated into the German National Socialist Party. In July Ada (whose feelings about the German invasion of her homeland are unrecorded) wrote Fehr a letter in which she expressed the hope that now that her husband had joined the Nazi Party things would improve for them.[34] However, matters simply got worse. At the beginning of 1941 Nolde was ordered to send all of those works done during the year 1940 to the Reichskammer der Bildenden Kunste ("Reich Chamber for the Fine Arts"), part of the Nazi-established Reichskulturkammer to which every artist, writer, or composer was supposed to belong. Nolde already had begun to paint his so-called "Forbidden Pictures" in 1938, and there was little doubt that the dedicated opponents of "degenerate art" knew about these. After increasingly threatening letters, Nolde finally did send a few oils and watercolors. More paintings were confiscated during the year, and in a letter of August 23, 1941, the president of the Reichskammer der Bildenden Kunste, a very pedestrian, mindless pedant by the name of Adolf Ziegler, informed Nolde that "due to a lack of reliability" he was being expelled from the Reichskammer forthwith and furthermore that he was now being forbidden to undertake "professional, as well as avocational activities in the areas of the fine arts."[35] Desperately unhappy, Nolde wrote an anguished letter to his friend Fehr. Perhaps his

patriotic comments at the end of it were meant for the eyes of a sympathetic censor as well as those of his friend.

> It has come thus far; everything great and beautiful for which I have striven is to be nothing. And is this to mean the end of artistic life? It is very painful to me, for my art was able to give much happiness to open eyes and hears--which was also our most beautiful joy and our lives' happiness. These measures are especially doleful for us in the present time of war, when we are following with all our senses the battles of our struggling, brave soldiers, in the great confidence that soon a victorious end for our beloved Germany will be achieved.[36]

Naturally, this letter had no effect on anything.

At Nolde's request, Fehr attempted to intercede through diplomatic channels on his behalf. Outside of finding out that his friend's paintings were safe and protected, however, his efforts accomplished little. Ada had had cordial relationships with some of the people around Baldur von Schirach, former head of the Hitler Jugend and now Gauleiter in Vienna, who had "broken a lance (to be sure with a soft point!) for the new art."[37] The Noldes traveled to Vienna hoping to influence von Schirach to utilize his good offices to ameliorate conditions and perhaps even to arrange for an exhibition in the Austrian capital. Before leaving for Vienna, Nolde sent Fehr a letter, dated April 4, 1942, in which he once again spoke of his loyalty to the German people and to German art. Again, one cannot escape the feeling that Nolde was hoping that some stern but just censor read it.

> You know that I am not "unreliable," decadent or degenerate, and you know how I have fought for everything beautiful and noble that could have been given to our German people, for my art, [and] against too much foreign influence and patronage.[38]

Nolde's visit with the genial ex-youth leader and apparent art critic was futile. In a letter of June 21, 1942, he declared that the whole trip, with all of the discomfort involved in traveling upon troop-crowded trains, had been in vain: "A theatrical

director had ruined everything through sensational love of gossip."[39] What Nolde meant by this is unclear; a possible answer to the riddle might be that a German or Austrian theater director had spoken to von Schirach about Nolde's involvement before the First World War with the theatrical group of the Jew, Max Reinhardt. Nolde had spent some time sketching and painting the various members of the troupe. The trip was too much for Ada, and she had to go to a sanatorium near Hamburg. "I have not lost courage," Nolde said, "but, it is difficult."[40] Whether or not Nolde came close to losing his courage is hard to say; he did lose many of his works. Besides those that had been confiscated or destroyed by the Nazis, virtually has entire graphic collection was demolished when Allied bombs leveled his Berlin home in 1943.

Nolde's suffering during the war was minor indeed compared to the agonies endured by millions at the hands of people to whom the painter wanted to lend support. Out of conscience we cannot romanicize it as Siegfried Lenz in his otherwise fine novel, The German Lesson, unfortunately tended to do.[41] Yet, divorced from humanity in so many ways, Nolde did suffer. Furthermore, living in isolation as he did, and in an area little touched by the war, it is doubtful that he knew very much about what was going on in Germany's monuments to völkische idealism-Buchenwald, Treblinka, Auschwitz, etc. Also, both he and Ada engaged in periodic correspondence with soldiers who knew of him and his works; in some of these letters statements were made which, in the eyes of the regime, were no doubt treasonable. A soldier stationed in Portland, one Dieter Keller, wrote a letter dated January 21, 1941, in which he spoke of seeing the Nazi propaganda film "The Eternal Jew" ("Der ewige Jude"), a movie which purported to depict Jewish materialism, cynicism, filth and, particularly shocking to a nation of animal lovers, cruel ritual slaughter. With some courage the soldier spoke of how he hated the film. Jewish influence, i.e., "domination," in the arts was also shown. As to be expected, the paintings of the German Expressionists were given special prominence. In anger and sorrow, the soldier declared that he could have wept when he saw this.[42] Whether or not either of the Noldes responded to this letter--written before the infamous letter of August 23, 1941--is not recorded. However, the fact that people did feel free to convey to them certain feelings of hostility toward the National

Socialist regime is of some significance. There is no evidence that letters concerning the slaughter of Jews, gypsies (who had so fascinated the painter), or Russian prisoners of war were sent to Nolde or to his wife. As the war grew more serious and censorship tightened, sending such letters would have been tantamount to suicide.

Nolde's defiant response to his situation found expression in a series of marginal notes, the first of which were undated: "In struggle and neglect I have lived for my art--I am also prepared to die for it."

> To burn my pictures, bury the ashes and still vegetate for a couple of years--as if I the painter had never existed--such would be my revenge on humanity for all the suffering and envy I have had to endure. It would be spiritual suicide. I shall not do it. Everything may change" (May 23, 1942) Pictures can be so beautiful that they cannot be exposed to profane eyes. (June 5, 1942)

> I am suffering so much injustice that I can hardly bear it. All the ideals of my life are turning into disgust. Will my life comes to its close in filth and neglect? Let it come as it may. Shall I, life's strong yea-sayer, become a despiser of mankind? (November 15, 1942)

> Paint, painter!
> Forbidden to paint, to what end shall I paint?
> My pictures weep.
> Their place is a prison.
> They wanted to rejoice, sincerely and happily.
> They are deathly sad.
> My pictures.
> (February 2, 1944)
> The stars know that I am suffering, the many small, dear stars. . . yellow, red. In reality they are mighty celestial bodies and our great earth a tiny speck of dust in the universe. My troubles are nothing.
> (July 25, 1944)[43]

Nolde wrote other notes as well, notes concerning issues that were always with him--nature, the passions of color, the role of the artist, etc. However, in these particular notes we can see defiance arising out

of a melange of confused and, at times, contradictory
emotions. Nolde, forbidden to paint, would paint
nonetheless. The results were the so-called
"Unpainted Pictures" of 1938-1945. These were
watercolors, often done on small scraps of paper and
hence easily concealed. The magnificent, at times
heart-breaking beauty of these paintings is a
testimony to the incredible strength of Nolde's
creative spirit. In their production and in the
emotions out of which they were produced, we perhaps
can gain a deeper understanding of the role Nazism
played in the life of Germany's most singular
twentieth-century painter.

Chapter Eight

Footnotes

[1] Koppel Pinson, Modern Germany (New York, 1965), p. 573.

[2] Letter from Emil Nolde to Ada Nolde, 25.1.07, property of Stiftung Seebüll Ada und Emil Nolde, courtesy of Dr. Martin Urban. Translated from the Danish by Christian Carstensen.

[3] Letter from Emil Nolde to Ada Nolde, 30.1.07, ibid.

[4] Ibid.

[5] Ibid.

[6] Letter of Emil Nolde to Hans Fehr, 22.5.1928, ibid.

[7] Hans Fehr, Emil Nolde. Ein Buch der Freundschaft (München, 1960), p. 111.

[8] Ibid.

[9] Emil Nolde, Aquarelle und Zeichnungen, Einführung von Martin Gosebruch (München, 1957), p. 24.

[10] Emil Nolde, Jahre Der Kämpfe, dritte Auflage (Köln, 1967), p. 137.

[11] Ibid.

[12] Ibid., p. 177.

[13] As an example of this, see Kate Baer's article, "Nochmals: Emil Nolde," in the June 22, 1973 issue of MB. Wochenzeitung des Irgun Olej Merkas Europa, Tel-Aviv. Baer apparently knew Nolde during the 1920s, and he was much fascinated by her Zionism, and by her trip to Palestine in 1926. There could well have been a negative side to this fascination, however, namely his desire to get the Jews out of the country. In the 1934 edition of Jahre der Kämpfe, such a wish, combined with vitriolic attacks upon the Jews, was clearly expressed. See a discussion of this in Chapter IV.

[14] Emil Nolde, Reisen, Ächtung, Befreiung, 1919-1946 (Köln, 1967), p. 115.

[15] See discussion in Chapter IV.

[16] Emil Nolde, Jahre der Kämpfe (Berlin, 1934), p. 243. These sentences are not to be found in later editions of this book.

[17] Alfred Rosenberg, *Der Mythus des 20 Jahrhunderts* (München, 1938), pp. 301, 303-304.

[18] On this interesting quarrel, see Hildegard Brenner's "Die Kunst im politischen Machtkampf 1933/34," in *Vierteljahrshefte für Zeitgeschichte*, Heft 1. Januar 1962. Her book, *Die Kunstpolitik des Nationalsozialismus* (Hamburg, 1963), is still the most thoroughgoing study of Nazi art policy to date. It has been complemented but not supplanted by Berthold Hinz, *Art in the Third Reich*, translated from the German by Robert Kimber and Rita Kimber (New York, 1979). See also Robert A. Pois's "German Expressionism in the Plastic Arts and Nazism: A Confrontation of Idealists" in *German Life & Letters*, XXI, No. 3 (April, 1968).

[19] Quoted in *Race and Race History and Other Essays*, by Alfred Rosenberg, ed. Robert A. Pois (New York, 1971), p. 160.

[20] Ibid., p. 161.

[21] Ibid. Emphasis is Rosenberg's.

[22] Pois, "German Expressionism in the Plastic Arts and Nazism," p. 211.

[23] Ibid., p. 210.

[24] Max Sauerlandt, *Die Kunst der letzen 30 Jahre* (Berlin, 1935).

[25] Ibid., p. 110. Emphasis is Sauerlandt's.

[26] Ibid., pp. 136-137.

[27] Ibid., pp. 142-143. Emphasis is Sauerlandt's.

[28] Ibid., p. 147.

[29] Ibid., p. 193.

[30] Rosenberg, *Race and Race History and Other Essays*, p. 163. Emphasis is Rosenberg's.

[31] Ibid., pp. 163-164.

[32] Fehr, pp. 118-119.

[33] Ibid., p. 124.

[34] Ibid., p. 125. It is unclear whether she was talking about Nolde's original joining of the Danish branch of the National Socialist Party or about his becoming part of the German National Socialist Party after the German conquest of Denmark.

[35] Emil Nolde, *Ungemalte Bilder 1938-1945*, Stiftung Seebüll Ada und Emil Nolde (Neukirchen, 1971), p. 11.

[36] Fehr, p. 127.

[37] Ibid., p. 129.

[38] Ibid., p. 130.

[39] Ibid.

[40] Ibid., p. 131.

[41] Siegfried Lenz, *The German Lesson*, translated from the German by Ernst Kaiser and Eithene Wilkens (New York, 1971). Lenz also understated Nolde's early interest in and support of Nazism.

[42] Nolde, *Reisen*, *Ächtung*, *Befreiung*, p. 145.

[43] Emil Nolde, *Unpainted Pictures* (New York, 1966), pp. 23-28.

Chapter Nine

The Psychic Significance of Nolde's Encounter with
Nazism

Nolde suffered a great deal from the Nazis,
people with whom he had wished to be identified. He
was forbidden to paint, his art described as
"degenerate." He lived in an anguish of enforced
self-denial, something against which he in part
rebelled through his magnificent "unpainted" or
"forbidden" pictures. Siegfried Lenz's portrayal of
Nolde (the "Max Ludwig Nansen" of The German Lesson)
as a man acting in small ways to defy an impersonal
state which expressed itself through drab, somewhat
imbecilic policemen and bureaucrats, is an accurate
one. Yet there was another aspect to Nolde's
relationship vis-à-vis the Nazi state that was
oppressing him. To gain at least a partial
understanding of this other aspect, we must review
again Nolde's personality.

Earlier in this work, we obtained the following
picture of Nolde: he was a man who idealized his part
yet had underlying feelings of hostility and guilt
involving both of his parents. His identification
with both of them, with the father as "man" and the
mother as "artist" was incomplete, and rebellion
against both of these peoples was a constant
characteristic of him after his early childhood. He
tended toward self-dramatization and toward a
glorification of his masculine, "harsh" independence,
something that was in part expressed in his art. He
had tendencies toward mysticism and a general
deprecation of science and reason, something which
also was reflected in his art. He glorified the
rural, simple life and professed an undying hatred
toward the sophisticated city. Yet at the same time
he was fascinated by cities and the diverse creatures
which inhabited them. Both this hatred and this love
found expression in his artistic works. He had a
divided attitude toward the Jews. On the one hand,
he hated them as embodying some of the characteristics
of his father--coldness, practicality, etc.--and as
projections of his own sensual drives. On the other
hand he was fascinated by them--particularly by Jewish
women--as warm, sensual creatures, as embodiments of
his own yearning for the primitive, indeed, really as
mother substitutes. This also was captured in his
paintings, while a general yearning for the

"primitive," for a recapturing of a lost matriarchal
world that he in reality never had, remained with him
for the rest of his life. Both as an expression of
hostility toward his mother and as an indication of an
unresolved longing for her, he tended to put women on
a rather low plane. There seemed to be something
base about them, unless they happened to be idealized
mothers. Nolde had a tendency to dichotomize, and
this was also reflected in his works. As we have
seen, he was himself aware of this tendency to be
concerned with tension and contrast: light/dark,
good/evil, sensual/spiritual, women/men, etc. Nolde
was most uncertain about himself sexually; something
of which he was very much aware, at least at times.
He was very dependent upon others, particularly women,
to take care of him (and, in Ada's case, as being
there for him to take of) even as he professed to
despise them.

In 1950 T. W. Adorno, Else Frankel-Brunswick,
Daniel J. Levinson and R. Nevitt Sanford produced a
monumental study entitled The Authoritarian
Personality. This was not really a study of the
"personality" who becomes an authoritarian or
totalitarian "leader"; rather, it was concerned with
describing the type of person who becomes a
"follower." Whereas work on this project had begun
in Germany, the subjects of the study were American.
The personality type that was being described, however,
was purported to be universal. If we examine the
Adorno model of the so-called authoritarian
personality, and if we bear in mind some of the
general discoveries that we have made regarding
Nolde's own psychological make-up, we can draw some
important conclusions.

According to Adorno, the authoritarian
personality is characterized by having had an
extremely authoritarian and at times harsh father.[1]
Moreover, this type of personality tends to remember
the father as being a stern figure who was often
unjust in his frequent discipline and meting out of
punishment.[2] If we recall some of Nolde's statements
about his own father, we can see that he viewed him as
stern, terrifying, and often unjust in his demands
upon and punishing of him.[3] The authoritarian or
Fascist personality thus comes from a home in which
the father is the dominant figure. The young boy
might well rebel against such a figure. The rebellion
is never a satisfactory one, however, and this is

expressed in a very pronounced tendency to remember oneself as being an almost unmanageable child as well as a tendency to glorify the parents and in an inability even as an adult to criticize them.[4] Due to unresolved Oedipal longings and the poorly developed ego that results from this, the authoritarian personality has a basic weakness and dependency. He "wants to be taken care of" like a child, and will seek out parent-substitutes who will fulfill this function.[5] However, conscious realization of this need would be unacceptable to the individual. Hence, he tries to hide it in various ways. The most common reaction against expressing helplessness or dependency is an over-emphasis upon "independence," "toughness," or "masculinity."[6] The authoritarian personality, if a male, identifies with the father in an exaggerated way in order to hide a basic lack of real identification. The father thus becomes a "moral Model" for the individual's "principled puritanism" and a general tendency toward moralistic sexual attitudes becomes characteristic.[7] This is linked with conscious identification with authoritarian rather than weak figures such as minority groups, women, etc.[8]

With so poorly developed an ego, it is not surprising that the authoritarian personality has an extremely negative view of the world. People are viewed with distrust and the world is seen as a jungle.[9] As protection against potentially hostile people and a dangerous world, the individual is dependent upon adherence to a strictly hierarchical conception of human relationships.[10] Since this person views himself and the world as being at war, he must adhere rigorously to the view of himself as a powerful, independent individual. This attitude is expressed in a strong tendency toward self-glorification, in a tendency to emphasize his struggles and achievements in the face of enormous odds.[11] Such a posture is, of course, reinforced by the individual's knowledge of his own weakness and dependency. A hierarchical view of the world and an emphasis upon strength and masculinity--both resulting from underlying fears and uncertainty regarding weakness, dependency and sexual inadequacy--combine to produce an extremely negative attitude toward women. They are viewed as being weak and inferior creatures; and the authoritarian personality has a marked tendency to draw a very sharp line between virtuous women who are idealizations of the mother and corrupt

women who are either antithetical to the mother or who stand as embodiments of hostile feelings toward her.[12]

Due to his poor ego development and the unconscious fears of his own sexual drives and hostilities, the personality in question cannot live with ambiguity in any form. He tends to dichotomize things into good/evil, moral/immoral, strong/weak, male/female, etc.[13] He is also unable to endure any sort of rational self-examination; he cannot face the sources of his own attenuated feelings and distortions of reality. The inability to face his drives and emotions directly causes the authoritarian personality to project all that he dislikes in himself onto others, e.g., the Jews. Of particular importance here is such a personality's tendency to project such qualities as impurity or materialism.[14] At the same time, the individual's inability to face an underlying hatred of his father causes him to hate the Jews--or any other readily available and/or weak minority--as being an embodiment of all those paternal qualities that he finds repulsive.

> The Jew frequently becomes a substitute for the hated father, often assuming, on a fantasy level, the very same qualities against which the subject revolted in the father, such as being practical, cold, domineering, and even a sexual rival.[15]

Unable to face reality or those forces which might alter his own distorted view of it, the authoritarian personality is often suspicious of reason, and this is expressed in a negative attitude toward science and a concurrent glorification of the mystical or of superstition.[16] The need for some sort of protective and warm "God" as a substitute for an aloof and fearful father--something which Freud considered in some detail, as we have seen--is expressed in a tendency toward fervent religiosity.[17] Finally, of very great importance was Adorno's conclusion that "the pattern developed in the relationship to the father tends to be transferred to other authorities and thus becomes crucial in forming social and political beliefs in men."[18] For Adorno and his colleagues, this was true for all men. In view of the etiology of the so-called authoritarian personality, however, such a tendency would have particularly ominous connotations.

Utilizing the Adorno model of the authoritarian personality, a rather clear picture of that of Emil Nolde's can be seen. Nolde revealed many traits of the authoritarian personality both as a man and in many of his works, and thus his initial attraction to Nazism becomes understandable. Of course, it is obvious that not all of the authoritarian qualities mentioned by Adorno and colleagues were to be found in Nolde. According to Adorno, authoritarian personalities tend to remember their mothers as being moralistic, restrictive and self-sacrificing, while non-authoritarian personalities remember their mothers as being warm, lovable and inclined toward aesthetic and/or intellectual interests.[19] By these criteria, Nolde's expressed attitude toward his mother must be seen as being rather mixed; it seems to include elements of both types of personality. Also, the non-authoritarian type of personality often remembers itself as being very shy as a child.[20] While fitting the authoritarian model in emphasizing his unmanageable nature, Nolde also recalled that he was very shy, at least as an adolescent.[21] Whereas neither Nolde nor anyone else can be viewed as having a personality which corresponds in all respects to the authoritarian one described by Adorno, however, it is obvious that he can be viewed as such a personality in most aspects.

The Authoritarian Personality is a valuable work, but there are general criticisms that can be made. With regard to Nolde, there are questions which such a work leave unresolved. Probably the two most damaging criticisms are the following: 1) implied throughout The Authoritarian Personality is the idea that the Nazi movement was basically conservative in nature, the Nazi phenomenon being in large measure rooted in a conservative family structure, and 2) the authoritarian personality would only appear on the right--the possibility of left-wing authoritarian personalities was never discussed. Whereas National Socialism was able to attract much conservative backing, the movement did have a dynamism of its own which gave it a putatively revolutionary character. The authors' failure to recognize this plus their understandable--when one considers their political backgrounds--unwillingness to deal with authoritarianism as a left-wing phenomenon constitute serious flaws in the work.[22] For our purposes, the second major criticism is not terribly important.

Most particularly with regard to Emil Nolde, however,
the first point must be examined at some length.

There can be no gainsaying the fact that, with
the exception noted above, Emil Nolde's personality
profile fits the prototype of the authoritarian
personality established by Adorno and colleagues. In
establishing this most important heuristic device,
however, the fugitives of the so-called Frankfurt
School did not--nor, in fairness, had they planned
to--consider the significance of authoritarian origins
and modes of behavior for personalities of a
peculiarly gifted nature. Instead, one is left with
the impression that the so-called authoritarian
personality approximates that of an Archie Bunker,
perpetually doomed by interacting and interrelated
socio-cultural and phylogenetic patterns to spending
his life ensconced in an intellectual easychair
overstuffed with Biedermeirisch superstitions. One
must recall that, confining our considerations to
the right, Ezra Pound and, to a lesser extent, T. S.
Eliot were drawn to Italian Fascism; that, perhaps of
great importance, notable representatives of the
Italian Futurist movement were able to find in
Fascism a dynamism spiritually kin to that which was
reflected in their art--an art which, incidentally,
reflected scorn for the past and joy in the mechanized
twentieth century. Germany's greatest existentialist
philosopher, Martin Heiddeger, threw in his lot with
National Socialism, at least at the beginning, as did
the Expressionist poet and critic Gottfried Benn and
the early Naturalist playwright Gerhardt Hauptmann
(admittedly beginning his dotage when Hitler came to
power). While it is true that, as men, each of the
individuals mentioned might well have had elements of
the authoritarian personality waxing large in his
psyche (a possibility with which we cannot concern
ourselves here)--elements which, upon examination,
should be perceivable in their art,--they cannot be
considered in the same manner as urban while-collar
workers or the embittered representatives of an
increasingly superannuated peasantry. As
psychoanalytical investigators have revealed, artists,
while most assuredly "real people" who have to be
treated as such, nevertheless have inborn abilities,
particularly with regard to sublimation which set them
apart from their fellows. Thus, as they represent--as
do we all--that melange of natural and societal
pressures which stamps them as human, they have at
their disposal a unique means of either recapitulating

or reflecting these pressures. Bearing this in mind, we must now devote our attention to the subject of this study.

None of what has been said above regarding the deficiencies of Adorno's and friends' efforts to apply a Marxist tinctured Freudian approach to the Fascist phenomenon should be taken to mean that the author has suddenly decided to reverse himself and throw out the psychological observations thus far made about Nolde. The great artist was the product, after all, of an increasingly superannuated peasantry with all of its petit bourgeois prejudices and superstitions. His attitudes toward himself, parents, women, and members of foreign, exotic races can be traced to this background. Yet, we are continuously driven to ask why Nolde as a creative artist as well as man--for after all, in spite of the strong psychic need to separate one from the other, man lived in his art--was literally driven to attempt to associate himself with a movement which he sensed despised him and everything he stood for.

Most certainly, an important reason why Nolde was predisposed toward, at the very least, extreme nationalism, was his being brought up in the border area of Schleswig-Holstein, quite naturally a place of extreme tension. Schleswig-Holstein was an area in which the Nazis were able to marshall a great deal of support. Furthermore, it is of interest to note that a great percentage of those militarized toward National Socialism came from occupied or border areas.[23] In his tendency toward xenophobia, Nolde was at one with many of his rural neighbors. Very meaningful interaction between those characteristics that were rooted in Nolde's family background and tensions peculiar to the vexed region in which he was brought up must be assumed. Naturally, Nolde was hardly alone in this. While there were forces in his psyche which could not be allowed expression in his art, Nolde did have a vehicle for expression denied to most people. Although he occasionally enjoyed depicting himself as politically naive, he certainly was aware of social and political tensions. This most certainly had consequences for art.

In a significant study, Carl E. Schorske demonstrated how, in Vienna, elements of the liberal bourgeoisie, but Jews in particular, tended to place an exaggerated emphasis upon art as the political and

social world became increasingly fraught with tension.[24] As Schorske saw it, art became a religion in a world in which meaningful political action on the part of liberals was virtually precluded.[25] To be sure, Schorske was talking about literary artists and an art public, i.e., collectors, critics, and so on. Furthermore, a substantial portion of this art public was Jewish. Nevertheless, certain parallels between fine-de-siècle Vienna and Schleswig-Holstein can be seen.

Most important of these parallels is the fact that both were border areas, characterized by national and cultural clashing. Also, there was in each area a very palpable threat which could be perceived. Although he was concerned with biblical themes throughout his career, in large measure due to a psychogenetic necessity for him to identify with Jesus Christ, Nolde really considered his art to be a religion. Not too differently from other artists, he viewed his own gifts to be divine. Nevertheless, Nolde lived in an area of extreme tension and this no doubt caused him to place an exaggerated emphasis upon his art as representing a singular outlet--indeed, a sacred one--for tensions which could achieve no release elsewhere. Art served a very profound psychological service for liberal Jews in Vienna. The same service was provided for Nolde, an individual whose psychological make-up and social background caused him to be hostile toward liberal values in general and Jews in particular. As we have seen earlier, his interest in primitivism and various forms of ethnic exotica can be traced back to a virtual sanctification of a fantasized homeland. It was in the heavily sensual process of artistic creation that Nolde was able to compensate for hostile or indifferent social and political realities, at the same time ennobling his sublimated sensuality with the aura of divinity.

It is of great importance for the psychohistorian to appreciate that whatever understanding we can gain of Nolde and, more importantly, his historical significance, is due not merely to an application of certain psychological categories to the life and career of a particular person, but rather to the application of such to an individual (or, for that matter, institution or movement) perceived as being subject to certain zeitgebunden social, political and ideational currents

and pressures. The dynamics which lay at the basis of art worship in the Viennese Jewish/liberal community at the beginning of the 20th century might well have been similar in form to those which drove Nolde to sanctify his art _faut de mieux_. The fact that Nolde's background was conservative-rural--with all of the ideational baggage that so antiquated a class-position implies--as opposed to cosmopolitan-liberal was more than enough to guarantee that Nolde's sanctification of art, and through it romanticization of his own past, would have vastly different consequences than those that would emerge from liberal involvement with aesthetics. One could argue that romanticization of the past had little real role in Jewish/liberal circles in Vienna. As Schorske pointed out, however, there was a very definite sense of loss, i.e., of the disappearance of a better age in which traditional liberal faith in "rationality, moral law, and progress" had not as yet been submerged beneath the grim realities of _fin-de-siècle_ mass politics. It was under the latter conditions that "Art became transformed from an ornament to an essence, from an expression of value to a source of value."[26]

For Nolde, as for the increasingly politically important stratum of Jewish/liberal Viennese intelligentsia, art became possessed of a dynamic beyond that involved in the usual sublimative processes of creation and enjoyment. For an artist, his or her work is everything, that behind which the person is supposed to disappear. In this sense, one could maintain that art always has been an absolute; art has not been merely for art's sake, but for the artist's sake. Even accepting this as valid, however (and there is no reason why we should not), we must also appreciate that aesthetic solutions to certain problems of alienation and/or ennui traditionally have not served to supplant those offered in political and social realms. To be sure, conscious involvement in political and social activities also involve phylogenetically determined processes of sublimation, identification, idealization, and so on. Furthermore, decision-making in the political arena can have far more awesome and, at times, atrocious consequences than those made at the conscious, pre-conscious, or unconscious levels that affect aesthetics. Psychoanalytical treatment of art demonstrates that the artist has the unique ability to summon forth unconscious materials and place them at the command of an ego which, in order that its products _be_ art,

213

cannot fully grasp the meaning of this unconscious
material in its raw form. For an artist for whom art
has become an absolute embracing or subsuming all
other elements of life, the now aestheticized world
has become the playground of untrammeled personal
fantasy. Art no longer "follows life," nor "life,
art," at least not in the mind of the artist. The
two really have become one and that separation between
art and life usually perceived of as being
characterized of the "real," objective world, remains
only within the psyche of the artist himself, i.e.,
as that division between creative and critical persons
often seen as characterizing the artistic spirit. At
the same time, of course, that which guarantees that
the artist always creates art, viz., the veiling of
its unconscious sources, must prevent the artist from
seeing that his or her aestheticized view of the world
is precisely that and further that judgment values
made in traditional social and political realms are
grounded in fantasy.

So often concerned to draw a line between man
and artist, Nolde may have succeeded in doing so in
his own mind. However, that perverse admixture of
personal, social, cultural and economic forces and
motives that constitutes the basis of one's ideational
approach to life's challenges made this division a
specious one. In Nolde, the artistic vision became
reality. Of course, if one makes the argument that,
under certain conditions, political, cultural, or
social situations necessitate that art play a role
hitherto not assigned to it--at least not in modern
times--then one would have to admit that, in
aestheticizing the world, Nolde or for that matter
the Jewish/liberal community of Vienna were hardly
alone. This, of course, is true. However, the
permutations of fantasy, displacement, projection and
sublimation would be different, subject as they were
to differing contextual backgrounds.

Nolde turned toward National Socialism because
the dynamics of the movement were congruent with
those of his personality. In this regard, it is far
too easy to over emphasize the conservative aspects
of Nazism--its antimodernity and what Ernst Nolte
calls "fear of transcendence." To be sure, these were
important considerations for National Socialists just
as they played important roles in Nolde's ideational
world. In its emphasis upon "movement" rather than
party and in its apparent mobilization of psychic

energies in the service of the racial/national Mythus, however, National Socialism revealed a dynamism utterly lacking in the traditional "conservative" parties of Germany or, for that matter, any other Western or Central European nation. Of particular importance in the ability to mobilize psychic forces was National Socialism's own aestheticizing of the world, this reflected in the establishment of fantasy-bound archetypes into models for the new Aryan Man (and his enemies) and criteria for political action.[27] Nazi archetypes, were, in large measure, rooted in a cultural milieu that helped to shape Nolde's own psychic development, as well as the dynamism that underlay his art. In its emphases upon masculine toughness, dynamic integration into the "natural world," radical separation between men and women, "authenticity" as constituting the axiological basis of political action, the Nazi Weltanschauung apotheosized a fantasy-world which was the product of bourgeois displacement, projection, and repression. This self-same world served in large measure to provide Nolde with sources for his art as well as ones that conditioned his ideological development.

All of this calls into question an important assumption of psychoanalytical investigators and of Nolde as well, namely that successful art is characterized by the artist's disappearance behind his work. Although such might well have been the case during periods of social and political stability (if, indeed, there are such halcyon days), the melding together of social, political, and aesthetic categories that occurs in times of tension provides an atmosphere in which aesthetic solipsism and socio-political reality merge, even if this process remains unrecognized by participants. Both art and ideology result, after all, from patterns of sublimation and, even if we agree that the artist sublimates in a singular manner, the ideological or aesthetic "true-believer" ultimately is driven, indeed, has to be driven, to gain the same ends--as Freud put it, "honour, power, and the love of women." Further, as the power of art subsists in its unconscious sources necessarily remaining veiled from analytical scrutiny, the power of an ideology must necessary also be dependent on a similar process.

There is another factor which, in our consideration of Nolde as man/artist, must give us pause: as we have noted, the so-called "Nazi

215

Revolution" was perhaps more thoroughly grounded in aesthetics than any other in modern times. Both its forebears--Wagner, Paul de Lagarde, Julius Langbehn, Lanz von Liebenfels, etc.--and its bearers--Himmler, Goebbels, Rosenberg and, of course, Hitler himself-- were involved directly in aesthetic activities or, at the very least, sought to impose standards of beauty upon the world in the form of an aestheticized society or some sort of "new man."[28] Of course, as we have seen, the Nazi regime, necessarily viewing art in terms of social control, had to impose its own Biedermeier tastes in such a manner as to severely inhibit free-willed artistic activity in general and Nolde's in particular. Yet, this cannot obscure the fact that the blending together of phylogenetic and socio-cultural forces which constituted Nolde's world was reponsible for his reaching out for the approval of a political movement in large measure the product of these same forces. Nolde, who conformed in so many ways to an archetypal artistic model provided by psychoanalysts, differed from most of them in his willingness, indeed eagerness, to immerse himself in a totalitarian movement which for good political reasons had to hurt him. Again, this was due to the ways in which phylogenetic dynamics were shaped by and interacted with Nolde's singular environment. For several factors--his rural background, the increasingly marginal position of the traditional German authoritarian family, and finally his being raised in a border area eventually torn from the Fatherland by insensitive political considerations-- were responsible for Nolde's stubborn identification with a Mythus-shrouded Heimat and, further, with that state power necessary to assure survival.

The source of Nolde's strong identification with the Heimat--identification with his mother--has been mentioned earlier. State authority was the father and, in this regard, Adorno's dictum concerning the transference of attitude from the father to any form of authority must be borne in mind. For Nolde, there must have been an added enticement toward association with Nazism. In becoming part of the National Socialist Revolution, he would have been putting his art--the means of identification with his mother--at the service of the state, his father. Thus, the gap between the two salient aspects of his psyche would have been bridged. Obviously, there were other more conscious reasons for his attempts to identify with the Nazis, namely their political romanticisim,

216

rejection of the big city, anti-Semitism, etc.
Although Nolde himself says nothing about it, however,
it is obvious that the National Socialist movement
represented a dynamic means by virtue of which
powerful psychic tensions could have been overcome.
Now, the maternal art drive could be put at the
disposal of that severe, paternal super-ego, from
which it had been painfully estranged for so long.
Naturally this would not have solved any of Nolde's
deeper-seated problems. However, one of which he was
often consciously aware would have been disposed of,
at least for a while. Nolde realized that there were
difficulties insofar as putting his art at the service
of the state/father was concerned. The encounter with
the SA man in Munich pointed to this. Fearfully,
Nolde had said, "Now I know my future." Did he? If
so, why was he so sanguine about the Nazis? Why,
except for the most opportunistic of reasons, did he
seek to identify himself with the party? As Selz
pointed out, he was after all a Danish citizen and, at
least until April 9, 1940, this prohibited the Nazis
from harming him or his future painting if he stayed
out of Germany. 29

Nolde had to identify himself with the Nazi
movement, even if he was aware that such a movement
eventually would harm him. Inexorably and tragically,
phylogenetic concerns, filtered through equally
definitive ones of time and place, had determined that
he be driven--in hideously morbid form--to seek that
paternal approval that had never been his. This,
combined with his well-established tendency toward
dramatization and "martyrdom" made the step toward the
Nazi party almost inevitable. He could no longer
embrace the whole world; however, he could embrace his
parents, now combined in a powerful synthesis of art
and the state. Also, of course, his joining of the
Nazi Party ended quite a few gnawing tensions.
Divided attitudes toward the city, patriotism, the
Jews and civilization in general could be resolved,
smoothed out, once and for all. All conscious
tensions--and perhaps a few unconscious ones as well--
could be dissolved in the universal solvent of an
ideology which offered a ruthlessly simplistic
idealism as the cure-all for all the ills of modern
German society. Nolde had had a very hard time
living with ambiguity. He had not been alone in this.

As described in the last chapter, the Nazis,
every bit as consistent in dichotomizing as Nolde had

217

been, spurned his pathetic efforts to lend support to
their "revolution." His reponse to this and to the
edict forbidding him to paint was his secret painting
of the "Unpainted Pictures." As darkness descended
upon Europe, Nolde produced a vibrant, tender
explosion of color. Hundreds upon hundreds of
watercolors appeared. Often done on small pieces of
paper in order to avoid detection, these paintings
spanned the awesome breadth of Nolde's incredible
imagination. All of Nolde's concerns and passions
were represented. We see men and women confronting
each other in spiritual tension, playful gnomes and
non-threatening monsters, young people and old people
in hopeless confrontation, northern skies, throbbing
with beauty. Yet, despite this color explosion,
there was, as Selz pointed out, no bitter or
"aggressive" quality about it. They were done
"without heaviness." "Indeed, Nolde's private world
has been transfigured into a serene realm of human
actors whose chief function is their subservience to
the color which gave them birth."[30] The "Unpainted
Pictures," many of which were so impressive that
Nolde transformed them into oils after the war, seemed
to lack that grim, occasionally morbid quality that
had often characterized a substantial portion of his
work before the Nazi period. In view of the fact that
Nolde was being persecuted and his art defamed, could
this have been so?

Selz explained this by saying that Nolde's less
aggressive wartime watercolors reflected the "wisdom
of old age." This is perhaps a partial explanation for
the phenomenon. There is another explanation, however,
one that is partly captured in one of his marginal
notes recorded on December 2, 1941: "Presently I live
with my work in a non-selling situation; it is an
impractical but wonderful condition, which I would
like to be in all my life, were it only possible."[31]
As oppressed as Nolde was during the Nazi period,
particularly after August 23, 1941, a certain pressure
had been lifted from him. He no longer had to live in
dread of seeing his art come into rude contact with a
world that did not understand him. Far from the eyes
of a lantern-bearing public, he could as never before
pour out his soul in a torrent of color to be seen
only by him. Nolde had lost freedom to place his art
before the public, the possibility of serving the
fatherly Nazi state. He had, however, gained that
elusive "inner freedom" so dear to the hearts of

Germany's romantics. He had been spurned once again by a misunderstanding and cold father. As once a small boy had engaged in religious and aesthetic fantasizing in the fields and barn of the family Hof, an old man now defied a harsh father by clinging to the warm and throbbing maternal world of unfulfilled dreams and unrealizable desires. The father was still to be feared, of course. Like the so-called "jealous God" of the Old Testament, he could not be depicted. In an earlier chapter, we examined the essay of Otto Antonia Graf in which this most perceptive of critics pointed out that Nolde could never paint that which he feared. This serves to answer Alfred Hentzen's bewilderment at Nolde's unwillingness to paint "angry caricatures of grimacing monsters who had thrown German art along with all of Europe into the abyss."[32] Nolde did fear the Nazis more than he had feared anybody or anything else. Yet, within the limits his condition and situation, he could defy them.

Throughout the war, Nolde painted. He also built a bomb-shelter to protect his "spiritual children" from harm. By the terms of his will, this was to serve as a tomb for Ada and himself.

The war ended and Nolde came out into a world eager to embrace him. In 1946 there was an exhibition of his paintings in Hamburg, and the government of Schleswig-Holstein appointed him to the post of professor. Ada died that same year. Nolde remarried after two years; his second wife, fifty-three years younger than he, was the former Jolanthe Erdmann. She was with him when, on April 13, 1956, he died at the age of eighty-eight. During his last years, he had turned more and more to the sea for inspiration.

The psychological significance of Nolde's encounter with Nazism was in a way the microcosm of Germany's. If, as Reich, Erikson and Adorno suggest, the roots of Fascism are to be discerned in the family, particularly that of the lower middle-class, then Nolde stands out as an example of how a sensitive and well-meaning person can be caught up in a dynamism which, without cool--and thus often unaesthetic-- reflection pushes one to rejoicing in political irrationality, apotheosized in Fascism. Nolde's separation between man and artist was aesthetically valuable, if not necessary, but politically disastrous. The unresolved tensions of Nolde the man--the tensions of Western civilization as they were conditioned by

and filtered through the German socio-cultural experience--provided the source for his art even, as multiplied manifold, they were largely responsible for a political movement that threatened him with extinction. As we ponder the works of this tortured human being, we become aware of how artistic creations, so stamped by the unique genius of an individual, speak for all men, even if in unanticipated and undesired ways. All the more do we become aware of the incredible depths of those forces which stirred in the man behind the painting, forces that had found but partial expression in art. The political mysticism proffered by Germany's variety of Fascism might well have been partially disingenuous. There can be no doubt at all that it did not offer any meaningful solutions to the socio-psychological problems that had developed within bourgeois society. Nevertheless, its appeal was a powerful one and the extent to which such an appeal could find resonance in the ranks of the alienated and nonreflective was very well demonstrated in Nolde's pathetic and ill-fated efforts to bring together his own strivings for the millenium with those of coarser men who could only have despised him.

Chapter Nine

Footnotes

[1] T. W. Adorno, et al., The Authoritarian Personality
(New York, 1964), p. 373.

[2] Ibid., p. 375.

[3] See discussion in Chapter III.

[4] Adorno, pp. 342-343, 435.

[5] Ibid., p. 353.

[6] Ibid., pp. 53, 237, 440.

[7] Ibid., pp. 361, 393. Emphasis is Adorno's.

[8] Ibid., p. 387.

[9] Ibid., pp. 406, 411.

[10] Ibid., p. 413. The reader will recall Nolde's early
emphasis upon there being a "natural order of
things," a conception to which he held even as he
recognized the need for social justice. See
discussion in Chapter III.

[11] Adorno, p. 423.

[12] Ibid., pp. 232-233, 397.

[13] Ibid., pp. 397, 480-481.

[14] Ibid., pp. 96, 240, 485.

[15] Ibid., II, 759. For a later, extremely perceptive
analysis of the role of unresolved feelings of
hostility toward the father in anti-Semitism, see
Martin Wangh's "National Socialism and the Genocide
of the Jew: A Psychoanalytic Study of a Historical
Event," in the International Journal of
Psychoanalysis, 45 (1964).

[16] Adorno, p. 465.

[17] Ibid., II, 804.

[18] Ibid., p. 315. See also, Erik H. Erikson's Childhood
and Society (New York, 1963), pp. 330-337.

[19] Adorno, pp. 366-367.

[20] Ibid., p. 435.

[21] See discussion in Chapter III.

[22]For an excellent critique of The Authoritarian Personality, see George M. Kren, "Psychohistorical Interpretations of National Socialism," in German Studies Review, I, No. 2 (May, 1978), pp. 169-170.

[23]Peter Merkl, Political Violence Under the Swastika: A Study of 58 Early Nazis (Princeton, 1975), pp. 322-323, 382.

[24]Carl E. Schorske, "Politics and the Psyche in Fin-de-Siècle Vienna: Schnitzler and Hofmannstahl," in American Historical Review, LXVI, No. 4 (July, 1961). Some of the issues considered here have been elaborated upon in Carl E. Schorske, Fin-de-Siècle Vienna: Politics and Culture, New York; 1980.

[25]Ibid., p. 935.

[26]See Schorske, p. 936.

[27]An unconventional and extremely valuable approach to this issue is provided by Bill Kinser and Neil Kleinman, The Dream That Was No More A Dream: A Search for Aesthetic Reality in Germany, 1890-1945 (New York, 1969). Also see Anson G. Rabinbach, "The Aesthetics of Production in the Third Reich," Journal of Contemporary History, XI, No. 4 (October 1976), and Georg Bussmann (Redaktion), Kunst im 3. Reich, Dokumente der Unterwerfung, Frankfurt, 1976.

[28]There are numerous books on this subject. Particularly useful are Fritz Stern, The Politics of Cultrual Despair (New York, 1962), and three works by George L. Mosse: The Crisis of the German Ideology (New York, 1964), Nazi Culture (New York, 1965), and The Nationalization of the Masses (New York, 1975).

[29]Peter Selz, Emil Nolde (New York, 1963), p. 70.

[30]Ibid., pp. 71-72.

[31]Emil Nolde, Unpainted Pictures (New York, 1966) p. 9.

[32]Ibid., p. 17.

Chapter Ten

Nolde's Significance in German Cultural History

If I am fond of the sea and of all that is of
the sea's kind, and fondest when it angrily
contradicts me; if that delight in searching
which drives the sails toward the undiscovered
is in me, if a seafarer's delight is in my
delight; if ever my jubilation cried, 'The
coast has vanished, now the last chain has
fallen from me; the boundless roars around me,
far out glisten space and time; be of good
cheer, old heart! Oh, how should I not lust
after eternity and after the nuptial ring of
rings, the ring of recurrence?

Never yet have I found the woman from whom
I wanted children, unless it be this woman whom
I love: I love you, O eternity.
For I love you, O eternity!
Thus Spoke
Zarathustra

Hans Fehr apparently was Nolde's only friend.
According to him, besides Viktor Scheffel's somewhat
gaudy medieval romance Ekkehard, the great artist had
a deep admiration for Nietzsche, and Nolde himself
mentioned him in his Aphorisms. It is doubtful if he
read very much of him, at least in a systematic
manner. Perhaps, though, since the philosopher/poet
eschewed systems of any kind, Nolde's no doubt rather
haphazard approach to him would have been preferable.
In his grandiose power and in his deepest sickness, in
his strengths and weaknesses, Nietzsche, both because
and in spite of his angry rejections of his own
people, is seen as being representative of Germany.
Romantic and cynic, worshipper of the man and despiser
of mankind, he has been linked to everything good and
evil in German cultural history, even as those more
sympathetic to him seek to emulate his harsh injunction
to pass beyond the sphere of moral judgment; and, in so
doing, violate the most disturbing command of all--that
no one should follow him.

Nietzsche was a hero in the profoundest sense of
that word. Like an earlier quasi-mythical figure out
of Germany's uniquely Faustian cultural history,
Meister Eckhardt, he searched for the eternal in
himself, passing beyond the comforting bonds proffered

by man and nature. There could be no compromise.
Hegel, the greatest of all idealists, also had
attempted to seek out the infinite in the finite; but
he had found this in generic man, in the comforting
collectivity of the human race discovering its own
divinity in history. Although it must be admitted
that his antihistorical predilections have been
exaggerated to some extent, Nietzsche, while exalting
the man, spurned mankind and thus history, at least
insofar as it could provide any axiological guidelines
for the discovery of infinitude within oneself. The
task which he thus imposed upon himself was too great
and the man who despised God for taking pity upon
those created in his image made the embracing of a
tormented horse his last public act, and spent the
last eleven years of his life in madness.

While he occasionally approached sanity's border,
Nolde never went mad. For reasons all of his own, he
too searched for the infinite within himself. Even if
his (and no doubt Nietzsche's as well) rejection of
men--at least insofar as they constituted a "public"--
can be traced back to mundane psychological sources,
one is still captivated by the grandiose nature of his
quest. Nolde's refusal to be identified with any
method, much less artistic school, awakens admiration
in those surfeited with the strictures of
classification and definition. Yet we must see that
Nolde, both as artist and as man--and so artificial a
division would have caused Nietzsche's gorge to
rise--was unable to cast off all lines and take the
prescribed voyage "toward the undiscovered." To be
sure, there was that within him which called for this
perilous journey. He never allowed himself to be
caught up in the "comfortable" for very long. In
terms of subject, theme and method, Nolde embraced
multitudes. He was, in many ways, one of the most
versatile artists of the German Expressionist
movement and, quite possibly, one of the most
versatile of the twentieth century. He was in many
ways, however, the most frightened.

First of all, while Nolde rejected men in the
form of a critical public, he did not reject the
human world out of hand. He wanted to be both apart
from it--but as a saviour--and part of it, in the
sense that he yearned to belong to something. His art
was meant for people (indeed, it would be difficult to
imagine an artist who was so honest in his solipsims
that he painted for nobody but himself). He wanted

224

them to "join in the intoxication" of his art, to
"be drawn along" by it "like children running along
behind a military band." For whatever the
psychological reasons, Nolde needed to be loved--
albeit mothered--by a woman. Professing to be
searching for the eternal, the "shoreless sea" of
Novalis, he needed a homeland. As estranged as he
often felt from the world of men and even at times
that of nature as well, he could not sever the bonds.
Like the Russian folk hero, Ilya Mouremetz, he had
always to touch upon firm earth. As imaginative as
he was, he had to set limits upon this imagination.
He did not reject non-representational art merely on
grounds of taste, but, out of a deep repugnance which
masked an underlying fear of that which he might have
discovered during the course of his own search for
infinity. Nietzsche strode with firm tread to the
edge of the abyss, looked into its darkness, and
jumped. Approaching the edge with considerably
greater hesitation, Nolde looked into the abyss and,
assailed by vertigo, stepped back.

Nolde's art reflects both those forces which
drove him to the pit and those which held him back.
In this there lies his artistic and human greatness.
In this we can also see that artist and man were
indeed one. Nolde, however, while aware of those
forces that surged within him, and aware also of their
importance in his art, was unable to face them
directly and thus to arrive at any real understanding
of himself. Perhaps, as indicated earlier, this was
all to the good insofar as his own artistic
creativity was concerned. Yet his unwillingness--so
very human in itself--to engage in serious self-
analysis allowed him to enjoy the dangerous luxury of
prejudice and to engage in the national pastime of
constructing an ideology, however synthetic and
jerrybuilt as it turned out to be, out of an
unreflective and ultimately self-negating "cultural
despair." In describing the foibles of people,
Nietzsche had his Zarathustra say, "Man, however, is
something that must be overcome." How one interprets
this sentence depends upon one's own ideational
orientation. Whether as existentialist or
psychologist, or as a combination of the two, however,
one must come to the conclusion that a very deep self-
understanding is of great importance in the overcoming
of human weaknesses. Whether Nietzsche himself had
this understanding is doubtful. Most certainly Nolde
did not.

The "self" which Nolde did not, and probably could not, know had to be the expression of his society. As we have seen, this was a society under extreme pressures particularly during the period of Nolde's youth and maturation. Increasing urbanization and industrialization had been responsible for social disjuncture and a growing sense of alienation, most particularly among the petit bourgeoisie and those ideologists and litterateurs who, consciously or not, represented petit bourgeois interests. The streaming to the right that resulted among these people represented a response that was virtually worldwide. Events before and after the appearance of German National Socialism demonstrate that the "Fascist" solution was hardly one confined to Germany. At the same time one cannot gainsay the fact that the German Fascist solution had a somewhat different character. Besides the reasons usually given for this--German xenophobic opposition to the Enlightenment, late unification of the country, unusually concentrated industrialization and urbanization--there was another reason, one which, if it does not serve to replace all others, nevertheless must be viewed with equal seriousness. This, of course, is the peculiar nature of the German family structure, something which, as we have seen, has been described at great length by both Erik Erikson and Wilhelm Reich among others.

The German family structure under consideration has traditionally been that of the middle and lower-middle class. In Nolde's case, the problems associated with this family structure as it was subjected to forces of massive socio-economic and cultural change were responsible for certain psychic phenomena which had to find reflections in his art and in his life as man. In many ways, the form of Nolde's personality conformed in an almost startling manner to that archetypal artist described by many psychoanalysts. The specific conditions of the German lower-middle class between 1870 and the outbreak of the First World War, however, plus Nolde's situation as a border man, were responsible for his artistic and human concerns assuming forms which reflected, either directly or indirectly, a particular ideational pattern that is associated with the German radical right.

At this point it is necessary to focus in upon something which we considered earlier, the relationship between psychoanalytical considerations

226

and those socio-economic, political, and cultural ones which we often consider to be those of traditional historiography. As we have seen, while psychoanalysis provides us with the means (or at least a set of means) to understand an archetypal artist and his or her quest, understanding how and, to a lesser extent of course, why a particular quest assumes a certain idiosyncratic character can only be determined by psychohistorical rather than baldly psychoanalytical means.

Psychoanalysis by itself cannot tell us how and why Nolde's life and art assumed the particular forms that they did, much less how and why both came to embody certain problems endemic to German cultural life between 1870 and 1933. Phylogenetic concerns which found expression in individual psychogenesis must be welded to those more traditional ones involving time and place. Only in such a fashion can we view Nolde's own search for an idealized past as being a microcosm of his nation's.

The effort to capture, or to create, an idealized past was often a most important element of the German romantic tradition. More often than not, romantics, from Herder to Langbehn, were not interested in actually living in such a past; certainly not consciously so. Rather, what was of importance for them, at least insofar as they were conscious ideologues, was making certain that, in one way or another, contemporary social life was rooted in the past. For Herder and those who came soon after him, the debilitating influences of French culture, as well as French political and military strength, were responsible for a profound sense of alienation. This was mostly the alienation of the few, however, of an intelligentsia mired in the enervating cultural realities of an antediluvian society facing changes forced upon it from the outside. The new romanticism of the late nineteenth century was the product of far more sweeping changes, ones that could be observed operating on all levels of German life. The very extent of these changes was responsible for informing this romanticism with a certain desperate quality. Early nineteenth-century romantics were, to be sure, interested in discovering a sort of idealized past in which they could be rooted. The rootlessness attendent upon the emergence of a full-blown industrialized society, however, in some cases within a matter of but a few years, was in large measure the

result of the collapse of a traditional family order as well.

 The ideational impediments of German romanticism are well known--revolt against reason, strong anti-urban and frequently anti-Semitic biases, and a general tendency toward mystification. All of these elements, ones that can be correlated back to that search for a mythical past which is the result of an unhappy childhood, can have political dimensions. This is especially the case because the search for an idealized childhood must necessarily involve the idealization of parents and parental roles. For a boy or young man this involves the elevation of the father or father-figure into a position of unchallengeable authority. As we have seen in the previous chapter, the father-figure of adulthood is the political leader or the state he represents. If one chooses to view the search for roots as being au fond a search for one's own personalized past, then the very close correlation between romantic mysticism and political authoritarianism becomes understandable, most particularly when we appreciate the apparent phylogenetic source of such a phenomenon.[1]

 Early commentators and critics pointed out that German Expressionism, in its concern for nature, mysticism and in its eschewing of rational controls and inhibitions, was very much a part of the German romantic tradition. As mentioned before in the introduction to this work, we are not concerned with whether or not Expressionism, to say nothing of Romanticism as a whole, can be viewed as being "Fascist" or "reactionary." Most certainly, parallels between Expressionism and at least Nazism can be found, and several critics have pointed to such shared concerns as mysticism, nature-worship, interest in loss of personal identify, etc.[2] By the same token, however, Expressionism, although containing within itself that longing for roots characteristic of romanticism in general, was, with the exception of Nolde, "unfolkish" in virtually all of its aspects. Furthermore, as we have noted earlier, only Nolde among the Expressionists evidenced a willingness to, at the very least, go along with National Socialism.

 Probably one of the most important factors separating Nolde from the rest of the Expressionists was that of background. Not only was Nolde somewhat older than virtually all of the rest of them, he was

228

the only major Expressionist painter who came from a
peasant background. Furthermore, as we have seen, he
came from an area of Germany beset with nationality
problems and tensions, some of which were no doubt
brought into the family due to his mother being
Danish. These factors, combined with his tendency to
be both frightened and suspicious of cities and
change, offer a partial explanation to why Nolde
developed a far different political orientation than
did his Expressionist comrades. To illumine this
further, however, it is important to remember what
the Expressionist artists were primarily concerned
with and, in connection with this, how Nolde's
personality assimilated this primary concern. As
Peter Selz points out, the Expressionists revealed
their romantic background not only through their
interest in nature and in escaping the alienation of
modern life. Most important of all was their concern
to see things as they really were, to perceive the
"inner forces in the outer world."3 In other words,
there was an extremely important critical function to
Expressionism. Nolde shared this to some extent, of
course, but in many ways he was far too uncertain of
himself to push this function to its limit. For
Nolde, non-representational art and Cubism were not
simply rejected on the basis of taste or preference.
He had almost a fear of the former and a hatred of the
latter. He feared that which he thought could set him
adrift on the turbulent sea of hiw own limitless
strivings and fantasies, while he hated anything which
in his eyes distorted the mothering world of nature.
For Nolde was not really an individualist. A weak ego,
in large measure the product of an authoritarian home
in a backward area whose völkische singularity was
doomed by modernity, made it impossible for him to
be one. He was, to be sure, isolated. The early
communal life of die Brücke was not for him and, as
we have seen, he prided himself on his almost
antisocial qualities. These were not signs of
strength, however, but rather of a fearful inability
to allow himself contact with a world that might
destroy him. Rather, through his own unique
permutations of religiosity, Nolde sought absorption
into the private, primitive world of blissful
childhood.

 To use Richard L. Rubenstein's phrase,
Expressionism as a whole may well have been critical
of the new "super culture" posed by the modern world.4
Nolde was really unable to face up to the alienation

posed by it. He did not have that inner strength
necessary to accept alienation in order to overcome
it. The world was far too frightening a place for
him and he reveled in isolation because he feared to
be alone. This is not meant to suggest that the
other participants in the Expressionist movement were
paragons of mental health or that they were not at
times possessed by some of the same morbid fantasies
as was Nolde. It would appear that Nolde's particular
brand of misanthropy was rooted in a melange of self-
doubt and uncertainty that made it impossible for him
to share in the more universalistic or humanist
aspects of the Expressionist movement.[5] It is perhaps
singularly ironic that Nolde, in many respects the
Expressionist par excellence, was no doubt correct
when he declared that, in his eyes, he was no
Expressionist, but rather a "German painter." For it
is in this most singular of men that we can observe
that phylogenetically rooted problem that has been the
burden of German cultural history in the twentieth
century.

Ernst Nolte, one of the most distinguished
scholars on Fascism, has maintained that all forms of
Fascism, including Nazism, can be characterized by
exhibiting a fear of "Transcendence." What he means
by this is that Fascism was the refuge for those who,
for one reason or the other, were unable to accept
challenge to the established patterns in their day-to-
day lives.[6] This notion has been rather heavily
criticized and, perhaps, for good reason. J. P.
Stern, for example, points out that Hitler's very
success as a politician was due to the fact that his
attack "on the idea of our common humanity" was
"conducted under the image and in the language of
transcendence."[7] Stern has a point here and perhaps
Nolte would have done better to have used a more
mundane phrase such as "fear of the future" rather
than the word "transcendence." In a very real sense,
however, Nolte has a valid point. To be sure, Hitler
expressed himself in quasi-religious, indeed at times
Messianic, language; and Nazi emphasis upon a putative
"revolution of the spirit" can be compared, in a
general sort of way, with a kind of "internal
eschatology" of the sort common in Christian
chiliastic speculation. Nevertheless, as has been
repeatedly stressed, there was no real revolution
in Germany in 1933, at least not in the traditional
sense of the word.[8] At the same time, though, people
thought and acted as if there had been one, and it is

here that the validity of much of what Nolte has to
say becomes apparent. The German people, fearing any
sort of substantive change, turned toward a movement
whose combination of political mysticism and petit
bourgeois bathos provided them with the trappings of
revolution, or at least with strong political
catharsis, while at the same time it offered
protection against the possibility of that fundamental
change (e.g., a revolution from the left) which would
have been genuinely disruptive. All the processes of
modernity-urbanization, concentration of industry,
decline in the number of family farms--continued
unabated, of course.[9] Yet, secure in the knowledge
that a threat from the left had been made impossible,
and united in a pathological crusade against the
archetypal internal enemy, the German people could and
did imagine themselves to be participating in a
movement of national rebirth, one justified by its
self proclaimed authenticity.[10]

The Nazi movement was the most successful mass
movement in German history, and most probably in the
history of the Western world. A fundamental reason
for this was the fact that it was rooted in a social
pathology which, while not unique to Germany,
nevertheless up until now has attained its greatest
degree of development in that country. The "fear of
transcendence" which found its expression in German
National Socialism was not only a function of
frustrated nationalistic longings and military
disaster; it was rooted in psychogenetic anguish,
itself the expression of pitiless phylogenesis.

All people fear change to one extent or the
other. All people long not so much to recapture but,
indeed, to create a past, a phantasmagorical world of
childlike dreams immune from the pain provided by the
necessary but uncalculated indifference of
civilization. Periodic waves of nostalgia over such
periods as the 1950s, the 1920s and, incredibly
enough, even that of the Great Depression (it is with
regard to the last "object of nostalgia" that the
almost primordial historical ignorance of contemporary
youth is most clearly revealed) must testify to this.
The German twentieth century experience, however,
provides us with a heartbreaking, and until now
unique, example of how a so-called search for the past
or, if one chooses, longing for return, can lead to
political results of a truly awesome nature. The
German search--like all of them, necessarily more

231

sentimental than historical in nature--was that of the individual writ large; German society, as all others, not being qualitatively larger than the childhood-haunted dreams of the single member.

The triumph of National Socialism was assured by the existence of seekers for an ex post facto utopia which, if they did not actively participate in the movement--and most, of course, did not--were at the very least able to stand aside and watch with at times undisguised approval as it implemented its policies, the most important of which was to be the annihilation of racial enemies. As we have seen earlier, one of the most important characteristics of the male personality produced by the patriarchal family under stress was a pronounced tendency toward religiosity (if not necessarily formal religion) and mysticism. That weak ego structure, which was and is the result of an authoritarian family background, must always shroud reality with the veils of mystery, fearing any sort of direct confrontation with it. Such an ego cannot, even for a moment, bear that alienaton which is at least at first necessary if a sense for true individual responsibility is to develop.[11] The world must be held so close that that rational examination made possible by reflective distance is rendered impossible. One cannot let himself see that the devil's face is in actuality his own.

The almost universal appeal of romanticism is in part rooted in the fact that there are mysteries in the world; the very existence of our world itself perhaps being the biggest one of them all. We know nothing about that most perplexing existential mystery--death. Maybe there are such things as "ghosts." In Scotland, there apparently is a species of creature which gleefully defies scientific analysis, stubbornly, even perversely, hanging on while nations eviscerate themselves and one another, and empires fade into historical memory. It is the stance assumed toward so mysterious a world that is of importance. Those who, out of deep psychogenetic dread, declare themselves four-square for the rejection of reason in favor of emotion, and for the muddled obscurantism of a self-indulgent religiosity instead of an acceptance of the awesome tasks imposed upon man by civilization, must appreciate that these decisions will have political consequences. For such decisions virtually necessitate the abandonment of personal responsibility in favor of a thoughless,

232

albeit temporarily comforting, acceptance of that
fantasy-rooted "natural order of things," whose
modern political form is Fascist dictatorship. As
difficult as this can be, it is absolutely necessary
that one be aware of where personal romantic musings,
the source of some of the most glorious cultural
episodes in Western civilization, end and political
romanticism begins. Since life is all of one piece,
this drawing of lines can be not only difficult, but
indeed rather painful.

German history, at least in the late nineteenth
and in the twentieth century, gives ample testimony to
the unity, even if dialectical, between political,
social, and cultural life. The political success of
National Socialism, as we have indicated previously,
was due in large part to its ability to draw upon a
reservoir of phylogentically rooted pathological
attitudes and rationalizations which, in turn, were
given their content in the environment provided by
the authoritarian home under stress. At the same
time, the neoromanticism which served both to define
and to deepen the contours of German cultural life was
also a product of this self-same conirontation between
the traditional German petit bourgeois family and the
emergence of modern industrialized society. German
Expressionism, to be sure, was in large measure, a
movement rooted in romantic soil. It had a critical
dimension to it, however, one that necessarily
involved a rejection of pat volkische solutions. In
this, it was at odds with German bourgeois society
in general. Emil Nolde was indeed a "German painter,"
as he put it, because he was so much of a "German
man," or at least that particular variety of such
whose personality weaknesses contributed, however
indirectly, to the triumph of Nazism. The fantasies
which found their way onto Nolde's canvases and Japan
paper--fantasies of rapacious/motherly women, weak/wise
men, and religiosity rooted in self-dramatization--
were indeed plastic hieroglyphs not only of Nolde's
own inner world, but of German society as well, a
society which, perhaps like most, could not face
itself. Maybe Nolde was "fortunate," if one can use
such a word, in being able to express himself in ways
impossible for the average person.

In Nolde's art, though, we see not merely his
own seemingly inexhaustible genius, but also those
elements that constituted the ideational backbone of
the authoritarian personality. Nolde's own journey

toward an imaginary past, one uninformed by criticism (no "lantern-carrying" trespassers were to be allowed here), was an expression of Germany's, and the great artist, if only for a moment, felt himself to be part of a national movement whose rigorous dichotomizing and masculine idealism banished all doubts.

Once in power, of course, the Nazis had to condemn Nolde's art along with that of the other Expressionists as degnerate. One is tempted to ask whether they did so largely because they were made uncomfortable by it; however, this is a no doubt unanswerable question, or at least is so within the context of this work. Looking at it from the point of view of social expression, we can see why the Nazis, deriving their axiological and agitational impetus from a disarmingly (literally) ingenuous official optimism, had to have banished Expressionism, Nolde's included, even though the latter wished desperately to be accepted by them. What the Nazis could not banish were those inexpressible fears and that gnawing guilt which subsisted at the origins of German National Socialism, elemental terrors which no program of annihilation and no string of military victories could have expunged. These were also those aspects of Nolde's own psychogenesis which lay behind--sometimes close to the canvas-surface, but always behind--his art. Those were the inexpressible fears of the Nolde who always remained Hansen.

If he actually had known himself in any meaningful way, perhaps his art might have suffered from it. If he had known himself, however, there is also the possibility that he might have understood the meaning of his unfulfillable longings and contradictory attitudes. An understanding of these could have prevented him from making decisions which have cast a shadow over him as a person, if not necessarily over his art. Perhaps then he also might have realized that political mysticism, while growing out of the same soil as the aesthetic variety, was an ideology which lent itself to a petit bourgeois masking of psychological and social ills and further, to an obfuscation of those idealistic motives that seek out the best for all men. Perhaps he could have seen that the political mysticism of the Nazis was something in which the most crass of petit bourgeois reactionaries could seek refuge, much as, according to Nietzsche, they were able to do in Wagner's music. He then would have been spared the disappointment of

234

having his art banned by a collection of ideological boors and aesthetic cretins. Yet, conditioned by time and circumstance, Nolde was unable to do this and thus, like so many people not only in Germany but all over the world, his ignorance of self contributed to the rise of a movement which in the end had to crush him the name of some perverse goal of national unification.

Nolde's greatest strengths as an artist came out of an historically conditioned tendency most prominent in German culture to seek out the mysterious in the mundane, the universal in the particular. When we examine the life of this great man, however, we are reminded once again of the dangers inherent in any sort of non-reflective mysticism. Paradoxically, that which can lead to the greatest of all philosophical and aesthetic ventures and discoveries can also serve to rationalize the grossest of political reaction and persecution and, further, to deaden one's sensibilities toward such horrors. In the tensions and striving of his art Nolde was unique. At the same time, though, he was a concrete embodiment of so much that was part of Germany's culture, awesome in its breadth of its concerns and in the depth of its seekings. In his inability to seek out the roots of these tensions and strivings--and again, if he had discovered them, his art might well have been poorer for it--Nolde is also an embodiment of his nation's particular tragedy, and of the tragedy of all men whose silent anguish has contributed to social horror.

If Freud is correct in his Civilization and Its Discontents when he states that all of human culture is necessarily based upon repression (and it would appear that there is little that we can say against such an assertion), there is yet another of his maxims that must give us pause: the existence of this self-same repression in the service of what he chose to call the "super-ego" provides the means by which "the present is changed into the past." For in the existence of this process, and especially as this becomes a primary motive force in society and politics, we have the instrument which, from time to time, must threaten the very bases of all cultural life. We are indeed living with a fearsome legacy. Whether or not we can modify or overthrow it remains to be seen. For now, we can gaze upon the works of Emil Nolde, in profound gratitude for the genius which lay behind their creation. At the same time,

we must appreciate the fact that his own, personal
suffering was as nothing compared to that endured by
people who had become targets for obscene forces
originating in that dark realm where personal
pathology becomes indistinguishable from that of
society's. In this regard, both Nolde and his art
provide awesome testimony to the persistence of one of
the most vexing problems posed by civilization: the
ability of beauty and all those elements which we
associate with the creative human spirit to exist
side by side with those forces which would annul not
only beauty but that human life which summons it
forth and from which it is drawn.

Chapter Ten

Footnotes

[1] As we have seen, a sort of romantic mysticism and authoritarianism were seen by Adorno as going together.

[2] Bernard Meyers, The German Expressionists (New York, 1956), pp. 282-283.

[3] Peter Selz, German Expressionist Painting From Its Inception to the First World War (Berkeley and Los Angeles, 1957), p. 20.

[4] Richard Rubenstein, After Auschwitz, Radical Theology and Contemporary Judaism (New York, 1966), p. 23.

[5] The concern of Expressionist artists that their art have a universal, humanistic goal was in part responsible for a general turning away from the idea of "art for art's sake." See Meyers, p. 282. On the humanistic character of Expressionism, see Herbert Read, The Philosophy of Modern Art (New York, 1960), p. 26.

[6] Ernst Nolte, Der Faschismus in seiner Epoche: Die Action française, Der italienische Faschismus, Der Nationalsozialismus (München, 1963). The topic of transcendence and those opposed to it is considered at great length in the last chapter.

[7] J. P. Stern, Hitler: The Führer and the People (Berkeley and Los Angeles, 1975), p. 9.

[8] The best discussion of this is still to be found in David Schoenbaum's Hitler's Social Revolution: Class and Status in Nazi Germany, 1933-1939 (New York, 1967).

[9] See Chapter V in Schoenbaum's work.

[10] On the role of the proclaimed "authentic experience" as self-justifying, see Stern, pp. 23-27.

[11] Rubenstein, p. 26.

Epilogue

Judging from Nolde's descriptions of his
northern homeland, a great deal has changed since the
days of his youth, and even from the more recent
period of his artistic activity. Much of the land has
been drained and, while there are still few roads,
these are well-used. Ironically enough, a good
portion of the traffic consists of auto-buses bearing
visitors to his home, which is now of course the
Nolde Museum. Niebüll, the town in which his funeral
took place, is a small but bustling symbol of post-
World War II Germany. Autotrains, now pulled by
smugly efficient diesel locomotives, carry thousands
from this city, over the Hindenburg Damm, to vacation
spots on the island of Sylt. Westerland, the most
prominent of them, is the modernistic, expensive
bourgeois watering-hole that it probably always was;
but now, there is just more of it and more of a
bourgeoisie to indulge itself in the comforting
anesthesia of salt air and casino decadence.

Yet, the massive skies of this land are the
same, and black and white cattle still stand out
against them, seemingly as timeless as the clouds
themselves. As ponderous as Nolde's home appears to
be in such a setting, the paths leading to it and the
garden which was, for him, so very important, do seem
to "place" the building. It does belong here even if,
perhaps somewhat snobbishly, one feels that all of the
visitors do not. There is at Seebüll, an awareness of
the fact that, although much of Nolde's work can and
perhaps must be analyzed, there is something elusive
about it, and no doubt about art in general. There is
something irreducible about his works which always
will shield them from the glare of lanterns, whether
these be borne by critics--sympathetic or
unsympathetic--by historians, or by those who would
seek to bring all secrets out into the open to mock
and degrade them.

To preserve a sense of balance--perhaps not a
very aesthetic need, but one which is necessary for
most of un--one cannot stay at Seebüll for too long.
Having been there, however, one can only hope that a
return to so unusually beautiful a place will not be
distant. To be sure, one then becomes part of a
crowd: of ordinary Germans and Danes; of
international hippies, alternately impressed and
blasé; children, alternately amused or bored; and

239

soldiers who, being there on orders, have no
alternative. In at least one respect Nolde was quite
consistent: his art was for all people. In enjoying
it, one ought not to be too bashful or exclusive.
Seebüll will remain, and for Nolde as he wished us to
know him that is all that matters.

Appendix

Nolde was fascinated by dreams, and in Jahre der
Kämpfe he mentions several that fascinated him to such
an extent he told his friend Max Sauerlandt about them.
If the conclusions that we have reached thus far
regarding Nolde's personality can be seen as being at
least grounded in fairly substantive documentary
evidence, then all the more must we admit that such
is not the case concerning conclusions that will be
drawn about his dreams. Dream interpretations,
according to all major schools of psychology, is very
much dependent upon an active interaction between
patient and analyst. It is out of this dialectical
relationship that the patient, assisted in large
measure by his analyst, is able to arrive at an
understanding of the meaning of his dreams. In
Nolde's case, of course, this vital condition does
not exist. Hence, in attempting to interpret his
dreams we will make generalizations which, while
grounded in a general knowledge of psychology, leave
a great deal to be desired even if we declare, with
strained cheerfulness, that we are dealing with the
problems and concerns of a man long dead, and thus not
attempting to affect a cure. Analysis is further
hindered by the fact that Nolde did not mention when
or under what conditions these dreams occurred. [1]

The first dream mentioned in Jahre der Kämpfe
concerned birds. Hearing a commotion, Nolde rushed
to a clearing; there, crows had attacked a nest-full
of baby storks. They had killed some of them--how
many, Nolde did not say--as well as the mother. The
father stork was poking around in the nest,
separating two live birds from their dead siblings.
Nolde yelled at the stork in Danish, declaring that if
he had a gun, he would shoot the marauding crows. The
father stork ignored him, seeming not to understand.
Then Nolde repeated what he had said in German. The
stork responded by nodding his head, as if now he
understood. [2] Freud often has been accused of being
rigid and dogmatic insofar as dream symbolism is
concerned. Both Freud and all those who follow his
lead closely, however, emphasize that symbols are

240

ambiguous, they can have a double meaning.
Nevertheless, having at least some knowledge of Nolde's
relationships, both real and fantasized, with his
parents, we can draw some tentative conclusions. In
general, birds are seen as representing either
masculinity or a penis.[3] A gun is a well-know phallic
symbol, while the nest, being an item which enclosed
something else, is probably the vagina.[4] In this
case, a tentative interpretation could be: the crows
and the stork were opposite sides of the same thing,
i.e., a masculine principle or penis with which Nolde
identified, at least in this dream. The crows are
destructive and have "killed" or assaulted the mother
stork. The crows were the destructive aspects of
Nolde's father. The stork, being an embodiment of the
penis, was having gentle intercourse with her now, at
the same time succoring those siblings that, for one
reason or another, survived his initial aggressive
fury. Nolde shouted to him that if he had a gun--a
penis--he would confront the evil side of the father
and prevent his violent assault. He spoke first in
Danish, the language of his mother, and the stork did
not understand him. He had to identify with it and
speak the language of the father--German--before the
large bird, a symbol for the penis, would respond. In
other words, Nolde, if he was to protect his mother
and also enjoy intercourse with her--the stork's
moving about in the nest symbolized a penis moving in
the vagina--had, first of all, to have a penis. This
would have put him on equal terms with his father.
Yet, even to explain this to the symbol for the
father's potency--now gentle and understanding--he had
to identify himself with it by speaking its language.
The language of the mother, Danish, was
nonunderstandable and, at the same time, underscored
her helplessness. Having observed that Nolde
identified himself with the father, the symbol of the
father was able to respond. The significance of
Nolde's speaking German becomes all the more apparent
when we consider the fact this his original spoken
language was not German but Danish or, at the very
least, part Danish. Another interpretation of this
could be that the crows and the father stork were
projections of Nolde's own personality, that if he had
a penis he would be able to squelch his dark wishes
for revenge upon an unresponsive mother and upon rival
siblings. The stork then would have been Nolde's own
phallus, something which responded to his ego only
when he identified with his father. Of course, there
are no doubt other interpretations as well. It would

241

appear probable, however, that no matter how one
chooses to interpret this dream, it did reveal a
basic contempt for his mother's weakness as well as
powerful Oedipal-type hostilities directed against
her for being so weak. This point can be developed
even further, as Professor Peter J. Loewenberg
pointed out to me in a letter of May 3, 1976, to
suggest that the dream specifically represented not
only a helpless mother but a kindly, caring father,
one who to be sure haunted Nolde's dream, but this
time as a beneficent spirit. At any rate, the need to
identify with the father-this case, by speaking
German--is readily apparent.

 The father probably appears again in another of
Nolde's dreams. In this one, "an enemy" of young art
wanted to take a picture of him. Nolde was not too
happy about this; but, he appeared to go along with
the request. Just as the critic--for such he probably
was--snapped the shutter, Nolde stuck out his tongue
at him. With eyes flasing angrily, the "enemy" said,
"If I publicize this picture, then all people will
stick out their tongues against this fellow, and he
will be thoroughly ridiculed."[5] In Freudian
psychology, any figure of authority usually represents
a parent.[6] In this case, the critic was Nolde's
father. As mentioned before, things that enclose are
often interpreted as being the woman's sex organ.
The role of the camera (the "chamber") is somewhat
uncertain (or even more so than anything else) in
this dream. One thing would appear to be clear,
though: the "critic"--i.e., Nolde's father--was
challenging him sexually, possibly through the mother.
Nolde responded by revealing his penis--sticking out
his tongue--only to be warned by the father that he
would be shamed by others, perhaps by men more secure
in their sexuality, if he dared to do so. At any
rate, this dream seemed to have disturbed Nolde a
good deal, for he immediately passed on to making
sweeping observations about dreams in general. In
this regard he made a most revealing statement: "Are
not dreams like tones and tones like colors and colors
like music? I love the music of the colors".[7] Colors
were, for Nolde, one of his most powerful means of
expressing emotion in general, and sensuality in
particular. He seemed to be recognizing, albeit on a
purely intuitive level, that in some ways his dreams
at night bore marked similarities to the daytime
reveries expressed on paper and canvas. He seemed to
know that both stemmed from the turbulent realm of his

subconscious. He was making an attempt to elevate the
world of the <u>mother</u> for certain; the colors were
music, that <u>form of</u> expression upon which she had
placed great significance.

Nolde described other dreams, including one in
which another rather elongated bird, in this case a
heron, put in an appearance. In another dream Nolde,
threatened by two ferocious lions, picked as much
reed-stubble as he could carry and, utilizing them as
he might a sword, he stabbed at the attacking beasts.
Desperately, Nolde shoved the stiffened reeds into
the throats and eyes of the lions; finally succeeding
in boring through their eyes, much blood spilled upon
the ground. With the lions blinded, Nolde left the
field victorious, experiencing great excitement.[8]
Lions, or any kind of carnivorous wild beast, can
symbolize sexual excitement, either that of the
dreamer or of some other person, more often than not
a parent.[9] In general, the throat is supposed to
symbolize the penis, while the eyes are supposed to
perform the same function for the testicles.[10] Blood
in a dream is usually seen as being indicative of
semen, while stabbing or thrusting, especially with
any sort of elongated object, is supposed to symbolize
the act of intercourse.[11] Since the mouth is seen as
representing the vagina, and since Nolde has stabbed
at it, it could be suggested that the dream concerns
his having intercourse with his mother or with some
other woman. Since the reeds were seen as filling the
throat and putting out the eyes, however, both of
which are supposed to be masculine sex symbols, it
would perhaps be safer to conclude that the dream
represented the following: Nolde, in fulfilling a
deeply felt wish, had armed himself with a penis (the
reeds) and, having done so, he was able to defend
himself against the threats of an overly sexual,
castrating father. Whether or not he had actual
intercourse with him is hard to say. Rather, he
seemed to have used his own phallus in a defensive
sort of way, castrating this threat by stuffing its
throat with reeds and boring through its eyes. The
situation is complicated by the presence of more than
one lion; perhaps Nolde's mother--despite the
prevalence of male sex symbols--also was being
depicted. He probably viewed her as a seductive
figure toward himself as well as weak <u>vis-à-vis</u> the
father; thus she might have come across in the dream
as being masculine in character. Again we are
confronted with the possibility of there being several

interpretations to one of Nolde's dreams. One thing
seems to be clear, however: he was deeply concerned
with his relationship to his parents and there were
tremendous underlying tensions and resentments against
them. Also evident--if Freudian dream analysis is
taken at all seriously--is the fact that the father
was perhaps of primary importance in Nolde's
subconscious, awesome testimony to the significance
of his role as Nolde's super-ego. In one form or
another, the father appeared in all of the dreams
described above, while the mother appeared for certain
in only one of them, and possibly in another. His
father truly did haunt his dreams, although it is
doubtful whether Nolde understood the significance of
this phenomenon. This puts into clearer perspective
his turning toward the realm of the mother--art--as
well as the sense of desperation which no doubt
underlay this effort.

These conclusions concerning Nolde's dreams are
quite provisional. Yet, if we take seriously some of
his own at times badly stated concerns--his fear of
the father, his feeling of sexual inadequacy, his
inability to get along with siblings and finally, his
longing for and attraction to his mother--then perhaps
these conclusions, however tentative, can be seen as
having at least heuristic value.

Appendix

Footnotes

[1]Freud himself was very cautious about dream
interpretation, its use and misuse. In a letter to
Andre Breton who, as is well known, was much taken
with Freudian psychology, he said the following: "A
mere collection of dreams without the dreamer's
association, without knowledge of the circumstances
in which they occurred, tells me nothing and I can
hardly imagine what it could tell anyone." See E. H.
Gombrich, "Psychoanalysis and the History of Art,"
in Benjamin Nelson, ed., Freud and the Twentieth
Century (New York, 1960), p. 188.

[2]Emil Nolde, Jahre der Kämpfe (Köln, 1965), p. 226.

[3]Angel Garma, The Psychoanalysis of Dreams (Chicago,
1966), p. 51.

[4]Ibid.

[5]Nolde, p. 227.

[6]Garma, p. 50.

[7]Nolde, p. 227.

[8]Ibid., pp. 228-229.

[9]Garma, pp. 52, 115. Sigmund Freud, The Complete
Psychological Works of Sigmund Freud, trans. James
Strachey, Vol. V, The Interpretation of Dreams
(London, 1953), p. 410.

[10]Garma, pp. 83, 91.

[11]Ibid., pp. 34, 92.

Bibliography

Primary Sources

Unpublished Sources
Interviews with Dr. Martin Urban, July 9 and 11, 1973.
Nolde, Emil. Briefe, property of Stiftung
Seebüll Ada und Emil Nolde.

Published Sources
Fehr, Hans. Emil Nolde Ein Buch der Freundschaft.
München, 1960.
Nietzsche, Friedrich. The Portable Nietzsche, trans.
and ed. by Walter Kaufmann. New York, 1969.
Nolde, Emil. Aus Leben und Werkstatt Emil Noldes.
Briefe aus den Jahren 1905-1910, in
Kunstlerbekenntnisse, ed. Paul Westheim. Berlin,
1965.
_____. Briefe 1895-1926, herausgegeben von Max
Sauerlandt. Hamburg, 1967.
_____. Brief, Aquarelle in Essener Privatbesitx,
Museum Essen, 1966.
_____. Das eigene Leben 1867-1901, zweite erweiterte
Auflage. Köln, 1949.
_____. Das eigene Leben 1867-1901, dritte erweiterte
Auflage. Köln, 1967.
_____. Jahre der Kämpfe 1901-1914. Berlin, 1934.
_____. Jahre der Kämpfe, 1901-1914, dritte
erweiterte Auflage. Köln, 1967.
_____. Reisen, Ächtung, Befreiung 1919-1946. Köln,
1967.
_____. Welt und Heimat 1913-1918. Köln, 1965.
Rosenberg, Alfred. Blut und Ehre, herausgegeben
von Thilo von Trotha, 13. Auflage. München,
1939.
_____. Der Mythus des 20. Jahrhunderts, 123-124
Auflage. Munchen, 1938.
_____. Memoirs of Alfred Rosenberg, commentaries by
Serge Lang and Ernst von Schenck, trans. by
Eric Posselt. Chicago, 1949.
_____. Race and Race History and Other Essays, trans.
and ed. by Robert A. Pois. New York, 1971.

Secondary Sources

Unpublished
Heinz, Dieter. "Emil Nolde, sein Leben und Werk als
Ausdruck seines Charakters." Unpublished dissertation.
Tübingen, 1948.

Newspapers
Baer, Kate. "Nochmals: Emil Nolde," in MB.
 Wochenzeitung des Olej Merkas Europa, Tel-Aviv,
 22 Juni 1973.
Deich, Friedrich. "Modern Kunst und Psychiatrie," in
 Die Welt, Hamburg, 23 September 1965.
Deutsche Allgemeine Zeitung, 11-12 Juli 1933.
Schapiere, Rose. "Anlässlich der Nolde-Ausstellung in
 der Commenterschen Kunsthandlung," in
 Zeitschrift für Heimat und Fremde, Hamburg, 1907.

Books and Catalogues

Adorno, T. W., et al. The Authoritarian Personality.
 2 vols. New York, 1964.
Arnheim, Rudolf. Toward a Psychology of Art:
 Collected Essays. Berkeley & Los Angeles, 1972.
Barzun, Jacques. Clio and Her Doctors: Psycho-
 History, Quantitative-History, and History.
 Chicago and London, 1974.
Benn, Gottfried. Kunst und Macht. Stuttgart/Berlin,
 1934.
Biermann, George. Max Pechstein. Leipzig, 1919.
Brenner, Hildegard. Die Kunstpolitik des
 Nationalsozialismus. Hamburg, 1963.
Buchheim, Lothar-Gunther. Des Kunstlergemeinschaft
 Brücke. Feldafing, 1956.
Bussmann, Georg, (Redaktion) Kunst im 3. Reich.
 Dokumente der Unterwerfung, Frankfurt, 1976.
Dube, Wolf-Dieter. Expressionism, trans. by Mary
 Whittall. New York, 1972.
Emil Nolde, Festschrift-Austellungseroffnung.
 Flensburg, 1957.
Erikson, Erik H. Childhood and Society. New York,
 1963.
Festschrift für Emil Nolde anlässlich seines 60:
 Geburtstages. Dresden, 1927.
Freud, Sigmund. A General Introduction to
 Psychoanalysis, trans. by Joan Riviere. New
 York, 1943.
_____. An Outline of Psychoanalysis, trans. by James
 Strachey. New York, 1969.
_____. Autobiography, trans. by James Strachey.
 New York, 1935.
_____. Civilization and its Discontents, trans. by
 James Strachey. New York, 1962.
_____. Group Psychology and the Analysis of the Ego,
 trans. by James Strachey. New York, 1965.
_____. Leonardo Da Vinci and a Memory of his
 Childhood, in The Complete Psychological Works

247

of Sigmund Freud, trans. from the German under
the general editorship of James Strachey.
Volume XI. London, 1968.

Freud, Sigmund. Outline of Psychoanalysis, trans. by
James Strachey. New York, 1962.
_____. The Interpretation of Dreams, in The Complete
Psychological Works of Sigmund Freud, trans.
from the German under the general editorship of
James Strachey. Volume V. New York, 1953.

Gardiner, Patrick. Theories of History. New York,
1959.

Garma, Angel. The Psychoanalysis of Dreams. Chicago
1966.

Gedo, John E. and Pollock, George H., eds. Freud.
The Fusion of Science and Humanism. The
Intellectual History of Psychoanalysis:
Psychological Issues, IX, Nos. 2/3, Monograph
34/35, 1976.

Gosebruch, Martin. Nolde: Aquarelle und Zeichnungen.
München, 1957.

Haftmann, Werner. Emil Nolde. Köln, 1958.
_____. Emil Nolde, The Forbidden Pictures, trans.
from the German by Inge Goodwin. London, 1965.

Heberle, Rudolf. From Democracy to Nazism: A Regional
Case Study on Political Parties in Germany.
New York, 1970.

Hinz, Berthold, Art in the Third Reich, trans. from
the German by Robert Kimber and Rita Kimber,
New York, 1979.

Hofmann, Werner. Zeichen und Gestalt.
Frankfurt-am-Main, 1957.

Horkheimer, Max, et al. Studien über Autoritat und
Familie. Paris, 1936.

Kinser, Bill and Kleinman, Neil. The Dream That Was
No More A Dream: A Search for Aesthetic Reality
in Germany, 1890-1945. New York, 1969.

Klein, Melanie. Love, Hate and Reparation. New York,
1964.

Kölnischer Kunstverein. Emil Nolde, Gemalde und
Aquarelle. Köln, 1950.

Kreitler, Hans and Shulamith. Psychology of the Arts.
Durham, North Carolina, 1972.

Kunstverein in Hamburg. Gedächtnisausstellung. Emil
Nolde, Hamburg, 1957.

Lehmann-Haupt, Hellmut. Art Under a Dictatorship.
New York, 1954.

Lenz, Siegfried. The German Lesson, trans. by Ernst
Kaiser and Eithene Winkins. New York, 1971.

Lifton, Robert J., ed. Explorations in Psychohistory.
 New York, 1974.
Loewenstein, Rudolph. Christians and Jews: A
 Psychoanalytic Study, trans. from the French by
 Vera Dammann. New York, 1963.
Lubin, Albert J. Stranger on the Earth. Bungay,
 Suffolk, 1975.
Mayer-Hillebrand, Franziska. Einführung in die
 Psychologie der bildenden Kunst. Meisenheim am
 Glan, 1966.
Mazlish, Bruce, ed. Psychoanalysis and History. New
 York, 1971.
_____. The Riddle of History. New York, 1966.
Meyers, Bernard. The German Expressionists.
 New York, 1956.
Mitscherlich, Alexander. Society Without the Father,
 trans. by Eric Mosbacher. London, 1969.
Mohler, Armin. Die konservative Revolution in
 Deutschland. Stuttgart, 1950.
Mosse, George L. The Crisis of German Ideology. New
 York, 1964.
Nelson, Benjamin, ed. Freud and the Twentieth
 Century. New York, 1960.
Nolte, Ernst. Der Faschismus in seiner Epoche: Die
 action francaise, Der italienische Faschismus,
 Der Nationalisozialismus. München, 1963.
Panofsky, Erwin. Problems in Titian: Mostly
 Iconographic. New York, 1969.
Pinson, Koppel S. Modern Germany: Its History and
 Civilization. New York, 1969.
Poliakov, Leon. The Aryan Myth: A History of Racist
 and Nationalist Ideas in Europe, trans. by
 Edmund Howard. New York, 1974.
Read, Herbert. Art Now. London, 1968.
_____. The Philosophy of Modern Art. New York, 1959.
Reich, Wilhelm. The Mass Psychology of Fascism, trans.
 by Vincent R. Carfagno. New York, 1970.
Roethal, Hans Konrad. Modern German Painting, trans.
 from the German by Desmond and Louise Clayton.
 New York, n.d.
Roh, Franz. Nach-Expressionismus. Leipzig, 1925.
Rubenstein, Richard. After Auschwitz: Radical
 Theology and Contemporary Judaism. New York,
 1966.
Ruitenback, Hendrik M., ed. The Creative Imagination:
 Psychoanalysis and the Genius of Inspiration.
 Chicago, 1965.
Sachs, Hanns. The Creative Unconscious: Studies in
 the Psychoanalysis of Art. Cambridge, Mass.,
 1951.

249

Sauerlandt, Max. Die Kunst der letzen 30. Jahre.
 Berlin, 1935.
 _____. Emil Nolde. München, 1921.
Schiefler, Gustav. Das graphische Werk von Emil Nolde
 1910-1925. Berlin, 1927.
Schmidt, Georg. Die Malerei in Deutschland, 1900-1918.
 Konigstein im Taunus, 1966.
Schoenbaum, David. Hitler's Social Revolution. New
 York, 1966.
Schorke, Carl E., Fin-de-Siècle Vienna: Politics and
 Culture, New York, 1980.
Selz, Peter H., Emil Nolde. New York, 1963.
 _____. German Expressionist Painting From Its
 Inception To The First World War. Berkeley and
 Los Angeles, 1957.
Spector, Jack J. The Aesthetics of Freud: A Study of
 Psychoanalysis and Art. New York & Washington,
 1972.
Stannard, David E., Shrinking History: On Freud and
 the Failure of Psychohistory, New York, 1980.
Stern, Fritz. The Politics of Cultural Despair. New
 York, 1964.
Stern, J. P. Hitler: The Fuhrer and the People.
 Berkeley and Los Angeles, 1975.
Stiftung Seebüll Ada und Emil Nolde. Jahrbuch 1958/59.
Stolper, Gustav. The German Economy: 1870 to the
 Present, trans. by Toni Stolper, New York, 1967.
Sydow, Eckart von. Die deutsche expressionistische
 Kultur und Malerei. Berlin, 1920.
Taylor, Harold. Art and the Intellect. New York,
 1960.
Urban, Martin. Emil Nolde, Aquarelle und
 Handzeichnung. Seebüll, 1971.
 _____. Emil Nolde, Aquarelle und Handzeichnungen
 aus dem Besitz der Stiftung Seebüll Ada und Emil
 Nolde. Bremen, 1971.
 _____. Emil Nolde, Blumen und Tiere; Aquarelle und
 Zeichnungen. Köln, 1972.
 _____. Emil Nolde. Festival Lyons. Lyons, 1969.
 _____. et al. Emil Nolde, Gemalde, Aquarelle,
 Zeichnungen und Druckgraphik, Köln, 1973.
Urban, Martin, Emil Nolde Landschaften: Aquarelle und
 Zeichnungen, Köln, 1969.
 _____. Emil Nolde Masken and Figuren. Bielefeld,
 1971.
 _____. Emil Nolde, Woodcuts, Lithographs, Etchings.
 Chicago, 1969.
 _____. Nolde, Ungemalte Bilder 1938-1945. Seebüll,
 1971.

250

Urban, Martin. "Unpainted Pictures" Emil Nolde. New
 York & London, 1966.
Walden, Herwarth. Expressionismus. Berlin, 1919.
Winkler, Walter. Psychologie der Modernen Kunst.
 Tübingen, 1949.

Essays and Journal Articles
Barzun, Jacques. "History: The Muse and Her Doctor."
 The American Historical Review, 77, No. 1
 (February, 1972).
Brenner, Hildegard. "Die Kunst im politischen
 Machtkamp 1933/34." Vierteljahrshefte für
 Zeitgeschichte, Heft I. (Januar, 1962).
Dowling, Joseph A. "Psychohistory and History:
 Problems and Applications." Psychoanalytic
 Review, 59, No. 3 (Fall, 1972).
Fehr, Hans. "Gespräche mit Nolde im Jahre 1908."
 Kontrapunkt: Jahrbuch der freien Akademic der
 Kunste. Hamburg, 1956.
Glaser, H. J. "Die Tage von Utenwarft." Deutscher
 Volkskalender Nordschleswig 1972. Aabenraa,
 1972.
Gordon, Donald E. "Kirchner in Dresden." The Art
 Bulletin, XLVIII, No. 34 (September-December,
 1966).
Graf, Otto Antonia. "Kampf um Möglichkeiten."
 Museum des 20. Jahrhunderts, Katalog 23. Wien,
 1965.
Heise, Carl Georg. "Ansprache zur Eröffnung der Nolde
 Ausstellung in München." Der gegenwärtige
 Augenblick: Reden und Aufsätze aus vier
 Jahrzehnten. Berlin, 1960.
Heise, Carl George. "Emil Noldes religiose Malerei."
 Ibid.
Hentzen, Alfred. "Emil Nolde: Zum Gedächtnis."
 Kontrapunkt: Jahrbuch der freien Akademie der
 Kunste. Hamburg, 1956.
Hesse-Frielinghaus, Herte. "Karl-Ernst Osthaus und
 Emil Nolde." Hagener Heimatkalender 1966.
 Hagen, 1966.
Jens, Walter. "Der Hundertjährige: Emil Nolde."
 Von deutscher Rede. München, 1969.
Jorn, Karl. "Ada und Emil Nolde auf Alsen 1902-1916."
 Deutscher Volkskalender Nordschleswig 1972.
 Aabenraa, 1972.
Kren, George M. "Psychohistorical Interpretations of
 National Socialism." German Studies Review, 1,
 No. 2 (May, 1978).
Kuppers, Paul Erich. "Emil Nolde." Das Kunstblatt,
 2. Jahrgang, Heft 11, 1918.

Leonhardi, Klaus. "Das Selbstbildnis bei Emil Nolde."
 Niederdeutsche Beiträge zur Kunstgeschichte,
 Band II. München/Berlin, 1962.
Loewenberg, Peter. "The Psychohistorical Origins of
 the Nazi Youth Cohort." The American Historical
 Review, 76, No. 5 (December, 1971).
Markle, Durward J. "Freud, Leonardo and the Lamb."
 Psychoanalytic Review, 57, No. 2 (Spring, 1970).
Mink, Louis O. "The Autonomy of Historical
 Understanding." History and Theory, V, 1
 (1966).
Pois, Robert A. "German Expressionism in the Plastic
 Arts and Nazism: A Confrontation of Idealists."
 German Life & Letters, XXI, No. 3 (April, 1968).
_____. "Historicism, Marxism and Psychohistory:
 Three Approaches to the Problem of Historical
 Individuality." The Social Science Journal,
 13, No. 3 (October, 1976).
Pois, Robert A. "The Cultural Despair of Emil Nolde."
 German Life & Letters, XXV, No. 3 (April, 1972).
Rabinbach, Anson G. "The Aesthetics of Production in
 the Third Reich." Journal of Contemporary
 History, XI, No. 4 (October, 1976).
Rom, Paul. "Some Modern Paintings and their Painters.
 Journal of Individual Psychology, 29, No. 2
 (November, 1973).
Sauerlandt, Max. "Zu einigen Aquarellen Emil Noldes."
 Das Kunstblatt, VII Jahrgang, Heft 8 (August
 1924).
_____. "Emil Nolde." Zeitschrift für bildende Kunst,
 neü Folge, funfundzwanzigster Jahrgang.
 Leipzig, 1914.
Schapiro, Meyer. "Leonardo and Freud: An Art-
 Historical Study." Journal of the History of
 Ideas, XVIII, No. 2 (April, 1956).
Schardt, Alois J. "Nolde als Graphiker." Das
 Kunstblatt, XI Jahrgang, Heft 8, 1927.
Schiefler, Gustav. "Emil Nolde." Zeitschrift für
 bildende Kunst, Neü Folge, neunzehnter Jahrgang.
 Leipzig, 1908.
Schmidl, Fritz. "Psychology and History."
 Psychoanalytical Quarterly, 31, No. 4 (1962).
Schmidt, Paul Ferdinand. "Emil Nolde." Junge Kunst,
 Band 53. Leipzig and Berlin, 1929.
Schorske, Carl E. "Politics and the Psyche in
 fin-de-siècle Vienna: Schnitzler and
 Hofmannstahl." American Historical Review, LXVI,
 No. 4 (July, 1961).

252

Segal, Hanna. "A Psychoanalytical Approach to
 Aesthetics." M. Klein, et al., eds., New
 Directions in Psychoanalysis: The Significance
 of Infant Conflict in the Pattern of Adult
 Behavior. London, 1971.
Stites, Raymond S. "Alfred Adler on Leonardo da
 Vinci." Journal of Individual Psychology, 27,
 No. 2 (November, 1971).
Urban, Martin. "Gedanken zur Kunst Emil Noldes."
 Kunst in Schleswig-Holstein 1952. Flensburg,
 1952.
_____. "Munch/Nolde: The Relationship of their
 Art." Munch/Nolde, Marlborough Fine Arts.
 London, 1969.
Wangh, Martin. "National Socialism and the Genocide
 of the Jews: A Psycho-Analytic Study of a
 Historical Event." International Journal of
 Psycho-Analysis, 45 (1964).
Wiesenhutter, Alfred. "Emil Nolde." Die Furche, in
 neür Folge Herausgegeben von Otto Schmitz, XVI
 Jahrgang. Berlin 1930.
Wyatt, Frederic. "A Psychologist Looks at History."
 Journal of Social Issues, 17, No. 1 (Spring,
 1961).

Index

Academie Julien, 40.
"Adam and Eve;" Nolde's use of theme to emphasize sexual tension, 130-131.
Adler, Alfred, 31.
Adorno, T. W., x, 206, 208-211, 219.
"Allegorie d'Avalos," 40.
"Allegorie d'Avalos," as revealing Nolde's concerns with sexual tensions, 44.
America, Nolde's attitude towards, 176.
Anti-Semitism, 94.
Anti-Semitism, growth of, 6-7.
Anti-Semitism, Nolde's tendency towards, 89, 95-98. (See also "Jews".)
Arendt, Hannah, 14, 17.
Arp, Hans, 18.
Art Nouveau, 11.
Artistic Personality, 153 ff.
Asian Journey of 1913-1914, Nolde's, 115 ff., 121.
"Audience in the Cabaret," 89.
Auschwitz, 198.
Authoritarian family, threat to, 165, 216, 226, 232-233.
Authoritarian Personality, The, 206, 209.
Authoritarian Personality, Nolde as, 206 ff.

Bahr, Hermann, 14, 15.
Bang, Hermann, 176.
Barlach, Ernst, 192.
Barzun, Jacques, xxvii, fn.
Bauhaus, 194.
"Before Dawn," xxx, 46-47.
Benn, Gottfried, 195, 210.
Beres, David, xxix.
Berlin Secession, 1904, 94.
Berlin Secession, 1906, 65, 73.
Berlin Secession, 1908, 81.
Berlin Secession, 1910, 95, 96, 98, 99.
Bernays, Minna, 57 fn.
Biermann, Georg, 178.
Bismarck, Otto von, 34, 127, 166.
Blaue Reiter, Der, 16, 104.
Böcklin, Arnold, 39, 40.
Bodo, Wilhelm von, 133.
"Border Areas," effect on art, 212, 216.
"Border Man," Nolde as, 126, 147 fn., 211, 229.
Boyen, Herr, 23, 24.
Brest-Litovsk, Treaty of, 180.
Breton, Andre, 245 fn.

Breysig, Kurt, 134.
Brücke, Die, 11, 12, 13, 72, 74, 75, 95, 104, 178, 229.
Buchenwald, 198.

Cassirer, Bruno, 73.
Cassirer Brothers, 74.
Cassirer, Paul, 59 fn. 73, 95, 133, 159, 177, 190.
Cezanne, Paul, 81, 98.
Chagall, Marc, 78.
Chamberlain, Houston Stewart, 102, 191.
Charcot, J. M., 57 fn.
China, Nolde's reaction to, 116.
Christ, 67.
"Christ and the Adultress," 137.
"Christ and the Children," 90, 129.
Christ, identified with man's "Oedipal Period," 146 fn.
"Christ in Bethany," 90.
Christ, Nolde's identification with, 25, 82, 84-85, 90-91, 93, 103-104, 129-130, 137-138.
Civilization and its Discontents, 235.
Class and Political Dangers, effects on art, 212-216, 228-229.
Colonialism, Nolde's hostility towards, 116-118, 179.
Color, Nolde's experiments with, 76-79, 83, 86, 105.
Communism, Nolde's opinion of, 187.
Conservative Party, 185.
Constable, John, 39.
Corinth, Lovis, 73.
"Crucifixion," 129.
Cubism, Nolde's dislike of, 142, 229.

Dadaism, 18.
"Dancing Partners," 88.
Danish Aborption of North Schleswig, Nolde's reaction to, 126, 136.
Dante, 67, 69.
Degas, Edgar, 98.
Denmark and Norway, Nazi invasion of, 196.
Depression (1930s), 231.
Der Sturm, 11.
"Devil and Scholar," 126.
Donagan, Alan, xxvii, fn.
Donatello, 69.
Dreams, Nolde's interest in, and possible interpretations of, 240 ff.
Dühring, Eugen, 102, 191.
"Dune Spirits," xxx.
Dürer, Albrecht, 81.

Eckhardt, Meister, 223.
Ego-psychology, xix-xx.
Eliot, T. S., 210.
England, Nolde's attitude towards, 118.
"Encounter," xxx, 64.
Ensor, James, 99-100.
"Entombment," 121-122, 124, 129.
Erdmann, Jolantha, 219.
Erikson, Erik, xxvii, 165, 219, 226.
Ernst, Max, 18.
"Exhibition of Degenerate Art," 1937, 195.
Expressionism, xii-xiii, 3, 11 ff., 17, 18, 229;
 defense of as "German Art," 193-194; Nazi need for
 rejection of, 234, romantic nature of, 124, 228.
Expulsion from Reichskammer, Nolde's response to,
 196-197, 199-200.
Ewald, Carl, 47.

"Fantasies," 74.
Fascism, x, 219, 229.
Father, influence of and Nolde's relationship to,
 22-23, 25, 27, 29, 33, 45-46, 52, 76, 85, 90, 94,
 149 ff., 158, 166, 205-206, 217, 219, 229.
Faust, 102.
Fauvists, 17, 106.
Fechter, Paul, 19 fn.
Fehr, Friedrich, 39.
Fehr, Hans, 35, 38, 40-44, 49, 52, 63, 66-67, 71, 74,
 77, 98-100, 106, 125, 132-133, 136, 144, 173 fn.,
 180, 185-187, 196-197, 223, 229; as father figure,
 51, 133.
Fehr, Nelly, 63, 133, 186.
Festschrift, 1927, 134-135.
Fischer, Otto, 134.
Flowers, Nolde's interest in, 76-77, 79-80.
Folkwang Museum, 72, 102.
Fraiberg, Louis, xxi.
France, Nolde's dislike of, 128, 180-181.
Frankel-Brunswick, Else, 206.
"Free Spirit," xxx, 75-76, 84.
Freud, Sigmund, ix, xviii-xix, 1, 24, 26, 28, 57 fn.,
 67, 110-111 fn., 151, 157, 168, 208, 215, 235,
 245 fn.; attitude towards aesthetics of, xxix-xx,
 xxii-xxiii, xxv; psychoanalytical method of,
 xiv-xvi.
Friedrich, Casper David, 140.
Futurists, 99.

Gauguin, Paul, 11, 81, 98, 117.
Gedo, John E., xxviii fn.

General Introduction to Psychoanalysis, xxii.
"German Art," Nolde's interest in, 98-99, 102, 178.
Gestalt psychology, xxv.
Gide, Andre, 1.
Glaser, H. J., 119, 167.
Goebbels, Paul Josef, 191-192, 195, 216.
Goethe, Johann Wolfgang von, 78.
Gombrich, E. H., xxix, fn.
Goppeln, xiii.
Gorki, Maxim, 35.
Gosebruch, Ernst, 134.
Gosebruch, Martin, 188.
Gotha Program of 1875, 5.
Goya, Francisco, 39, 40.
Graef, Botha, 86, 99, 106.
Graf, Otto Antonia, 48-49, 67, 118, 160, 219.
Greenacre, Phyllis, xxi, 153, 154, 155, 172 fn.
Gründerzeit, 7.
Grünewald, Mathias, 81.
Gypsies, Nolde's fascination wity, xiii, 52, 128.

Haftmann, Werner, 147 fn.
Haig, Douglas, 160.
Hallig Hooge Experience, 126-127, 132, 160.
Hamburg Harbor, etchings of, 86, 89.
Hamsun, Knut, 35.
Hansen, Christine (Nolde's sister), 21.
Hansen, Hans (Nolde's brother), 21, 63.
Hansen, Leonhard (Nolde's brother) 21, 23.
Hansen, Nikolai (Nolde's brother), 21.
"Harvest Day," 65, 73.
Hauptmann, Gerhardt, 8, 210.
Heartfield, John, 18.
Heckel, Ernst, 13, 75.
Heidegger, Martin, 195, 210.
Heimat, identification with mother, 163-164, 216
 (see also "Mother").
Heinz, Dieter, 25, 46.
Heise, Georg, 83.
Hentzen, Alfred, 219.
Herder, Johann Gottfried, 99, 189, 227.
Hesse-Frielinghaus, Herta, 73.
Himmler, Heinrich, 216.
Hitler, Adolf, 57 fn., 194, 216, 230.
Holbein, Hans, 81.
Hölzel, Adolf, 39-40.
"Homecoming," xxx, 64.
Humanity, Nolde's dislike of, 68, 132.

Ibsen, Henrik, 35, 99.

"If you do not Become as Little Children," xxx, 137.
Impressionism, 11, 64, 99, 163, 178.
Industrialization, German, 3 ff.
Isenheim Altar, 102, 134.
Italian Fascism, 210.
Italian visit of 1904, 1905, Nolde's, 69-71.

Jahn, Friedrich Ludwig, 160.
Japan, Nolde's negative attitude towards, 115.
Jens, Walter, 87, 167.
Jews, Nolde's attitudes towards, x, 89, 91, 93, 94, 97-98, 102, 106, 149 ff., 163, 177, 191, 205, 217 (see also "Anti-Semitism, Nolde's tendency towards").
Jorn, Karl, 66.
"Joseph Explains his Dreams," 91, 92.
Jung, Carl Gustav, 1, 31.
Junge Kunst series, 135.

Kandinsky Wassily, 16, 17, 78, 81, 96, 143, 177.
Kaplan, Abraham, xxi.
Keller, Dieter, 198.
Kerr, Alfred, 95.
Kirchner, Ernst Ludwig, xiii, 12, 13, 16, 75, 178, 196.
Klee, Paul, 96, 134, 135, 138, 143, 177.
Klein, Melainie, 171 fn.
Klimt, Gustav, 12.
Kokoschka, Oskar, 12, 96, 177.
Kreitler, Hans and Shulamith, 78, 142.
Kretschmer, E., 25, 31.
Kris, Ernst, xx, 172 fn.
Kunst der Nation, 194.
Kunst und Künstler, 95.
Küppers, Paul Erich, 123, 124.

Lagarde, Paul de, 7, 216.
Landscapes, Nolde's emotional involvement with, 138-140.
Langbehn, Julius, 7, 134, 216, 227.
Le Bon, Gustav, 1.
Leistikow, Walter, 73.
Lenz, Siegfried, The German Lesson, 199, 205.
Leonardo da Vinci, xxiv, 35, 69, 82-83, 98, 110-111 fn.
Leonhardi, Klaus, 61.
Levinson, Daniel J., 206.
Liebenfels, Lanz von, 216.
Liebermann, Max, 39, 73-74, 95, 133, 152, 177, 190.
Lildstrand Experience, 48-50, 53, 64-65, 126, 139.

Loewenberg, Peter J., 171 fn., 172 fn., 242.
Loewenstein, Rudolph, 146 fn.
Louvre, 40.

Madsen, Paul, 119-120.
Manet, Edouard, 81, 98.
Marc, Franz, 16, 17, 18, 96, 141, 177, 188.
Marees, Hans von, 39.
Mark, Wilhelm, 191.
Marxism, 1, 2.
Marziani, 69, 70.
"Martyrdom," 128-130.
Mary, as Nolde's mother, 104.
Mary, Jewishness of, 103.
"Mary of Egypt," 93, 105, 122.
May, Rollo, xxvii, fn.
McDougall, William, 1.
Michelangelo, 98.
Mink, Louis O., xxvii, fn.
Modersohn-Becker, Paula, xiii.
Moltke, Helmuth von, 33, 166.
Monet, Claude, 41, 98, 133.
"Moonlit Night," 64.
Moscow Debates of 1937-1938, xiii.
Mother, Nolde's relationship to, 24, 26-27, 29, 32,
 33, 35-36, 45-46, 47, 63, 76, 80, 85, 89, 90-91,
 94, 122, 149 ff., 158, 166, 175, 205-206, 217, 229.
Muhammed, 67.
Müller, Otto, xiii, 13.
Munch, Edvard, 11, 74, 80, 102.
Murphy, Gardner, xxi.

National Socialism, x-xi, 18, 70, 94, 96, 159, 187-
 188, 190 ff., 218-219; aestheticizing efforts of,
 215-216; as substitute for true revolution, 230-
 231
National Socialist Party (Danish Branch), Nolde's
 joining of, 187.
National-Sozialistischer Deutscher Studentenbund,
 p. 192.
Nationalism, psychological role of, 164 ff.
Nature-worship, Nolde's tendency towards, 72.
Nelson, Benjamin, xxviii, fn.
Neo-Realism, 18.
Neue-Sezession, 104.
Niebüll, 239.
Nietzsche, Friedrich, 34, 67, 102, 166; comparison of
 Nolde with, 223-225.
Nolde, Ada (neé Vilstrup), 58 fn., 62-63, 73, 82, 100,
 106, 119, 180, 196, 198, 219 (see also Vilstrup,
 Ada); 1904 Berlin experience of, 66-67.

Nolde Museum, 239.
Nolte, Ernst, 214, 230-231.
Non-representational art, Nolde's dislike of, 141-143, 229.
"Northern art," Nolde identified with, 123-124, 134-135.
NS-Gemeinschaft Kraft durch Freude, 194.
Nye, Gerald, 120.

Old Testament Paintings, 89, 91, 93-94; differences between them and New Testament Paintings, 91-93.
Osthaus, Gertrud, 73.
Osthaus, Karl-Ernst, 72, 99, 102, 106.

"Paradise Lost," 130-131, 195.
Pastor, Willy, 98.
Pauli, Gustav, 134.
Pechstein, Max, xiii, 13, 178.
Peguy, Charles, 183 fn.
"Pentecost," xxx, 82, 83, 85, 92, 95, 100, 122, 129.
"Pharaoh's Daughter Discovering Moses," 91, 92, 93.
Picasso, Pablo, 185.
Pierro della Francesca, 69.
Pissarro, Camille, 41, 133.
Pois, Anne Marie, 147 fn.
Political Remonaticism, dangers of xi-xii, 232 ff.
Pollock, George H., xxviii, fn.
Pound, Ezra, 210.
Primitivism, Nolde's interest in, 87, 100, 151, 159, 178-179, 186, 205.
Probst, Rudolf, 134.
Proust, Marcel, 1.

Racism, Nolde's tendency towards, 41-42, 70, 81, 177, 189-190.
Rank, Otto, 156, 157.
Raphael, 98.
Rasmussen, Kund, 47-48.
Read, Herbert, 14, 17.
Reich, Wilhelm, 24, 164, 188. 226.
Reichskammer der Bildenden Kunste, 196.
Reinhardt, Max, 198.
Religion, Nolde's early interest in, 24.
Rembrandt, 40.
Renoir, Pierre Auguste, 41, 98.
Rickman, John, 109 fn., 156.
"Ridicule," xxx, 82, 83, 84, 85, 122.
Rodin, Auguste, 98.
Roethal, Hans Konrad, 12.
Romanticism and "Idealized Past," 227-228.

Rosenberg, Alfred, 97, 191-192, 194-195, 216.
Rousseau, Henri, 11.
Rubenstein, Richard, 229.
Ruitenbeek, Hendrik, xxvii fn., xxix fn.
Russian Revolution, Nolde's awareness of, 181.
Rutherford, Ernest, 16.

Sachs, Hanns, xx, xxix fn., 154.
Sanford, R. Nevitt, 206
Sauerlandt, Max, 82-83, 103, 105, 106, 115, 121, 123,
 124, 133, 134, 193, 194, 196, 240.
Schäfer, Wilhelm, 72.
Schapiere, Rosa, 80, 95, 177.
Schapiro, Meyer, 111 fn.
Schardt, Alois, 134, 193, 194.
Scheffel, Viktor, Ekkehard, 223.
Schiefler, Gustav, 74, 80, 99, 106, 120.
Schiller, Friedrich, his distinction between "naive"
 and "sentimental," 179-180.
Schirach, Baldur von, 197-198.
Schleswig-Holstein; Nolde's reactions to political
 and technological changes in, 175-176.
Schleswig Holstein, plebiscite in, 125.
Schmidt, Paul Ferdinand, 135.
Schoenbaum, David, 4.
Schmidt-Rottluff, Karl, 13, 16, 74, 75.
Schorske, Carl E., 211-212, 213.
Schreiber, Otto Andreas, 193, 194.
Seebüll, 136-137, 239.
Self-dramatization, Nolde's tendency towards, 70,
 117, 119, 160-161, 217.
Self-portraits, Nolde's involvement with, 61-62.
Selz, Peter, 17, 38, 64, 65, 75, 82, 83, 91, 94,
 100, 105, 121, 122, 137, 138, 217, 218, 229.
"Sentimental Man," Nolde as, 180.
Shakespeare, William, 134.
Signac, Paul, 81.
Silesian, plebiscite in, 125.
Sisley, Alfred, 98, 133.
Slevogt, Max, 73.
Social Democratic Party, 186; Nolde's support of,
 185.
Soldaten pictures, 106.
"Solomon and his Wives," 93.
Sonderbund, Cologne, 104.
Spain, Nolde's reaction to, 128.
Spector, Jack J., xix.
"Spring Indoors," xxx, 64, 65, 73.
Stannard, David E., xxvii fn.
State authority, as father figure, 216, 219, 228.

Stern, Fritz, x, 7, 176.
Stern, J. P., 230.
Stites, Raymond, S., 111 fn.
Stolper, Gustav, 5.
Strauss, Richard, 8.
Strindberg, August, 35, 41.
Stuck, Franz von, 38, 39, 57 fn.
"Sultry Evening," 138-139, 141.
Sylt, Island of, 239.
"The Clever and Foolish Maidens," 90, 115.
"The Dance around the Golden Calf," 91, 92, 93.
"The Eternal Jew" (film), 198.
"The Fanatic," xxx, 126.
"The Last Supper," xxx, 82, 84, 115, 122.
"The life of Christ," xxx, 98, 100-104, 195.
"The Prophet," 106.
"The Street," 178.
"The Temptation of Joseph," 91, 92, 93.
Tillberg, Herr, 74.
Titian, 40, 44, 69, 98.
Treblinka, 198.
"Trophies of the Wild," 179.
Trosman, Harry, 155.

"Unpainted Pictures," 218-219.
Urban life, Nolde's attitudes towards, 72, 86-89, 94,
 162-163, 176-179, 205, 217.
Urban Martin, 44, 58 fn., 79, 86, 140, 147 fn.

"Vacation Guests," xxx, 105.
Van Gogh, Vincent, 11, 65, 75, 77, 80-81, 98, 112 fn.
Versailles, Treaty of, 127.
Vienna, role of art in fin de siècle, 211-213.
Vilstrup, Ada, 47-51, 53; as mother figure, 51-52
 (see also Nolde, Ada).
"Volk Art," debate over, 192-194.
Völkischer Beobachter, 192.

Wagner, Richard, 216.
Walden, Herwarth, 96, 177.
Wandervögel, 7.
Wangh, Martin, M.D., 56 fn., 112.
Watts, George, 39, 40.
Wedekind, Frank, 1, 8, 35.
Westheim, Paul, 135.
Westerland, 139.
Whistler, James, 39.
Wiesenhutter, Alfred, 160.
"Wildly Dancing Children," 93.
Wilhelm II, 62, 127.

Wilson, Woodrow, 125.
"Windmill," 138, 141.
Winkler, Walter, 25, 31, 46.
Wittner, Max, 35, 41-42, 50, 58 fn., 67, 177.
Wolf, Ernest S., xxviii fn.
Women, Nolde's attitudes towards, 30-31, 36-37,
 43-45, 47, 65, 88-89, 150, 161-162.
World War I, Nolde's reactions to, 118-119, 120,
 125, 132.
Worpswede, xiii.
Worringer, Wilhelm, 14, 16, 142.

Zarathustra, 223, 225.
Ziegler, Adolf, 196.
Zeitschrift für bildende Kunst, 123.
Zimmer, Heinrich, 135.
Zionism, Nolde's interest in, 190.

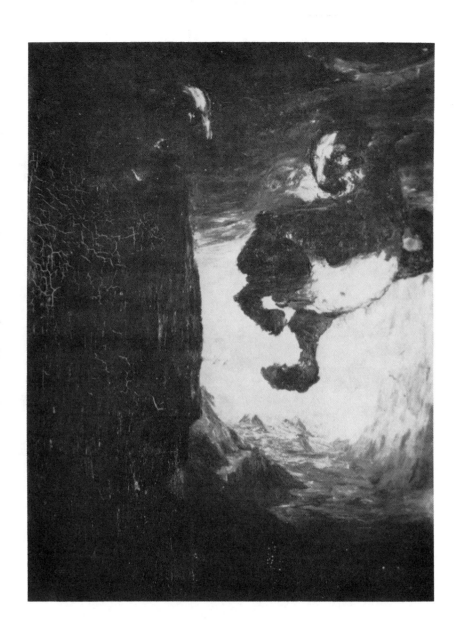

"BEFORE DAWN"

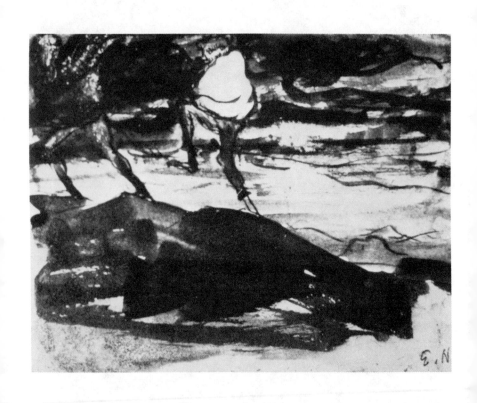

"DUNE SPIRITS"

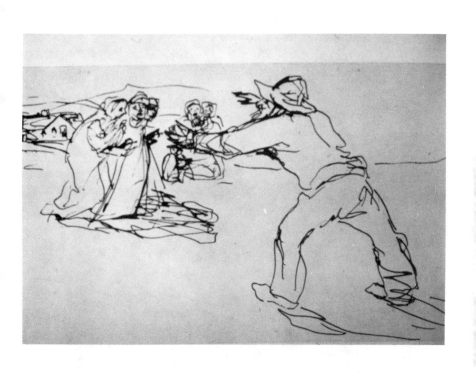

"HOMECOMING"

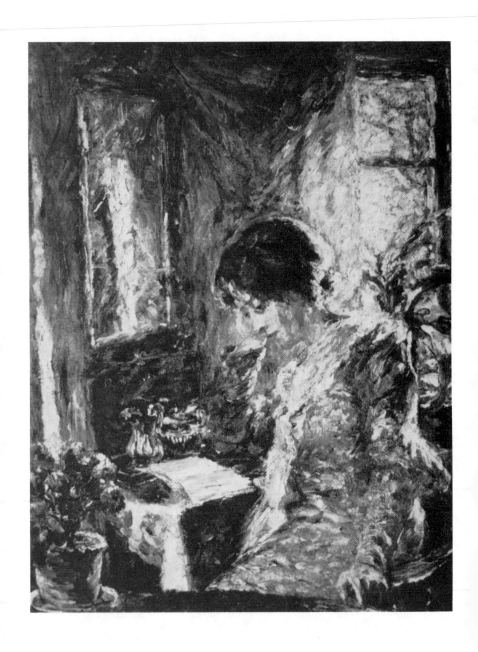

"SPRING INDOORS"

"ENCOUNTER"

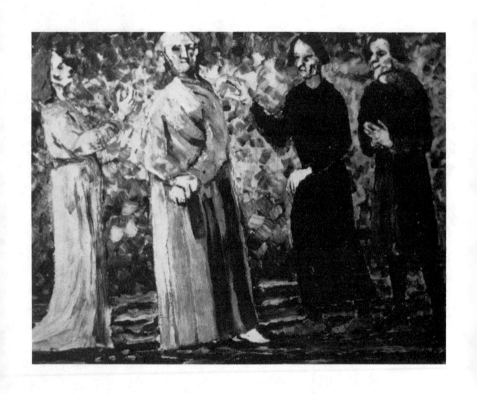

"FREE SPIRIT"

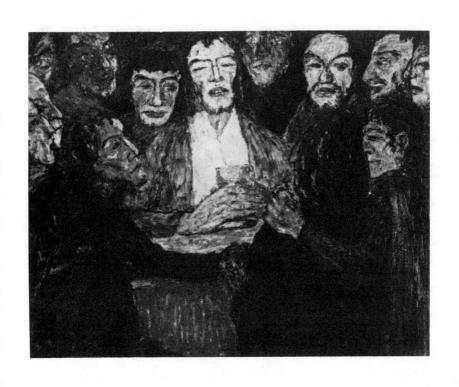

"THE LAST SUPPER"

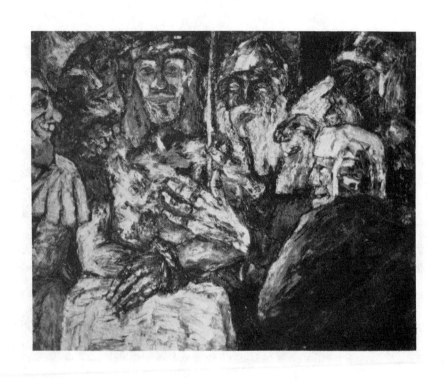

"RIDICULE"

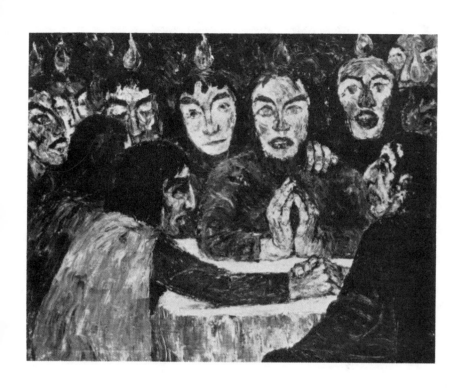

"PENTECOST"

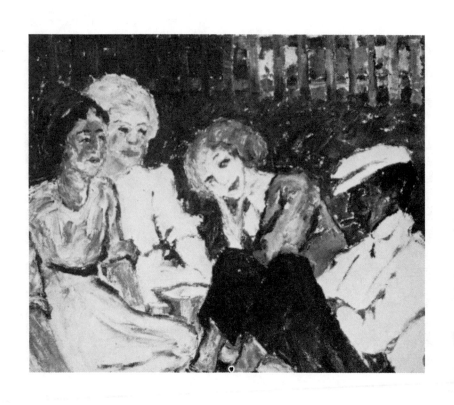

"VACATION GUESTS"

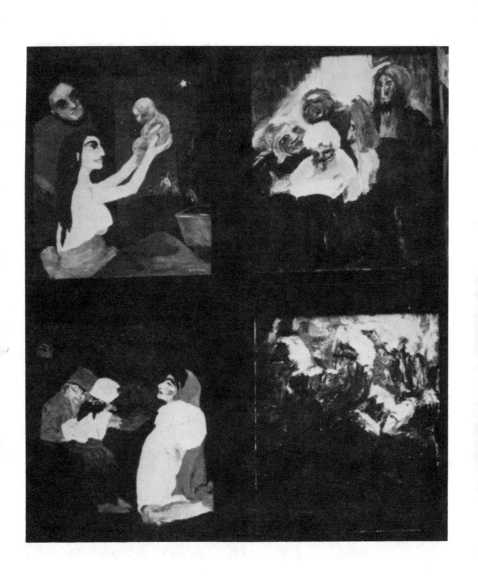

"THE LIFE OF CHRIST"

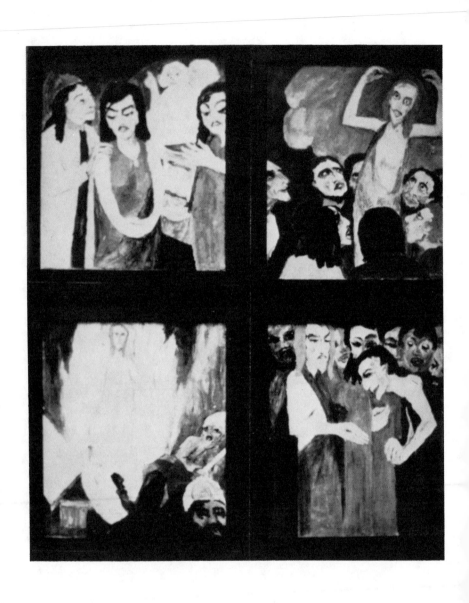

"THE LIFE OF CHRIST"

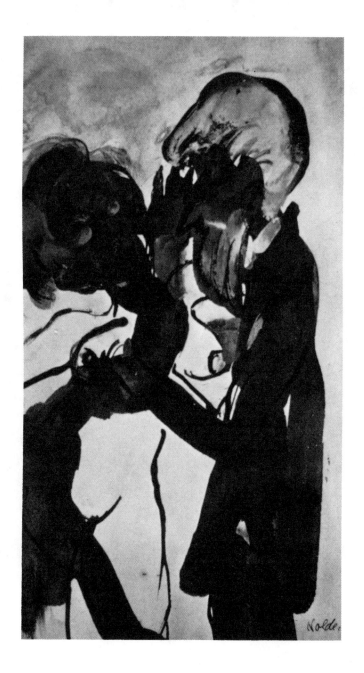

"THE FANATIC"

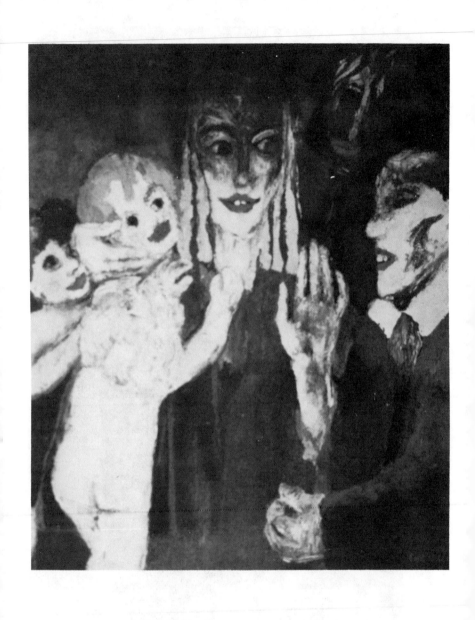

"IF YOU DO NOT BECOME AS

LITTLE CHILDREN"

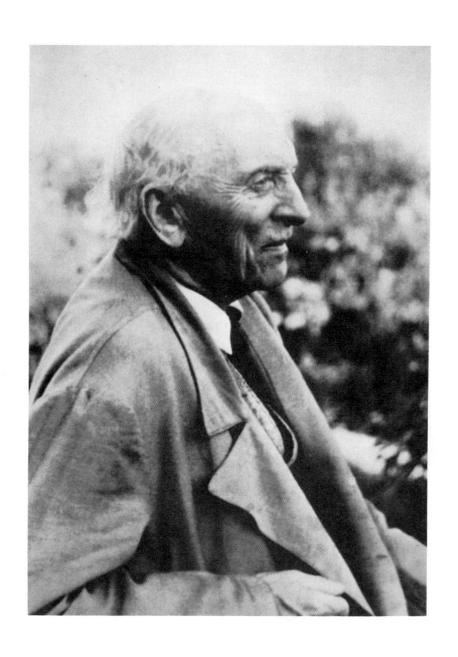

EMIL NOLDE: 1867-1956